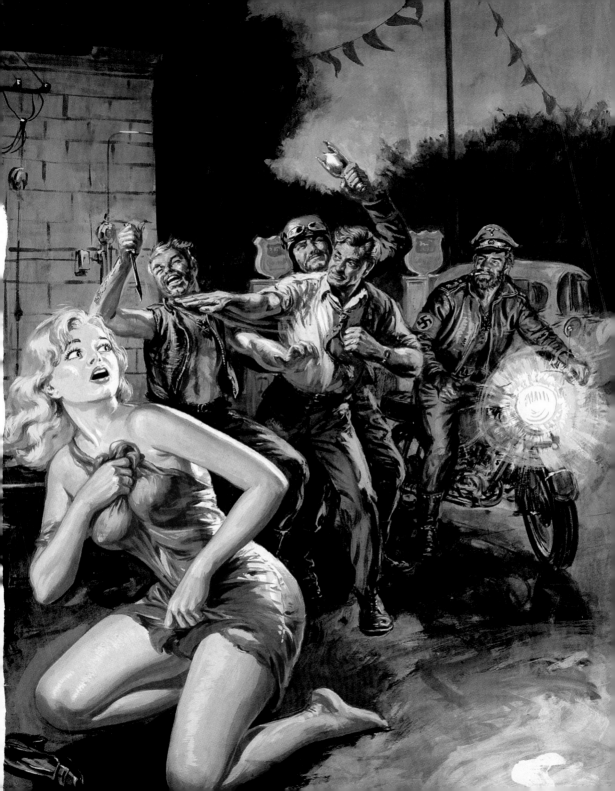

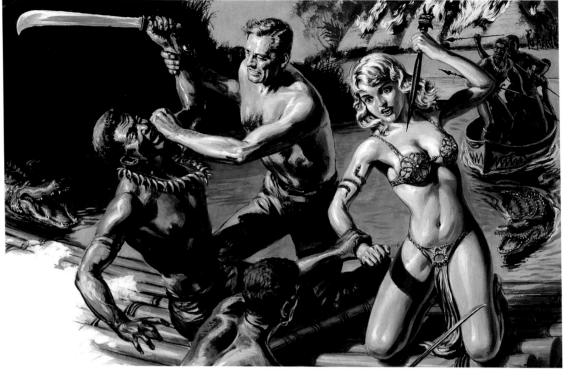

NEW MAN, 5/1965, Norman Saunders, gouache, 54 x 40 cm
◄◄ **MAN'S STORY**, 10/1968, Norman Saunders

All images are from the collection of Rich Oberg unless otherwise noted. Any omissions for copyright credit are unintentional and appropriate credit will be given in future editions if such copyright holders contact the publisher.

The December 1953 Cover of Playboy Magazine is © 1953 by Playboy and is used courtesy of Playboy.

Original paintings by Gil Cohen are © and courtesy Gil Cohen
Original paintings by Rafael DeSoto are © Rafael M. DeSoto and courtesy of Rafael M. DeSoto Estate
Original paintings by Norm Eastman are © and courtesy Norm and Jane Eastman
Original paintings by Basil Gogos are © and courtesy Basil Gogos
Original paintings by Earl Norem are © and courtesy Craig Clemments and Earl Norem
Original paintings by Samson Pollen are © and courtesy Samson Pollen
Original paintings by Norman Saunders are © Norman Saunders and courtesy www.normansaunders.com

Images on the following pages are courtesy of George Hagenauer: 9 all, 10, 13, 14 middle, 21, 26, 28, 30, 33, 42

A note on the captions: Due to the sometimes anonymous nature of painting for men's adventure magazines, a substantial number of covers cannot be attributed to any given artist. Only in cases of confident identification is the artist listed after the publication name and date (month/year). All original paintings in the book were done on illustration board, a fact omitted from the captions for reasons of space.

To stay informed about upcoming TASCHEN titles, please request our magazine at www.taschen.com/magazine or write to TASCHEN, Hohenzollernring 53, D-50672 Cologne, Germany, contact@taschen.com, Fax: +49-221-254919. We will be happy to send you a free copy of our magazine which is filled with information about all of our books.

© 2008 TASCHEN GmbH
Hohenzollernring 53, D–50672 Köln
www.taschen.com

Editors: Jim Heimann & Nina Wiener, Los Angeles
Cover design: Sense/Net, Andy Disl and Birgit Reber, Cologne
Design: Steve Vance, Modern Art & Design, Los Angeles
Digital scans: Artworks, Pasadena
Production: Tina Ciborowius, Cologne
Project management: Sonja Altmeppen & Christiane Blass, Cologne
Copyeditor: Janet Duckworth, Los Angeles
German translation: Anke Burger, Berlin
French translation: Daniel Roche, Paris

Printed in China
ISBN 978-3-8365-0312-9

MEN'S ADVENTURE MAGAZINES IN POSTWAR AMERICA

The Rich Oberg Collection
Text by Max Allan Collins and George Hagenauer
With an essay by Steven Heller

TASCHEN

HONG KONG KÖLN LONDON LOS ANGELES MADRID PARIS TOKYO

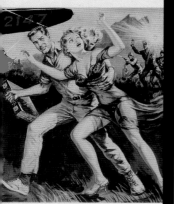

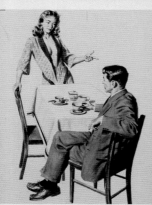

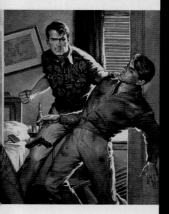

MEN'S ADVENTURE MAGAZINES
IN POSTWAR AMERICA

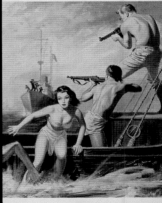

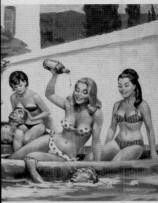

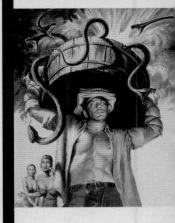

BLOOD, SWEAT, AND TITS

A HISTORY OF
MEN'S ADVENTURE MAGAZINES

A beautiful blonde is draped upside down over a cylindrical metal cage, her hands chained to her feet, her full breasts straining against her tattered blue dress. A bare-chested, sweat-slicked, Nazi soldier slowly turns the crank that moves the cage over a fire pit before a swastika-emblazoned wall. "Sizzle, My Sweet, in the Flames of the Damned!" screams the headline of this "true" story of wartime adventure.

The magazine in hand is *Man's Story*, February 1966; its riveting cover painting is the work of prolific illustrator Norm Eastman. Across the top a banner asks, "How Normal Are Your Sex Needs?" In one corner, a tiny photo of a brown-haired vixen in bra and lace panties reminds the reader that not just history awaits within these pages.

The cover promises other stories — "Smash the Sultan's Fabulous Flesh Palace" and "Exposed: Passion Playground of the Teen Jet Set" — and all for just thirty-five cents, for which the buyer got seventy-four pages of cheap pulp paper depicting these tales as well as three sets of pinup photos, including several of a great Dane named Greta.

As Depression-era ad man Elmer Wheeler put it, "Sell the sizzle, not the steak," a philosophy to which the men's adventure magazines of the fifties, sixties, and seventies religiously adhered. The lurid covers and provocative titles oversold the stories, mostly fictitious "true" tales of women being stripped and tortured. The '66 *Man's Story* cover piece, "Sizzle, My Sweet ...," is a fake reminiscence of a beautiful young German woman who falls in love with a Jew and is condemned to be tortured and raped at a concentration camp as a result. The reporter of course marries her and decides, years after her death, to tell her story. What better way to eulogize his bride?

"Smash the Sultan's Fabulous Flesh Palace" chronicles a young, American, oil wildcatter's exploits in the Middle East, in which he single-handedly saves a beautiful blonde up for auction at an underground slave market in Kuwait. The story showcases a strange vernacular — the villains are all called "zaps" and the "Boss Man smokes a hubble bubble pipe."

One must not overlook the theme of sex education in this issue, though admittedly the "true sex" stories deliver few details about procreation, but plenty of recreation, namely, descriptions of undressing and degradation. "Teen Jet Set" lists locations (beaches, barns, backyards, and more) where teenagers sneak off to undress and have sex, yet the piece is illustrated with a photo of two older adults making out. "How Normal Are Your Sex Needs?" basically reassures the reader that anything consenting adults do is just fine — except, of course, for homosexuality, transvestitism, and masochism.

Readers still hungry for more learning could turn to articles such as "Helpless Brides of the Lash in Stone Hell," a nineteenth-century memoir of an aristocratic ladies' society outing to watch women being tortured the day of their hanging at London's Newgate Prison. "The Lust Escape of the Incendiary Blonde" is a detective story that kicks off with a well-endowed, fair-haired beauty seducing her jailer, including a detailed description of the striptease she performs to lure him into her cell; she then escapes to prove her innocence (that is, of the crime for which she was imprisoned).

To ensure that readers would not succumb entirely to their newfound sense of sexual liberation, the last article is a cautionary tale. "I Joined a Suburban Orgy Cult" by Margaret Sims opens with the line: "The first time you stand naked before a mixed group you think you'll die on the spot." Still, she apparently enjoyed the degradation, describing her experiences over several years of increasingly kinky hijinks with neighbors and others.

The likes of these could be found in the average issue of any men's adventure magazine of the sexually liberated sixties. *Man's Story* and dozens of its ilk spread the gospel of sexual repression — sex is dirty and dangerous — all the while providing sexual titillation for voyeuristic readers, without ever describing any real ... well, sex.

Despite their emphasis on bondage, sadism, and masochism, the men's "adventure," "he-man," or, later, "sweat" magazines were not available solely at adult bookstores or from the secret stash under a newsstand counter. Quite the contrary; they were sold openly at local drug stores and newsstands, displayed along with *Time, Look, The Saturday Evening Post,* and *Ladies' Home Journal.* At their peak in the late fifties, over fifty different incarnations — most with "Man" or "Men" in the title

MEN TODAY, 10/1963, Norm Eastman, acrylic, 42 x 54 cm ▶

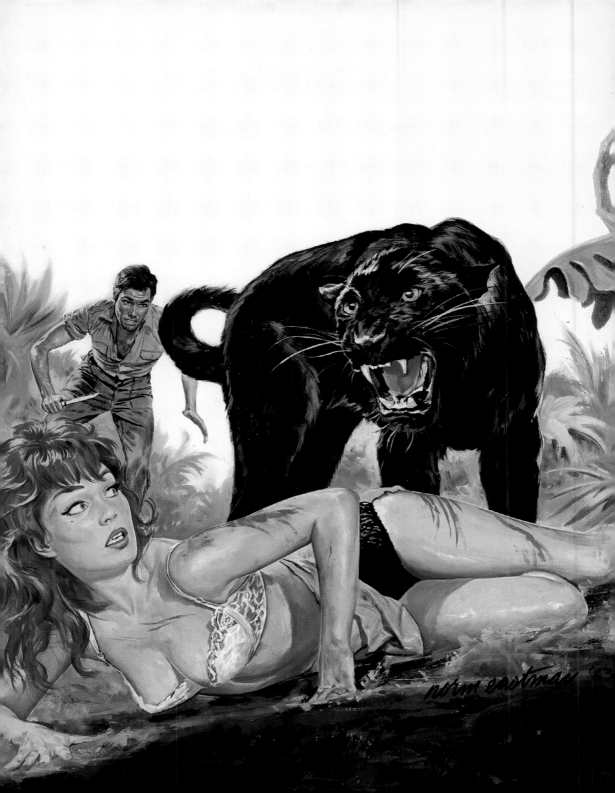

— sold in the hundreds of thousands, not to a small, misogynistic underground within America, but to a significant portion of the male population.

Men's adventure magazines reflected a very real aspect of the male culture of the times; the dark side of America's "greatest generation," the boys-to-men who won World War II. The heroes who beat Hitler and Hirohito came back home to a period of difficult adjustment — a postwar economy that initially had few jobs and a shortage of housing. Many went from their courageous battle to save democracy to unemployment or repetitive, blue-collar manufacturing or service jobs. As horrific as the war was, for many it would be their greatest adventure.

There was also a gap between what the veterans had seen and what the highly censored American press (which forbade photos of dead American soldiers) had reported. Men who had walked through the charred remains of Hiroshima or the gory battlefields of Europe returned to families and friends acquainted only with the sanitized version of the war that had been fed to the home front. Sex with prostitutes or starving refugees, the need to kill a sixteen-year-old kid or be killed, and suicide missions that left battalions decimated were experiences that only other vets could understand.

Men's adventure magazines spoke their language, and reassured an entire generation that they were indeed heroes. They delivered the "true," declassified version of the war, as did countless historical biographies, histories, fiction, comics, and movies dealing with World War II and military life. In addition, for the males who did not serve in the military, the magazines provided the vicarious means to experience the combat they had missed as civilians. The men's adventure magazines were Wisconsin cannibal killer Ed Gein's favorite magazines; Gein, inspiration for half a dozen horror films, including *Psycho*, *The Texas Chainsaw Massacre*, and *The Silence of the Lambs* was even the subject of stories in later sweats. Where else could he have found articles on cannibalism, shrunken heads, and tanning human skin? These were sadistic, conservative publications that were uniquely American, spanning both the McCarthy era and the countercultural sixties.

The "true" stories of the men's adventure magazines sprang from their prede-

PLAYING FAST AND LOOSE WITH THE TRUTH DID NOT SEEM TO HURT SALES.

cessors, the nonfiction detective magazines, which brought the real-life drama of Al Capone and John Dillinger to mass audiences, while the adventure mags' lurid cover paintings had their roots in the fictional pulps. These seven-by-ten-inch, genre-driven magazines — detective, western, science fiction, romance, war — derived their nickname from the cheap, pulp paper on which their black-and-white interiors were printed. Their covers, however, were

Publisher Bernarr Macfadden, the father of the men's adventure magazines.

glossy, lushly painted, full-color extravaganzas, often featuring scenes of imaginative mayhem involving scantily clad women. In a larger, eight-and-a-half-by-eleven size, the later men's adventure covers often pushed this sex-and-sadism angle to an even more outrageous level, with some of the top pulp cover artists finding steady work from this new breed of publication.

Though the men's adventure magazines drew from numerous sources, if the genre had a single father, it was eccentric, American magazine publisher, Bernarr Macfadden.

Born in 1868, Macfadden grew up in the rural Ozarks, poor, sick, and orphaned

by the age of six. His life changed dramatically in his early teens when he discovered physical fitness. German immigrants had brought bodybuilding and gymnasium programs to the United States in the mid nineteenth century and Macfadden began following a regimen of weight training and physical exercise. Within a year, he was a top gymnast, wrestling professionally and selling occasional articles on physical culture to national magazines. However, the health movement — though faddishly popular — was viewed as eccentric humbug by many Americans; and Macfadden received more rejections than checks for his articles. Impressed with the continual sale of his own pamphlets, in 1899 Macfadden began *Physical Culture* magazine from his gym in New York City. Macfadden combined articles on health and nutrition with polemics against modern drugs and medicine. He included photo essays on how to do exercises, liberally illustrated with images of attractive women in bathing suits or tights — the *Playboy* Playmates of the Victorian age. Men were featured too, posing in wrestler's straps, Macfadden himself a frequent model. These photographic testimonials were presented at first as "Artistic Body Photography" and then, more directly, as "The Body Beautiful" sections of the magazine.

In such puritanical times, the illustrations in *Physical Culture* were pretty stuff. Since the risqué photos appeared amid scientific articles on health and fitness, Macfadden avoided many of the problems faced by more lurid publications. Eventually, a series of exposés on the ravages of syphilis would lead to obscenity charges, but a two-year crusade against his conviction prompted a pardon by President Taft.

After World War I, Macfadden prospered as soldiers returned with an increased openness about sex (some had been to France, after all), and many "blue" laws, instituted to regulate moral conduct in colonial times, were relaxed. Ironically, this seemingly unhealthy era of gangsters, bathtub gin, and flappers proved to be most profitable for Macfadden's publishing empire. *Physical Culture* regularly featured testimonials — "I Was Going to Be a Gangster" — describing how physical culture had changed someone's life, complete with the required photos of the barely dressed young bodybuilder. Many of the stories submitted — detailing sordid sexual or criminal aspects of the author's prior life — went beyond the bounds of *Physical Culture*'s

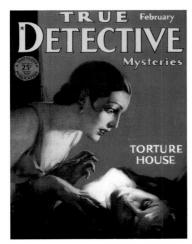

TRUE DETECTIVE MYSTERIES, 2/1930

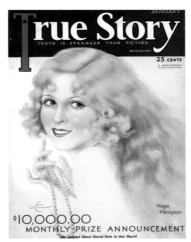

TRUE STORY, 1/1931, Jules Cannert

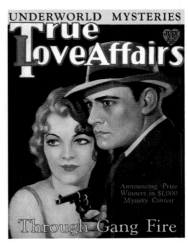

TRUE LOVE AFFAIRS, 7/1929

format, but they were to find a home in Macfadden's new entry, *True Story*.

True Story was composed mainly of first-person narratives of people overcoming tragedies or challenges — from being Hitler's maid to a female leader of the Chinese resistance against the Japanese. The backbone of the magazine (and its many imitators), however, was the romance story: tales of men and women solving problems in their marriages or overcoming dark secrets in their past to attain true love.

While Macfadden felt these stories would attract a large readership, especially among women, he nonetheless faced the challenge of how to illustrate them. The heroine writing "Degradation" or "Love's Cruel Dictum" was a Plain Jane, after all, and did not meet the physical criteria to be pictured in *Physical Culture*. For the covers, Macfadden intended to use compelling paintings by major artists (he had lined up F. Earl Christy, among others); but employing interior drawings to illustrate true stories seemed all wrong.

It occurred to Macfadden that the best way to capitalize on the "truth" would be by staging fake photos. *Physical Culture* already had an in-house photo studio for its Venus and Adonis layouts, so all he had to do was provide the attractive models to bring these real-life tragedies into pictorial being. Some models went on to successful acting careers, including such luminaries as Katharine Hepburn and Frederic March.

Playing fast and loose with the truth, however, did not seem to hurt sales. By

1926, *True Story* had reached an astonishing circulation of two million. By now, the stories had become almost as phony as the photos. Spurred on by large fees — as much as $1,000 in contests seeking sensational "true" stories — many professional writers submitted fictional stories as fact. (Legendary mystery writer Mickey Spillane, for example, passed himself off as an unwed mother numerous times.) Fictional, first-person accounts became all the more prevalent in 1927, after a factual story resulted in a half-million-dollar libel suit, and Macfadden instituted a policy of changing the names of everyone in the stories.

In the meantime, Macfadden had conceived *True Detective Mysteries* in 1924. *True Story* had always run stories about crime — "I Was a Gang Girl," "I Fell in Love with a Gangster." Prohibition was fueling organized gangs like Capone's in Chicago and Lucky Luciano's in New York, sensational murder cases like Leopold and Loeb's thrill killing of young Bobby Franks were boosting newspaper circulation, and writers such as Dashiell Hammett and Carroll John Daly were defining hardboiled crime fiction in the popular pulp magazine *Black Mask*.

True Detective Mysteries targeted the *True Story* approach at a predominantly male audience. Between moonlighting police reporters and staff members rewriting experiences shared by local police detectives and sheriffs, coverage of real crimes was no problem. Inside, *True Detective* published gruesome murder scene photographs that newspapers dared not run —

though it cloaked the mayhem in high-quality cover paintings that newsstands were willing to display. In late 1928 Macfadden started an adventure pulp, *Red Blooded Stories*. With the sixth issue, it became *Tales of Danger and Daring*, the same size as *True Detective* with sixteen pages of true adventure stories on slick paper. This hybrid pulp/men's adventure magazine lasted until June 1929. While short-lived in this case, the Macfadden formula for was soon adopted by other publishers.

By the late thirties, the stage was set for the development of a true-story magazine with a broadly male viewpoint. Oddly enough, it was not Macfadden but competitor Fawcett Publishing that pioneered the form.

Fawcett Publishing had grown out of the highly successful *Captain Billy's Whiz Bang*, a monthly collection of slightly risqué humor produced as a cottage industry by Captain Wilford H. Fawcett after World War I. In 1931, one of its editors, Ralph Daigh, read a study that indicated men were more interested in factual than fictional stories. Daigh did a mock-up of a magazine he called *True*. It was 1937, however, before Fawcett allowed him to apply the Macfadden formula to the men's market with *True* and *True Adventure Tales*. Both were about eight-by-eleven inches, a format similar to true-detective and romance magazines.

The short-lived *True Adventure Tales* — printed on slick, rotogravure paper —

TALES OF
DANGER and DARING

formerly RED BLOODED STORIES

MAY

A MACFADDEN PUBLICATION

PRICE
UNITED STATES
25¢
CANADA
30¢

In this Issue JAMES STEVENS
HAROLD BRADLEY SAY
FRANK C. ROBERTSON
and many others

GREAT SPORTSMEN—
GREAT SOLDIERS
*Sixteen Pages
of Rotogravure*

*A Complete
Novelette*

By Nels Leroy
JORGENSEN

ORCHIDS OF DEATH

foreshadowed the men's adventure magazines with paintings on its covers. The second issue featured an image that would have been at home on the newsstands twenty years later: a sword-wielding native, poised to chop the head off a jungle explorer sprawled helplessly at his heathen feet. Inside could be found an assortment of true-life adventure stories, with authentic photos and occasional illustrations from jungle exploration and airplane test flights to standard western and arctic adventures.

The more tersely titled *True* was far more lurid. The first issue was packaged with a close-up photo of a grimacing woman against a bright yellow background and bold headlines: "200 Stark Photos! 23 Complete Stories! Solving the Perfumed Death of the Ravishing Actress! Why I Chose Suicide — Norma Millen's Confession!" Later issues were nearly all adorned with bondage-themed covers. Approximately half the magazine's stories were the most sensational of true crime tales, with grisly photo spreads ranging from executions and gang hits to exposés on abortion mills and swindles. Racy subjects included a breach of promise suit involving a pretty blonde cigarette girl, and a burlesque tell-all illustrated with photos of topless Minsky girls.

Bare breasts, sex, and violence trumped arctic sled dogs and jungle explorers, and *True Adventure Tales* soon folded, its exotic adventure stories now finding a home in *True*. The magazine's monthly circulation climbed to 250,000. Covers showcased photos of women in bondage or other peril, and interiors were filled with lurid tales of necrophilia, living with cannibals, and pre-World War II Japanese and German atrocities. In spite of the wild and woolly subject matter, only the cover photos were posed. The thriving *True* spawned several imitations: the very short-lived 1937 tabloid *Personal Adventure Stories*; the fleeting 1939 *Sensation* (cobbled together from the most lurid of stories in the Hearst newspaper tabloid Sunday sections); the more successful

A TYPICAL HORROR PULP COVER FEATURED A NEARLY NUDE WOMAN BEING WHIPPED BY DEFORMED DWARFS.

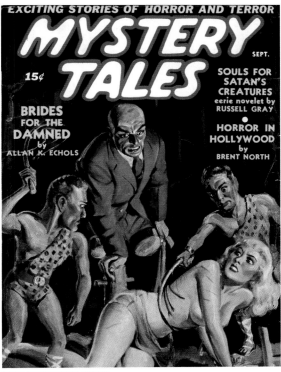

MYSTERY TALES, 9/1939

1941 *Sensation*; and Fawcett's 1941 entry *True Thrills*, a quarterly that chiefly recycled stories from *True*.

That same year, longtime pulp publisher Munsey revamped *Flynn's Detective Fiction* and *Argosy* into new magazines that were mixes of fact and fiction. They were the same size as *True*, but had half the pages. The cheap pulp paper — unlike rotogravure paper — did not reproduce photos well, so the "true fact" articles were illustrated with standard interior ink or wash drawings. *Flynn's* flourished under

the new formula, sporting outlandish cover paintings.

Argosy, on the other hand, alternated between painted covers ("Fighting through Hell with Suicide Commandos!") and obviously posed photo covers ("Sex Outrages by Jap Soldiers," with a not very Asian-looking soldier ripping the blouse off a cringing blonde). This inconsistency resulted in poor sales, losing existing *Argosy* readers and gaining few new ones. After the attack on Pearl Harbor things only grew worse — *Argosy's* popular serialized novels frustrated soldiers who were unable to get several issues in a row. Munsey finally sold its entire pulp line to Henry Steeger of Popular Publications.

Meanwhile, Martin Goodman was beginning his own journey toward the men's adventure field. The successful publisher of Timely (today Marvel) Comics, home of *Captain America*, Sub-Mariner, and *The Human Torch*, also put out the Red Circle pulp fiction magazines. With story titles like "Honeymoon in Hell," "I Satan Take Thee Sin Child," and "Pawn of Hideous Desire," Goodman's thirties horror pulps were often sold under the counter. A typical cover might scream "A Girl Debased, Who Had Learned the Lure of Things Unspeakable," illustrated with a nearly nude woman being whipped by deformed dwarfs.

Goodman's magazines had made him wealthy, but he aspired to a higher-class publication like *Esquire*, that success story of the Depression. While publishers across America were cutting the price of quarter pulps to a dime and dime weeklies to a nickel, David Smart and Arnold Gingrich introduced *Esquire* in 1933 at an astonishing fifty cents. A lushly designed, oversized magazine, *Esquire* was printed in full color on thick, glossy stock; aimed at the sophisticated, upper-class male, an issue might feature a story or article by Ernest Hemingway alongside a beautifully painted and sexy cartoon by E. Sims Campbell. The magazine that experts predicted would fail sold 100,000 copies of its first issue and soon

◀ **TALES OF DANGER AND DARING**, 5/1929

was selling over 500,000 copies every month.

In 1941, Joseph Alvin Kugelmass, a freelance writer, approached Goodman with a proposition. He claimed to have contacts that could get him the rights to stories by many of America's most prominent writers at low rates. Manuscripts of this caliber, he suggested, would allow Goodman to produce a champagne magazine on a beer budget and go head-to-head with *Esquire* — at a fraction of the newsstand price. In return, Kugelmass wanted to be the magazine's editor.

Stars in his eyes, Goodman readily agreed. The new magazine, *Stag*, was designed to look exactly like *Esquire*, but where *Esquire* hired the highest-priced, best illustrators in America, Goodman and Kugelmass relied on Timely Comics' lesser-known artists, such as Gasparo Ricca, Al Avison, Chad Grothkopf, and Don Rico, as well as pulp artists such as Norman Saunders. The pinups (normally the domain of superstar George Petty and popular newcomer Alberto Vargas in *Esquire*) were supplied by Timely's second-tier artists, Cardwell Higgins and Peter Driben, the latter of whom had been a cover painter for low-end, sex pulps that were harassed heavily by the New York Vice Commission. The end result looked less like a clone of *Esquire* than a lampoon.

Publication was swiftly followed by calls and letters from writers or their agents inquiring about payment for stories — including such top names as Robert Benchley, Ogden Nash, and August Derleth. A federal court sent Goodman an injunction halting further publication of *Stag* until the writers' claims were paid.

What did the editorial genius who had rounded up this top talent have to say? Not much. He had disappeared. A quick internal investigation revealed that many of the checks made out to writers had been endorsed in handwriting distinctly similar to that of one J. A. Kugelmass.

The stories had never really been submitted to *Stag*. Instead, the brazen Kugel-

MEN'S ADVENTURE COVERS PUSHED THE SEX-AND-SADISM ANGLE TO AN EVEN MORE OUTRAGEOUS LEVEL.

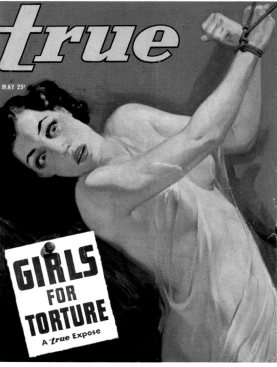

TRUE, 5/1938

mass had retyped stories or portions of novels and paid himself for the copies. Of course, Goodman — despite his desire to create a high-tone magazine — had read little of the major authors whose material he had purchased and, as such, never realized that it had all been previously, and prominently, published. He settled with the writers, put out a few more issues to use up his inventory, then folded the magazine.

Kugelmass fled to New Orleans, was captured, and served time in prison. But the industrious con did not waste his time in jail

— surrounded by criminals, he wrote numerous stories for true-detective magazines, even (using an alias) selling several to Goodman.

In the meantime, Henry Steeger and Fawcett Publications were in the hot seat with the Postmaster General of the United States. In 1940, Frank Walker had become the postal czar; a Catholic, he was heavily influenced by the church's National Office for Decent Literature (NODL). His crusade was to rid the mail of what he and the NODL considered objectionable magazines. His hammer: revoking their second-class mailing rights, which provided reduced postal costs critical to the success of so many periodicals.

The postmaster's powers were heightened by Pearl Harbor. Walker was authorized to remove seditious literature from the mail, and from May 1942 to May 1943 he revoked the mailing privileges of seventy magazines, including truly insurrectionist publications (the *American Bund Newsletter* and Father Coughlin's pro-Nazi *Social Justice*), but also a couple dozen magazines he declared obscene, such as *Esquire*, Munsey's *Argosy*, and Fawcett's *True Confessions* (but not *True*, even with its tied-up cover girls). *Esquire* successfully defended itself, though Walker pursued the case all the way to the Supreme Court. Because a large percentage of male readers were on military bases, where PXs (post exchanges, i.e., base stores) had moral standards for magazines, however, this government crusade caused other publishers to rethink their approach. Within a few months of Pearl Harbor, the entire *Spicy* pulp line (*Spicy Detective*, *Spicy Western*, *Spicy Adventure*) had changed its titles from "Spicy" to "Speed." It also painted tops on its previously bare-breasted cover heroines, though they were still usually bound.

The postmaster's campaign prompted Steeger to reinvent his newly acquired *Argosy*, the longest-lived and once one of the most popular pulps, just as Fawcett was giving a similar overhaul to the more successful *True*.

A goal of increasing advertising revenue also spurred the revamps. Unlike the slick magazines of their day, pulp, true-detective, romance, and men's adventure magazines made their money, not from advertising, but from newsstand and subscription sales. Most contained virtually no ads, as their cheap stock did not lend itself to high-priced, four-color advertising. Regardless, few major corporations would place ads inside a cover of a trussed-up beauty labeled "Girls for Torture!" With wartime paper shortages driving up printing costs and limiting print runs, boosting ad sales was the most effective means of maintaining a profit.

In late 1943 and early 1944, respectively, rivals *True* and *Argosy* unveiled slick new formats with four-color interiors. Gone were the lurid headlines, rapacious Jap soldiers, and cowering bound women; in their place were such harbingers of the sedate fifties as older men fishing and pretty young women in Women's Army Corps uniforms.

Argosy's stories — both fact and fiction — ranged from war-slanted, human-interest pieces, to speculation by economic and political experts on the postwar world, to psychological, self-help pieces. *True* stuck to factual stories and took on a more conservative tone, running fewer photos and more interior illustrations, usually by such top-notch illustrators as Charles LaSalle, Hardie Gramatky, and Albert Dorne. Despite their heritage of sleaze, both evolved into magazines that dad or grandpa could enjoy reading and leave lying around, without worrying about whether neighbors or children might see them.

The strategy worked. The new, improved, cleaned-up *True* saw its circulation almost double within a year. In 1944, Fawcett signed George Petty to paint a foldout pinup in every issue. From sales in the low thousands, *Argosy* was soon moving a quarter of a million copies monthly. Both magazines also saw growth in advertising, especially after the war ended and the economy improved.

The Postal Service's campaign against "objectionable" magazines clearly in check with a 1945 Supreme Court ruling in favor of *Esquire*, Goodman again considered the men's magazine market. He was in the process of launching several new tabloid magazines, which had found renewed popularity in postwar America. Oversize picture periodicals — printed on cheap Sunday newspaper magazine stock in the late thirties and upgraded to slick paper within a few years — popularized a mix of cheesecake and hard news. Exemplified by *Look*,

HIDE AND SEEK THE MOST SUSPENSE-FILLED STORY OF THE WAR

TRUE, 11/1945, Roy Collins

which boasted a circulation of two million by 1940, the tabloids enjoyed a predominantly male audience, presumably attracted by the "showgirl of the week" in a scanty bathing suit on the cover. After the war, Goodman wondered if a readership of returned vets might not respond to a men's adventure tabloid. He also had a brand name to protect, as competing publisher Adrian D. Lopez ran the tagline "The Stag Magazine" on his new *Man to Man*.

In December 1949, for the first time, Goodman created an original magazine instead of just copying whatever was hot. After a dull first issue cover by Albert Fisher of cheering football fans, the all-new tabloid-size *Stag* featured sensational cover paintings worthy of the classic pulps: Tahitian maidens poised with spears, ready to save their man from an octopus; a scantily clad woman cringing while French Foreign Legionnaires battle Arabs; a bare-chested man sneaking a beauty in a badly torn dress onto a ship. In bright boxes, cover blurbs screamed: "I Sailed through Hell!," "7 Ways to Improve Your Sex Technique!," and "Sin City U.S.A." Goodman knew just what attracted working-class men: sex, adventure, war, scandal, photo spreads of young starlets, and "nature gone wild."

Using pulp-style cover paintings instead of the photos that blanketed the covers of "true" men's magazines was an innovation. Granted, a sensational cover story in *Stag* was usually fiction or highly fictionalized fact, but many readers figured it was "true" since the surrounding stories were. Thus, Goodman and soon other publishers could freely commission exciting — if often absurd — cover art and cover stories by artists and writers, unencumbered by mere fact.

Harry Matetsky, who worked at Sterling Publications (which published *Man's Illustrated*), and who later associated with Martin Goodman, explains, "They always designed the cover first, as it was the hook, the big draw. The more 'pow' they put in the cover, the higher the sales. Often this meant giving the painting to a writer, who would then do a 'true story' around it."

While Goodman's later men's magazines were noted for their first-rate, if outrageous, interior illustrations, the early issues of *Stag* relied on a mix of real and fake photos — including an exposé of how photos were faked for true-crime magazines.

The shots in *Stag* (and its later competitors) were often lifted from other sources — as in an article on motorcycle gangs illustrated by uncredited stills from *The Wild One* with Marlon Brando. Many images

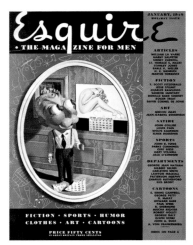

ESQUIRE, 1/1940, A. Von Frankenberg

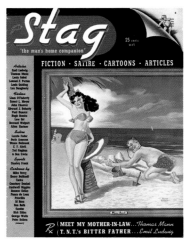

STAG, 5/1942, Peter Driben

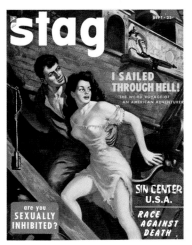

STAG, 9/1950, Charles Andres

illustrating the sex articles are frames from the tamer moments in porn movies of the forties or fifties. In general, black bars were placed over the upper portion of faces to prevent identification – and lawsuits – as when a newspaper photo of a Vietnamese woman posing in a traditional *ao dai* dress for a fashion article was appropriated to portray a Vietnamese hooker who preys on American servicemen.

Stag's posed photo spreads often looked more realistic than those of its competitors because they did not always use professional models. All of Goodman's magazines were usually billeted in one office building and, to save money, *Stag* and the others would just recruit "models" from staff or visiting freelancers.

Former Marvel Comics editor (and acclaimed comics scribe) Roy Thomas recounts a typical recruitment by *Stag* through the sixties. "Artist Bill Everett [best known for creating Sub-Mariner] was in, dropping off a story," Thomas told us. "Somebody from the *Stag* staff walked up to him and started sweet-talking him about being in the magazine, saying he looked very dignified – amusing, considering Bill was an alcoholic and half-smashed at the time – and looked like a doctor. When Bill had the photos taken, it turned out he was portrayed as some seedy abortionist."

The practice of drafting staff to pose for photos continued until almost the end of the men's adventure era. Around the late sixties, someone took pictures of a man and woman on staff and stuck them in an article about dangerous killers "wanted

dead or alive." It finally occurred to an editor that, if somebody gunned down one of these people because of the photos, there just might be a major lawsuit. After that, *Stag* used only professional models and even occasionally labeled the photographs as posed.

Goodman recycled everything: stories, covers, and especially photos. The cuckolded husband one month could be a gay pedophile the following year; a nymphomaniac wife might return as a communist hooker seducing American soldiers. *Stag* editors also utilized New York photo services and kept in contact with news photographers for shots that were difficult to stage: close-ups of mangled bodies in car crashes; grisly dismemberments; brutal and bloody boxing scenes; detailed sequences taken during actual brain operations; and other delights. Some of this verisimilitude graced feature-length articles; others ran in the news section, "On the Stag Line."

INTERIORS WERE FILLED WITH LURID TALES OF NECROPHILIA, LIVING WITH CANNIBALS, AND PRE-WORLD WAR II ATROCITIES.

Such images were part of the magazine's gritty mystique. A *Stag* reader could endure with squinty-eyed stoicism grotesque photos of bodies mangled by disaster, crime, or war. What Goodman was selling was a concept of manhood – the John Wayne myth translated to the reality of blue-collar America, in tales of tough men able to withstand any pain dished out by man, beast, or nature.

Stag heroes needed the call of adventure; many of its readers had either heeded a letter from Uncle Sam or a patriotic impulse spurred by the attack on Pearl Harbor. It was war that had torn them from their homes and sent them overseas, where many experienced sex for the first time, in most cases with a prostitute. *Stag* spoke to these vets with tales of heroic hookers battling to defeat the Nazis or the "Japs" side-by-side with American servicemen. Goodman also included practical sex advice, often revealing the "secret" of what women want – namely, foreplay.

Initially, Goodman was cautious about his experiment – *Stag* would publish bimonthly for almost a year. In 1950, however – and minus Bernarr Macfadden, who had been ousted in a coup – Macfadden Publications released *Saga*, in an eight-by-eleven-inch format similar to *True* and *Argosy*. *Saga* had the men's adventure formula down pat from the start, though the early issues lacked the typical, pinup girl photo spread. In its early years, *Saga* remained almost as sexless as *True* or *Argosy*, its covers featuring close-up portraits of male explorers, sea captains, or soldiers.

STAG, 11/1950, George Mayers ▶

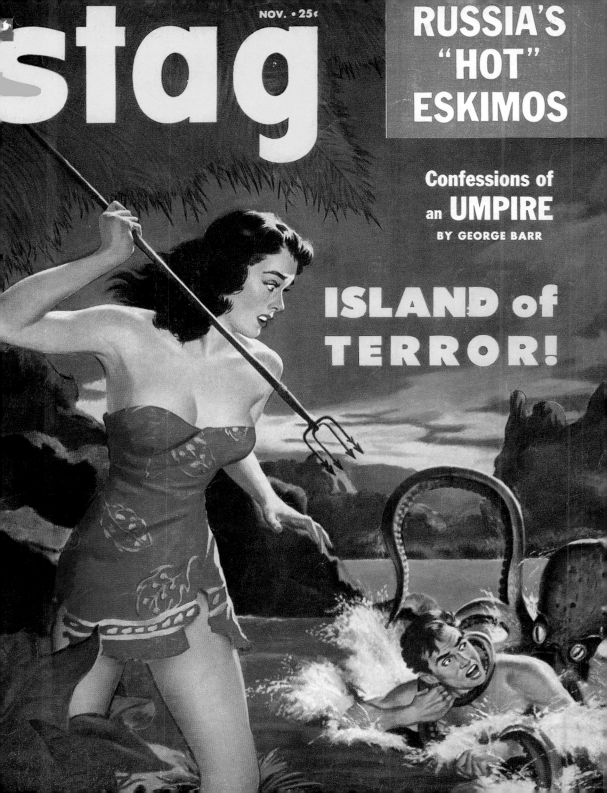

In response, Goodman released *Male* in late 1950. The Korean War, which had begun that June, provided him with an incentive to reduce the size of his magazines, as the tabloids did not fit into soldiers' backpacks. *Male* was the first Goodman magazine to shrink to the eight-by-eleven-inch format, followed by *Stag* in 1951. *Male* also began using paintings and drawings in place of interior photos. During the Korean conflict, Goodman toned down his cover paintings à la *Saga*, replacing half-naked native girls and rabid beasts with portraits of soldiers or adventurers, primarily to appease post exchange stores (the Navy PX in Brooklyn sold more magazines than any other outlet in the voluminous New York/New Jersey market). In 1952, Goodman added *Men* and publisher Pyramid came out with *Man's Magazine*, both launching in tabloid size and soon shrinking to standard format.

Companies publishing dozens of he-man, scandal, and detective magazines rarely had anyone on staff selling advertising. Ad "jobbers" like David Galler would buy up several pages for a few thousand dollars, mark up the price slightly, and resell the space to mail-order houses. Such ads were usually for correspondence schools, patent medicines, or wonder cures ("End Hernia Pain Now"). Vendors of sexual material — ranging from standard "how-to" sex manuals and nudist films to racy "eight-pager" cartoon books ("The Kind Men Like!") and lingerie from Lili St. Cyr or Frederick's of Hollywood, not to mention standard soft- and hard-core pornography — had few other outlets in which to advertise. During the fifties, the men's adventure publishers came under regular attack in Congressional pornography hearings that attempted to root out those responsible for smut peddling. Accused of collaborating with pornographers to whom they had not sold the ad space, the publishers did not even reap much of a financial benefit for the risk, as the ads yielded only small profits over the print cost.

A NYMPHOMANIAC WIFE MIGHT RETURN AS A COMMUNIST HOOKER SEDUCING AMERICAN SOLDIERS.

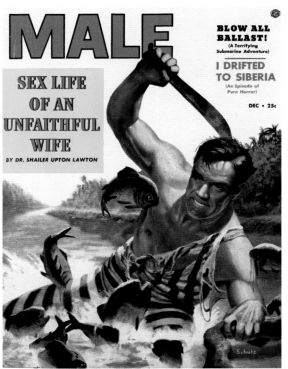

MALE, 12/1953, Robert Schulz

In spite of all this, in 1953, the men's adventure magazine market grew. From five magazines in 1950 to eight in '51 and eleven in '52, the field just kept expanding. Fawcett added a racier version of *True* called *Cavalier*; *Argosy* converted the venerable old pulp *Adventure* into a true adventure magazine; and Macfadden added *Impact* and the raciest titled of them all, *Climax*.

Impact and some other magazines ran occasional photo covers, but an experiment by *Stag* competitor *Man's Magazine* in 1954 put an end to that. It produced its February issue with two covers: one a painting of an explorer confronting a tribe of Australian bushmen, the other a pinup photo of Eve Meyer (pneumatic bride of photographer and filmmaker Russ Meyer). Strangely enough, the explorer outsold the lovely Eve, and most he-man magazine publishers stuck to cover paintings for nearly two decades.

Muscleman and bodybuilder Joe Weider had followed Macfadden's blueprint for success, working his way up from mimeographed physical fitness pamphlets to magazines and books on bodybuilding and health. In 1952, he changed *Your Physique: The Magazine of Constructive Living* into *Mr. America: The Magazine of Constructive Living*, possibly as a result of positive responses to Weider ads for bodybuilding courses and equipment. With a painted cover and a few he-man stories about death in Korea, Weider effectively repackaged his publication as a men's adventure magazine. When the publication again changed its title to the oxymoronic *Fury: The Magazine of Constructive Living*, it had only a few pages related to bodybuilding; the rest ranged from articles on Elvis Presley and James Dean to tales of "America's Sinful Towns" and "Black Magic Worshippers of the Anti-Christ." Such stories provided a strange contrast to Weider's published mission statement: *"Fury* will not satisfy those who find pleasure only in reading about sex, sadism, rape, and murder. We refuse to cater to man's lower instincts." The reader then turned the page to discover "The Road to Prostitution" or "When America Ate Their Dead."

The success of *Fury* spawned several more men's-adventure-style hunting magazines at Weider, including *Outdoor Adventures* and *Animal Life*. The latter became *Safari*, which, in addition to the usual gorillas and mauling leopards, introduced safaris into outer space. Weider also contributed two oddities to the genre — *True Strange* and *True Weird* — which mixed tales of the supernatural with stories like

"The Miracle that Made Sophia Loren a Star." The first *True Weird* had one of the best covers, an eye-catching painting by Clarence Doore of a blonde in a bikini menaced by fish men straight out of Universal Pictures' *Creature from the Black Lagoon*.

Nevertheless, Weider soon returned to doing what he did best — muscle- and body-building magazines — becoming a multimillionaire.

At the peak of the explosion, in 1953, Hugh Hefner published the first issue of his revolutionary *Playboy*. It cheerfully declared that the war between men and women was a lie, and a terribly un-hip lie at that. The *Playboy* philosophy spoke of willing women — not joy girls or hookers, but ordinary females — actually enjoying sex, with pleasure as the key rather than pain. Two breeds of American men had returned from World War II, it seemed. The *Stag* reader rejoined the normal world in a thankless job at a factory or store, the high point of his life having been losing a leg in France or getting laid in the Pacific. *Playboy*'s readers went to college on the GI Bill and discovered jazz, high-tech stereos, sporty cars, and the Kinsey Report. *Stag*'s readers read the Kinsey Report and worried that their girls might be lesbians or that their wives were cheating on them.

The postwar era remains one of great contradictions in American culture. On the one hand, it was a time of repression — the conversion of years of anti-Nazi propaganda into rabid, often misguided, anti-communist propaganda. On the other hand, a liberal court, freed from the constraints of the war years, opposed an extension of the Cold War to broader aspects of American culture, especially as it related to sex. In spite of Hefner's skirmishes with the law, *Playboy* prevailed in this odd dialectic of repression and hedonism. The battle between Hugh Hefner at the one extreme and the Catholic NODL at the other delineated the boundaries within which the men's adventure magazines would grow,

prosper, and finally die, over the next twenty-five years.

The early fifties saw a new factor emerge in the censorship battle, as communities across the nation mobilized to defend children from pernicious books and magazines, especially comic books. In the late forties, psychologist Frederic Wertham had initiated a crusade against crime and, later, horror comic books. Previous battles had been waged over sexually oriented publications, but Wertham's primary concern (notwithstanding his famous outing of

PLAYBOY, 12/1953

Batman and Robin as homosexuals) was with the effects of violent media. His articles, later expanded into the best-selling book *Seduction of the Innocent* (1954), revitalized the NODL and other decency groups that had suffered defeats in the courts relating to Postmaster Frank Walker's attempts to rid the mail of objectionable magazines. The NODL expanded its activities, attacking not only comics but all low-cost magazines and paperbacks with the supposed potential to corrupt children.

One of the most detailed articles on tac-

tics a local Parent Teacher Association (PTA) or church group could use to pressure local stores to stop carrying objectionable magazines was penned in 1952 by Joseph Alvin Kugelmass. Yes, the shameless Kugelmass — the former *Stag* editor who had bilked Martin Goodman out of thousands — was now on the staff of the *Christian Herald*, whose editors were presumably unaware that he was at the same time writing articles for magazines on the NODL "banned publication" list.

Comic books, however, remained the primary focus of national decency groups as the media most accessible to children. Local boycotts through 1954 and 1955 led to the formation of the Comics Code, an industry self-censoring body, in 1956. This drove a number of publishers of comic books into other, more adult media, most notably men's adventure magazines — just as Timely/Marvel publisher Goodman had done earlier in the decade.

Hillman Periodicals, which had produced comics and other publications since the early forties, entered the men's adventure field with *Real Adventure* in 1955. In the same year, Stanley Morse — the ultimate fly-by-night publisher, and creator of some of the most extreme horror comic books of the early fifties — transformed his *Battle Cry* comic book into a men's adventure magazine. Best known as a comic for a cover on which an American GI graphically torches Korean soldiers with his flame thrower, *Battle Cry*'s initial foray as a men's adventure magazine featured a sedate cover painting of two GIs driving a coffin-carting jeep. It was not long before images of extreme mayhem again reigned, including bondage, exotic sacrificial rites, and those ever-lovable, heroic World War II hookers. Stanley Publications soon became the second-largest publisher after Martin Goodman, producing at least eighteen titles and enduring until the genre's demise in the seventies.

In 1956, Everett "Busy" Arnold sold his comic line to DC Comics and turned to men's adventure magazines, producing

WORLD OF MEN, 5/1968, Norm Eastman, acrylic, 51 × 58 cm ▶▶

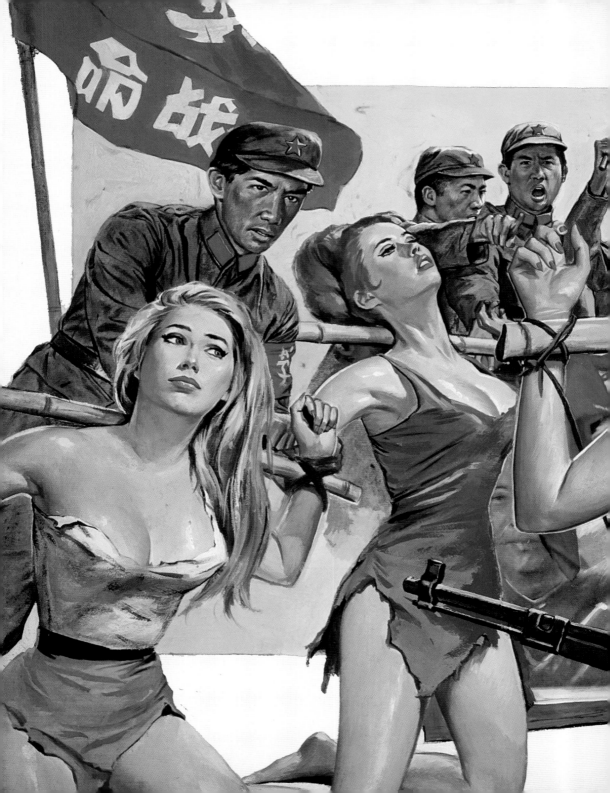

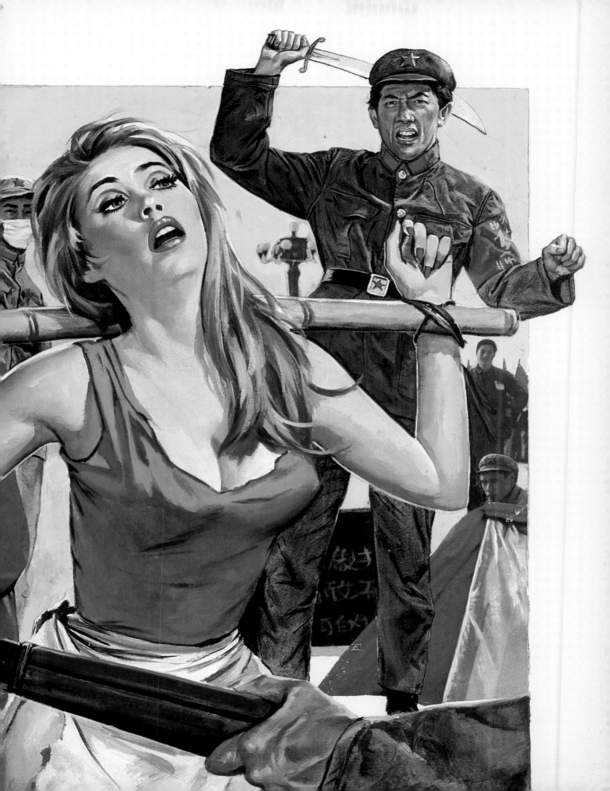

several titles that lasted at best two years, as his artistic sensibilities were apparently too refined for the field. Comics artist L. B. Cole also branched out into the he-man game, but, while his graphics had been popular in comic books, his men's adventure magazines enjoyed only brief success. Bob Sproul — the successful publisher of *Cracked*, the only enduring competitor to *Mad* magazine — debuted *Man's Action* in 1958. Sproul took well to the market, expanding to five magazines, most of which were published into the seventies.

Not just comic publishers were drawn to the sweats as an alternative in the post-Wertham era. Literary Enterprises — which, if nothing else, had the most impressive corporate moniker of all of the publishers — produced *Real* and then converted the *See* tabloid into *See for Men*. Both magazines inched closer to the higher standards set by *Cavalier* and *Saga*. Adrian D. Lopez began *Escape to Adventure* in 1957 and added the men's adventure category to the list of incarnations of his long-running *Sir!* and *Man to Man*, which shifted genres like snakes shedding skins, moving from girlie to scandal to men's adventure.

Among the new players in the sweat field were a pair of publishers with a personal history. Sterling Publications was owned by Morris Latzen and its rival, Skye Publishing Company, by Arthur Bernard. The two had been partners who had each gone his own way, starting similar publishing houses with a pulp-paper mix of movie, romance, and true-detective magazines. Sterling bought the conservative old pulp *Blue Book* and converted it to a sweat, later adding *Man's Conquest* and *Man's Illustrated*. Sterling's men's titles were moderate but steady sellers through the seventies. Skye took a more tasteful approach, buying reprint rights to articles or short stories by major writers, including the likes of William Faulkner. Such literary merit, however, did not match readers' tastes, and the magazines were short-lived.

UNTIL THE LATE SIXTIES, MOST SWEATS WENT TO GREAT LENGTHS NOT TO SHOW FEMALE NIPPLES.

MAN'S COMBAT, 10/1969, John Duillo

Oddly, the men's adventure explosion did not result in any trademark lawsuits, despite the rather limited vocabulary ("men," "man," "male") the publishers often drew upon, though Goodman did threaten to sue Hefner over his original name for *Playboy* — *Stag Party*. In the case of *True Men* and *Men*, for example, the logos were distinctly similar, since the *True Men Stories* logo was designed with a small "true" and a large "men." The result: a confusing display on newsstands.

Goodman had expanded his operation to

thirteen magazines by 1957, the year his business manager, Monroe Froehlich, Jr., convinced him to close his own magazine distribution company and sign with the American News Company (ANC) to save money. ANC, however, soon went bankrupt, not only throwing Goodman's enterprise into chaos but also taking down a number of his competitors. Froehlich was unceremoniously fired for the misstep, and started his own men's adventure magazines, *Guy* and the short-lived *O.K. for Men*.

In 1958, the Supreme Court substantially weakened the government's power to regulate obscenity with its ruling in *The United States v.* Samuel *Roth*. Roth was a long time seller of erotica in New York City, ranging from early Hindu texts, to James Joyce's *Ulysses*, to his own magazines *Good Times* and *American Aphrodite*. In 1953, he was charged with dissemination of obscene materials relating to *American Aphrodite*.

Roth's defense was that obscenity was a form of speech protected by the First Amendment and challenged the Court to distinguish between erotic art and obscenity. The Court's decision included the first definition of obscenity in American law: "The dominant theme" of the material had to promote lust and be obscene in a manner appealing to prurient interest. The court also ruled that the book or magazine must be taken as a whole — reducing the chance that a single sequence taken out of context could be used to ban a publication. Finally, the court asserted that "all ideas having even the slightest redeeming social importance — unorthodox ideas, controversial ideas, even ideas hateful to the prevailing climate of opinion — have the full protection of the guarantees [of the free press]."

The new definitions opened the door to an avalanche of men's interest publications, but ironically did not benefit Roth. He was found guilty of disseminating obscenity and sentenced to five years in prison. It was not his magazine that led to his con-

viction, but the brochures describing it that he randomly distributed through the mail. In the court's opinion, these could too easily fall into the hands of children, making Roth a public menace. This was a major blow to NODL and other community pressure groups, after their triumph over the comic-book industry. The violence and bondage on many of the men's adventure covers became more extreme — and more sweaty. (Most of the images in this book of severe bondage and torture date from 1959 on.)

While most sweats were on NODL's condemned list, they came in a far second to the new peril: a sexed-up *Playboy* and its slick spawn of over a dozen sophisticated men's magazines, rife with nudes. Men's adventure magazines straddled another decade of court battles, with definitions of obscenity leading to some ridiculously simplistic parameters being set. Illustrations had always had more leeway than photographs, because classical painters and sculptors had depicted nudes; thus, a painting of a bound woman in panties being whipped by a Nazi on the cover of *Real Men* was deemed less offensive than a nude centerfold. Until the late sixties, most sweats went to great lengths not to show female nipples — inevitably the model would move a guitar, a towel, or a stuffed fish over the tip of any offending aureole. The stories, however, might include the most explicit descriptions of communist or biker tortures of the "exquisite" naked flesh of many a damsel in distress. A store's decision to stock a magazine in an area with an active NODL group depended on how much of a woman's breasts was shown, not the content of the magazine.

In the early sixties, the sweats continued to flourish, with most of the lower-tier magazines selling in the range of 100,000 to 250,000 copies every month — the early sixties were, after all, still rooted in the mores of the fifties, and local church groups focused their efforts on pressuring small neighborhood retailers not to stock *Playboy* or similar magazines.

Meanwhile, men's adventure magazines, which benefited from the purchasing policies of military post exchange stores, geared many regular features toward soldiers. Pinups were labeled "GI's favorites," and one magazine had a servicemen's column answering questions and linking them to resources. The PXs, though, could be easily influenced by the military bureaucracy — piss off a chaplain, a general, or a bureaucrat, and a magazine could say "sayonara" to that market. Many men's magazines morphed once again after the *Over-*

TRUE, 1/1976

seas Media Corporation v. McNamara lawsuit of late 1967. The publisher produced *Overseas Weekly*, a tabloid newspaper for the servicemen's market that ran a heady mix of exposés on military life (often critical of the brass), typical racy tabloid news, and self-help columns. A large, black-and-white centerfold of a topless or nude young woman, and later comic strips like *Sally Forth* and *Cannon* (both produced by stellar comic-book artist Wally Wood and his assistants), gave *Overseas Weekly* the flavor of a blue-collar *Playboy*. Unlike many

of the radical underground papers sold near US bases as part of the anti-Vietnam War movement — and unlike its rival, *Yank* — *Overseas Weekly* was not out to change US foreign policy; it simply wanted to remain independent of military censorship. When the Pentagon decided to restrict the tabloid's access to PXs in the Asian market, where a high percentage of the military was stationed, Overseas Media sued, and in late 1967 the United States Court of Appeals ruled in its favor.

This opened many doors previously forbidden. From 1968 on, men's adventure publications transformed themselves into "skin" magazines, predominantly devoted to photos of nude women and explicit articles about sex. For some, the change was rapid — one issue a men's adventure magazine, the next issue (with no title change) a girlie magazine. For most, the change was incremental — a cover painting was replaced by a pinup photo, and interior black-and-whites showed bare breasts and bottoms.

The introduction of full-frontal, female nudity into the American market, sparingly by *Playboy* in 1969 and aggressively by the new British import *Penthouse* in 1970, inspired even more drastic changes. Magazines one month would show nothing racier than photos of women in bra and panties, while the next would showcase women spread-eagle, proudly displaying copious amounts of pubic hair.

After Fawcett had sold it to Adrian D. Lopez, even the sedate *True* contained mainly nude photos. The he-men had been defeated, neither by rabid weasel, nor towering grizzly, nor Nazi hooker, nor even a gay predator, but by girls...women... British birds and American girls-next-door who uncrossed their legs and invited an altogether different kind of hair-raising adventure. By the end of the seventies — without an obituary, much less a memorial service — the genre was gone.

BLUT, SCHWEISS UND TITTEN. DIE GESCHICHTE DER MÄNNER-ABENTEUER-HEFTE

Eine schöne Blondine ist kopfüber auf einen runden Metallkäfig gespannt, die Hände an die Füße gefesselt drängt ihr praller Busen gegen das zerfetzte blaue Kleid. Ein Nazi mit nacktem, schweißglänzendem Oberkörper bewegt langsam die Kurbel, die den Käfig über einer Feuerstelle vor einer Wand mit Hakenkreuz dreht. „Schmore im Feuer der Verdammten, mein Schatz!", schreit der Titel dieses „wahren" Kriegsabenteuers.

Dieses Titelbild ziert das Groschenheft *Man's Story* vom Februar 1966 und ist das Werk des äußerst produktiven Illustrators Norm Eastman. Am oberen Rand fragt eine Schlagzeile: „Wie normal sind Ihre sexuellen Bedürfnisse?" Ein winziges Foto einer aufreizenden Brünetten in BH und Spitzenhöschen erinnert den Leser, dass ihn auf diesen Seiten nicht nur nüchterne Geschichte erwartet.

Der Umschlag verspricht auch noch andere Geschichten – „Zerstört den fantastischen Fleischpalast des Sultans" und „Enthüllt: Der Spielplatz der Leidenschaften für den Teen Jet Set" – und das alles kostet nur 35 Cent, für die der Käufer auf 74 Seiten mit billigem, dickem Papier auch noch drei Pinup-Foto-Serien bekommt, darunter mehrere Bilder von einer großen Dänin namens Greta.

Der Werbemann Elmer Wheeler drückte es während der großen Depression so aus: „Verkauf das Brutzeln, nicht das Steak", eine Philosophie, die in den Abenteuerheften für Männer der Fünfziger, Sechziger und Siebziger mit beinahe religiöser Inbrunst befolgt wurde. Die grellen Einbände und reißerischen Titel versprachen mehr, als die Storys halten konnten, meist frei erfundene „wahre Geschichten" von Frauen, die ausgezogen und gefoltert wurden. Die Titelstory des *Man's Story* „Schmore im Feuer ..." von 1966 sind die frei erfundenen Erinnerungen einer schönen, jungen Deutschen, die sich in einen Juden verliebt und deswegen dazu verurteilt wird, in einem Konzentrationslager gefoltert und vergewaltigt zu werden. Der Reporter heiratet sie natürlich und beschließt viele Jahre nach ihrem Tod,

MAN'S STORY, 2/1966, article

ihre Geschichte zu erzählen. Welch schöneren Nachruf könnte es geben?

„Zerstört den fantastischen Fleischpalast des Sultans" ist die Abenteuerchronik eines jungen amerikanischen Ölprospektors, der im Alleingang eine schöne Blondine rettet, die auf einem geheimen Sklavenmarkt in Kuwait zum Verkauf angeboten wird. Die Erzählung pflegt ein äußerst merkwürdiges Englisch – „Boss Man smokes a hubble bubble pipe" – und die Bösen werden allesamt „zaps" genannt.

Das Thema Aufklärung darf in dieser Ausgabe natürlich ebenfalls nicht übersehen werden, auch wenn die „wahren Sexgeschichten" zugegebenermaßen nur wenig Aufschlussreiches zum Thema Fortpflanzung zu bieten haben, dafür aber

langwierige Beschreibungen der Entkleidung und Erniedrigung von Frauen. Der „Teen Jet Set" wartet mit einer Liste von Orten auf (Strände, Heuschober, Gärten und viele mehr), an denen Halbwüchsige sich heimlich treffen, um sich auszuziehen und rumzuvögeln, doch die Geschichte wird durch ein Foto von zwei älteren Erwachsenen illustriert, die es miteinander treiben. „Wie normal sind Ihre sexuellen Bedürfnisse?" bietet dem Leser im Wesentlichen die Bestätigung, dass alles, was Erwachsene freiwillig miteinander tun, in Ordnung ist – außer natürlich Homosexualität, Transvestismus und Masochismus.

Leser, die immer noch nicht mehr hungern, können sich über Artikel hermachen wie zum Beispiel „Hilflose Bräute der Peitsche in der steinernen Hölle", die Memoiren eines aristokratischen Damenzirkels des 19. Jahrhunderts, der einen Ausflug unternimmt, um sich die Folterung von Frauen am Tag ihrer Erhängung im englischen Gefängnis Newgate anzusehen. „Die Lustflucht des blonden Feuerteufels" ist eine Detektivgeschichte, die damit anfängt, dass eine wohl ausgestattete Blondine ihren Gefängniswärter verführt; der Striptease, den sie für ihn hinlegt, um ihn in ihre Zelle zu locken, wird in allen Einzelheiten beschrieben. Dann flieht sie, um ihre Unschuld (an dem Verbrechen, für das sie eingesperrt wurde) beweisen zu können.

Um sicherzustellen, dass die Leser sich ihrem neu entdeckten Gefühl der sexuellen Befreiung nicht zu hemmungslos hingaben, warnt der letzte Beitrag. „Ich wurde Mitglied in einer Orgiensekte im Vorort" von Margaret Sims beginnt mit dem Satz: „Wenn man zum ersten Mal nackt vor einer gemischten Gruppe steht, meint man, auf der Stelle sterben zu müssen." Dennoch schien sie die Demütigung genossen zu haben, da sie ihre Erfahrungen, die sie mit zunehmend ausgefallenen Sexspielchen mit den Nachbarn und anderen gemacht hat, über mehrere Jahre hinweg beschreibt.

REAL

DEC.
35¢

THE CRAZY LITTLE WAR OF
CAPTAIN LOLADZE:
When the Nazis and Russians
Fought It Out in Holland!

The Shocking Facts Exposed:

MONEY MADNESS
AND THE
MISSILE MESS!

THE BIG CLEM

REAL, 12/1962, George Gross

Artikel dieser Art waren zur Zeit der sexuellen Revolution in den Sechzigern für gewöhnlich in jeder Ausgabe der Abenteuerheftchen für Männer zu finden. *Man's Story* und Dutzende seiner Machart verbreiteten die frohe Botschaft der sexuellen Unterdrückung — Sex ist schmutzig und gefährlich —, während sie dem voyeuristischen Leser zugleich die gewünschte sexuelle Erregung verschafften, ohne je wirklich Sex zu beschreiben.

Trotz des Schwerpunkts auf Bondage, Sadismus und Masochismus wurden die Abenteuerheftchen, später „He-man" oder „Sweat Magazines" genannt, nicht in Erotikbuchläden oder aus dem Giftschrank unter der Ladentheke verkauft. Sie waren vielmehr ganz offen in jedem Drugstore und an jedem Zeitungskiosk zu haben, wo sie neben *Time*, *Look*, *The Saturday Evening Post* und *Ladies' Home Journal* auslagen. Zum Höhepunkt ihrer Verbreitung wurden von über 50 verschiedenen Varianten dieses Genres — meistens mit „Man" oder „Men" im Titel — Hunderttausende Exemplare wöchentlich verkauft, und zwar nicht an einen kleinen, geheimen Kreis von Frauenhassern, sondern an einen beträchtlichen Teil der männlichen Bevölkerung der Vereinigten Staaten.

Abenteuerheftchen für Männer reflektierten einen sehr realen Aspekt der Männerkultur jener Zeit, die Schattenseite von Amerikas „großartigster Generation", den jungen Männern, die den Zweiten Weltkrieg gewonnen hatten. Die Helden, die Hitler und Hirohito geschlagen hatten, befanden sich nach ihrer Rückkehr in einer schwierigen Phase der Umstellung — der Nachkriegswirtschaft, in der es anfangs nur wenig Arbeit und einen Mangel an Wohnraum gab. Viele durchlebten den Absturz vom kühnen Kampf für die Demokratie in die Arbeitslosigkeit oder in stupide Fabrik- oder Dienstleistungsjobs. So schrecklich der Krieg auch war, für viele blieb es das größte Abenteuer ihres Lebens.

Es bestand auch eine Kluft zwischen

dem, was die Kriegsteilnehmer gesehen hatten und dem, was die stark zensierte amerikanische Presse (in der Fotos von gefallenen amerikanischen Soldaten verboten waren) berichtet hatte. Männer, die durch die ausgebrannten Überreste Hiroshimas oder die blutigen Schlachtfelder Europas gelaufen waren, kehrten heim zu Familien und Freunden, die nur die entschärfte Version des Krieges kannten, die der Heimatfront vorgesetzt worden war. Sex mit Prostituierten oder verhungernden Flüchtlingsfrauen, die Notwendigkeit, einen 16-jährigen Jungen zu töten oder selbst getötet zu werden, und Selbstmordkommandos, bei dem die Bataillone stark dezimiert wurden, all das waren Erfahrungen, die nur andere Kriegsveteranen verstehen konnten.

Die Abenteuerheftchen für Männer sprachen deren Sprache und bestätigten eine ganze Generation darin, dass sie in der Tat Helden waren. Dort wurde die „wahre", die unzensierte Version des Krieges dargestellt, genau wie in unzähligen historischen Biographien, Geschichtsbüchern, Romanen, Comics und Filmen, die sich mit dem Zweiten Weltkrieg und dem Soldatenleben beschäftigten. Und für die Männer, die nicht im Krieg gewesen waren, boten die Schundhefte außerdem die Möglichkeit, an den Kampfhandlungen teilzuhaben. Die Abenteuerheftchen für Männer waren die Lieblingslektüre des kannibalistischen Mörders Ed Gein; Gein, der als halbes Dutzend Horrorfilmen als Vorbild diente, unter anderem *Psycho*, *The Texas Chain-*

saw Massacre und *Das Schweigen der Lämmer*, wurde später in den „Sweats" sogar zum Gegenstand der Geschichten. Wo hätte er sonst Informationen über Kannibalismus, Schrumpfköpfe und das Gerben von menschlicher Haut hernehmen sollen? Diese Hefte waren sadistische, konservative und spezifisch amerikanische Druckerzeugnisse, die sowohl die McCarthy-Ära als auch die Sechziger mit ihrer Gegenkultur überdauerten.

Die „wahren" Geschichten der Abenteuerheftchen für Männer hatten ihren Ursprung in den älteren „True Detective"-Serien, die einem Massenpublikum das dramatische Leben von Al Capone und John Dillinger nahe brachten, während die reißerischen Titelbilder auf die „Pulp Fiction", die Heftchenromane, zurückgehen. Diese 18 x 25 cm kleinen Heftchen, die es in verschiedenen Genres gab — Detektiv, Western, Science Fiction, Liebesroman, Krieg —, hatten ihren Beinamen von dem billigen Papierbrei, der Pulpe, auf den die schwarzweißen Innenseiten gedruckt wurden. Der Umschlag bestand jedoch aus Hochglanzpapier mit vierfarbigen, opulent gemalten Bildern, die meist fantasievoll ausge-

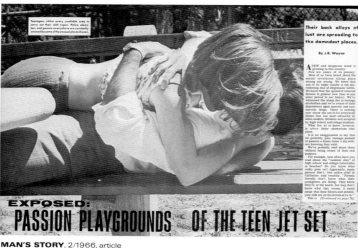

MAN'S STORY, 2/1966, article

staltete Gewaltszenen mit kaum bekleideten Frauen zeigten. In dem größeren Format (22,5 x 25,5 cm) wurden Sex und Sadismus noch extremer dargestellt, und etliche der besten Illustratoren aus dem Schundroman-Bereich fanden in diesem neuen Genre ein ständiges Auskommen.

Die Abenteuerheftchen für Männer wurden von diversen Richtungen beeinflusst, aber wenn das Genre einen Vater hatte, dann war es der exzentrische amerikanische Zeitschriftenverleger Bernarr Macfadden.

Der 1868 geborene Macfadden wuchs als bitterarmer, kranker Waisenjunge (seine Eltern starben, als er sechs war) mitten in den Ozark-Bergen auf. Sein Leben veränderte sich jedoch dramatisch, als er in

seiner Jugend den Sport für sich entdeckte. Mit den deutschen Immigranten waren Mitte des 19. Jahrhunderts Körperertüchtigung und Turnprogramme in die USA gelangt und Macfadden begann mit regelmäßigem Gewichtheben und Gymnastik. Innerhalb eines Jahres wurde er zum Spitzenturner und professionellen Ringer und verkaufte hin und wieder Artikel über Körperkultur an überregionale Zeitschriften. Die Gesundheitsbewegung wurde jedoch – trotz ihrer enormen Popularität – von vielen Amerikanern als versponnene Marotte angesehen und Macfadden erhielt mehr Absagen als Schecks für seine Artikel. Macfadden war jedoch vom fortlaufenden Verkauf seiner eigenen Pamphlete erstaunt und gab ab 1899 in seiner Turnhalle in New York City die Zeitschrift *Physical Culture* heraus. Macfadden verband Beiträge über Gesundheit und Ernährung mit Polemiken gegen moderne Arzneimittel und Heilmethoden. Er brachte auch Fotoserien, wie seine gymnastischen Übungen auszuführen waren, die reichlich mit Bildern attraktiver Frauen in Bade- oder Gymnastikanzügen illustriert waren – die Playmates des viktorianischen Zeitalters. Auch Männer wurden abgebildet, in den dekorativen Lederriemen der Ringer, wobei Macfadden selbst häufig Modell stand. Diese fotografischen Selbstzeugnisse wurden zunächst als „Künstlerische Körperfotografie", später direkter als „Der schöne Körper".

Gemessen an den puritanischen Moralvorstellungen jener Zeit waren die Illustrationen in *Physical Culture* ziemlich heiße Ware. Da die gewagten Fotos inmitten von wissenschaftlichen Artikeln über Gesundheit und Fitness erschienen, konnte Macfadden viele der Probleme umschiffen, denen sich die reißerisch aufgemachten Publikationen gegenübersahen. Eine Serie von Enthüllungen über die Verwüstungen der Syphilis brachten ihm dann doch noch eine Anklage wegen Obszönität ein. Eine zweijährige Kampagne gegen seine Verurteilung führte dann allerdings zu seiner Begnadigung durch Präsident Taft.

Nach dem Ersten Weltkrieg florierte Macfaddens Geschäft, als die Soldaten mit gelockerten Einstellungen zum Geschlechtsleben nach Hause zurückkehrten (etliche waren immerhin in Frankreich gewesen), und viele der puritanischen Sittengesetze („Blue Laws") aus der Kolonialzeiten wurden gelockert. Ironischerweise sollte diese scheinbar so wenig auf Gesundheit bedachte Ära der Gangster, des

DIE WAHRHEIT SPIELTE FÜR DEN VERKAUF KEINE SO GROSSE ROLLE.

selbstgebrannten Gins und der Flapper zur gewinnträchtigsten für Macfaddens Verlagsimperium werden. *Physical Culture* brachte regelmäßig Selbstzeugnisse – „Ich war zum Gangster vorherbestimmt" –, die beschrieben, wie die Körperkultur das Leben eines Menschen verändert hatte, stets begleitet von den Beweisfotos des kaum bekleideten, jungen Muskelmanns. Viele der eingereichten Erfahrungsberichte – die das verkommene sexuelle oder krimi-

PHYSICAL CULTURE, 12/1936

nelle Vorleben des Autors in allen Einzelheiten schilderten – sprengten das Format von *Physical Culture*, sollten aber in Macfaddens neuem Organ *True Story* ein Zuhause finden.

True Story setzte sich größtenteils aus Ich-Erzählungen von Leuten zusammen, die Tragödien oder Schwierigkeiten überwunden hatten – von Hitlers Dienstmädchen bis zu einer Anführerin des chinesischen Widerstands gegen die Japaner. Das Rückgrat des Magazins (und seiner vielen Nachahmer) bildeten jedoch die Liebesgeschichten: Männer und Frauen, die Eheprobleme überwanden oder dunkle Geheimnisse ihrer Vergangenheit bewältigten, um zu wahrer Liebe fähig zu werden.

Macfadden war zwar überzeugt, dass

diese Geschichten eine breite, vor allem weibliche Leserschaft ansprechen würden, wusste jedoch nicht, wie er sie illustrieren sollte. Die Heldinnen, die „Erniedrigung" oder „Die grausamen Worte der Liebe" schrieben, waren immerhin ganz normale Durchschnittsfrauen und erfüllten nicht die körperlichen Voraussetzungen, um in *Physical Culture* abgebildet zu werden. Für die Umschläge stellte Macfadden sich emotional aufgeladene Bilder von wichtigen Malern vor (er hatte beispielsweise F. Earl Christy angeheuert). Doch im Textteil Zeichnungen zu verwenden, um wahre Geschichten zu illustrieren, schien nicht zu passen.

Gestellte Fotos schienen am besten geeignet, um der Wahrheit ein Gesicht zu geben. *Physical Culture* hatte bereits ein eigenes Fotostudio für seine Venus- und Adonis-Beiträge; Macfadden brauchte also nur attraktive Modelle zu besorgen, um die Tragödien des echten Lebens in Szene zu setzen. Einige dieser Modelle wurden später erfolgreiche Schauspielerinnen und Schauspieler, unter anderem Stars wie Katharine Hepburn und Frederic March.

Es mit der Wahrheit nicht ganz so genau zu nehmen, schien den Verkaufszahlen keinen Abbruch zu tun. Im Jahr 1926 hatte *True Story* die unglaubliche Auflage von zwei Millionen erreicht. Mittlerweile waren die Geschichten fast genauso gefälscht wie die Fotos. Angestachelt von hohen Honoraren – bis zu $ 1.000 wurden in Wettbewerben für „wahre" Sensationsgeschichten geboten – sandten viele professionelle Autoren rein erfundene Geschichten als Tatsachenberichte ein. (Der legendäre Krimiautor Mickey Spillane gab sich zum Beispiel unzählige Male als unverheiratete Mutter aus.) Fiktive Augenzeugenberichte wurden 1927 sogar noch vorherrschender, nachdem ein tatsachengestützter Artikel zu einer halben Million Dollar schweren Verurteilung wegen Verleumdung führte und Macfadden die Vorschrift einführte, dass sämtliche Namen in den Storys geändert werden mussten.

Inzwischen (1924) hatte sich Macfadden das Konzept für *True Detective Mysteries* ausgedacht. In *True Story* hatte es immer Geschichten über die Unterwelt gegeben – „Ich war das Mädchen in einer Verbrecherbande", „Ich verliebte mich in einen Gangster". Das Alkoholverbot in den USA gab organisierten Verbrecherbanden wie denen von Al Capone in Chicago und Lucky Luciano in New York starken Auftrieb, sensationelle Mordfälle wie die Er-

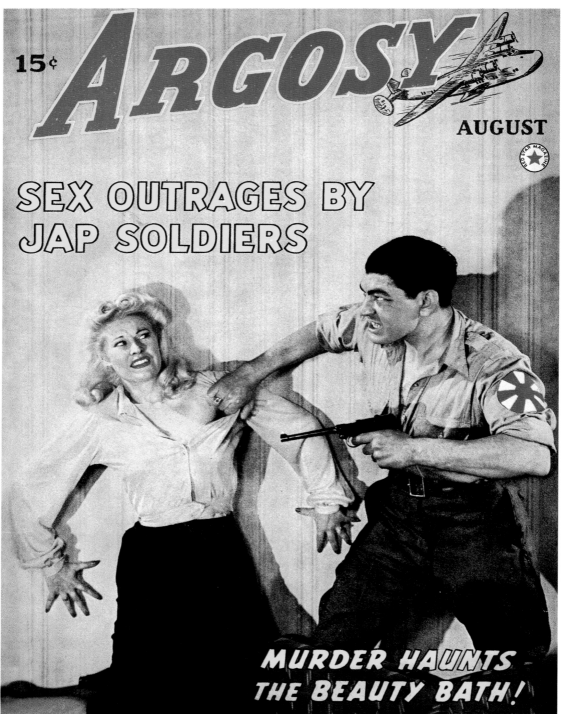

mordung des jungen Bobby Franks „zum Spaß" durch Leopold und Loeb sorgten für höhere Auflagen der Zeitungen und Schriftsteller wie Dashiell Hammett und Carroll John Daly erfanden in dem populären Pulp-Magazin *Black Mask* den „Hardboiled"-Krimi.

True Detective Mysteries hatte den Ansatz wie *True Story*, war aber auf ein überwiegend männliches Zielpublikum ausgerichtet. Für die Berichterstattung über wahre Verbrechen gab es ausreichend Quellen, von Polizeireportern, die ein Nebeneinkommen suchten, bis zu Redaktionsangestellten, die Informationen umschrieben, die sie von den örtlichen Detectives und Sheriffs bekommen hatten. Auf den Innenseiten veröffentlichte *True Detective* blutrünstige Fotos von Mordschauplätzen, welche die Zeitungen nicht zu bringen wagten – sie hüllte diese Blutbäder jedoch in qualitativ hochwertige, gemalte Einbände, die die Zeitungskioske akzeptierten. Ende 1928 warf Macfadden ein Abenteuergeschichtenheft namens *Red Blooded Stories* auf den Markt. Mit der sechsten Ausgabe wurde es umbenannt in *Tales of Danger and Daring* und hatte jetzt dasselbe Format wie *True Detective*: 16 Seiten wahre Abenteuerstorys auf holzfreiem Papier. Diesen Zwitter aus Pulp- und Männerabenteuermagazin gab es bis Juni 1929. Der Macfadden-Formel war zwar in diesem Fall nur ein kurzes Leben beschert, doch sie wurde bald von anderen Verlagen nachgeahmt.

Ende der Dreißiger war die Zeit dann reif für die Entwicklung eines Magazins mit wahren Geschichten aus männlichem Blickwinkel. Merkwürdigerweise war es nicht Macfadden, sondern sein Konkurrent Fawcett Publishing, der mit diesem Genre als erstes herauskam.

Fawcett Publishing hatte sich aus dem äußerst erfolgreichen *Captain Billy's Whiz Bang* entwickelt, einer monatlichen Sammlung leicht frivolen Humors, die Captain Wilford H. Fawcett seit dem Ersten Weltkrieg im Ein-Mann-Betrieb herausgab. 1931 stellte der Redakteure, Ralph Daigh, eine Studie, die auf ein größeres Interesse von Männern an Tatsachenberichten als an fiktiven Geschichten hindeutete. Daigh entwarf die Nullnummer eines Heftes, das er *True* nannte. Aber erst 1937 erlaubte Fawcett ihm, die Macfadden-Formel auf den Männermarkt anzuwenden und *True* und *True Adventure Tales* herauszubringen.

Beide Hefte waren ca. 20 x 25 cm groß, so wie auch die Heftchenreihen mit wahren Kriminalgeschichten und Liebesromanen.

Das kurzlebige *True Adventure Tales* – gedruckt auf hochwertigem Rollenpapier im Rotationstiefdruck – war ein Vorläufer der Männer-Abenteuerheftchen mit gemalten Titelblättern. Die zweite Ausgabe zeigte ein Bild, das 20 Jahre später in jeden Zeitungskiosk gepasst hätte: ein Schwert schwingender Eingeborener im Begriff, den Kopf eines Urwaldforschers abzuschlagen, der hilflos vor den Füßen des Heiden lag. Der Inhalt bestand aus einer ganzen Reihe wahrer Abenteuergeschichten mit authentischen Fotos und vereinzelten Illustrationen, von Urwaldforschung und Flugzeugtestflügen zu altbekannten Erlebnissen im Wilden Westen und der Arktis.

LOOK, 7/1947

Die kurz und bündig *True* genannte Reihe war wesentlich sensationeller gestaltet. Der Aufmacher der ersten Ausgabe war eine Nahaufnahme einer Frau mit verzerrtem Gesicht vor einem knallgelben Hintergrund und fetten Schlagzeilen: „200 ungeschönte Fotos! 23 abgeschlossene Geschichten! Die Lösung des parfümierten Todes der hinreißenden Schauspielerin! Warum ich mich für Selbstmord entschied – Norma Millens Geständnis!" Spätere Ausgaben wurden praktisch alle von Sado-Maso-Umschlägen geziert. Ungefähr die Hälfte der Storys in den Heften waren haarsträubende Sensationsgeschichten von wahren Verbrechen, mit grausigen Fotostrecken von Hinrichtungen und Bandenmorden bis hin zu Artikeln über Abtrei-

bungsfabriken und -schwindeln. Zu den pikanteren Themen gehörte auch ein Gerichtsverfahren wegen Wortbruch, in dessen Mittelpunkt ein hübsches, blondes Zigarettenmädchen stand, und eine Burleske, in der nichts verschwiegen wurde und die mit Fotos von barbusigen Minsky-Mädchen illustriert war.

Nackte Brüste, Sex und Gewalt gewannen die Oberhand über arktische Schlittenhunde und Urwaldforscher und *True Adventure Tales* ging bald ein, seine exotischen Abenteuer wurden jedoch in *True* fortgesetzt. Die monatliche Auflage des Magazins stieg auf 250.000. Auf den Titelbildern wurden Fotos von gefesselten oder anderweitig bedrohten Frauen zur Schau gestellt, und im Heftinneren gab es reißerische Schauergeschichten von Nekrophilie, dem Leben unter Kannibalen und den vor dem Zweiten Weltkrieg verübten japanischen und deutschen Gräueltaten. Trotz der wüsten, krausen Themen waren nur die Titelbilder gestellt, alles andere war wahr. Das florierende *True* hatte mehrere Nachahmer: das sehr kurzlebige Boulevardblatt *Personal Adventure Stories* (1937), das ebenfalls kurzlebige *Sensation* (1939, zusammengeflickt aus den reißerischsten Storys des Regenbogenpresseteils, der den Hearst-Sonntagszeitungen beilag), das erfolgreichere *Sensation* von 1941 und Fawcetts 1941 auf den Markt geworfenes *True Thrills*, eine vierteljährlich erscheinende Heftreihe, die im wesentlichen Geschichten aus *True* wiederverwertete.

Im selben Jahr möbelte der altgediente Pulp-Verlag Munsey *Flynn's Detective Fiction* und *Argosy* wieder auf und machte jetzt eine Mischung aus Fakt und Fiktion aus ihnen. Sie hatten dasselbe Format wie *True*, aber nur halb so viele Seiten. Auf dem billigen Zeitungspapier ließen sich Fotos – im Gegensatz zum Papier im Rotationstiefdruckverfahren – nur schlecht abdrucken, weswegen die „Tatsachenberichte" mit normalen Tuschezeichnungen oder lavierten Federzeichnungen illustriert wurden. *Flynn's* florierte mit der neuen Formel, weil es haarsträubende, gemalte Titelbilder brachte.

Argosy hingegen wechselte zwischen gemalten Einbänden („Marsch durch die Hölle mit Selbstmordkommandos!") und offensichtlich gestellten Fotoumschlägen („Die Sexverbrechen der japanischen Soldaten", auf dem ein nicht sehr asiatisch aussehender Soldat einer sich windenden Blondine die Bluse vom Leib reißt). Diese Widersprüche spiegelten sich in schlechten

Verkaufszahlen, alte *Argosy*-Leser gingen verloren und nur wenige neue wurden dazu gewonnen. Nach dem Angriff auf Pearl Harbor verschlechterte sich die Lage noch — die Soldaten waren verärgert, weil sie *Argosys* beliebte Serienromane nicht wie gewohnt in mehreren Ausgaben hintereinander kaufen konnten. Schließlich veräußerte Munsey seine gesamten Groschenhefte an Henry Steeger bei Popular Publications.

Martin Goodman hatte sich ebenfalls auf die Reise in das Feld der Männerabenteuer begeben. Der erfolgreiche Verleger der Timely (heute Marvel) Comics, Heimat von *Captain America*, *Prinz Namor* (Sub-Mariner) und *The Human Torch*, brachte auch die Red Circle Pulp-Fiction-Hefte heraus. Mit Überschriften wie „Flitterwochen in der Hölle", „Ich, Satan, nehme dich, Sündenkind", „Pfand grausamer Begierden" wurden Goodmans Schauergeschichten in den Dreißigern oft noch unter dem Ladentisch verkauft. Von einem typischen Titelblatt schrie es einem entgegen: „Ein entwürdigtes Mädchen, das die Verlockungen unaussprechlicher Dinge erlernt", illustriert von einer praktisch nackten Frau, die von missgestalteten Liliputanern ausgepeitscht wurde.

Goodmans Heftchen machten ihn reich, aber sein wahres Ziel war eine höherwertige Publikation wie *Esquire*, die große Erfolgsstory der Depressionszeit. Während die Verleger überall in den USA den Preis der Vierteldollar-Pulps auf zehn Cent und den der „Dime Weeklies" auf fünf Cent reduzierten, führten David Smart und Arnold Gingrich *Esquire* 1933 mit dem erstaunlichen Preis von 50 Cent ein. *Esquire*, ein üppig gestaltetes, übergroßes Magazin, wurde vierfarbig auf schwerem, glänzendem Papier gedruckt; auf den gebildeten Mann der oberen Schichten ausgerichtet gab es in einer Ausgabe zum Beispiel eine Kurzgeschichte oder einen Artikel von Ernest Hemingway neben einem sorgfältig gezeichneten, sexy Comic von E. Sims Campbell. Die Zeitschrift, der Experten völliges Versagen prophezeiten, ging bei der ersten Ausgabe gleich 100.000 Mal über den Ladentisch und schon bald wurden jeden Monat über 500.000 Exemplare verkauft.

1941 wandte sich der freie Autor Joseph Alvin Kugelmass an Goodman. Er gab vor, die Rechte an Kurzgeschichten von populären amerikanischen Schriftstellern zu günstigen Preisen bekommen zu können, und behauptete, dass Goodman mit Ma-

IM INNENTEIL GAB ES SCHAUER-MÄRCHEN VON NEKROPHILIE, KANNIBALISMUS UND VORKRIEGS-GRÄUELTATEN.

nuskripten dieses Kalibers ein „Champagnermagazin" zu „Bierpreisen" produzieren und *Esquire* Paroli bieten könne ... und das zu einem Bruchteil des Verkaufspreises. Als Gegenleistung wollte Kugelmass Herausgeber der Zeitschrift werden.

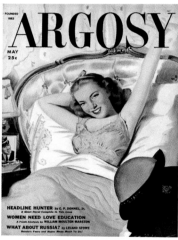

ARGOSY, 5/1944, Ernest Chiriacka

Mit glitzernden Augen sagte Goodman zu. Das neue Magazin, *Stag*, hatte genau die gleiche Aufmachung wie *Esquire*, doch während *Esquire* die höchst bezahlten, besten Illustratoren Amerikas beschäftigte, stützten sich Goodman und Kugelmass auf weniger bekannte Zeichner von Timely Comics, zum Beispiel Gasparo Ricca, Al Avison, Chad Grothkopf und Don Rico, und auf solche Pulp-Künstler wie Norman Saunders. Die Pin-ups (bei *Esquire* für gewöhnlich die Domäne von Superstar George Petty und dem Newcomer Alberto Vargas) wurden von Timely-Zeichnern der zweiten Riege produziert, von Cardwell Higgins und Peter Driben; Letzterer war ein Umschlagzeichner für Sexschundheftchen gewesen, die von der New Yorker Sitten-

polizei stark verfolgt wurden. Das Endergebnis sah weniger wie eine Kopie, sondern eher wie eine Satire von *Esquire* aus.

Auf die erste Ausgabe folgten prompt Anrufe und Briefe von Schriftstellern oder deren Agenten, die sich nach der Bezahlung für die abgedruckten Storys erkundigten — darunter solch bekannte Namen wie Robert Benchley, Ogden Nash und August Derleth. Ein Bundesgericht erließ eine Verfügung, mit der das weitere Erscheinen von *Stag* untersagt wurde, bis die Autoren ihr Geld bekommen hatten.

Was hatte das verlegerische Genie, das diese Top-Talente zusammengetrommelt hatte, dazu zu sagen? Nicht viel. Es war untergetaucht. Eine rasche interne Untersuchung ergab, dass viele der Schecks an die Autoren von jemandem mit einer verdächtig ähnlichen Handschrift wie J. A. Kugelmass eingelöst worden waren.

Die Storys waren nie bei *Stag* eingereicht worden. Kugelmass hatte unverfroren die Kurzgeschichten oder Romanausschnitte abgetippt und sich selbst dafür bezahlt. Goodman hatte — obwohl er ein Edelmagazin schaffen wollte — von den wichtigen Autoren, deren Material er veröffentlichte, nur wenig gelesen und merkte nicht, dass alles bereits an prominenter Stelle veröffentlicht worden war. Nach einer außergerichtlichen Einigung mit den Schriftstellern brachte er noch ein paar Ausgaben heraus und stellte das Erscheinen der Zeitschrift dann ein.

Kugelmass floh nach New Orleans, wurde dort gestellt und ins Gefängnis geworfen. Der unternehmerische Geist vergeudete jedoch im Gefängnis keinerlei Zeit — umgeben von Kriminellen schrieb er eine Menge Storys für die Wahren-Detektiv-Heftchen, von denen er sogar mehrere (unter Pseudonym) an Goodman verkaufte.

Henry Steeger und Fawcett Publications befanden sich ebenfalls auf dem Schleudersitz, denn sie hatten Schwierigkeiten mit dem Chef des amerikanischen Postdienstes. Frank Walker war 1940 „Postmaster General of the United States" geworden; als Katholik war er stark beeinflusst vom National Office for Decent Literature, NODL) der katholischen Kirche. Ziel seines Kreuzzuges war, alles aus der Post zu verbannen, was er und die NODL für anstößige Zeitschriften hielten. Seine Methode: Aberkennung des Rechtes zur Versendung der Zeitschriften als billige Drucksachen; die geringeren Portokosten waren für den Erfolg der Magazine entscheidend.

Mit dem Kriegseintritt der USA wurde die Macht des Post-Chefs noch erhöht. Walker hatte nun das Recht, mit der Post versandte Hetzliteratur zu beschlagnahmen. Zwischen Mai 1942 und Mai 1943 entzog er 70 Magazinen die Versendungsprivilegien, wozu wirklich zersetzerische Publikationen gehörten (der *American Bund Newsletter* und Father Coughlins nazifreundliches *Social Justice*, aber auch mehrere Dutzend Hefte, die er für obszön erklärte, wie *Esquire*, Munseys *Argosy* und Fawcetts *True Confessions* (*True* allerdings nicht, trotz der gefesselten Mädchen auf dem Einband). *Esquire* konnte sich erfolgreich gegen diesen Angriff wehren, obwohl Walker den Fall bis vor das Oberste Bundesgericht brachte. Da sich ein großer Teil der männlichen Leser in den Militärstützpunkten befand, deren PX-Läden ("Post exchanges", d.h. die Einkaufsläden der Soldaten) Moralrichtlinien für Zeitschriften hatten, veranlasste diese Treibjagd der Regierung auch andere Herausgeber dazu, ihren Ansatz zu überdenken. Innerhalb weniger Monate nach Kriegseintritt wurden die Titel aller Spicy-Serien (*Spicy Detective*, *Spicy Western*, *Spicy Adventure*) von "Spicy" in "Speed" umbenannt. Die bisher barbusigen Titelheldinnen bekamen Oberteile gemalt, auch wenn sie für gewöhnlich immer noch gefesselt waren.

Die Kampagne des amerikanischen Bundespostchefs veranlasste Steeger, sein gerade erworbenes *Argosy*, das langlebigste und beliebteste aller Pulps, völlig umzugestalten; Fawcett überholte das erfolgreiche *True* auf ähnliche Weise.

Auch zur Steigerung der Werbeeinnahmen wurden die Groschenhefte aufgepeppt. Im Gegensatz zu den Hochglanzzeitschriften finanzierten sich die Pulp-, Detektiv-, Liebesroman- und Männerabenteuer-Reihen nicht durch Werbung, sondern durch den Verkauf am Kiosk und per Abonnement. Es gab dort praktisch keine Anzeigen, da das billige Druckmaterial teure, vierfarbige Werbung nicht zuließ. Außerdem hätten nur wenige große Unternehmen Anzeigen in einem Heft aufgegeben, dessen gefesselte Titel-Schönheit die Überschrift "Mädchen zum Foltern!" trug. Als während des Krieges die Papierknappheit zu steigenden Druckkosten und niedrigeren Auflagen führte, waren höhere Werbeeinnahmen die effektivste Methode zur Wahrung der Gewinne.

Ende 1943 bzw. Anfang 1944 kamen die Rivalinnen *True* und *Argosy* mit neuen Hochglanzformaten und vierfarbig be-

TYPISCHER HORROR-PULP ZEIGTE FAST NACKTE FRAUEN, AUSGEPEITSCHT VON MISSGESTALTETEN LILIPUTANERN.

druckten Innenseiten auf den Markt. Verschwunden waren reißerische Überschriften, lüsterne "Japse" und zitternde Frauen in Fesseln; an ihre Stelle traten die Vorboten der braven Fünfziger: alte Männer beim Angeln und hübsche, junge Frauen in den Uniformen des Women's Army Corps.

Die Storys von *Argosy* – Tatsachen- und Fantasieberichte – reichten von persönlichen Schicksalen während des Krieges über Prognosen von Wirtschafts- und Politikexperten zur Nachkriegswelt bis zu Artikeln über psychologische Selbsthilfe. *True* hielt sich an Tatsachenberichte und schlug einen konservativeren Ton an mit weniger Fotos und mehr gezeichneten Illustrationen im Heftinneren, für gewöhnlich von solchen Top-Illustratoren wie Charles LaSalle, Hardie Gramatky und Albert Dorne. Trotz ihrer Vergangenheit als Schundheftchen verwandelten sich beide zu Zeitschriften, die Dad oder Grandpa gerne lasen, aber nicht vor den Nachbarn oder Kindern zu verstecken brauchten.

Die Strategie ging auf. Die neue, verbesserte, gesäuberte *True* konnte in einem Jahr ihre Auflage verdoppeln. 1944 nahm Fawcett George Petty unter Vertrag, der für jede Ausgabe ein Pin-up zum Auseinanderfalten malen sollte. Bald setzte *Argosy* nicht mehr ein paar Tausend, sondern eine Viertelmillion Hefte monatlich um. Die Werbeeinnahmen stiegen ebenfalls bei beiden Heften, besonders mit Verbesserung der Wirtschaftslage nach Kriegsende.

Die Kampagne der amerikanischen Bundespost gegen "anstößige" Zeitschriften erlitt 1945 einen empfindlichen Dämpfer, als der Oberste Gerichtshof der USA für *Esquire* entschied, und Goodman wandte seine Aufmerksamkeit von neuem dem Markt der Männerhefte zu. Er war gerade dabei, mehrere neue Boulevardzeitungen herauszubringen, die im Nach-

kriegsamerika wieder auf verstärktes Interesse stoßen sollten. Bildzeitschriften in Übergröße – die Ende der Dreißiger auf billiges Sonntagszeitungsbeilagenpapier und bald darauf auf besseres, glatteres Papier gedruckt wurden – machten eine Mischung aus Pin-up-Girls und harten Nachrichten populär. Bekanntestes Beispiel war *Look*, das sich im Jahr 1940 einer Auflage von zwei Millionen rühmen konnte; die illustrierten Boulevardzeitungen hatten eine vorwiegend männliche Leserschaft, vermutlich angezogen vom "Revuemädchen der Woche", das im knappen Badeanzug die Titelseite schmückte. Nach dem Krieg fragte Goodman sich, ob die Veteranen unter seinen Lesern nicht auf eine Boulevardzeitung mit Männerabenteuern anspringen würden. Außerdem hatte er einen Markennamen, den er schützen musste, da sein Konkurrent Adrian D. Lopez seinem neuen *Man to Man* den Slogan "The Stag Magazine" gegeben hatte.

Im Dezember 1949 schuf Goodman erstmals eine wirklich originale Zeitschrift. Nach einem langweiligen Titelbild (jubelnde Footballfans von Albert Fisher) auf der ersten Ausgabe zeigte sich das völlig neue, boulevardzeitungsgroße *Stag* mit sensationellen Umschlagsmalereien, die des klassischen Pulp Magazines würdig waren: tahitianische Mädchen mit gezückten Speeren, die ihren Mann vor einem Riesentintenfisch retten wollten; eine sich windende, knapp bekleidete Frau vor französischen Fremdenlegionären im Kampf gegen Araber; ein Mann mit nacktem Oberkörper, der eine Schönheit im zerfetzten Kleid auf ein Schiff schmuggelte. Die Überschriften verkündeten in schreiend bunten Kästen: "Ich segelte durch die Hölle!", "7 Tipps zur Verbesserung Ihrer Sextechniken!" und "Sündenbabel U.S.A." Goodman wusste genau, worauf die Männer aus der Arbeiterklasse standen: Sex, Abenteuer, Krieg, Skandal, Poster von jungen Starlets und "die unberechenbare Natur".

Gemalte Einbände im Pulp-Stil und nicht mehr die Umschlag-Fotos der "wahren" Männermagazine zu verwenden, war sehr innovativ. Die sensationelle Titelgeschichte im *Stag* war zwar erfunden oder sehr stark ausgeschmückt, aber viele Leser hielten sie für wahr, da die anderen Geschichten auch wahr waren. Das gab Goodman und bald auch anderen Verlegern die Freiheit, ganz offen, ohne Rücksicht auf Fakten, bei Zeichnern und Autoren dramatische – oft absurde – Titelbilder und -geschichten in Auftrag zu geben.

Harry Matetsky, der bei Sterling Publications arbeitete (Verleger von *Man's Illustrated*) und sich später mit Martin Goodman zusammentat, erklärte: „Die Titelbilder wurden immer als erstes entworfen, weil die die Köder waren, der große Kaufanreiz. Je mehr ‚pow' auf dem Umschlag, desto höher die Verkaufszahlen. Das führte oft dazu, dass ein Autor ein Bild vorgesetzt bekam und dann eine ‚wahre Geschichte' drum herum schrieb."

Während Goodmans spätere Männermagazine für erstklassige, wenn auch empörende Innenillustrationen standen, brachte *Stag* anfangs eine Mischung aus echten und gestellten Fotos – es gab sogar eine Dokumentation, wie Fotos für Wahre-Verbrechen-Heftchen getürkt wurden.

Die Fotos in *Stag* (und seiner späteren Konkurrenz) wurden oft aus anderen Quellen gestohlen – ein Artikel über Motorradbanden wurde zum Beispiel mit Standfotos ohne Namensnennung aus dem Film *Der Wilde* mit Marlon Brando bebildert. Viele Illustrationen zu Sexartikeln waren Einzelbilder aus den harmloseren Szenen der Pornofilme der Vierziger und Fünfziger. Im Allgemeinen wurde die obere Hälfte des Gesichts mit schwarzen Balken ausgeblockt, um eine Identifizierung – und mögliche Anzeigen – zu verhindern, so zum Beispiel beim Zeitungsfoto einer Vietnamesin, die in einem traditionellen ao dai-Kleid für einen Artikel über Mode Modell steht, das nun als Porträt einer vietnamesischen Prostituierten, die amerikanischen Soldaten auflauert, wiederverwertet wurde.

Die gestellten Fotostrecken von *Stag* wirkten oft realistischer als die ihrer Konkurrenten, weil sie nicht immer Profi-Fotomodelle benutzten. Sämtliche Goodman-Periodika waren im selben Bürogebäude untergebracht. Um Geld zu sparen, setzten *Stag* und die anderen einfach Mitarbeiter und Freie auf Besuch als „Modelle" ein.

Der ehemalige Herausgeber der Marvel Comics (und bekannte Comicautor) Roy Thomas erinnert sich an eine typische Rekrutierungsaktion bei *Stag* in den Sechzigern: „Der Maler Bill Everett [bekannt als Schöpfer von Sub-Mariner, dt. Prinz Namor] kam vorbei und lieferte eine Geschichte ab", erzählte Thomas uns. „Irgendjemand von *Stag* ging einfach zu ihm hin und beschwatzte ihn, ob er nicht in der Zeitschrift erscheinen wolle, er sähe so würdevoll und wie ein Arzt aus – was ziemlich lustig war, da Bill Alkoholiker und zu diesem Zeitpunkt bereits halb betrunken war. Als Bill sich dann bereit erklärte, für die

Fotos zu posieren, stellte sich heraus, dass er als zwielichtiger Abtreibungsarzt abgebildet werden sollte."

Die Methode, verlagsangehörige Modell stehen zu lassen, setzte sich fast bis ans Ende der Männerabenteuer-Ära fort. Irgendwann Ende der Sechziger fotografierte jemand einen Mann und eine Frau aus der Belegschaft und veröffentlichte das Bild in einem Artikel über gemeingefährliche Mörder, die „tot oder lebendig" gesucht würden. Einem der Redakteure fiel schließlich auf, dass es zu einer unangenehmen Anklage führen könnte, wenn jemand die beiden aufgrund des Fotos niederschießen würde. Danach wurden bei *Stag* nur noch professionelle Fotomodelle eingesetzt und die Fotos sogar bisweilen als gestellt gekennzeichnet.

CAVALIER, 10/1956, Frank McCarthy

Goodman recycelte alles: Geschichten, Titelbilder und besonders Fotos. Der gehörnte Ehemann im einen Monat wurde im nächsten Jahr zum schwulen Pädophilen; eine nymphomanische Gattin kehrte als kommunistische Hure wieder, die amerikanische Soldaten verführte. Die *Stag*-Redakteure verwendeten auch die New Yorker Fotodienste und hielten für Aufnahmen, die schwer nachzustellen waren, Kontakt zu Pressefotografen: Nahaufnahmen von zerfetzten Leichnamen bei Autounfällen, grausige Zerstückelungen, brutale und blutige Boxkampfszenen, detaillierte Sequenzen, die bei Hirnoperationen aufgenommen wurden, und ähnlich appetitliche Szenen. Einiges aus dieser Wirklichkeitsnähe zierte längere Beiträge, anderes landete in der Abteilung Nachrich-

ten, genannt „On the Stag Line" („Im Visier der Junggesellen").

Solche Bilder trugen zum abgebrühten Image des Magazins bei. Ein *Stag*-Leser konnte mit zusammengekniffenen Augen und Stoizismus groteske Bilder von durch Katastrophen, Verbrechen oder Krieg verunstalteten Leichen ertragen. Goodman verkaufte ein Bild von Männlichkeit – den John-Wayne-Mythos, übertragen auf die Realität der amerikanischen Arbeiterschaft, in Fabeln von harten Männern, die jeden Schmerz ertrugen, der ihnen von Mensch, Tier oder Umwelt zugefügt wurde.

Stag-Helden brauchten den Kitzel des Abenteuers; viele von ihnen waren entweder dem Ruf von Uncle Sam gefolgt oder einem vom Überfall auf Pearl Harbor angestachelten patriotischen Impuls. Der Krieg hatte sie von ihren Familien weggerissen und ins Ausland verschickt, wo viele zum ersten Mal mit einer Frau schliefen, in den meisten Fällen mit einer Prostituierten; *Stag* sprach diese Kriegsveteranen mit Geschichten von heldenhaften Huren an, die Seite an Seite mit amerikanischen Soldaten gegen Nazis oder „Japsen" kämpften. Bei Goodman gab es auch praktische Aufklärung, in der oft enthüllt wurde, was Frauen wirklich wollten – Vorspiel nämlich.

Anfangs war Goodman sich seines Experiments nicht sicher – fast ein Jahr lang erschien *Stag* nur alle 14 Tage. 1950 brachte Macfadden Publications – ohne Bernarr Macfadden, der in einem Coup herausgeworfen worden war – *Saga* in einem 20 x 28 cm großen Format, ähnlich wie *True* und *Argosy*, auf den Markt. *Saga* hatte die Männerabenteuerformel von Anfang an heraus, auch wenn in den frühen Ausgaben das typische Großfoto eines Pin-up-Girls in der Mitte fehlte. In den ersten Jahren blieb *Saga* fast so sexfrei wie *True* oder *Argosy*, auf den Einbänden waren Porträts von Entdeckern, Schiffskapitänen oder Soldaten zu sehen.

Goodman reagierte Ende 1950 mit dem neuen Magazin *Male*. Der im Juni 1950 ausgebrochene Koreakrieg bot einen Anlass, die Heftgröße seiner Zeitschriften zu verringern, weil die Boulevardblätter nicht in die Rucksäcke der Soldaten passten. *Male* war das erste Goodman-Magazin, das auf das 20 x 28 cm Format geschrumpft wurde, 1951 folgte *Stag*. In *Male* wurden die Innenteilfotos allmählich durch gemalte und gezeichnete Illustrationen ersetzt. Während des Koreakonflikts wurden die Goodman-Cover harmloser, ähnlich wie

ADVENTURES FOR MEN, 4/1959, Stan Borack, mixed media, 33 x 43 cm ▶

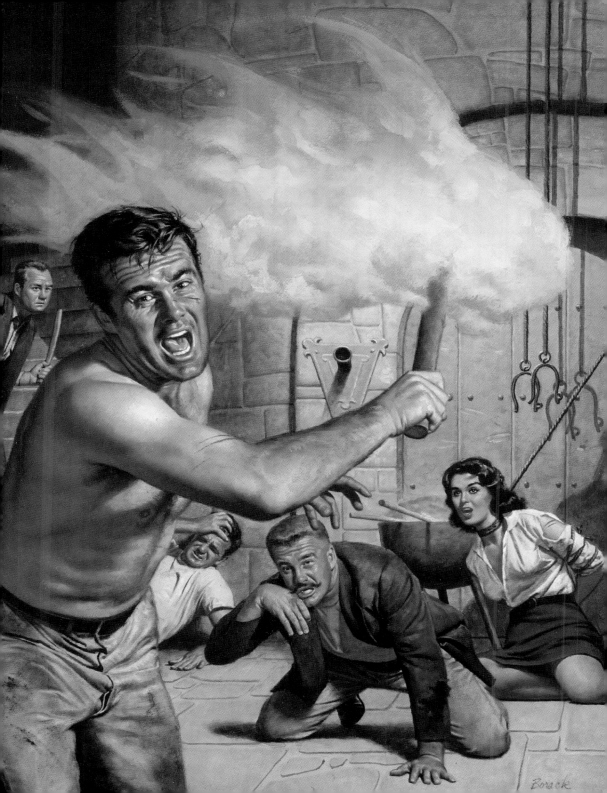

bei *Saga*. Die halbnackten Eingeborenenmädchen und tollwütigen Tiere wurden durch Porträts von Soldaten oder Abenteurern ersetzt, hauptsächlich, um die PX-Läden zu besänftigen (im Navy-PX in Brooklyn wurden mehr Zeitschriften verkauft als anderswo auf dem gewaltigen Markt von New York/New Jersey). 1952 fügte Goodman *Men* hinzu und Pyramid kam mit *Man's Magazine* heraus, beide anfänglich im Zeitungsformat, das jedoch bald auf das Standardformat verringert wurde.

Verlagshäuser, die Dutzende von Männer-, Sensations- und Detektivserien veröffentlichten, hatten oft nicht einen einzigen Mitarbeiter für Anzeigen. Werbe-„Großhändler" wie David Galler kauften mehrere Seiten für ein paar tausend Dollar, warben ein wenig darauf und verkauften den Platz an Versandhäuser weiter. In den Anzeigen wurde meist für Fernschulen, patentierte Arzneimittel oder Wunderheilmittel („So werden Sie Ihre Bruchschmerzen los") geworben. Anbieter von Erotikartikeln – die von „Gewusst wie"-Sexhandbüchern und FKK-Filmen über frivole achtseitige Comicheftchen („So wie Männer sie mögen!") und Reizwäsche von Lili St. Cyr oder Frederick's of Hollywood bis zu normaler Soft- und Hardcore-Pornografie reichten – konnten nur in wenigen anderen Organen werben. In den Fünfzigern gerieten die Verlage der Abenteuerhefte deshalb regelmäßig ins Kreuzfeuer der Anhörungen zur Pornografie im amerikanischen Kongress, die die Verantwortlichen für die wirklich obszönen Heftchen aus dem Verkehr ziehen sollten. Die Verlage wurden der Zusammenarbeit mit Pornografen beschuldigt, obwohl sie den Anzeigenplatz nicht selbst verkauft hatten und nur wenig finanziellen Nutzen aus diesem Risiko zogen, lagen die Werbeeinnahmen doch wenig über den Druckkosten.

Trotz alledem wuchs 1953 der Markt der Abenteuerheftchen für Männer. Die Heftreihen nahmen zu, von fünf 1950 auf acht 1951 und elf im Jahr 1952. Fawcett bereicherte das Feld mit eine gewagtere Version von *True*, genannt *Cavalier*; *Argosy* verwandelte das altehrwürdige Pulp-Heft *Adventure* in ein echtes Abenteuermagazin, und Macfadden fügte seinem Stall das Magazin *Impact* und den schlüpfrigsten Titel von allen: *Climax*.

Impact und einige andere Serien brachten vereinzelte Fotocover, doch das Experi-

EINE NYMPHO-MANISCHE GATTIN KEHRTE ALS KOMMU-NISTISCHE HURE ZURÜCK.

ment des *Stag*-Konkurrenten *Man's Magazine* stoppte diese Versuche 1954. Es produzierte seine Februar-Ausgabe mit zwei verschiedenen Umschlägen: der eine ein gemaltes Bild eines Entdeckers, der es mit einem Stamm australischer Aborigines aufnimmt, der andere mit einem Pin-up-Foto von Eve Meyer (pneumatische Braut von Fotograf und Filmemacher Russ Meyer).

FOR MEN ONLY, 7/1956, Rafael DeSoto

Unglaublicherweise verkaufte sich der Entdecker besser als die liebliche Eve und so kam es, dass sich die meisten Männerhefte von nun an fast zwei Jahrzehnte lang an gemalte Titelbilder hielten.

Muskelmann und Bodybuilder Joe Weider hatte Macfaddens Erfolgsrezept nachgeahmt und sich von handvervielfältigten Fitnesspamphleten zu Magazinen und Büchern über Bodybuilding und Gesundheit hochgearbeitet. 1952 machte er aus *Your Physique: The Magazine of Constructive Living* das aufregendere *Mr. America: The Magazine of Constructive Living*, vermutlich aufgrund der positiven Reaktionen auf Weiders Anzeigen für Bodybuilding-Kurse und -Ausrüstung. Mit einem gemalten Umschlag und ein paar Chauvi-Storys über den

Tod in Korea gelang Weider die Ummodelung seiner Zeitschrift in ein Abenteuerheftchen für Männer. Als das Periodikum seinen Namen wieder wechselte, diesmal zum widersprüchlichen *Fury: The Magazine of Constructive Living*, waren nur noch ein paar Seiten übrig geblieben, die etwas mit Bodybuilding zu tun hatten; der Rest bestand aus Artikeln über Elvis Presley und James Dean bis hin zu Räuberpistolen über „Amerikas sündige Städte" und „Schwarze Magie – Die Anhänger des Anti-Christen". Diese Storys standen in seltsamem Kontrast zu Weiders veröffentlichter Absichtserklärung: *„Fury* wird diejenigen nicht befriedigen, die nur Freude daran haben, über Sex, Sadismus, Vergewaltigung und Mord zu lesen. Wir weigern uns, die niederen Instinkte des Menschen anzusprechen." Der Leser blätterte um und fand auf der nächsten Seite „Der Weg in die Prostitution" oder „Als Amerika seine Toten aß".

Der Erfolg von *Fury* brachte weitere Jagdzeitschriften im Stil der Abenteuerhefte aus dem Hause Weider hervor, unter anderem *Outdoor Adventures* und *Animal Life*. Aus Letzterem wurde *Safari*, das zusätzlich zu den gewohnten Gorillas und Menschen fressenden Leoparden Safaris im Weltall einführte. Weider steuerte auch zwei Ausnahmeerscheinungen des Genres bei, genannt *True Strange* und *True Weird*, in denen Geschichten über Übernatürlichen mit Artikeln wie „Das Wunder, das Sophia Loren zum Star machte" vermischt wurden. Das erste Cover von *True Weird* war eines der besten, ein ins Auge springendes Bild, gemalt von Clarence Doore, mit einer Blondine im Bikini, die von Fischmännern bedroht wurde, die geradewegs dem Universal-Film *Der Schrecken vom Amazonas* entsprungen zu sein schienen.

Trotz alledem kehrte Weider bald zu der Nische zurück, in der er sich am besten auskannte – Muskel- und Bodybuildingzeitschriften – und wurde Millionär.

Auf dem Höhepunkt der Periodika-Explosion 1953 veröffentlichte Hugh Hefner die erste Ausgabe des revolutionären *Playboy*. Die Zeitschrift verkündete freudig, es sei eine Lüge, dass zwischen Männern und Frauen Krieg herrsche, und zwar eine schrecklich altmodische Lüge. Die Playboy-Philosophie kündete von willigen Frauen, nicht Freudenmädchen oder Prostituierten, sondern normalen Frauen, denen Sex wirklich Spaß machte und für die Lust das Schlüsselwort war, nicht Schmerz. Es sah

so aus, als seien zwei Sorten Männer aus dem Krieg zurückgekehrt: der *Stag*-Leser reihte sich auf einem undankbaren Posten in einer Fabrik oder einem Laden in die normale Welt ein, ein Bein in Frankreich oder seine Unschuld im Pazifik verloren zu haben, blieb der Höhepunkt seines Lebens. Die *Playboy*-Leser studierten mit Hilfe eines Wiedereingliederungsprogramms der Regierung an der Uni und entdeckten Jazz, Stereoanlagen, Sportwagen und den Kinsey-Report. Die *Stag*-Leser kannten die umfangreiche Untersuchung zum menschlichen Sexualverhalten natürlich auch, sorgten sich aber nur, ob ihre Töchter lesbisch waren oder ihre Frauen fremdgingen.

Die Nachkriegszeit bleibt einer der größten Widersprüche der amerikanischen Kultur. Einerseits war es eine Zeit großer Unfreiheit — die Verwandlung jahrelanger antinationalsozialistischer Propaganda in fanatischen, oft fehlgeleiteten Antikommunismus. Andererseits stellte sich eine liberale, von den Zwängen der Kriegsjahre befreite Rechtsprechung der Ausweitung des Kalten Krieges auf die allgemeineren Aspekte des amerikanischen (Geschlechts-) Lebens entgegen. Hefner geriet zwar immer wieder mit dem Gesetz in Konflikt, schaffte jedoch in dieser merkwürdig dialektischen Zeit aus sexueller Unterdrückung und Hedonismus mit *Playboy* den Durchbruch. Der Kampf zwischen Hugh Hefner und der katholischen NODL markierte die Grenzen, innerhalb derer die Abenteuerhefte für Männer in den nächsten 25 Jahren expandierten, florierten und schließlich wieder verschwanden.

Anfang der Fünfziger entstand eine neue Front im Kampf um die Zensur: Vereinigungen im ganzen Land machten mobil, um Kinder vor schädlichen Büchern und Schundheften und insbesondere Comics zu schützen. Ende der Vierziger hatte der Psychologe Frederic Wertham zu einem Feldzug gegen Verbrechen und später gegen Gruselcomics aufgerufen. Bisher war es beim Schrei nach Zensur um Publikationen sexueller Art gegangen, doch Wertham hatte es vorwiegend auf den negativen Einfluss von Gewalt in den Medien abgesehen (mit Ausnahme seiner berüchtigten Feststellung, dass Batman und Robin Homosexuelle seien). Seine Artikel, die später zu dem Bestseller *Seduction of the Innocent* (1954) erweitert wurden, spornten die NODL und andere Moralwächter nach den Rückschlägen beim Versuch, anstößige Periodika aus der Post zu entfernen, erneut an. Die NODL weitete ihre Aktivitäten aus und nahm nicht nur Comics, sondern alle Schund- und Schmutzliteratur aufs Korn, durch die Kinder möglicherweise verdorben werden könnten.

Einer der detailliertesten Artikel über mögliche Taktiken einer Parent Teacher Association (PTA) oder einer kirchlichen Gruppe, mit der die lokalen Läden gezwungen werden sollten, keine anstößigen Magazine mehr zu führen, wurde 1952 von niemand anderem als Joseph Alvin Kugelmass verfasst. Genau, der schamlose Kugelmass, der Martin Goodman um Tausende von Dollar betrogen hatte, arbeitete jetzt beim *Christian Herald*, dessen Herausgeber wohl nicht wussten, dass er gleichzeitig für Hefte schrieb, die auf der NODL-Liste „verbotener" Publikationen standen.

Das Hauptaugenmerk der Moralwäch-

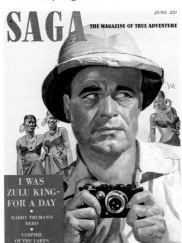

SAGA, 6/1951

ter lag jedoch auf den Comicbüchern, da sie für Kinder das zugänglichste Medium darstellten. Lokale Boykotte 1954 und 1955 führten 1956 zur Bildung des „Comics Code", einer Selbstzensureinrichtung der Industrie. Das vertrieb eine Reihe von Comic-Verlegern in andere, für Erwachsene bestimmte Branchen, insbesondere in die Heftchenreihen für Männer — genau die gleiche Abwanderungsbewegung wie beim Timely/Marvel-Verleger Goodman ein Jahrzehnt zuvor.

Hillman Periodicals, die seit den frühen Vierzigern Comics und andere Publikationen herausgebracht hatten, stürzten sich 1955 mit *Real Adventure* ebenfalls auf den Männerabenteuer-Markt. Im selben Jahr verwandelte Stanley Morse — der dubio-

seste aller Verleger und Produzent von einigen der grässlichsten Horrorcomics in den frühen Fünfzigern — seinen Comic *Battle Cry* in ein Abenteuerheftchen für Männer. Als Comic wurde *Battle Cry* mit einem äußerst drastischen Titelbild bekannt, auf dem ein amerikanischer GI koreanische Soldaten mit dem Flammenwerfer abfackelt; die erste Ausgabe als Abenteuerheftchen für Männer hatte einen sehr zahmen Einband: Zwei GIs fahren einen mit Särgen beladenen Jeep. Es sollte aber nicht lange dauern, bis wieder schockierende Gewaltszenen vorherrschten, mit Fesselungen, exotischen Opferriten und den immer liebenswerten, heldenhaften Huren im Zweiten Weltkrieg. Stanley Publications wurde bald nach Martin Goodman zum zweitgrößten Verlag dieses Sektors mit mindestens 18 verschiedenen Titeln. Er blieb bis zum Niedergang des Genres in den Siebzigern dabei.

1956 verkaufte Everett „Busy" Arnold seine Comicserien an DC Comics und wandte sich den Abenteuerheftchen für Männer zu, produzierte mehrere Titel, die bestenfalls zwei Jahre lang durchhielten, da sein künstlerischer Geschmack für das Genre offensichtlich nicht simpel genug war. Der Comiczeichner L. B. Cole spielte ebenfalls im Machomännerbereich mit, doch obwohl seine Zeichnungen in Comics sehr beliebt gewesen waren, erfreuten sich seine Abenteuerheftchen für Männer nur eines kurzen Erfolgs. Bob Sproul — der erfolgreiche Verleger von *Cracked*, der einzigen längerfristigen Konkurrenz zu *Mad* — stellte 1958 *Man's Action* vor. Sproul hielt sich auf dem Markt gut und expandierte auf fünf Zeitschriften, von denen die meisten bis in die Siebzigerjahre hinein erschienen.

In der Ära nach Wertham sahen nicht nur Comicverlage die Groschenhefte als eine gute Alternative. Der Verlag Literary Enterprises — der von allen Verlagshäusern auf jeden Fall den wohl tönendsten Namen hatte — produzierte *Real* und verwandelte dann das Boulevardblatt *See* in *See for Men*. Beide Magazine bewegten sich ein kleines bisschen in Richtung der höheren Standards, die *Cavalier* und *Saga* gesetzt hatten. Adrian D. Lopez begann 1957 mit *Escape to Adventure* und ließ die altgedienten *Sir!* und *Man to Man* als Abenteuerhefte wieder auferstehen — Titel, die das Genre sehr oft wechselten, von Girly- zu Sensations- zu Männerabenteuerreihen.

STAG, 7/1973, Samson Pollen, mixed media, 61 x 41 cm ▶▶

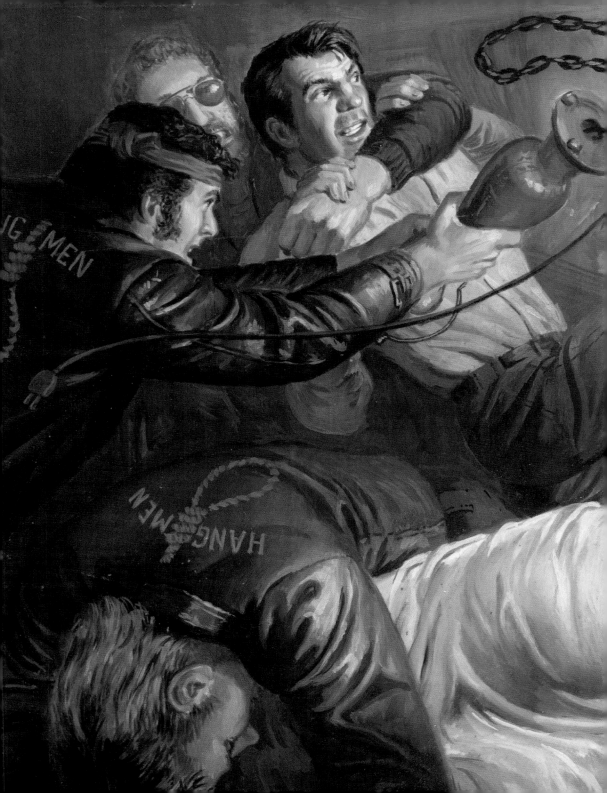

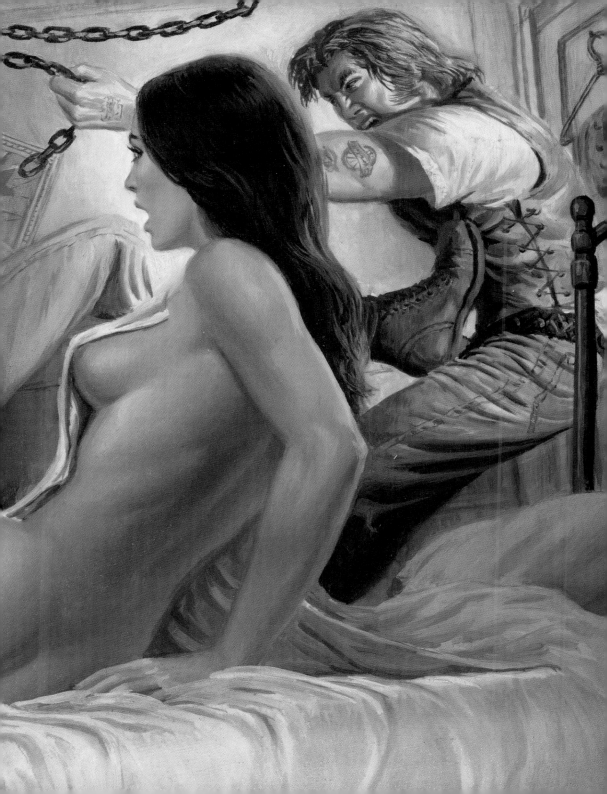

Zu den neuen Mitbewerbern im Bereich der Sweats gehörten auch zwei Verleger mit einer gemeinsamen Geschichte. Sterling Publications gehörte Morris Latzen und sein Konkurrent Skye Publishing Company gehörte Arthur Bernard. Die beiden waren ehemals Partner und haben danach ähnliche Verlagshäuser gegründet, beide mit einer Pulp-und-Papier-Mischung aus Film-, Liebesroman- und Wahren-Detektiv-Heften. Sterling kaufte den konservativen, alten Pulptitel *Blue Book* und machte ein Abenteuerheft daraus, dem er später noch *Man's Conquest* und *Man's Illustrated* hinterher schickte. Sterlings Hefte hatten bis in die Siebziger hinein mittlere, aber konstante Verkaufszahlen. Skye hatte mehr Geschmack und erwarb die Nachdruckrechte an Artikeln und Kurzgeschichten von wichtigen Schriftstellern, auch vom Format eines William Faulkner. Diese literarischen Höhenflüge trafen allerdings nicht den Geschmack der Leser, sodass die Magazine nur eine kurze Lebensdauer hatten.

Erstaunlicherweise führte die Explosion von Heftserien im Männerabenteuersegment nicht zu Gerichtsverfahren um geschützte Titel, trotz des doch eher begrenzten Vokabulars („Men", „Man", „Male") der Verleger. Goodman drohte Hefner allerdings mit einem Verfahren gegen dessen ersten Namen für das *Playboy*-Magazin: *Stag Party*. Im Fall von *True Men* und *Men* zum Beispiel unterschieden sich die Logos deutlich, da das *True Men Stories*-Logo aus einem kleinen „True" und einem großen „Men" bestand. Ergebnis dieser Titelflut: ein verwirrendes Bild am Zeitungskiosk.

Goodman hatte sein Unternehmen 1957 auf 13 Magazine ausgeweitet; im selben Jahr überzeugte ihn sein Geschäftsführer, Monroe Froehlich Jr., davon, den eigenen Vertrieb der Periodika einzustellen und diesen von der American News Company (ANC) durchführen zu lassen, um Geld zu sparen. ANC ging jedoch bald in Konkurs, wodurch nicht nur Goodmans Unternehmen ins Chaos gestürzt wurde, sondern auch etliche seiner Konkurrenten. Diesen Fehltritt bezahlte Froehlich umgehend mit seinem Rauswurf. Er gründete

BIS ENDE DER SECHZIGER VERMIEDEN VIELE SWEATS, WEIBLICHE BRUSTWARZEN ZU ZEIGEN.

daraufhin eigene Abenteuerhefte für Männer, *Guy* und das kurzlebige *O.K. for Men.*

TRUE ADVENTURES, 6/1966, Vic Prezio

1958 wurden die Möglichkeiten der Regierung, bei Sittenwidrigkeiten direkt einzugreifen, maßgeblich geschwächt, als der Oberste Gerichtshof der USA sein Urteil im Fall The United States v. Samuel Roth fällte. Roth hatte seit langem Erotika in New York City verkauft, von frühen hinduistischen Texten über James Joyce *Ulysses* bis zu seinen Magazinen *Good Times* und *American Aphrodite*. 1953 wurde er wegen Verbreitung von sittenwidrigem Material in *American Aphrodite* angeklagt.

Roth brachte zu seiner Verteidigung vor,

dass Obszönität eine Art der Meinungsäußerung sei, die im ersten Zusatzartikel zur amerikanischen Verfassung geschützt werde, und forderte das Gericht dazu auf, zwischen erotischer Kunst und Obszönität zu unterscheiden. Im Gerichtsurteil ist dann die erste Definition von Obszönität in der amerikanischen Rechtsprechung zu finden: „Das vorherrschende Thema" des Materials müsse die Förderung sexueller Begierde sein und es müsse auf eine Art obszön sein, die lüsterne Interessen anspricht. Das Gericht entschied weiterhin, dass das Buch oder die Zeitschrift als Ganzes betrachtet werden müsse. Dadurch sank die Gefahr, dass ein einzelner, aus dem Zusammenhang gerissener Absatz benutzt werden konnte, um eine Publikation ganz zu verbieten. Schließlich unterstrich das Gericht, dass „alle Ideen, die selbst die kleinste, positive soziale Bedeutung haben — unorthodoxe Ideen, kontroverse Ideen, sogar Ideen, die im herrschenden Klima abscheulich wirken — den vollen Schutz der Garantien (der Pressefreiheit) genießen."

Diese neuen Definitionen öffneten einer wahren Flut von Männerpublikationen Tür und Tor, nutzten Roth selbst ironischerweise aber nicht. Er wurde der Verbreitung sittenwidrigen Materials für schuldig befunden und zu fünf Jahren Haft verurteilt. Nicht seine Zeitschrift hatte zu diesem Urteil geführt, sondern die als Massenpostsendungen mitverschickten Broschüren, in denen diese angepriesen wurde. Nach Ansicht des Gerichtshofs konnten diese Kindern zu leicht in die Hände fallen, was Roth zu einer öffentlichen Gefahr werden ließ. Für NODL und andere Pressuregroups war das Urteil nach ihrem Triumph gegen die Comicindustrie ein schwerer Schlag. Gewalt und Bondage auf den Covern der Abenteuerhefte wurden drastischer und verschwitzter. (Die meisten Abbildungen in diesem Buch von schweren Fesselungen und Folter stammen aus der Zeit nach 1959.)

Die meisten Sweats standen zwar auf der schwarzen Liste der NODL, allerdings abgeschlagen auf dem zweiten Platz nach einer neuen Gefahr: dem sexgeladenen

Playboy und seinen Hochglanznachkömmlingen, über ein Dutzend anspruchsvoller Männermagazine voll nackter Frauen. Die Abenteuerheftchen für Männer überstanden ein weiteres Jahrzehnt voll gerichtlicher Auseinandersetzungen, wobei die nun existierenden Definitionen von Obszönität dazu führten, dass lächerliche, viel zu grobe Kriterien aufgestellt wurden. Illustrationen wurden immer großzügiger bewertet als Fotografien, da auch die klassischen Maler und Bildhauer Akte dargestellt hatten. Das Gemälde einer gefesselten Frau im Slip, die von einem Nazi auf dem Einband von *Real Men* ausgepeitscht wurde, erschien deshalb weniger anstößig als ein nacktes Centerfold. Bis Ende der Sechziger vermieden die meisten Sweats es, weibliche Brustwarzen zu zeigen — das Modell hielt stets eine Gitarre, ein Handtuch oder einen ausgestopften Fisch über die Anstoß erregenden Körperteile. In den Storys selbst konnte es explizite Beschreibungen der Torturen geben, die Kommunisten oder Rocker dem „exquisiten" Fleisch der jungen Damen in Not angedeihen ließen. Ob ein Geschäft nahe einer aktiven NODL-Gruppe ein Magazin führte oder nicht, hing nur davon ab, wie viel von der Brust einer Frau auf dem Umschlag zu sehen war, nicht vom Inhalt.

In den frühen Sechzigern florierten die Männerhefte weiter; die meisten Magazine der unteren Liga verkauften sich monatlich zwischen 100.000 und 250.000 Mal — die frühen Sechziger waren immer noch fest in den Sitten der Fünfziger verankert und viele Kirchengemeinden konzentrierten ihre Bemühungen darauf, die kleinen örtlichen Händler zu bewegen, keinen *Playboy* oder ähnliche Magazine zu führen.

Die Abenteuerheftchen für Männer profitierten von der Verkaufspolitik der militärischen PX-Läden und richteten viele Beiträge auf Soldaten aus. Die Pin-ups hießen „GI's Favorites" und ein Magazin brachte eine Kolumne, in der ein einfacher Soldat Fragen beantwortete und Tipps gab. Die PX-Läden standen jedoch unter dem Einfluss der militärischen Bürokratie — ein Heft brauchte bloß einen Militärgeist-

lichen, General oder Bürokraten zu verärgern und die Serie konnte sich von diesem Markt verabschieden. Ende 1967, nach dem Gerichtsurteil Overseas Media Corporation v. McNamara, schlüpften viele Männerhefte mal wieder in eine neue Haut. Das Verlagshaus war Produzent von *Overseas Weekly*, einer Boulevardzeitung für Militärpersonal, in dem ein unbeschwertes Nebeneinander von Artikeln über das militärische Leben (oft kritisch gegenüber Ranghöheren), typischen Sensationsklatsch und Selbsthilfe-Kolumnen herrsch-

te. Ein großes Poster einer halb oder völlig unbekleideten jungen Frau und später Comicstrips wie *Sally Forth* und *Cannon* (beide aus der Feder des begnadeten Comiczeichners Wally Wood und seines Teams) verliehen *Overseas Weekly* den Geschmack eines *Playboy* für den einfachen Mann. Im Gegensatz zu vielen radikalen Untergrundzeitungen, die im Rahmen der Anti-Vietnamkrieg-Bewegung in der Nähe von U.S.-Militärstützpunkten verkauft wurden, und im Gegensatz zu seinem Rivalen *Yank* hatte Over-

seas Weekly nicht die Absicht, die amerikanische Außenpolitik zu beeinflussen; es wollte nur unabhängig von der Militärzensur bleiben. Als das Pentagon beschloss, den Verkauf von Sensationsblättern in den PX-Läden in Asien zu beschränken, wo ein großer Teil des Militärs stationiert war, erhob Overseas Media Anklage dagegen, und das oberste amerikanische Berufungsgericht entschied Ende 1967 zugunsten des Verlages.

Dadurch öffneten sich viele, bisher verschlossene Türen. Ab 1968 wurden aus den Abenteuerheftchen für Männer die „Skin Magazines", die vorwiegend Aktfotos und explizite Artikel über Sex brachten. Bei einigen Publikationsreihen war es ein sehr schneller Wechsel — in der einen Ausgabe noch ein Abenteuerheft, in der nächsten (ohne jede Veränderung im Titel) ein Tittenmagazin. Bei den meisten ging der Wechsel allmählich vor sich — ein gemalter Umschlag wurde durch ein Pin-up-Foto ersetzt, und auf den Schwarzweißbildern im Heft waren unverhüllte Busen und Hinterteile zu sehen.

Die Einführung völliger weiblicher Nacktheit auf dem amerikanischen Markt, erst vereinzelt 1969 durch den *Playboy*, 1970 dann aggressiv durch das neue englische Importmagazin *Penthouse*, sorgte für noch drastischere Veränderungen. Zeitschriften, die einen Monat zuvor noch nichts Gewagteres als Frauen in BH und Slip zeigten, präsentierten im Monat darauf Frauen mit gespreizten Beinen und stolzer Zurschaustellung üppigen Schamhaars.

Nach dem Verkauf an Adrian D. Lopez enthielt selbst das brave *True* zum größten Teil Aktfotos. Die Machomänner waren besiegt, jedoch weder von einem tollwütigen Wiesel oder einem riesigen Grizzly, noch von einer Nazihure oder einem schwulen Profiteur, sondern von Mädchen ... Frauen ... von englischen Sexbienen und amerikanischen Mädels von nebenan, die die Beine breit machten und zu einem Abenteuer ganz anderer Art aufforderten. Ende der Siebziger — ohne Nachruf und erst recht ohne Gedenkfeier — war das Genre der Abenteuerheftchen verschwunden.

$200 FOR YOUR STORY $200

TRUE **Adventures**

OCTOBER / 35¢

SPICY GIRLS of SPICE ISLAND

BRITAIN'S FORTUNATE BLONDES

BIKINIS of the RIVIERA

SOUTH SEA ADVENTURE at a BARGAIN

DREAM GIRL for GI's

TRUE ADVENTURES, 10/1967

DU SANG, DE LA SUEUR ET DES TETONS. L'HISTOIRE DES MAGAZINES D'AVENTURES POUR HOMMES

Une belle blonde est attachée la tête en bas à une cage de métal cylindrique, bras et jambes liés par des chaînes, ses seins bombant sous sa robe bleue déchiquetée. Un soldat nazi torse nu, suant à grosses gouttes, tourne lentement la manivelle qui fait avancer la cage vers un brasier derrière lequel, sur le mur, on aperçoit une croix gammée. « Va griller en enfer, sale garce ! » clame le gros titre de cette « histoire vécue » de la Seconde Guerre.

Le magazine, dont il s'agit s'intitule *Man's Story* (histoire d'homme) et il date de février 1966. Sa captivante illustration de couverture est l'œuvre du prolifique illustrateur Norm Eastman. Un bandeau, en haut de la page, interroge : « Vos besoins sexuels sont-ils vraiment normaux ? » Dans un coin, la photo minuscule d'une opulente créature à cheveux bruns en soutien-gorge et panty de dentelles rappelle que l'Histoire contemporaine n'est qu'un prétexte.

La couverture le renseigne sur le contenu : « Pulvérisez le fabuleux palais charnel du Sultan ! », et « Exhibitions : les distractions préférées des rejetons de la Jet-Set ». Le tout pour seulement trente-cinq cents. Sur soixante-quatorze pages de mauvais papier jaunâtre, en plus de ces palpitants récits, il aura droit à trois séries de photos de pin-up, dont plusieurs d'une grande danoise nommée Greta.

Comme le notait finement Elmer Wheeler, publicitaire des années trente, « Ce n'est pas la viande qu'il faut vendre, mais la cuisson », un credo auquel ont adhéré religieusement les magazines d'aventures pour hommes de l'après guerre jusqu'aux années soixante-dix. Couvertures tapageuses et titres provocants ont permis d'inonder le marché d'histoires « vraies » la plupart du temps inventées, de femmes déshabillées et torturées. La couverture précitée de *Man's Story* (Va griller en

enfer...) est une variante d'une autre histoire « vraie », celle de la belle jeune Allemande amoureuse d'un Juif qui paye cette passion d'un internement dans un camp de concentration, avec viols et tortures à la clé. Le « reporter » auteur de l'article finit bien sûr par l'épouser et se décide, des années après la mort de sa femme, à révéler son histoire. N'est-ce pas le meilleur hommage posthume à rendre à sa chère et tendre ?

« Pulvérisez le fabuleux palais charnel du Sultan ! » raconte les aventures d'un jeune Américain chercheur d'or noir au Proche Orient, où il arrache une belle blonde aux trafiquants d'esclaves qui l'ont mise en vente sur un marché clandestin du Koweït. L'histoire est écrite dans un jargon plutôt bizarre, les méchants sont tous des « fumiers » et leur chef fume une sorte de narguilé.

S'il ne faut certes pas négliger le thème de l'éducation sexuelle dans ces fascicules, il faut bien reconnaître que ces « histoires vécues » ne s'intéressent qu'accessoirement à l'acte sexuel, alors qu'elles sont intarissables sur les sévices possibles (déshabillages et humiliations diverses). Ainsi, « Les rejetons de la Jet-Set », énumère les endroits (plages, granges, arrière-cours, etc.) où les ados se planquent pour... se déshabiller et copuler, mais bizarrement, la photo qui illustre ce récit montre deux adultes d'âge mûr en train de flirter. « Vos besoins sexuels sont-ils vraiment normaux ? » se propose de rassurer le lecteur : entre adultes consentants, tous les jeux sont permis, hormis, bien entendu, l'homosexualité, le travestissement et le masochisme.

Les lecteurs qu'un tel apéritif aura mis en appétit, pourront se rassasier avec des articles comme « Fouettées à outrance le jour de leur pendaison », les mémoires d'un club de grandes dames du XIXe siècle, qui consacrent leurs sorties à regarder des détenues suppliciées à la Prison de Newgate (Angleterre). « L'évasion très chaude de la blonde incendiaire » est l'histoire à suspense d'une jeune et pulpeuse beauté blonde, qui, pour attirer son geôlier dans sa cellule, effectue un strip-tease décrit dans le moindre détail. Après quoi elle s'enfuit pour prouver son innocence.

Pour s'assurer que les lecteurs ne vont pas succomber entièrement au vertige de la libération sexuelle, encore toute récente, le dernier article se présente comme une mise en garde, « J'ai participé à un culte orgiaque dans un pavillon de banlieue », signé Margaret Sims. Il commence par cette phrase : « La première fois que vous vous déshabillez devant un groupe mixte,

vous êtes quasi morte de honte. » Et pourtant, Margaret semble avoir apprécié cette expérience d'avilissement, puisqu'elle décrit ses parties de jambes en l'air de plus en plus baroques, notamment avec ses voisins, dans les années qui ont suivi.

On trouverait des témoignages similaires dans n'importe quel numéro de la plupart des magazines d'aventures masculins de l'époque de la libération sexuelle — les années soixante et soixante-dix. *Man's Story* et des dizaines de périodiques similaires, ont propagé l'évangile de la répression sexuelle — la sexualité est sale et dangereuse — tout en titillant la libido voyeuriste de ses lecteurs et cela sans jamais présenter le moindre acte sexuel !

Malgré leur insistance sur le bondage, le sadisme et le masochisme, les magazines « d'aventures », pour « vrais hommes », ou plus tard « d'action », n'étaient pas seulement disponibles dans les librairies pour adultes ou planqués sous le comptoir des kiosques. Au contraire, on les vendait ouvertement chez les marchands de journaux ou dans les drugstores, à côté de *Time*, *Look*, du *Saturday Evening Post*, et du *Ladie's Home Journal*. A leur apogée, à la fin des années cinquante, on en trouvait plus d'une cinquantaine de variantes (la plupart du temps avec « homme » au singulier ou au pluriel dans le titre) et ils se vendaient par centaines de milliers, et ce, non à une petite minorité de beaufs misogynes, mais à une importante fraction de la population masculine américaine.

Les magazines d'aventures pour hommes reflètent un aspect bien réel de la culture masculine de l'époque, le côté obscur de la meilleure génération américaine, celle des jeunes hommes qui ont gagné la Seconde Guerre mondiale. Ces héros qui ont vaincu Hitler et Hirohito ont connu, de retour aux Etats-Unis, une difficile période d'adaptation : une économie qui redémarrait lentement, des emplois rares, des difficultés de logement. Nombre de ceux qui avaient courageusement servi le combat pour la démocratie se sont retrouvés au chômage ou ont accepté un travail répétitif et fastidieux de col bleu ou blanc tout en bas de l'échelle. Si horrible qu'ait pu être la guerre, ce souvenir devait rester celui de leur plus grande aventure.

Il y avait aussi un fossé entre ce que les anciens combattants avaient vu et ce que la presse américaine, soumise à une censure extrêmement stricte de l'armée avait rapporté : les photos de cadavres de soldats américains, étaient notamment inter-

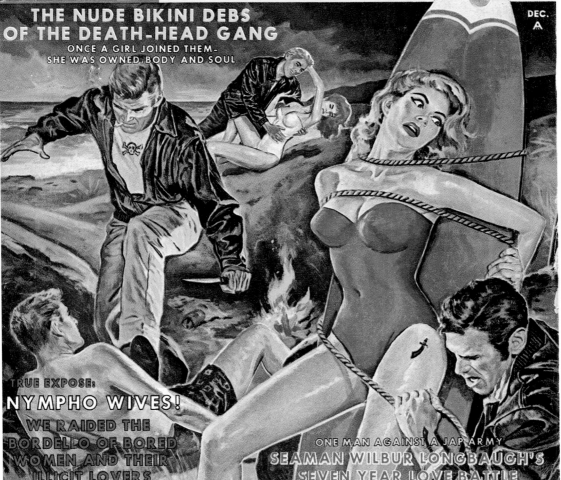

MAN'S

NINE LOVE TRAPS TO BE AWARE OF!

TRUE DANGER

35¢

DEC.
A

THE NUDE BIKINI DEBS OF THE DEATH-HEAD GANG

ONCE A GIRL JOINED THEM—
SHE WAS OWNED, BODY AND SOUL

TRUE EXPOSE:
NYMPHO WIVES!

WE RAIDED THE
BORDELLO OF BORED
WOMEN AND THEIR
ILLICIT LOVERS

ONE MAN AGAINST A JAP ARMY
SEAMAN WILBUR LONGBAUGH'S
SEVEN YEAR LOVE BATTLE

MAN'S TRUE DANGER, 12/1962, Norm Eastman

dites. Les hommes qui avaient vu les restes carbonisés d'Hiroshima ou les champs de bataille sanglants d'Europe retrouvaient des amis et des familles qui n'avaient eu de la guerre que la version expurgée autorisée par leur gouvernement au nom du moral de la nation. Les rapports sexuels avec des prostituées ou des réfugiées mourant de faim, la nécessité de tuer un gosse de seize ans pour ne pas être abattu par lui, et les missions-suicide qui décimèrent des bataillons entiers : autant d'expériences que seuls des anciens combattants pouvaient comprendre.

Les magazines d'aventures pour hommes qui parlaient leur langage ont servi à rassurer une génération tout entière : ils étaient bien des héros. Comme d'innombrables biographies, récits, romans, BD et films qui racontaient la Seconde Guerre et le quotidien des soldats, ces périodiques présentaient la « véritable » version de la guerre (c'est-à-dire la version autorisée). Et, pour les hommes qui n'avaient pas fait cette guerre, ces magazines offraient une sorte d'ersatz de vécu du combat qu'ils avaient manqué en tant que civils.

Les magazines d'aventures pour hommes étaient fort appréciés du tueur cannibale Ed Gein. Gein, qui a inspiré une demi-douzaine de films d'horreur, dont *Psycho, Massacre à la tronçonneuse* et le *Silence des Agneaux*, devait à son tour devenir le sujet d'histoires semblables à celles dont il s'était inspiré. Où, sinon dans ces magazines bon marché, aurait-il pu trouver des articles sur le cannibalisme, la réduction des têtes et le tannage de peau humaine ? Ces fascicules mi-sadiques mi-rigoristes, si américains, forment un trait d'union entre l'ère maccarthyste et la contre-culture des années soixante.

Les magazines pour hommes des années soixante avec leurs (fausses) « histoires vraies » découlent en droite ligne de leurs prédécesseurs, les magazines de faits divers bien réels ceux-là, qui firent connaître au grand public les épopées de gangsters comme John Dillinger ou Al Capone. Ils s'opposent en cela aux magazines d'aventures dont les couvertures scabreu-

ses dérivent directement des pulps romanesques, des fascicules en noir et blanc au format 20/30. Cette littérature regroupe divers genres: polar, science-fiction, western, romance, guerre, et son surnom (« pulp ») provient du papier de mauvaise qualité sur lequel étaient imprimés, en noir et blanc, ces périodiques. Leurs couvertures colorées étaient, en revanche, imprimées sur un papier brillant et elles représentaient souvent d'étonnantes scènes de torture au premier plan desquels on pouvait admirer des créatures très déshabillées. Dans un

DETECTIVE FICTION, FORMERLY FLYNN'S, 2/21/1942

format légèrement plus grand (25/33) les couvertures des publications ultérieures, destinées au même public masculin, poussèrent la transgression sadico-voyeuriste encore plus loin. Certains des artistes qui composaient ces peintures de couvertures vivaient du travail que leur procurait ce nouveau type de publications.

Bien que les magazines d'aventures pour hommes aient puisé à différentes sources, s'il ne fallait citer qu'un des pères de ce genre ce serait l'excentrique patron de presse américain, Bernarr Macfadden.

Né en 1868, Macfadden a passé son enfance dans la région rurale des Ozarks et ses débuts dans la vie ont été assez difficiles : orphelin à l'âge de six ans, pauvre et malade, sa vie a connu un tournant spectaculaire, au début de son adolescence, quand il a découvert la gymnastique. Au milieu du XIXe siècle, les immigrants allemands avaient importé aux Etats-Unis leurs méthodes d'exercice physique et de musculation et Macfadden commença à suivre un programme de musculation, s'astreignant à un exercice physique régulier. Un an plus tard, il était devenu un gymnaste de haut niveau, un lutteur professionnel et un rédacteur occasionnel d'articles sur la culture physique pour des magazines nationaux. Mais ce mouvement hygiéniste, malgré sa popularité croissante, restait pour la grande majorité des Américains, une invention de charlatan et Macfadden essuya pour ses articles plus de refus qu'il ne reçut de chèques. Impressionné par la vente de ses propres brochures, il fonda néanmoins en 1899 dans son club de gym new yorkais son propre magazine, *Physical Culture* (Culture physique). Il y mélangeait articles sur la gymnastique et la diététique et articles polémiques sur les médicaments et la médecine moderne. Ses articles étaient illustrés de photos (généralement de femmes en combinaison moulante ou maillot de bain) montrant comment pratiquer les exercices : en quelque sorte les playmates de l'ère victorienne. On y voit aussi des hommes en tenue de lutteur, et Macfadden lui-même, qui pose souvent pour son magazine. Ces clichés furent d'abord regroupés dans le magazine dans la rubrique Photographie artistique du corps, plus franchement intitulée par la suite : le Beau Corps.

Compte tenu du puritanisme de l'époque, les illustrations qui paraissaient dans *Physical Culture*, étaient assez « chaudes ». Mais comme ses photos osées apparaissaient au milieu d'articles scientifiques sur la santé et la forme physique, Macfadden évita nombre des problèmes que connaissaient des publications plus scabreuses. Une série d'articles sur les ravages de la sy-

philis allait tout de même lui valoir les foudres de la justice et il fut condamné pour obscénité, mais au terme d'une croisade de deux ans contre ce jugement, il obtint la grâce du président Taft.

Au lendemain de la Première Guerre mondiale, Macfadden profita de la relative libéralisation des moeurs des soldats (dont un certain nombre revenaient, après tout, de France) et de l'assouplissement de toute une série de législations conservatrices érigées pour encadrer les moeurs sous l'Empire. Paradoxalement, cette époque apparemment malsaine, pleine de gangsters, de fêtes très arrosées et de jeunes filles délurées, s'avère la plus profitable pour le groupe de presse Macfadden. *Physical Culture* publie régulièrement des témoignages — du type « J'allais devenir un gangster… » — décrivant comment la culture physique avait changé la vie d'un homme, illustré, comme de bien entendu, par des photos très dénudées du jeune gymnaste revenu dans le droit chemin. Nombre des récits que reçoit Macfadden sont impubliables dans un magazine de culture physique, car ils évoquent de manière trop détaillée des épisodes sordides ou criminels de la vie antérieure de l'auteur, mais ils vont trouver un cadre plus approprié avec le nouveau magazine de Macfadden : *True Story* (histoire vraie).

True Story se compose principalement de personnages qui ont réussi à triompher d'épreuves surhumaines ou de défis hors norme : telle héroïne a été la soubrette de Hitler, telle autre, une dirigeante de la résistance chinoise contre les Japonais. Mais la moelle du magazine (et de tous ses imitateurs), c'est l'histoire d'amour à l'eau de rose : des histoires d'hommes et de femmes qui surmontent les embûches de la vie conjugale ou les noirs secrets de leur passé pour parvenir finalement au véritable amour.

Tout en pressentant que ces histoires vont attirer un large public, , surtout parmi les lectrices, Macfadden est confronté à un nouveau défi : comment les illustrer ? L'héroïne qui écrit « La Déchéance » ou « Le cruel Postulat de l'amour » n'est de fait qu'une femme très quelconque dénuée des qualités requises pour figurer dans *Physical Culture*. Pour les couvertures, Macfadden a l'intention d'utiliser des tableaux accrocheurs, oeuvres d'artistes confirmés (il contactera notamment F. Earl Christy). Mais utiliser des croquis d'intérieurs pour illustrer des histoires vraies lui semble un mauvais choix.

Macfadden comprend alors que la meilleure façon de capitaliser sur la « vérité » sera de mettre en scène des photos bidonnées. *Physical Culture* dispose déjà d'un studio photo maison pour ses clichés de « Vénus » et d' « Adonis », il suffira donc à Macfadden de fournir de séduisants modèles pour donner à ces tragédies « réelles » une vie picturale. Certains de ses modèles feront une carrière de comédien, deux futures stars travailleront même pour lui : Katharine Hepburn et Frederic March.

Les libertés que Macfadden prend avec la « vérité » semblent lui réussir, puisque en 1926, *True Story* a atteint un tirage de deux millions d'exemplaires — un chiffre étonnant. Les récits sont désormais presque aussi « bidonnés » que les photos. Stimulés par

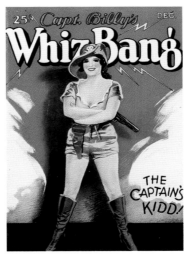

CAPT. BILLY'S WHIZ BANG, 12/1929

des honoraires juteux (jusqu'à mille dollars pour l'histoire vraie la plus sensationnelle) bon nombre d'écrivains de métier envoient des histoires « vraies » inventées au fil de la plume. C'est ainsi que Mickey Spillane, légendaire auteur de romans policiers, se fait par exemple passer à maintes reprises pour une fille-mère. En 1927, après le procès en diffamation qu'entraîne la publication d'une (véritable) histoire vraie, les récits de fiction à la première personne se généralisent. Macfadden, contraint de payer des dommages intérêts d'un demi-million de dollars, décide de faire systématiquement changer les noms de personnages des histoires qu'il publie.

En 1924, le talentueux homme d'affaires a lancé un autre titre : *True Detective*

Mysteries. *True Story* avait déjà publié des histoires criminelles (« J'étais une fille à gangsters », « Je suis tombée amoureuse d'un gangster »). La prohibition entraîne un énorme développement de la mafia à la solde de puissants parrains : Al Capone, à Chicago, Lucky Luciano à New York. Des affaires de meurtre sensationnelles défient la chronique et font vendre du papier, tel l'assassinat du petit Bobby Franks par Leopold et Loeb. Des écrivains comme Dashiell Hammett et Carroll John Daly inventent le nouveau roman noir dans le populaire pulp magazine *Black Mask*.

True Detective Mysteries permet de toucher un public principalement masculin. Entre les reporters qui suivent les enquêtes policières et les journalistes qui récrivent les faits divers que leur livrent inspecteurs et commissaires de police locaux, la couverture des crimes est on ne peut plus simple à réaliser. Dans *True Detective*, on peut contempler d'atroces photos de scènes du crime que les journaux n'osent pas publier, mais elle habille son voyeurisme gore de couvertures à l'esthétique irréprochable qui incitent les kiosquiers à mettre le magazine en évidence. Fin 1928, Macfadden lançait un pulp d'aventures, *Red Blooded Stories*. Au sixième numéro, le titre change pour devenir *Tales of Danger and Daring* au même format que *True Detective*. Le magazine comporte seize pages d'enquêtes criminelles sur papier épais. Cet hybride de pulp et de magazine d'aventures pour hommes n'a duré jusqu'en juin 1929. Malgré l'existence éphémère de cette formule, celle-ci allait être rapidement adoptée par d'autres patrons de presse.

A la fin des années trente, le marché est prêt pour le lancement d'un magazine d'histoires vraies destiné plus particulièrement aux hommes. Assez bizarrement, ce n'est pas Macfadden mais son concurrent Fawcett Publishing qui invente la formule. Fawcett Publishing s'est développé à partir du très populaire *Captain Billy's Whiz Bang*, mensuel d'humour grivois concocté artisanalement par le capitaine Wilford H. Fawcett au lendemain de la Première Guerre mondiale. En 1931, un de ses journalistes, Ralph Daigh, a lu une étude indiquant que les hommes préféraient les faits divers aux histoires inventées de toutes pièces. Daigh réalisa la maquette d'un magazine qu'il intitula *True*. Il faudra cependant attendre 1937 pour que Fawcett l'autorise à appliquer la formule de Macfadden au marché

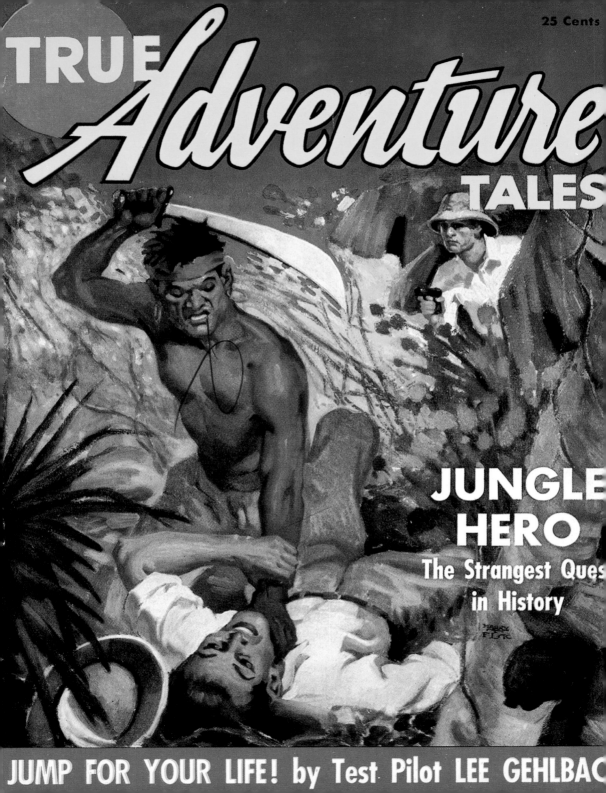

25 Cents

TRUE *Adventure* TALES

JUNGLE
HERO
The Strangest Ques
in History

JUMP FOR YOUR LIFE! by Test Pilot LEE GEHLBAC

des fascicules populaires pour hommes avec *True* et *True Adventure Tales*. Le format de ces deux publications est de 25/33, comme celui des magazines policiers ou sentimentaux.

True Adventure Tales ne connaîtra qu'une brève existence. Imprimé en rotogravure sur papier glacé, il annonce les magazines d'aventures masculins, avec ses couvertures aux peintures accrocheuses. Le numéro deux montre une image qui aurait été parfaitement à sa place dans un kiosque vingt ans plus tard : un « sauvage » brandissant une épée avec laquelle il est sur le point de décapiter un explorateur gisant, impuissant, à ses pieds. On y trouve aussi une série d'aventures réelles avec photos authentiques et quelques illustrations, qu'il s'agisse d'exploration de la jungle africaine ou d'aventures aériennes à l'époque des pionniers, ou encore d'aventures plus banales, arctiques ou autres

True, avec son titre plus laconique est beaucoup plus scabreux. Sur la couverture du premier numéro, on peut admirer la photo en gros plan d'une femme grimaçante qui se détache sur un fond jaune vif avec ces gros titres : « 200 photos choc ! 23 histoires complètes ! Solution de la mort parfumée de la ravissante actrice ! Pourquoi j'ai choisi le suicide, la confession de Norma Millen ! ». Sur les couvertures des numéros suivants on voit presque toujours des créatures déshabillées et attachées. Presque la moitié des histoires que présente le magazine sont choisies parmi les faits divers criminels les plus sensationnels, avec des séquences photos macabres, d'exécutions de criminels, ou d'exactions perpétrées par les bandes de malfrats, ou encore des articles sur les faiseuses d'anges et les escrocs les plus en vue du moment.

Parmi les sujets osés, on citera un procès pour violation de promesse de mariage avec en exergue une jolie blonde à cigarette, et un reportage burlesque illustré de photos de danseuses nues.

Seins nus, sexe et violence l'emportent sur les aventures des explorateurs des pôles ou des jungles et *True Adventure Tales* prend bientôt la relève, ses histoires d'aventures exotiques trouvant leur place naturelle dans *True*. Le tirage mensuel du magazine grimpe à 250.000 exemplaires. Les couvertures montrent des photos de femmes attachées ou en péril tandis qu'à l'intérieur, on peut se régaler d'horribles histoires nécrophiles, d'expériences cannibales ou encore d'atrocités japonaises ou allemandes d'avant la Deuxième Guerre

LES PAGES ETAIENT REMPLIES D'AFFREUSES HISTOIRES DE NECROPHILIE, DE CANNIBALES, ET D'ATROCITES D'AVANT GUERRE.

mondiale. Malgré le caractère scabreux et nébuleux des sujets abordés, seules les photos de couvertures sont posées. Le florissant *True* a eu quelques imitateurs : *Personal Adventure Stories* qui connut une très brève existence (1937). L'éphémère *Sensation*, en 1939, qui reprenait quelques unes des histoires les plus sensationnelles parues dans Sunday, un journal du groupe Hearst ; un deuxième *Sensation*, de 1941, cette fois, qui connut un succès plus net ; et *True Thrills* (vrais frissons), un titre Fawcett également de 1941, trimestriel qui recyclait, pour l'essentiel, des histoires déjà parues dans *True*.

La même année, le groupe Munsey, éditeur chevronné de pulps, remaniait *Flynn's Detective Fiction* et *Argosy* et en lançait de nouvelles versions mêlant réalité et fiction. Au même format que *True*, ils étaient néanmoins deux fois moins épais. Le papier de mauvaise qualité sur lequel ils étaient imprimés ne permettant pas de bonnes reproductions photo, les articles de « faits divers authentiques » étaient illustrés de dessins plus ordinaires à l'encre ou au lavis. Cette nouvelle formule aux couvertures exotiques valut un gros succès populaire à *Flynn's*.

Argosy, d'autre part, alternait couvertures peintes (« Au bout de l'enfer avec les commandos suicides ! ») et photos de couvertures évidemment posées (« Violentées par les Japs ! »), avec un soldat à la mine fort peu asiatique déchirant le chemisier d'une blonde timide. Cette politique incohérente fut sanctionnée par une chute des ventes, une hémorragie de lecteurs sans gain réel d'un nouveau public. Après l'attaque de Pearl Harbour, la situation ne fit que s'aggraver, les soldats qui ne pouvaient obtenir plusieurs numéros d'*Argosy* étant frustrés de ne pas pouvoir suivre leurs romans feuilletons. Munsey finit par céder tous ses

pulps à Henry Steeger des Popular Publications.

Pendant ce temps, Martin Goodman commençait son propre voyage dans l'univers des aventures pour hommes. Editeur comblé de Timely (aujourd'hui Marvel) Comics, qui publiait notamment *Captain America*, Sub-Mariner et *The Human Torch*, Goodman diffusait aussi des collections de pulps d'horreur aux titres évocateurs (« Lune de miel en enfer », « Moi, Satan, je prends ton enfant, fruit du péché », et « jouet d'un hideux désir »). Ces magazines se vendent souvent sous le comptoir. Sur l'une de ces couvertures, on peut ainsi admirer une « fille avilie qui a appris la séduction de choses inavouables », en fait une jeune femme presque nue, fouettée par des gnomes monstrueux.

Les magazines de Goodman l'ont enrichi, mais il aspire à une publication de plus haute gamme comme *Esquire*, cette réussite des années de la crise. Tandis que les patrons de presse, aux quatre coins de l'Amérique, réduisent le prix des pulps à dix cents et celui des hebdos à cinq cents, en 1933, David Smart et Arnold Gingrich lancent *Esquire*, vendu au prix étonnant de cinquante cents. Conception luxueuse, format hors norme, impression en couleurs sur un épais papier glacé, ainsi se présente *Esquire*. Destiné à la population masculine aisée, ce magazine mêle articles d'Hemingway et dessins sexy et raffinés en couleurs d'E. Sims Campbell. Le magazine dont les experts avaient prédit l'échec vend plus de cent mille exemplaires de son premier numéro et atteint rapidement un rythme de croisière de plus de 500.000 exemplaires.

En 1941, Joseph Alvin Kugelmass, écrivain indépendant, fait une proposition à Goodman. Il prétend qu'il a des contacts qui lui permettront d'obtenir les droits de textes de nombreux écrivains américains célèbres à des prix très bas. Avec des manuscrits de ce calibre, Goodman va pouvoir fabriquer un magazine de grande classe pour un prix défiant toute concurrence. Il damera le pion à *Esquire* pour un investissement beaucoup plus modique. En retour, Kugelmass demande le poste de rédacteur en chef.

Des dollars plein les yeux, Goodman accepte aussitôt. Le nouveau magazine, *Stag*, est conçu pour ressembler comme deux gouttes d'eau à *Esquire*, mais alors que ce dernier s'adresse aux dessinateurs américains les plus cotés, Goodman et Kugelmass s'appuient sur des artistes moins connus de Timely Comics comme Gasparo

Ricca, Al Avison, Chad Grothkopf et Don Rico ainsi que des illustrateurs de pulps comme Norman Saunders. Les Pin-ups (normalement le domaine de la superstar George Petty et du nouveau venu Roberto Vargas dans *Esquire*) sont réalisés par des artistes de second rayon comme Cardwell Higgins et Peter Driben, lequel a été peintre de couvertures pour des magazines érotiques bas de gamme dont la New York Vice Commission a fait sa bête noire. Le résultat final ressemble moins à un clone qu'à une parodie d'*Esquire*.

La publication de ce numéro est rapidement suivie par des appels et des lettres d'écrivains ou d'agents demandant le règlement de leurs honoraires. Parmi ceux-ci figurent Robert Benchley, Ogden Nash et August Derleth. Un tribunal fédéral ordonne à Goodman d'interrompre la publication de *Stag* jusqu'à ce que les auteurs aient été payés.

Quant au génie éditorial qui a su trouver les arguments irrésistibles pour réunir ces célébrités, il réagit d'autant moins qu'il a disparu. Une rapide enquête interne révèle alors que toute une série de chèques qu'auraient dû recevoir les auteurs ont été endossés par Joseph Alvin Kugelmass : son écriture est parfaitement reconnaissable.

En fait ces histoires n'ont jamais été réellement adressées à *Stag*. L'impudent Kugelmass a imaginé de reproduire des histoires ou des chapitres de romans et de se payer ces textes lui-même ! Bien sûr, Goodman, malgré son désir de créer un magazine haut de gamme, n'a pour ainsi dire pas lu les grands auteurs dont il a acheté les œuvres et il est bien incapable de reconnaître qu'il ne s'agit nullement de textes inédits. Il passe des arrangements avec les auteurs, fait paraître quelques numéros pour écouler son stock de textes, puis met la clé sous la porte.

Kugelmass, qui s'est enfui à la Nouvelle-Orléans, est arrêté et emprisonné. Mais l'industrieux escroc ne perd pas son temps en prison où, entouré de criminels, il écrit une kyrielle d'histoires vraies pour des détecti-

UNE EPOUSE NYMPHOMANE POUVAIT REAP-PARAITRE EN PROSTITUEE COMMUNISTE SEDUISANT DES SOLDATS AMERICAINS.

ve magazines. Il en vendra même (sous un pseudonyme) quelques unes à Goodman !

Au même moment, Henry Steeger et les Fawcett Publications connaissent quelques problèmes avec le Directeur général

MAN'S MAGAZINE, 2/1954, reader survey

de la Poste des Etats-Unis, autrement dit la censure postale. En 1940, Frank Walker est devenu son patron tout puissant. Catholique, il est très influencé par le National Office for Decent Literature (l'Office national pour la littérature décente, NODL), émanation de l'Eglise. Et il lance une croisade contre les magazines qu'il considère, en accord avec l'Office, comme nuisibles pour la morale publique. Son arme suprême ? L'annulation de leur tarif réduit dit « de seconde classe », absolument vital pour la survie de ces magazines.

Le désastre de Pearl Harbour va encore renforcer les pouvoirs de la censure postale. Walker est autorisé à écarter d'office la littérature séditieuse du courrier postal et de mai 1942 à mai 1943, il annule les privilèges postaux de soixante-dix magazines

parmi lesquels des publications authentiquement séditieuses comme la lettre d'actualité *American Bund Newsletter*, ou *Social Justice*, feuille pronazie du révérend Coughlin. En revanche il s'en prend aussi à une vingtaine de magazines qu'il juge obscènes, comme *Esquire*, *Argosy* de Munsey et *True Confessions* de Fawcett (mais pas *True* avec ses créatures ficelées en couverture). *Esquire* riposte efficacement, malgré la ténacité de Walker qui poursuit l'affaire jusque devant la Cour Suprême. Mais comme une grande partie des lecteurs masculins sont des militaires et que les points de vente de l'armée sont également soumis à la censure, cette croisade gouvernementale pousse d'autres magazines à revoir leur politique éditoriale. Quelque mois après Pearl Harbor, tous les *Spicy* (*Spicy Detective*, *Spicy Western*, *Spicy Adventure*) ont changé leur titre en « Speed » et voilé les poitrines auparavant dénudées de ses héroïnes — qui restent cependant ligotées.

La campagne du directeur de la Poste décide Steeger à concocter une nouvelle formule d'*Argosy*, qu'il vient d'acquérir. *Argosy* est l'un des pulps les plus populaires et celui dont la vie a été la plus longue. Fawcett, lui aussi est contraint de revoir le contenu de *True*, plus populaire encore.

Il s'agit aussi pour ces patrons de presse d'accroître les recettes publicitaires. Contrairement aux magazines « présentables » de leur époque, les pulps, les policiers, les magazines d'aventures pour hommes et les magazines sentimentaux vivent non de la publicité mais grâce aux ventes en kiosques et aux abonnements. La plupart ne comportent presque pas de publicité, d'autant que la qualité du papier exclue les onéreuses pubs en quadrichromie. De plus, rares sont les grands groupes qui risqueraient l'image de leurs marques en louant une page dans un magazine dont la une affiche une fille déshabillée au-dessus de laquelle un bandeau clame « Filles à torturer ! ». Avec la pénurie de papier due à la guerre, les coûts d'impression ont grimpé en flèche

et pour maintenir les bénéfices il ne reste qu'à augmenter les recettes publicitaires.

Fin 1943 pour le premier et début 1944 pour le second, les concurrents *True* et *Argosy* dévoilent leurs nouveaux formats sur un papier de qualité et des pages intérieures en quadrichromie. Fini les gros titres scabreux, les soldats japonais sadiques et les femmes nues ficelées et apeurées. Place aux images qui annoncent les douces années cinquante : vieux messieurs en partie de pêche et jolies jeunes femmes en uniformes.

Les histoires d'*Argosy* — les faits divers comme la fiction — restent influencées par l'ambiance de ces années de guerre, mais on y trouve aussi les spéculations de politologues et d'économistes sur l'évolution du monde après la guerre, comme des articles de développement personnel et psychologique. *True*, lui, reste attaché aux histoires factuelles et adopte un ton plus conservateur avec moins de photos et plus d'illustrations intérieures, en général signées par des grands noms de l'illustration comme Charles LaSalle, Hardie Gramatky et Albert Dorne. Malgré leur héritage scabreux, voire sordide, tous deux deviennent des magazines que Papa ou Papi peuvent lire et même laisser traîner sans craindre que les gosses tombent dessus.

Cette stratégie réussit. Le nouveau *True* bien sous tous rapports voit son tirage presque doubler en un an. En 1944, Fawcett signe un contrat avec Petty pour qu'il crée une pin-up destinée à l'encart central de chaque numéro. Le chiffre des ventes d'*Argosy*, qui plafonne à quelques milliers d'exemplaires, atteint quant à lui les deux cent cinquante mille mensuels. Quant aux recettes publicitaires elles ne vont pas tarder à décoller avec la fin de la guerre et le redémarrage de l'économie.

En rendant, en 1945, un arrêt en faveur d'*Esquire*, la Cour Suprême met le holà à la campagne du Service Postal contre les magazines « répréhensibles » et Goodman se réinvestit dans le marché des magazines pour hommes. Il va lancer plusieurs tabloïds, lesquels ont retrouvé un public dans l'Amérique de l'après-guerre. Les périodiques grand format illustrés, d'abord imprimés sur un papier médiocre type supplément dominical à la fin des années trente, sont maintenant imprimés sur un beau papier. Outre les articles d'information, on y trouve les habituelles pin-ups. *Look*, dont le tirage avoisine les deux millions d'exem-

LES GRANDES LIBERTES PRISES AVEC LA VERITE NE SEMBLAIENT PAS AFFECTER LES VENTES.

plaires en 1940 est alors le modèle de cette presse qui s'adresse à un public essentiellement masculin, sans doute attiré par la « danseuse de la semaine » en minuscule maillot de bain sur la couverture. Après la guerre, Goodman se demandait si un lectorat d'anciens combattants réagirait positivement à un magazine d'aventures pour hommes. Il avait aussi un nom de marque à protéger, car l'éditeur Adrian D. Lopez, son concurrent, arborait sur son nouveau *Man to Man* le slogan : Le Magazine des Mecs. »

En décembre 1949, pour la première fois, Goodman crée un magazine original au lieu de se contenter de copier les formules qui gagnent. Après une première couverture terne, signée Albert Fisher et représentant des supporters de football en liesse, le nouveau *Stag* au format tabloïd refondu de A à Z gratifie ses lecteurs de sensationnelles couvertures dont les peintures sont dignes des pulps classiques : De la Tahitienne brandissant des lances vers la pieuvre qui s'est attaquée à son bien-aimé, à la créature très déshabillée et résignée à son sort sur fond de combat entre soldats de la Légion Etrangère et guerriers arabes, sans oublier cet homme torse nu qui grimpe sur un bateau, une beauté à la robe en lambeaux sur l'épaule. Les couvertures sur papier glacé proclament « J'ai navigué au bout de l'enfer ! », « Les 7 moyens d'améliorer votre technique sexuelle ! », ou « La capitale du vice aux Etats-Unis ». Goodman connaît le dosage exact des ingrédients qui vont lui attirer le public populaire qu'il convoite : sexe, aventure, guerre, scandale, photos de jeunes starlettes et « nature devenue folle ».

L'utilisation des peintures de style pulp pour les couvertures, au lieu des photos, réservées aux couvertures des « vrais » magazines pour hommes, est une innovation. Certes, la couverture sensationnelle de *Stag* annonce en général une histoire complètement ou partiellement inventée, mais pour beaucoup de lecteurs, elle est vraie parce que les histoires qui l'entourent le

sont. Ce qui permet à Goodman, bientôt suivi par ses pairs, de commander des illustrations de couverture — voire absurdes — et des récits à des auteurs délivrés de l'asservissement aux simples faits.

Harry Matetsky, qui travaillait alors pour Sterling Publications (*Man's Illustrated*) et qui devait s'associer par la suite avec Martin Goodman, explique : « Ils commençaient toujours par dessiner la couverture, parce que c'était le hameçon, l'atout numéro un. Plus la couverture avait un impact fort, plus les ventes grimpaient. Et souvent ça signifiait qu'on demandait à un auteur de concevoir une « histoire vraie » à partir de la couverture ».

Alors que les magazines pour hommes que Goodman conçoit par la suite se font remarquer pour la qualité exceptionnelle de leurs illustrations intérieures, fussent-elles scandaleuses, les premiers numéros de *Stag* mêlent photos sincères et fabriquées. C'est une excellente source documentaire sur le bidonnage des photos pour les magazines policiers « d'histoires vraies ».

Les clichés pour *Stag* (et ses rivaux ultérieurs) sont souvent empruntés à d'autres sources. C'est notamment le cas pour un article sur les bandes de motards illustré par des clichés non crédités du Film *The Wild One*, avec Marlon Brando. Beaucoup d'images illustrant les articles sur la sexualité sont des images tirées des scènes les moins osées de films porno des années quarante ou cinquante. En général, la partie supérieure de la photo est caviardée en noir pour empêcher son identification et d'éventuelles poursuites judiciaires, comme le montre l'exemple de cette Vietnamienne posant en robe traditionnelle ao dai pour un article de mode, transformée en prostituée proposant ses services à des soldats américains.

Les photos de couverture de *Stag*, avec leurs mises en scène savantes, semblent souvent plus réalistes que celles de ses concurrents parce qu'elles n'utilisent pas toujours des modèles professionnels. Toutes celles des magazines Goodman sont en général réalisées dans les bureaux du groupe et, par souci d'économie, les modèles sont choisis parmi les employés ou les pigistes.

Roy Thomas, ex-rédacteur en chef de Marvel Comics et auteur de BD réputé se rappelle l'ambiance de *Stag* dans les années soixante : « L'artiste Bill Everett (surtout connu comme créateur de *Sub-Mariner*) était venu proposer une histoire. Un journaliste de *Stag* est venu le voir et s'est

mis à le flatter, lui proposant de figurer dans le magazine, l'assurant qu'il avait l'air très digne – alors que Bill était alcoolique et que ce jour-là, il était à moitié bourré – bref qu'il ferait un « docteur » parfait. Bill s'exécuta et quand les photos furent tirées, il s'aperçut que le « docteur » en question était une sorte d'avorteur sordide. »

Cette habitude de faire poser le personnel pour les illustrations du magazine se poursuivra presque jusqu'à la fin de l'ère des magazines d'aventures pour hommes. A la fin des années soixante, un photographe eut même l'idée de faire poser un homme et une femme de l'équipe de rédaction et de s'en servir pour illustrer un article sur de dangereux criminels recherchés « morts ou vifs ». Mais le rédacteur en chef ne tarda pas à comprendre qu' il risquait un très dangereux procès pour peu qu'un hurluberlu abatte à vue ses collaborateurs après avoir lu le magazine. Stag se résolut donc à embaucher des modèles professionnels, et alla même jusqu'à informer ses lecteurs que ses illustrations étaient des mises en scène.

Goodman « recyclait » tout : les histoires, les couvertures et surtout les photos. Le mari trompé de l'année précédente pouvait fort bien être l'homosexuel pédophile de l'année suivante. Une épouse nymphomane pouvait à volonté se transformer en prostituée communiste séduisant des militaires américains. Les journalistes de Stag utilisent aussi des photographes new-yorkais et notamment des reporters d'actualité quand ils veulent obtenir des clichés difficiles à mettre en scène : gros plans de corps estropiés dans des accidents de voitures ; cadavres disloqués par des ours sauvages ; scènes de combats de boxe brutaux et sanglants ; clichés pris sur le vif durant une opération du cerveau, et autres gracieusetés du même ordre. Certaines de ces photos illustrent des articles de fond, d'autres paraissent dans la rubrique « dernières nouvelles ». De telles images confortent l'image macho du magazine. Un lecteur de Stag doit être capable d'endurer avec un stoïcisme inébranlable ces images grotesques de corps désarticulés, de crimes,

de guerres. Ce que Goodman vend c'est un concept de virilité, le mythe John Wayne transposé à la réalité de l'Amérique en col bleu, dans des contes dont les héros peuvent supporter n'importe quelle douleur infligée par des hommes, des bêtes sauvages, ou une nature hostile.

Les héros de Stag ont besoin de l'appel de l'aventure : bien des lecteurs du magazine ont reçu leur ordre de mobilisation, ou obéi à un élan patriotique stimulé par l'attaque de Pearl Harbour. Toujours est-il qu'ils ont été arrachés à leur foyer par la

MAN'S MAGAZINE, 12/1953, Frederick's of Hollywood ad

guerre et envoyés au bout du monde, où beaucoup d'entre eux ont eu leur première expérience sexuelle, dans la plupart des cas avec une prostituée. Or, Stag raconte à ces anciens combattants des histoires de prostituées héroïques luttant contre les nazis ou les « Japs » aux côtés des militaires américains. Goodman donnait aussi des conseils pratiques en matière de sexualité, révélant souvent l' « attente secrète » des femmes, à savoir les préliminaires.

A l'origine, Goodman s'est montré prudent dans ses expérimentations : Stag a

d'abord été bimensuel pendant presque un an. Mais en 1950, les Macfadden Publications – sauf Bernarr qui a été évincé à la suite d'un putsch – ont fait paraître Saga dans un format 24/33 similaire à ceux de True et Argosy. Saga flirte dès le début avec la formule du magazine d'aventures pour hommes, bien que les premiers numéros ne comportent pas, au centre, les pin-ups dépliables. Dans ses premières années, Saga est aussi asexuée que True ou Argosy, ses couvertures montrant des gros plans d'explorateurs, de capitaines ou de soldats.

En réponse, Goodman lance Male à la fin des années cinquante. La guerre de Corée qui a commencé en juin lui a donné un bon prétexte pour réduire le format de ses magazines, les tabloïds ne rentrant pas dans le paquetage des soldats. Male est le premier magazine pour lequel Goodman adopte le format 24/33, suivi par Stag en 1951.

Male utilise aussi des dessins et des peintures au lieu des photos pour ses illustrations intérieures. Durant la guerre de Corée, Goodman édulcore ses peintures de couvertures ; s'alignant sur Saga, il remplace les filles indigènes à moitié nues et les bêtes féroces par des portraits de soldats ou d'aventuriers. Au départ, cette évolution est destinée à amadouer les services de diffusion de presse de l'armée (celui de la marine, à Brooklyn vend à lui tout seul plus de magazines qu'aucun autre point de vente de l'énorme marché de New York et du New Jersey). En 1952, Goodman lance Men bientôt suivi par Pyramid avec Man's Magazine. Ces deux magazines lancés au format tabloïd sont bientôt réduits au format standard.

Les sociétés qui publient des dizaines de magazines masculins, à scandales ou policiers n'ont en général pas de régie publicitaire intégrée. Des intermédiaires professionnels comme David Galler achètent plusieurs pages pour quelques milliers de dollars et les revendent à des sociétés de vente par correspondance en augmentant légèrement le prix. Ces annonces sont

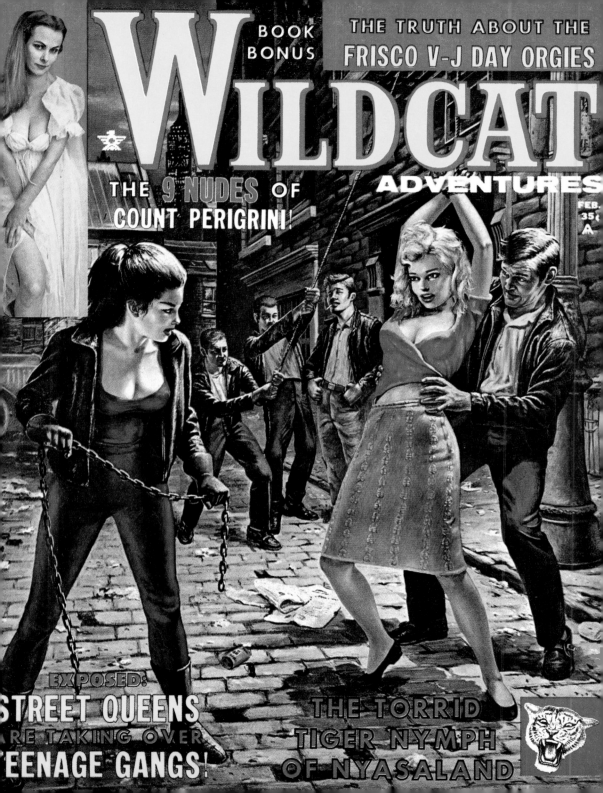

généralement achetées par des écoles par correspondance, des marchands de remèdes miracles et autres panacées (« Ne souffrez plus de votre hernie ! »). Les supports susceptibles d'accepter les publicités de distributeurs d'articles érotiques — qu'il s'agisse des manuels standard et autres films nudistes ou des fascicules eight pager (« Le genre qu'aiment les hommes ! »), de la lingerie fine de Lili St. Cyr ou de Frederick's of Hollywood, sans parler de la pornographie standard, soft ou hard — ne sont pas légion. Dans les années cinquante, les éditeurs de magazines d'aventures pour hommes font régulièrement l'objet de campagnes des commissions sénatoriales contre la pornographie, lesquelles poursuivent de leur vindicte les revendeurs de gadgets érotiques hard. Accusés de collaborer avec des pornographes auxquels ils n'ont pas eux-mêmes vendu d'espaces publicitaires, les éditeurs tirent en fin de compte des bénéfices très limités d'un type de publicité, compte tenu des risques qu'elle présente et des frais d'impression qu'elle suppose.

Malgré des conditions aussi défavorables, le marché des magazines d'aventures pour hommes s'élargit en 1953. Il est passé de cinq magazines en 1950 à huit en 1951, onze en 1952, et ne cesse de s'agrandir. Fawcett lance alors une version plus osée de True intitulée Cavalier ; Argosy marque la transition du vénérable vieux pulp Adventure en un véritable magazine d'aventures ; et Macfadden lance de son côté Impact et le plus osé de tous ces titres, Climax (apogée/orgasme).

Impact ainsi que quelques autres magazines optent parfois pour des photos de couverture, mais un test de Man's Magazine, un concurrent de Stag, met un terme à cette pratique. Le numéro de février 1954 de Man's Magazine est en effet disponible en deux versions : l'une avec peinture de couverture représentant un explorateur confronté à une tribu d'aborigènes australiens, l'autre avec une photo d'Eve Meyer (la pulpeuse fiancée du photographe et réalisateur Russ Meyer). Bizarrement, c'est la couverture à l'explorateur qui conquiert les

lecteurs et la plupart des éditeurs de magazines masculins optent unanimement et pour une vingtaine d'années pour les couvertures peintes.

Le culturiste et bodybuilder Joe Weider a suivi la recette qui avait fait le succès de Macfadden, passant des fascicules ronéotypés de culture physique aux magazines et ouvrages sur la musculation et la santé. En 1952, il rebaptisait le magazine : Your Physique : The Magazine of Constructive Living en Mr. America : The Magazine of Constructive Living (M. Amérique, le maga-

TRUE WEIRD, 11/1955, Clarence Doore

zine de la vie constructive). Ce changement fut peut-être le résultat de réponses positives aux annonces de Weider pour ses cours et appareils de musculation dans les magazines d'aventures pour hommes. Avec une peinture de couverture et quelques histoires viriles sur la guerre de Corée, Weider transforma effectivement sa publication en magazine d'aventures pour hommes. Quand cette publication changea encore une fois de titre pour s'appeler désormais d'un titre paradoxal Fury : The Magazine of Constructive Living (Rage, le maga-

zine de la vie constructive), il ne réservait plus que quelques pages à la musculation. Les autres articles parlaient d'Elvis Presley, de James Dean, des « cités américaines du péché » ou encore des « démoniaques adorateurs de l'antéchrist ». Ce type d'histoires contrastait étrangement avec le discours de ce prédicateur d'un genre nouveau : « Fury ne satisfera pas ceux qui ne trouvent de plaisir qu'à la lecture d'histoires de sexe, de sadisme, de viols et de meurtres. Nous refusons de flatter les instincts les plus vils de l'homme ». Le lecteur qui tournait la page, pouvait alors entamer sa lecture de « La route de la prostitution » ou de « Quand l'Amérique mangeait ses morts »…

Le succès de Fury pousse Weider à créer plusieurs autres magazines d'aventures pour hommes ou de « chasse », dont Outdoor Adventures et Animal Life. Ce dernier, bientôt rebaptisé Safari, présente les habituels gorilles et autres félins mangeurs d'hommes dans leur cadre de vie naturel. Weider ajoute au genre deux magazines assez insolites : True Strange et True Weird, lesquels mêlent des contes surnaturels avec des histoires comme « Le miracle qui fit de Sophie Loren une star ». La créature du premier True Weird reste un modèle du genre : sur une peinture accrocheuse de Clarence Doore, on peut admirer une blonde en bikini menacée par des hommes poissons qui semblent sortis tout droit de Creature from the Black Lagoon (la créature du lagon noir), un film de l'époque.

Tout ceci n'empêcha cependant pas Weider de revenir rapidement au genre qu'il connaissait le mieux, les magazines de culture physique et de musculation — et de devenir multimilliardaire.

A l'apogée du boum de cette presse, en 1953, Hugh Hefner publie le premier numéro de Playboy, son magazine révolutionnaire. Il proclame gaiement que la guerre des sexes est un mensonge et un mensonge particulièrement démodé. Playboy met en avant le désir des femmes en tant que telles, ni filles faciles ni prostituées,

mais femmes-femmes aimant la sexualité et plus adeptes du plaisir que de la douleur. Comme si les vétérans de la Seconde Guerre se partageaient en deux grandes catégories : le lecteur de *Stag* représente la population ordinaire des hommes qui accomplissent un travail ingrat de serveur ou d'ouvrier. Pour ceux-là, le grand moment de leur vie reste celui où ils ont perdu une jambe lors de la campagne de France ou perdu leur pucelage sur une île du Pacifique. Les lecteurs de *Playboy*, eux, ont par exemple, entrepris des études supérieures grâce à une bourse d'ancien combattant et découvert le jazz, la stéréo high-tech, les voitures de sport et le rapport Kinsey sur la sexualité. Alors que les lecteurs de *Stag*, à la lecture du rapport Kinsey, se demandent si leur petite amie n'est pas lesbienne ou si leur femme les trompe.

L'après-guerre reste une ère de grandes contradictions dans la culture américaine. D'une part, c'est une époque de répression : la propagande anti-nazie des années précédentes se transforme en furieuse propagande anti-communiste, souvent dévoyée. D'autre part un courant libéral, délivré des contraintes des années de guerre, freine l'extension de l'idéologie de la Guerre Froide à d'autres aspects de la culture américaine et notamment à la morale sexuelle. Malgré les mésaventures judiciaires de Hefner, *Playboy* va triompher dans cette dialectique étrange entre répression et hédonisme. La bagarre entre Hugh Hefner et le National Office for Decent Literature, aux deux extrêmes, délimitent le cadre à l'intérieur duquel les magazines d'aventures pour hommes vont croître, prospérer et finalement mourir, dans les vingt-cinq années suivantes.

Le début des années cinquante voit l'apparition d'un nouveau paramètre dans la bataille de la censure, celui des communautés qui se mobilisent sur tout le territoire des Etats-Unis pour protéger les enfants contre l'influence pernicieuse de certaines lectures, livres, magazines, et surtout bandes dessinées. A la fin des années quarante, le psychologue Frederic Wertham a lancé une croisade contre le crime et, par la suite, les histoires d'horreur dans les bandes dessinées. On a assisté, auparavant, à des campagnes contre les publications licencieuses, mais Wertham (outre sa célèbre dénonciation de l'homosexualité de Batman et Robin) concentre son tir de barrage sur les conséquences de la violence dans les médias. Ses articles, plus tard développés dans le best-seller *Seduction of the Innocent* (1954) ont

LES COUVERTURES DES MAH EXPLOITERENT LA VEINE SEXE ET SADISME ENCORE PLUS SCANDALEUSEMENT QU'AVANT.

donné un nouvel essor au NODL et autres associations de défense des bonnes mœurs qui avaient essuyé quelques échecs devant les tribunaux, après que Frank Walker, Directeur de la Poste, ait tenté de censurer les magazines « répréhensibles ». Le NODL développa ses activités, s'en prenant non seulement aux BD mais aussi à tous les magazines et livres de poche censés représenter un risque de corruption pour les enfants. L'auteur d'un des articles les plus détaillés sur la tactique à suivre, quand on est une association locale de parents d'élèves ou un groupe de fidèles, pour inciter les marchands de journaux à cesser de vendre des magazines répréhensibles, n'est autre que Joseph Alvin Kugelmass ! Le même Kugelmass ex-rédacteur en chef de *Stag* qui a grugé Martin Goodman de milliers de dollars et fait désormais partie de l'équipe du *Christian Herald*, dont on peut présumer que les éditeurs ignorent qu'il écrit au même moment des articles pour des magazines figurant sur la « liste noire » de la NODL.

Mais les illustrés, en tant que magazines les plus accessibles aux enfants, restent la bête noire numéro un des groupes qui s'efforcent de lutter contre la dégradation des mœurs. Des campagnes de boycottage locales, en 1954 et 1955, conduisent à l'instauration d'un code de déontologie, le Comics Code, contrôlé par un organe de censure mis en place par les patrons de presse en 1956. Ce nouveau revers conduit un certain nombre de groupes à créer des supports différents, plus adultes, notamment des magazines d'aventures pour hommes, exactement comme Goodman, l'éditeur de Timely/Marvel l'avait fait quelques années auparavant.

Hillman Periodicals qui a créé plusieurs illustrés depuis le début des années quarante, se risque dans le domaine des aventures pour hommes avec *Real Adventure* lancé en 1955. La même année Stanley Morse, le dernier électron libre de la filière et créateur de quelques-uns des illustrés

d'horreur les plus extrêmes du début des années cinquante, transforme son titre *Battle Cry* en magazine d'aventures pour homme. Célèbre pour une couverture très détaillée sur laquelle on voit un GI américain transformer avec son lance-flammes ses adversaires coréens en torches vivantes, *Battle Cry*, fait des débuts fort convenables dans l'univers du magazine pour hommes avec une couverture peinte sur laquelle on voit deux GI dans une camionnette Jeep réservée au transport de cadavres. A peine a-t-on tourné quelques pages qu'on voit réapparaître des images très gore, de bondage, de rites sacrificiels exotiques sans oublier les merveilleuses, les héroïques, prostituées de la Seconde Guerre mondiale. Stanley Publications devient bientôt le second groupe de magazines d'aventures pour hommes avec au moins dix-huit titres et il perdurera jusqu'à la décadence ultime du genre dans les années soixante-dix.

En 1956, Everett « Busy » Arnold, vend ses titres comiques à DC Comics et se tourne vers les magazines d'aventures pour hommes, lançant plusieurs titres qui ne durent jamais (dans le meilleur des cas) plus de deux ans : sa sensibilité artistique semble trop raffinée pour ce genre. Le dessinateur satirique L.B. Cole se reconvertit aussi dans les magazines pour hommes. Mais alors que ses illustrations faisaient un tabac dans les magazines satiriques, ses magazines d'aventures pour hommes ne connaîtront qu'un éphémère succès. Bob Sproul — l'éditeur à succès de *Cracked*, le seul concurrent sérieux du magazine satirique *Mad*, sort *Man's Action* en 1958. Sproul réussit très bien sur ce marché et il lancera jusqu'à cinq magazines, dont la plupart subsisteront jusqu'aux années soixante-dix.

Les éditeurs d'illustrés satiriques ne sont pas les seuls à se tourner vers les cols bleus, en réaction à la nouvelle prohibition initiée par Wertham et consorts. Literary Enterprises — qui, à défaut d'autre chose, a choisi le titre le plus ronflant de son secteur — lance de son côté *Real* avant de convertir le tabloïd *See* en *See for Men*. Ces deux magazines se rapprochent des standards établis par *Cavalier* et *Saga*. Adrian D. Lopez crée *Escape to Adventure* en 1957 et ajoute la catégorie des aventures pour hommes à la liste des avatars de *Sir!* et *Man to Man*, deux publications qui changent de peau aussi régulièrement que des mues de serpents, puisqu'ils ont commen-

FOR MEN ONLY, 7/1967, Mort Künstler ▶▶

cé par les « pin-ups », passant ensuite à la feuille à scandales pour finir en magazine d'aventures pour homme.

Parmi les nouveaux venus sur le marché du magazine masculin il faut mentionner deux éditeurs et leur histoire personnelle. Sterling Publications était la propriété de Morris Latzen et son rival Skye Publishing Company d' Arthur Bernard. Ces deux hommes ont été associés avant de suivre deux voies différentes mais parallèles, puisqu'ils ont tous deux lancé des maisons d'édition qui fabriquaient des magazines sur papier « pulp », avec des titres cinéma, romance, et policiers (histoires « vraies »). Sterling rachète le vieux pulp conservateur *Blue Book* et le transforma en magazine résolument masculin, avant de lui ajouter par la suite *Man's Conquest* et *Man's Illustrated*. Malgré des tirages modestes, les fascicules pour hommes du groupe Sterling se vendront modérément mais sans discontinuer jusque dans les années soixante-dix. Skye choisit une approche plus « littéraire », n'hésitant pas à acheter les droits de réimpression d'articles ou de nouvelles de grands écrivains, sans oublier William Faulkner. Cette ambition littéraire ne coïncide toutefois pas avec les goûts de ses lecteurs et ces magazines disparaissent rapidement.

Bizarrement, l'explosion des magazines d'aventures pour hommes n'entraîna aucun procès en contrefaçon malgré le champ lexical assez limité des éditeurs (homme au singulier et au pluriel, mâle…). Certes Goodman menaça de poursuivre Hefner qui avait d'abord intitulé son magazine *Playboy – Stag Party*. Dans le cas de *True Men Stories* et de *Men*, par exemple, les logos étaient difficiles à distinguer, dans la mesure où « true » était imprimé en petits caractères. D'où de fréquentes confusions dans les kiosques à journaux.

Goodman avait étendu ses opérations à treize magazines en 1957, l'année où son directeur commercial, Monroe Froehlich Jr., le persuada de fermer son entreprise de distribution et de signer un accord avec l'American News Company par souci de rentabilité. Mais l'ANC ne tarda pas à faire

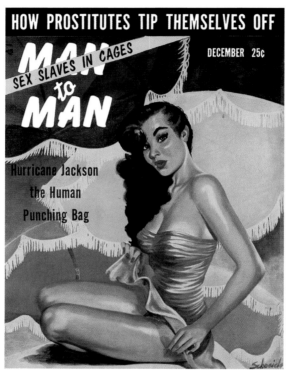

MAN TO MAN, 12/1955, Mark Schneider

faillite, perturbant considérablement les affaires de Goodman, mais entraînant dans sa chute bon nombre de ses concurrents. Froehlich fut congédié sans cérémonie pour ce faux pas et il en profita pour créer son propre magazine d'aventures, *Guy*, suivi de l'éphémère *O.K. for Men*.

En 1958, dans son jugement The United States v. Samuel Roth, la Cour Suprême réduit substantiellement les pouvoirs gouvernementaux en matière de réglementa-

tion de l'obscénité. Roth est un libraire New Yorkais spécialisé depuis longtemps dans les Erotica, diffusant aussi bien des textes hindous primitifs que l'*Ulysse* de James Joyce ou encore ses propres magazines, *Good Times*, ou *American Aphrodite*. En 1953, il est inculpé, pour *American Aphrodite*, de propagation d'obscénités.

Pour sa défense, Roth fait valoir que l'obscénité est une forme de discours protégée par le Premier Amendement de la Constitution américaine et met au défi la Cour de distinguer entre art érotique et obscénité. La décision de la Cour comporte la première définition de l'obscénité dans l'histoire juridique américaine : le « thème dominant » du document doit promouvoir le plaisir et être obscène, c'est-à-dire susciter un intérêt lascif. Les juges suprêmes allèguent aussi que l'ouvrage ou le magazine considéré doit être envisagé dans son ensemble, ceci afin de limiter les risques qu'une seule séquence coupée de son contexte soit utilisée pour interdire une publication. La Cour affirmait enfin que « toutes les idées présentant une importance sociale même très modeste — idées anti-conformistes, polémiques, y compris les idées haineusement opposées au climat d'opinion dominant, bénéficient d'une complète protection des garanties (accordées à la presse libre) ».

Ces nouvelles définitions ouvrait la porte à une avalanche de publications réservées au public masculin, mais, paradoxalement, elles ne bénéficièrent pas à Roth. Jugé coupable de propagation d'obscénités, ce dernier fut en effet condamné à cinq ans de prison. Ce n'est pas son magazine qui entraîna sa condamnation mais les prospectus qui le décrivaient et étaient distribués avec le courrier. Pour le tribunal, ceux-ci pouvaient trop facilement tomber entre les mains d'enfants, ce qui faisait de Roth une menace pour le public. Mais l'arrêt de la Cour Suprême représenta un échec majeur pour le NODL et les autres groupes de pression communautaires, après leur triomphe sur l'industrie de la bande dessinée. Violence et bondage sur bien des couvertures de maga-

zines d'aventures pour homme se firent plus extrêmes et plus corsés.

Si la plupart des magazines d'aventures pour hommes étaient inscrits sur la liste noire de la NODL, ils représentèrent un risque anodin devant le nouveau péril : *Playboy* et une dizaine de magazines sophistiqués du même type, avec photos de nus sur papier glacé, attaquaient le marché. Les magazines d'aventures pour hommes allaient affronter une nouvelle décennie de procédures judiciaires, et voir apparaître des définitions de l'obscénité conduisant à l'établissement de critères ridicules. Les illustrations avaient toujours joui d'une tolérance plus grande parce que le nu appartenait à la tradition de la peinture et de la sculpture classique. Une femme en petite culotte ligotée et fouettée par un nazi sur la couverture de *Real Men* était jugée moins outrageante qu'une photo de femme nue en encart central. Jusqu'à la fin des années soixante, la plupart des magazines pour hommes multipliaient les stratagèmes pour ne pas montrer de mamelons féminins — la jeune femme tenait une guitare, une serviette éponge voire un poisson farci devant sa poitrine —, honnies les pointes et autres aréoles ! Ce qui n'empêchait pas les auteurs des récits illustrés de décrire avec force détails les tortures (que le bourreau soit un communiste ou un motard) infligées à l'exquise chair nue de mainte demoiselle en détresse. Dans les secteurs où les groupes NODL veillaient sur la morale publique, la décision d'un marchand de journaux d'accepter de vendre un magazine dépendait souvent de ce qui était montré de la poitrine féminine et non du contenu du magazine en question.

Au début des années soixante, les magazines pour hommes continuent de prospérer et les périodiques « répréhensibles » tirent entre 100.000 et 250.000 exemplaires mensuels. En ce sens, le climat des années cinquante perdure et les groupes religieux locaux concentrent leurs efforts sur les pressions aux détaillants locaux, s'efforçant de les empêcher de diffuser *Playboy* et ses semblables.

Au même moment, les magazines d'aventures pour hommes qui bénéficient de la politique d'achat des magasins de l'armée multiplient les clins d'œil aux militaires. Les pin-ups deviennent les « préférées des soldats » et un magazine a créé une rubrique réservée à ces derniers où l'on répond à leurs questions avec les références ad hoc. Mais ces points de vente sont très perméables aux arguments de la hiérarchie militaire et il faut veiller à ne pas énerver un général ou un haut responsable, voire un aumônier, faute de quoi le magazine en

HAREM STEALING YANK IN ARABIA
Bill Miner's fantastic—but true—desert adventures

PDC

Man TO Man

NOV. 35¢

BOOK LENGTH FEATURE
KILL HARD — KILL FAST
The story of a tough undercover agent
by CONNIE SELLERS

HOW TO MAKE FAST MONEY FROM SLOW HORSES
It's the payoff that counts—not the number of winners

THE NAKED MORALISTS
Whether you're considered a sinner, or an average Joe, depends on where you live

question peut dire adieu à ce marché. Nombre de magazines pour hommes se transforment encore après l'arrêt de la Cour Suprême dans l'affaire Overseas Media Corporation v. McNamara (1967). L'éditeur poursuivi publie *Overseas Weekly*, un tabloïd pour soldats mêlant articles sur la vie militaire (souvent critiques envers la hiérarchie), papiers pleins de verve sur l'actualité et rubriques de développement personnel. Un encart central en noir et blanc d'une jeune femme nue ou topless, et des BD ultérieures comme *Sally Forth* ou *Cannon* (toutes deux réalisées par l'excellent dessi-

nateur Wally Wood et ses assistants) donnent à *Overseas Weekly* l'allure d'un *Playboy* pour cols bleus. Contrairement à quantité de journaux radicaux underground contre la guerre au Vietnam vendus à proximité des bases militaires US, et à son rival *Yank*, *Overseas Weekly* ne prétend nullement changer la politique étrangère américaine. Il entend simplement ne pas céder au diktat de la censure militaire. Quand le Pentagone décide d'interdire la diffusion de tabloïds sur la bases d'Asie où sont stationnées des unités de l'armée américaine, Overseas Media l'attaque en justice et, fin 1967, la Cour d'Appel tranche en sa faveur.

Cette décision ouvre de nouvelles perspectives jusqu'alors fermées : dès 1968, les magazines d'aventures pour hommes se transforment en magazines « skin » (peau) dont le contenu se compose de photos de femmes nues et d'articles sur la sexualité. Pour certains, le changement est abrupt : ils sont passés sans transition du magazine d'aventures pour hommes au magazine de pin-ups (sans changement de titre). Pour la plupart le changement représente un progrès : la peinture de couverture est remplacée par une photo de pin-up et les photos en noir et blanc de l'intérieur montrent des fesses et des seins nus.

L'introduction timide en 1969, par *Playboy*, de la femme entièrement nue de face sur le marché américain, puis agressive, par le nouveau magazine *Penthouse* importé d'Angleterre dès 1970, inspire des changements plus radicaux. D'un mois sur l'autre on est passé de magazines montrant des femmes en soutien-gorge et culotte à des créatures jambes et bras largement ouverts exhibant une toison pubienne fournie.

Après sa cession par Fawcett à Adrian D. Lopez, même le paisible *True* multiplie les photos de filles nues. Les super mâles ont été défaits par des filles, des femmes, de mignonnes Anglaises ou Américaines décroisant leurs jambes et invitant à des aventures d'un genre nouveau. A la fin des années soixante-dix le genre a vécu.

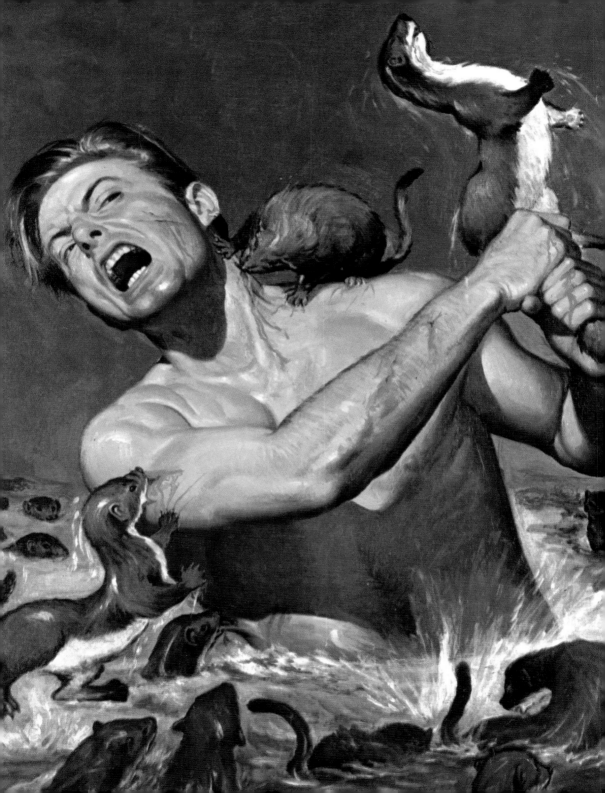

WHEN ANIMALS ATTACK

At the dawn of the men's adventure era, the majority of Americans either still lived in rural communities or were one generation removed from the farm, where survival often meant doing battle with Mother Nature. Hunting had always been a national pastime, with many Americans still scheduling vacations during hunting season to bag a buck or shoot a duck.

If it was war with nature readers wanted, it was war with nature the men's adventure magazines gave them. Extreme covers depicting all sorts of animals attacking humans were the norm for the genre, especially throughout the fifties.

Probably the earliest such cover was the sixth issue (January 1951) of *Stag* — "Mad Monkeys Manned the Lifeboats," the "true" story of an unidentified sailor on a sinking ship whose cargo-load of caged monkeys escaped and battled the crew for the lifeboats. The sailor narrator supposedly ended up in an insane asylum.

More humdrum stories of survival in the same issue included hunting killer whales and the standard bear mauling. It is not known who came up with the idea for the monkey story — possibly longtime men's adventure editor Noah Sarlat, or perhaps art director Mel Blum, or even the uncredited cover artist. Whichever genius was responsible, the story was a hit, and man versus nature became a regular theme.

Rapacious bears, man-eating tigers, and psychotic moose, however, were simply too similar to the usual fare of the mainstream hunting magazines already on newsstands. The sweat editors needed more exotic tales. In addition to the classic "Weasels Ripped

My Flesh," which later inspired the Frank Zappa record, readers could enjoy "Attack of the Sex Mad Hippo," "Mating Raid of the Red Ape," "Ambush of the Rabid Minks," and "An Army of Ants Ate the Flesh Off My Body." The delightfully silly "Flying Rodents Ripped My Flesh" inspired a cover populated by the most menacing of rodents — squirrels. That issue of *True Men Stories* also ran a story on a man attacked by pangolins, an exotic breed of toothless anteater.

In addition to braving a Garden of Eden's worth of crushing boa constrictors and cobras poised to bite, the heroes of these yarns suffered innumerable shark attacks, traversed piranha-infested rivers, and did their best to sidestep mad elephants, which were usually more interested in ripping the blouse off a young, busty, blonde explorer anyway.

In spite of hundreds of such covers, few of the artists — however adept at depicting gorillas, eels, boars, or alligators — went on to a career in serious animal art. One illustrator who did make a career in that field — noted bird and nature illustrator Robert Abbett — actually produced little of it for the men's adventure market, painting more Nazis than grizzlies.

The popularity of extreme animal covers spawned a small number of men's adventure magazines devoted to such stories. Martin Goodman offered *Sportsman*, *Sport Life*, *Hunting Adventures*, and *Fishing Adventures*, the latter covering countless manta ray, giant squid, and octopus attacks. The Weider brothers created *Animal Life*, *Safari*, and *Outdoor Adventure*. Wallace Taber,

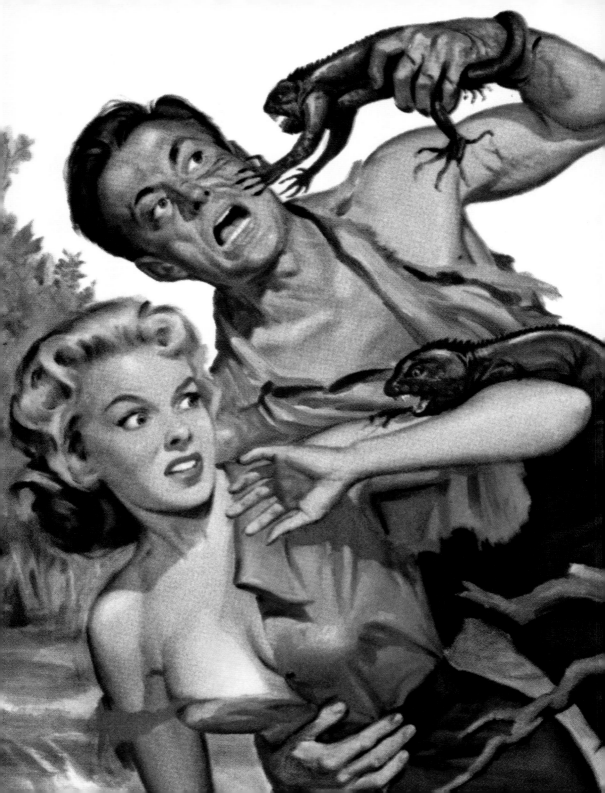

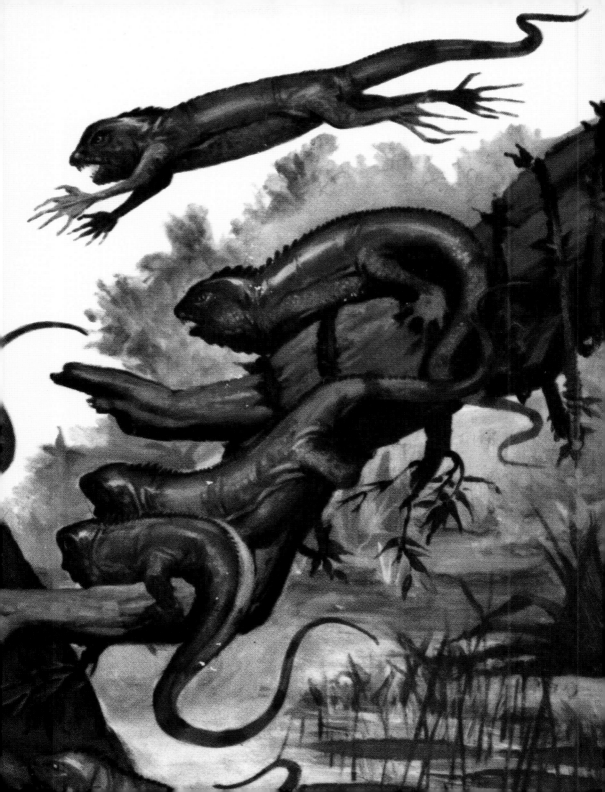

a big-game hunter who appeared occasionally in *Safari*, published the short-lived *Wallace Taber Safaris Unlimited*, which included full-color photos of topless African tribeswomen for the serious anthropologists in the audience.

While these magazines resembled traditional hunting magazines such as *Field & Stream* and *Outdoor Life*, the differences were striking. In addition to production values — no color photography and pulp as opposed to slick paper — the he-man incarnations lacked the usual articles on equipment, guns, and rods-and-tackle. The stories of hunting or fishing adventures, meanwhile, nearly always deviated toward a taste of the exotic; interspersed among gorilla, lion, and tiger covers were the likes of "Captured by the Man-Hungry Women of Mt. Saphos" [*sic*] or "I Rose from the Grave … Twice."

Unlike most sweat magazines, the man-versus-nature niche did not run pinup pictures. They did, however, take advantage of the *National Geographic*-style exclusion of nudity in magazines, and liberally spiced their stories with photos of bare-breasted babes from jungle or island tribes — confirming our suspicion that the animal feared most by sweat-reading men was woman.

WIESEL ZERFETZTEN MIR DAS FLEISCH! DER ANGRIFF DER TIERE

Als die große Ära der Abenteuerheftchen für Männer begann, lebte die Mehrzahl der Amerikaner entweder noch auf dem Lande oder war dem Leben als Bauern, das oft ein Kampf ums Überleben gegen die Natur bedeutete, erst seit einer Generation entwachsen. Die Jagd war von Anfang an ein im ganzen Land beliebter Zeitvertreib gewesen, und viele Amerikaner nahmen sich immer noch während der Jagdsaison frei, um einen Hirsch aufs Korn zu nehmen oder eine Ente zu schießen.

Wenn die Leser der Abenteuermagazine den Krieg gegen die Natur wollten, dann sollten sie ihn bekommen. Blutrünstige Titelbilder, auf denen alle möglichen Tiere Menschen angriffen, waren in diesem Genre, besonders in den Fünfzigerjahren, die Norm.

Der vermutlich früheste Einband dieser Art zierte die sechste Ausgabe von *Stag* (Januar 1951) — „Wahnsinnige Affen kaperten die Rettungsboote", die „wahre" Geschichte eines ungenannten Matrosen, der zusammen mit der Mannschaft

MAN'S ACTION, 11/1957
REAL ADVENTURE, 5/1956 ▶

eines sinkenden Schiffes gegen eine ganze Ladung voller Affen kämpfen musste, die sich befreit hatten und die Rettungsboote für sich haben wollten. Der Matrose endete angeblich im Irrenhaus.

Im selben Heft gab es eine Reihe leicht eintöniger Berichte, wie Leute knapp mit dem Leben davon gekommen waren, unter anderem bei der Jagd auf Killerwale und einem eher standardmäßigen Bärenüberfall. Wer die Idee zu der Affengeschichte hatte, ist unbekannt, aber es hätten Noah Sarlat, der altgediente Herausgeber von Männerabenteuern, oder Artdirector Mel Blum oder sogar der ungenannte Maler des Titelbildes sein können. Wie dem auch sein mag, die Geschichte war der Hit, und Mann gegen Natur wurde zum regelmäßigen Thema.

Berichte von raubgierigen Bären, menschenfressenden Tigern und durchgeknallten Elchen waren jedoch denen in den normalen Jagdzeitschriften zu ähnlich, die bereits am Zeitungskiosk zu finden waren. Die Herausgeber der „Sweats" genannten Abenteuerhefte brauchten aufregenderes Garn. Neben dem Klassiker „Weasels Ripped My Flesh" („Wiesel zerfetzten mir das Fleisch!"), das der gleichnamigen Frank-Zappa-Schallplatte als Vorbild diente, konnten sich die Leser an Folgendem delektieren: „Angriff des sexbesessenen Nilpferds", „Der Paarungskampf der roten Affen", „Hinterhalt der tollwütigen Nerze" und „Eine Armee von Ameisen fraß mir das Fleisch vom Körper!". Die herrlich alberne Schlagzeile „Fliegende Nagetiere zerfetzten mir das Fleisch" diente als Inspiration für einen Einband, auf dem sich ganz grauenhafte Nagetiere tummelten — Eichhörnchen. Diese Ausgabe von *True Men Stories* brachte außerdem die Story eines Mannes, der von Javanischen Schuppentieren, einer exotischen Untergattung des zahnlosen Ameisenbären, angegriffen wurde.

Die Helden dieser Räuberpistolen nahmen es nicht nur mit einem kompletten Garten Eden voll würgender Boa Constrictors und zum Biss ansetzender Kobras auf, sondern durchlitten auch Haiattacken, durchquerten piranhaverseuchte Flüsse und versuchten, wahnsinnigen Elefanten zu entkommen, die allerdings sowieso mehr Interesse daran zeigten, einer jungen, blonden, vollbusigen Entdeckerin die Bluse wegzureißen.

Obwohl die Illustratoren Hunderte dieser Titelbilder malten und Gorillas, Alligatoren und Wildschweine äußerst versiert darstellten, machten nur wenige von ihnen eine Karriere mit seriöser Tiermalerei. Ein Illustrator, der es in diesem Feld doch zu etwas brachte — der bekannte Vogel- und Tierzeichner Robert Abbett — produzierte nur wenig für den Männerabenteuermarkt und malte dort mehr Nazis als Grizzlys.

Die Beliebtheit extremer Tierillustrationen führte zur Entstehung einiger Abenteuerserien

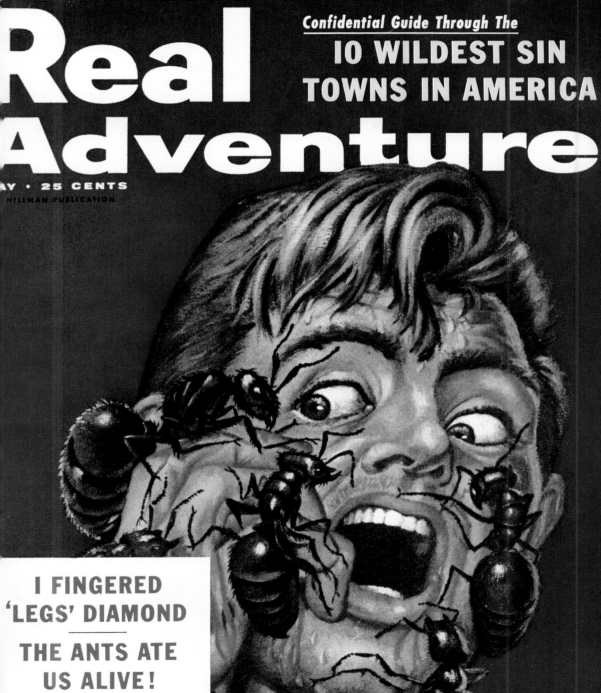

WHO TURNED THE KILLERS LOOSE?

O Slaughtered GI's of the Malmedy Massacre cry vengeance

Confidential Guide Through The
IO WILDEST SIN TOWNS IN AMERICA

Real Adventure

AY · 25 CENTS

HILLMAN PUBLICATION

I FINGERED 'LEGS' DIAMOND

THE ANTS ATE US ALIVE!

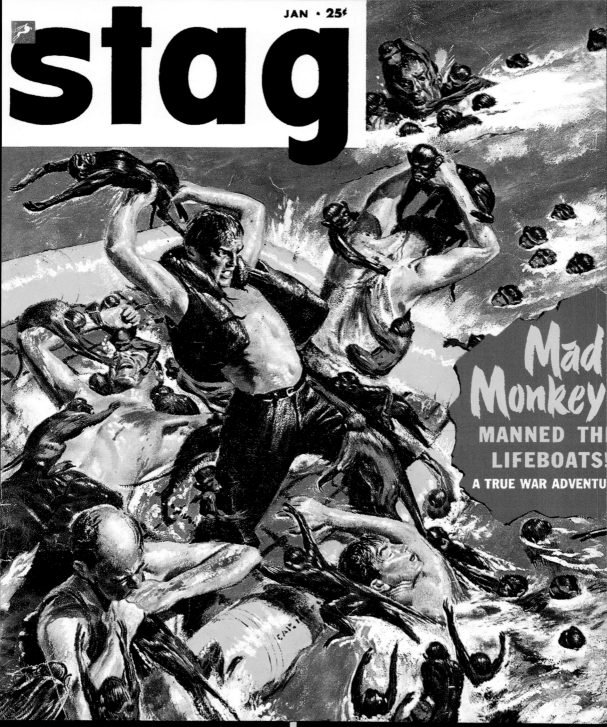

JAN • 25¢

stag

Mad Monkey MANNED THE LIFEBOATS!
A TRUE WAR ADVENTU

Life and Death of
A MANIAC

How They
BEAT THE DRAFT

für Männer, die ausschließlich solchen Storys gewidmet waren. Martin Goodman gab *Sportsman*, *Sport Life*, *Hunting Adventures* und *Fishing Adventures* heraus, wobei das letztgenannte Magazin unzählige Angriffe von Stachelrochen, Riesentintenfischen und Kraken brachte. Die Weider Brothers schufen *Animal Life*, *Safari* und *Outdoor Adventure*. Wallace Taber, ein Großwildjäger, der hin und wieder in *Safari* auftrat, veröffentlichte das kurzlebige *Wallace Taber Safaris Unlimited*, in dem für die ernsthaften Völkerkundler unter den Lesern auch vierfarbige Fotos von halbnackten Stammesfrauen aus Afrika gezeigt wurden.

Während diese Magazine herkömmlichen Jagdzeitschriften wie *Field & Stream* und *Outdoor Life* ähnelten, gab es auch große Unterschiede. Die Lektüre für den starken Mann war billiger gemacht — keine Farbfotos und holzhaltiges statt glattes Papier — und enthielt keine Artikel über Ausrüstung, Gewehre und Ruten, Rollen und Köder. Die Berichte von Jagd- oder Angelabenteuern zeigten fast immer ein perverses Interesse am Exotischen. Zwischen Titelgeschichten von Gorillas und Löwen waren Beiträge wie „Gefangener bei den mannshungrigen Frauen von Mt. Saphos" [sic] oder „Ich bin aus dem Grab auferstanden … zwei Mal!" zu finden.

Im Gegensatz zu den meisten anderen „Schweißmagazinen" fand man in der Mann-gegen-Natur-Nische keine Pin-up-Girls. Sie machten sich allerdings die von *National Geographic* eingeführte Erlaubnis von Nacktheit in Zeitschriften zunutze und würzten ihre Geschichten reichlich mit barbusigen Urwald- oder Inselschönheiten — und schienen damit den Verdacht zu bestätigen, dass das von Männern am meisten gefürchtete Tier doch die Frau war.

DÉCHIQUÉTÉ PAR DES BELETTES ! LES BÊTES SAUVAGES ATTAQUENT

Quand apparaissent les premiers magazines d'aventures pour hommes, la majorité des Américains vit dans des communautés rurales, et les citadins ont gardé des attaches avec la ferme familiale, où la survie suppose souvent une lutte impitoyable avec Mère Nature. La chasse a toujours été un passe-temps national et beaucoup d'Américains s'arrangent pour prendre leurs vacances durant les périodes de chasse, pour tirer le lapin ou le canard.

Les lecteurs veulent la guerre avec la Nature ? Les magazines d'aventures pour hommes leur en donnent. Les couvertures sensationnelles montrant toutes sortes d'animaux attaquant des hommes sont la norme du genre, surtout dans les années cinquante. Le sixième numéro de *Stag* (janvier 1951) présente la (probable) première couverture de ce genre — « Des singes déchaînés s'emparent des canots de sauvetage ! ». Il s'agit de la « vraie » histoire d'un marin anonyme sur un bateau en train de sombrer qui transporte une cargaison de singes en cage, lesquels parviennent à se libérer et attaquent l'équipage pour s'emparer des canots de sauvetage. Le marin qui raconte cette histoire est censé avoir fini dans un asile d'aliénés.

Entre autres histoires de survie composant ce même numéro, mentionnons la chasse aux requins tueurs et l'inévitable ours qui déchiquette un pauvre diable. Personne ne sait qui a inventé l'histoire des singes ; peut-être le rédacteur en chef Noah Sarlat, un professionnel chevronné, à moins que ce ne soit Mel Blum, le directeur artistique, ou encore le dessinateur responsable de la couverture, lequel n'est pas crédité… Quel que soit le nom du génie en question, cette histoire connaît un grand succès et la lutte de l'homme et de la nature devient un thème régulier du genre.

Pourtant, les ours rapaces, tigres mangeurs d'hommes et autres souris psychotiques ressemblent encore trop aux magazines de chasse ordinaires qu'on trouve dans les kiosques. Les éditeurs de pulps à sensations ont besoin d'histoires plus exotiques. Outre le classique « Déchiqueté par les belettes ! », qui devait inspirer un disque de Frank Zappa, les lecteurs peuvent apprécier « L'attaque de l'hippopotame fou de sexe », « Frénésie d'accouplement des fourmis rouges », « L'embuscade des visons enragés », et « Dépecé par une armée de fourmis ». Sans oublier le délicieusement absurde « Lacéré par des rongeurs volants » qui inspira une couverture peuplée des rongeurs les plus inquiétants qui soient : les écureuils ! Ce numéro de *True Men Stories* proposait aussi l'histoire d'un homme attaqué par des pangolins, une espèce de fourmiliers exotiques et dépourvus de dents.

Les héros de ces magazines bravent des boas constrictors dignes du serpent biblique ou des cobras prêts à mordre, mais ils doivent aussi endurer d'innombrables attaques de requins, traverser des rivières infestées de piranhas et échapper à une charge d'éléphants déchaînés, lesquels s'intéressent de toute façon plus aux charmes rebondis de la jeune exploratrice blonde de service.

En dépit de centaines de couvertures de ce genre, peu nombreux sont les auteurs de ces couvertures — si virtuoses soient-ils dans la peinture de gorilles, d'anguilles, de sangliers ou d'alligators, à faire carrière dans l'art animalier proprement dit. L'un des illustrateurs qui a fait une véritable carrière dans ce secteur, Robert Abbett, a dessiné peu d'animaux pour les magazines d'aventures pour hommes et peint plus de nazis que de grizzlis.

La popularité de ces couvertures animalières sensationnelles se propage à un petit nombre de magazines d'aventures pour hommes qui se consacrent à ce type d'histoires. Martin Goodman publie ainsi *Sportsman*, *Sport Life*, *Hunting Adventures* et *Fishing Adventures*, ce dernier multipliant les récits sur les raies manta, les calamars géants et les attaques de pieuvres. Les frères Weider créent *Animal Life*, *Safari* et *Outdoor Adventure*. Wallace Taber, un grand chasseur de gibier à plume qui apparaissait régulièrement dans *Safari*, fit paraître l'éphémère *Wallace Taber Safaris Unlimited* qui montrait, entre autres, de splendides photos d'Africaines aux seins nus, destinées, comme il se doit, aux amateurs d'ethnologie.

Alors que ces magazines ressemblaient à première vue aux magazines traditionnels de chasse comme *Field & Stream* (plaines et rivières) ou *Outdoor Life*, ils s'en distinguaient par quelques différences frappantes. Outre les normes de fabrication (absence de photos couleur, papier « pulp » de mauvaise qualité), ces histoires mettant en scène le Mâle avec un M majuscule négligeaient les considérations habituelles sur l'équipement, les fusils et autres panoplies de parfait pêcheur. Les récits de parties de pêche ou de chasse, en revanche étaient presque toujours pimentées d'un zeste d'exotisme. Ainsi, parmi les couvertures de gorilles, de lions et de tigres, on trouvait des récits comme « Capturé par les femmes du Mont Saphos [sic] avides de prendre mari » ou encore « Ressuscité des morts… pour la seconde fois ».

A la différence des autres pulps à sensations, les magazines type l'homme-contre-la-nature ne montraient pas de photos de pin-ups. Mais ils profitèrent de la prohibition de la nudité telle que l'avait imposée des magazines comme le *National Geographic*, pour émailler leurs histoires de photos de jolies femmes aux seins nus ce qui confirme notre soupçon : l'animal que craignait le lecteur des pulps à sensations… c'était la femme.

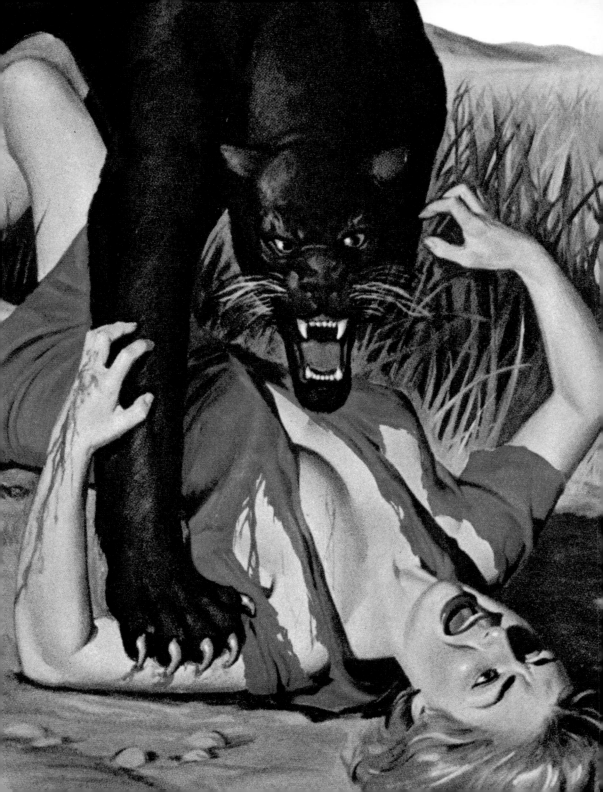

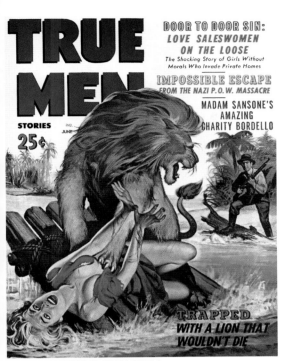

TRUE MEN STORIES, 6/1960, Will Hulsey

DOOR TO DOOR SIN:
LOVE SALESWOMEN ON THE LOOSE
The Shocking Story of Girls Without
Morals Who Invade Private Homes

IMPOSSIBLE ESCAPE
FROM THE NAZI P.O.W. MASSACRE

MADAM SANSONE'S AMAZING CHARITY BORDELLO

TRAPPED
WITH A LION THAT WOULDN'T DIE

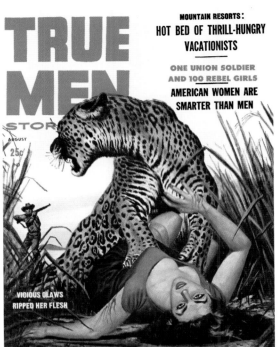

TRUE MEN STORIES, 8/1958, Will Hulsey

MOUNTAIN RESORTS:
HOT BED OF THRILL-HUNGRY VACATIONISTS

ONE UNION SOLDIER
AND 100 REBEL GIRLS

AMERICAN WOMEN ARE SMARTER THAN MEN

VICIOUS CLAWS
RIPPED HER FLESH

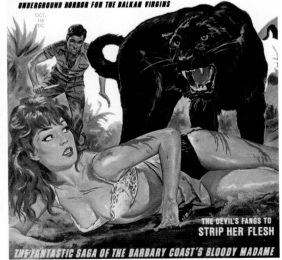

NUDE LUST SLAVES OF HITLER'S RUSSIAN MONSTER

SCORCH THEIR GUTS
IN HELL'S VALLEY

SEX PERVERSION:
THE GROWING MENACE OF THE 60'S

UNDERGROUND HORROR FOR THE BALKAN VIRGINS

THE DEVIL'S FANGS TO
STRIP HER FLESH

THE FANTASTIC SAGA OF THE BARBARY COAST'S BLOODY MADAME

MEN TODAY, 10/1963, Norm Eastman
◄ **TRUE MEN STORIES**, 9/1961, Will Hulsey

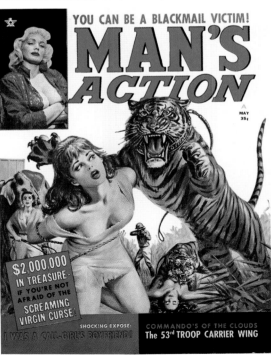

YOU CAN BE A BLACKMAIL VICTIM!

MAN'S ACTION

$2,000,000
IN TREASURE –
IF YOU'RE NOT
AFRAID OF THE
**SCREAMING
VIRGIN CURSE**

SHOCKING EXPOSE:
I WAS A CALL-GIRL'S BOYFRIEND!

COMMANDO'S OF THE CLOUDS
The 53rd TROOP CARRIER WING

MAN'S ACTION, 5/1962

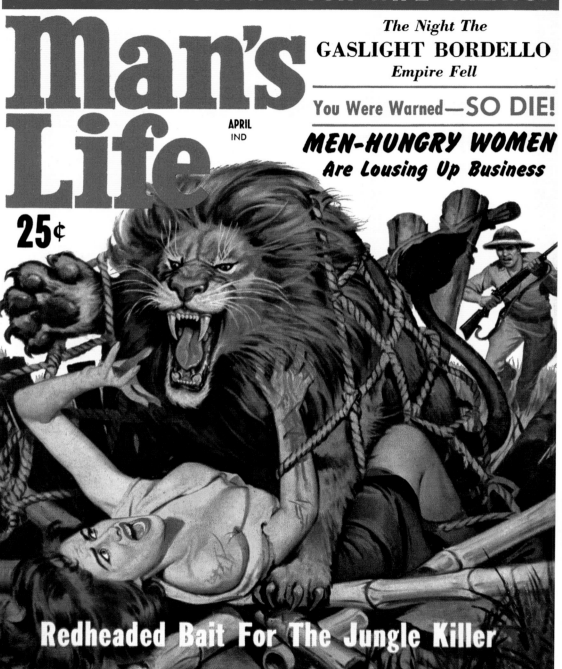

IT'S YOUR FAULT IF YOUR WIFE CHEATS!

man's Life

APRIL
IND

25¢

The Night The
GASLIGHT BORDELLO
Empire Fell

You Were Warned—**SO DIE!**

MEN-HUNGRY WOMEN
Are Lousing Up Business

Redheaded Bait For The Jungle Killer

MAN'S LIFE, 4/1959, Will Hulsey

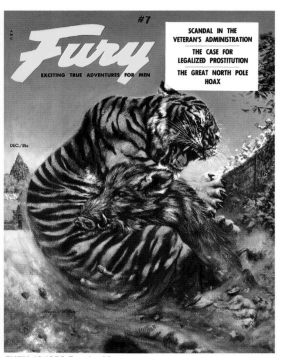

FURY, 12/1956, Douglas Allen

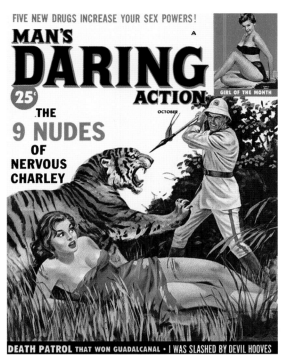

MAN'S DARING ACTION, 10/1959, Ed Moritz

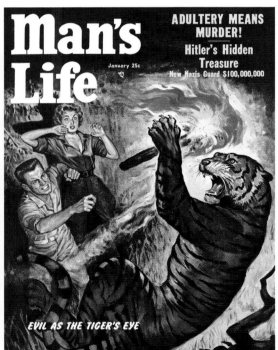

MAN'S LIFE, 1/1955, Milton Luros

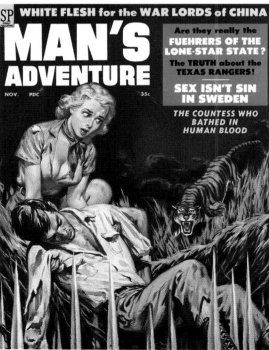

MAN'S ADVENTURE, 11/1958, Clarence Doore

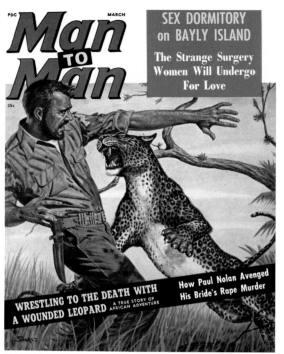

MAN TO MAN, 3/1963, Syd Shores

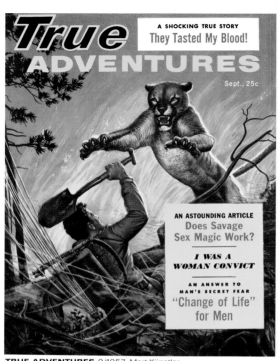

TRUE ADVENTURES, 9/1957, Mort Künstler

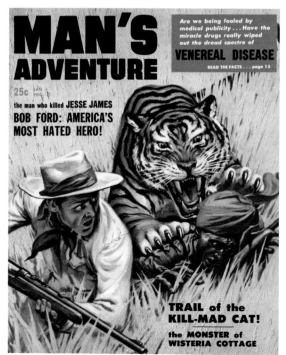

MAN'S ADVENTURE, 1/1958, Clarence Doore

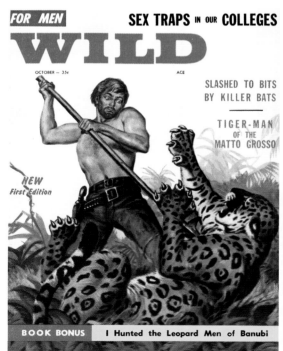

WILD, 10/1957, Roy Balden
MAN'S LIFE, 9/1955, Will Hulsey ▶

man's Life

ptember 25c

I'M TEACHING MY KID TO FIGHT DIRTY

SEX CAN BE FUN!

IS OUR AIR FORCE COMMITTING SUICIDE?

RED TIDE OF DEATH

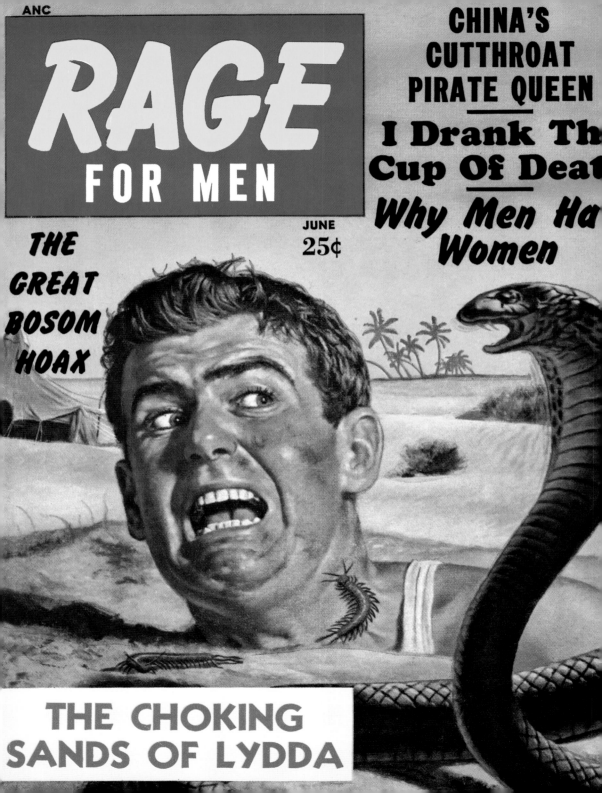

ANC

RAGE
FOR MEN

JUNE
25¢

CHINA'S
CUTTHROAT
PIRATE QUEEN

I Drank Th
Cup Of Deat

Why Men Ha
Women

THE
GREAT
BOSOM
HOAX

THE CHOKING
SANDS OF LYDDA

AMERICAN MEN ARE SLAVES TO THEIR WIVES

PERIL, 12/1958

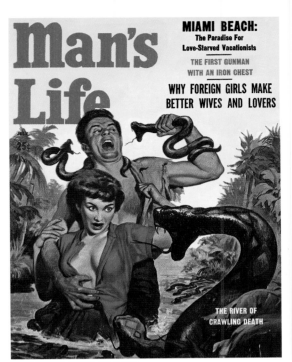

MIAMI BEACH:
The Paradise For
Love-Starved Vacationists

THE FIRST GUNMAN
WITH AN IRON CHEST

WHY FOREIGN GIRLS MAKE
BETTER WIVES AND LOVERS

THE RIVER OF
CRAWLING DEATH

MAN'S LIFE, 7/1958, Will Hulsey

MAN'S AGE, 7/1962
◄ **RAGE FOR MEN**, 6/1957

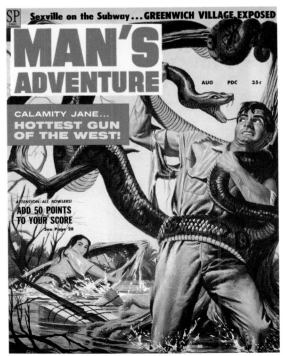

MAN'S ADVENTURE, 8/1958
MAN'S LIFE, 7/1956, Norman Saunders ►►

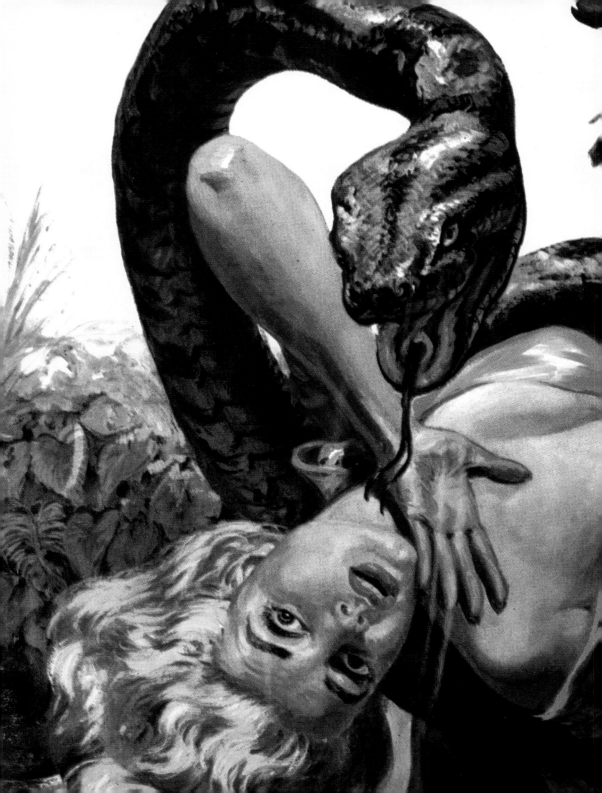

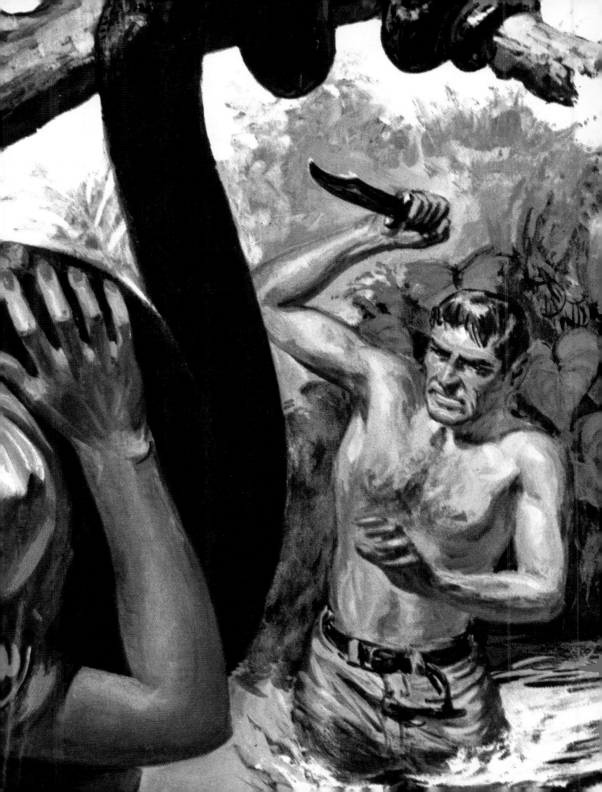

HUNTING

ADVENTURES

FALL

35

THE 5-TON KILL

EXTRA:
16-PAG
BOOK BONUS

FURY, 10/1955, Tom Beecham

MAN'S EXPLOITS, 11/1957, George Gross

MAN'S EXPLOITS, 9/1963, Norm Eastman
◄ HUNTING ADVENTURES, Fall 1954, Simon Greco

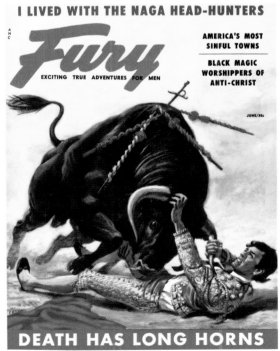

FURY, 6/1955, Tom Beecham

THE WOMAN AND THE WHIP: last stop on the Paris Underground

ALL MAN

CHICAGO'S WILDEST SISTER ACT
**THE HOT-HOUSE HUSSIES
WHO TEASED A KING!**

•

FRY ME IN ACID

•

The inside story of...
**THE DOLLS WHO MAKE
THE DICE BEHAVE**

NOV. 35¢ PDC

ALL MAN, 11/1959, Clarence Doore

man's CONQUEST

ANC

**WHY MARRY
A VIRGIN?**
(See Page 34)

TARGET: MEN! America's
Five Top Sex Rackets Exposed

STERLING

NOVEMBER • 25¢

CANNIBAL CRABS CRAWL TO KILL

Exclusive Photo-Feature:
CHEESECAKE MODEL

MAN'S CONQUEST, 11/1956

Man's Life

MARCH
IND.

25¢

LOVE-STARVED WOMEN
ARE LOUSING UP
COLLEGE TOWNS

**BLOODY BREAKOUT
FROM STALAG 20**

MADAM ANNIE'S
*OPEN-AIR BORDELLO
FOR SPORTSMEN*

TRAPPED IN THE WEB OF CREEPING DEATH

MAN'S LIFE, 3/1959, Will Hulsey

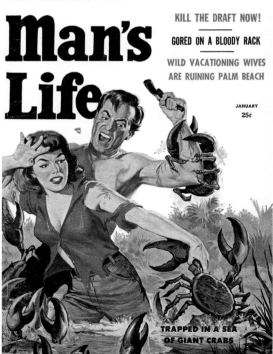

Man's Life

KILL THE DRAFT NOW!

GORED ON A BLOODY RACK

**WILD VACATIONING WIVES
ARE RUINING PALM BEACH**

JANUARY
25¢

**TRAPPED IN A SEA
OF GIANT CRABS**

MAN'S LIFE, 1/1958, Will Hulsey
MAN'S LIFE, 5/1957, Will Hulsey ▶

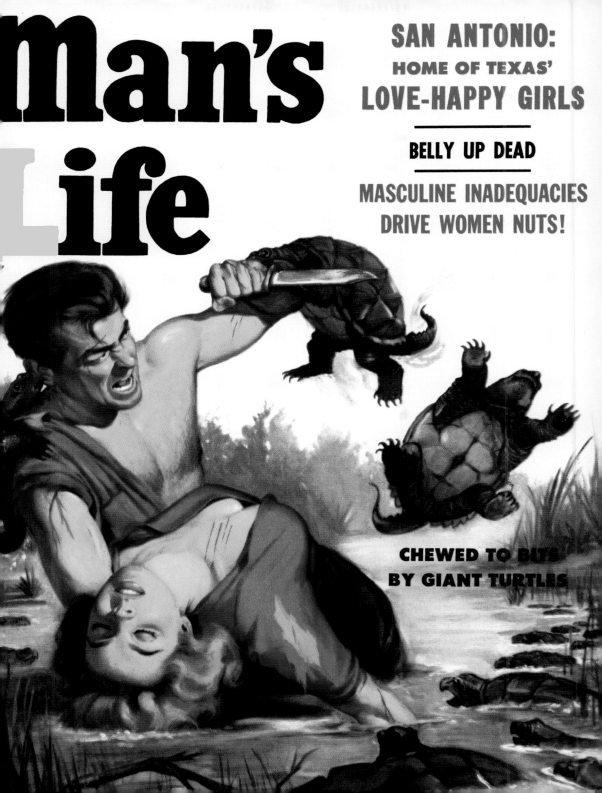

Man's Life

SAN ANTONIO:
HOME OF TEXAS'
LOVE-HAPPY GIRLS

BELLY UP DEAD

MASCULINE INADEQUACIES DRIVE WOMEN NUTS!

CHEWED TO BITS
BY GIANT TURTLES

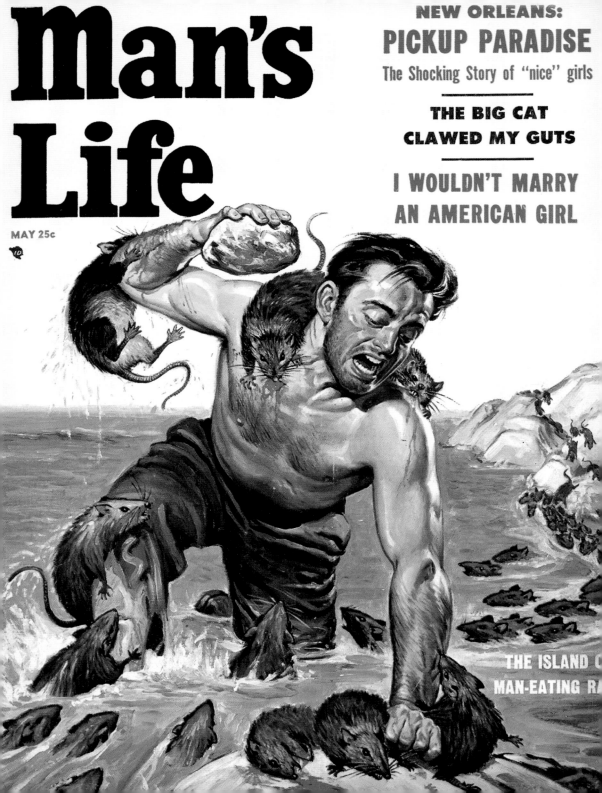

Man's Life

MAY 25c

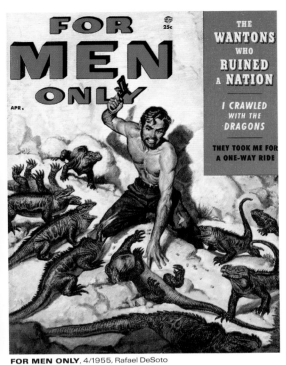

FOR MEN ONLY, 4/1955, Rafael DeSoto

RUGGED MEN, 11/1956, Clarence Doore

They look like pop-eyed gawky creatures out of Mother Goose, but when they start pecking at your eyes, that's no fairy tale. Cock ostriches stand 10 feet tall and weigh 300 pounds, and if one of them gets you down he can kick your brains out . . .

Want to make a fortune? Start an ostrich ranch. It's easy. All you have to do is buy a pair of good birds; cost maybe $200. In a year they can hatch out 80 chicks worth at least ten bucks each. You can get a couple of clips of feathers worth about $60. Profit for a year $660. Cost of upkeep is practically nothing. They feed on grass, pebbles, and chopped bone, and they drink once every seven months.

If you want to make real money you'll run a ranch of five thousand birds like old Oom Krantz up in the Little Karoo Desert beyond Montagu.

That Boer didn't waste a thing. He fed bad eggs to the chicks, took *two* clips of feathers a year, and sold hides for around twelve bucks apiece. Furthermore, ostrich "biltong" is worth two bits a pound. I worked for him for a season. Quit, because I thought my tombstone would look undignified if it read: KICKED TO DEATH BY AN OSTRICH.

Who'd think to look at the long neck and big melting eye of a cock ostrich that he is a man-killer? I didn't believe it until I saw it done. Even then I didn't think it could happen to me.

By James Grey
As told to Brian O'Brien

ILLUSTRATED BY ROB CARBOE

The Murdering Bird of Little Karoo

SEE FOR MEN, 1/1962, Rob Carboe
◄ **MAN'S LIFE**, 5/1956, Will Hulsey

TRUE ADVENTURES, 3/1957, Martin Kay ▶▶

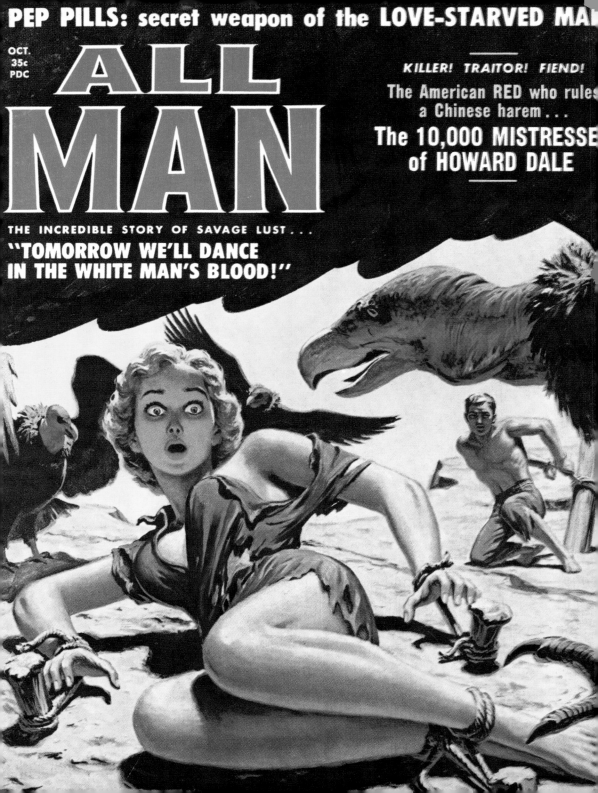

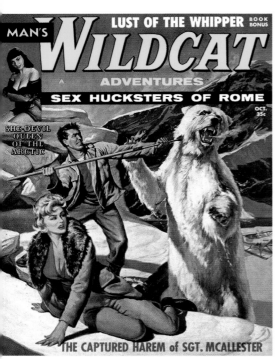

WILDCAT ADVENTURES, 10/1959

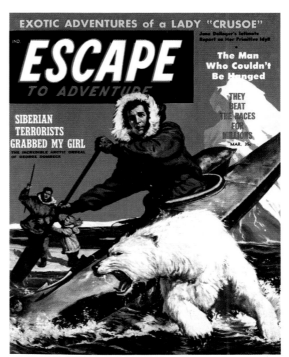

ESCAPE TO ADVENTURE, 3/1959, Victor Olson

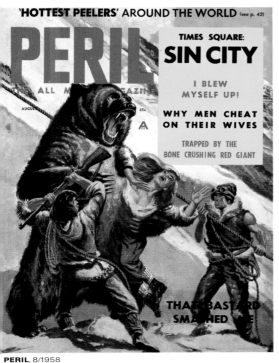

PERIL, 8/1958
◄ ALL MAN, 10/1959, Clarence Doore

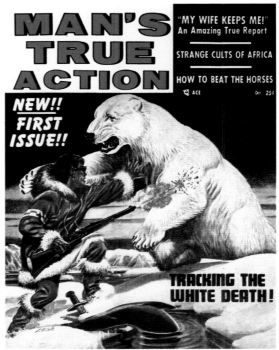

MAN'S TRUE ACTION, 10/1955, L. B. Cole

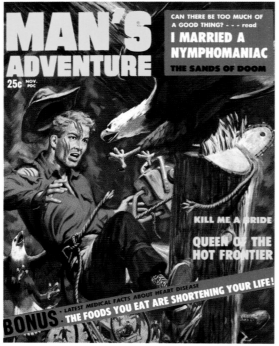

MAN'S ADVENTURE, 11/1957, Clarence Doore

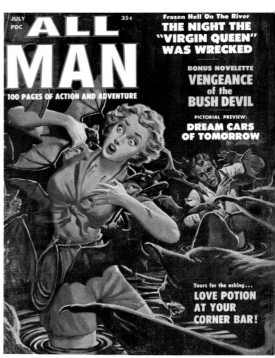

ALL MAN, 7/1959, Clarence Doore

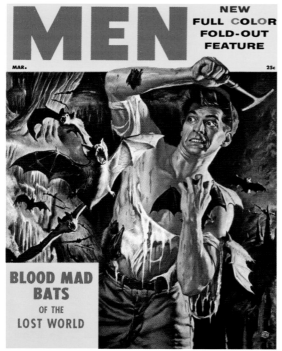

MEN, 3/1955, Robert Schulz

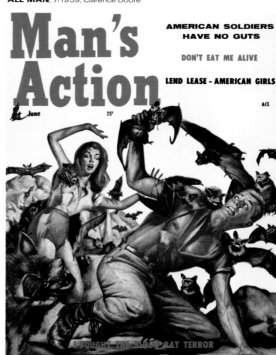

MAN'S ACTION, 6/1956, John Fay

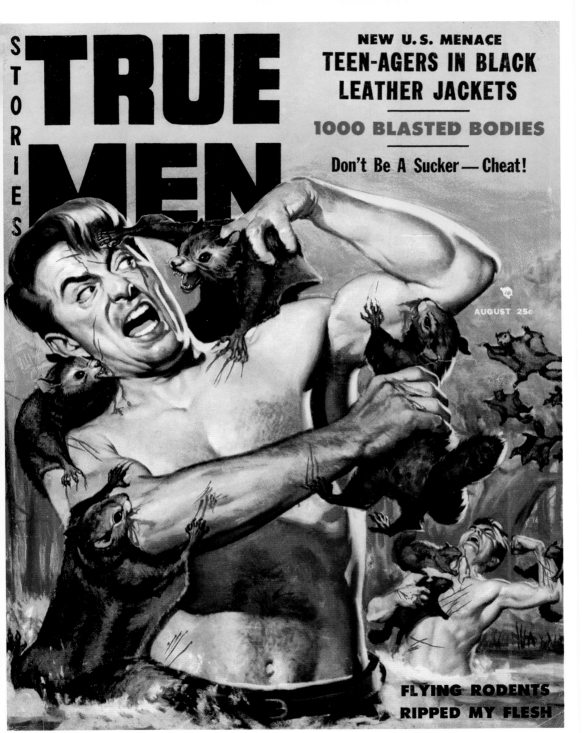

STORIES

TRUE MEN

NEW U.S. MENACE
TEEN-AGERS IN BLACK LEATHER JACKETS

1000 BLASTED BODIES

Don't Be A Sucker—Cheat!

AUGUST 25c

FLYING RODENTS
RIPPED MY FLESH

TRUE MEN STORIES, *8/1957, Will Hulsey*

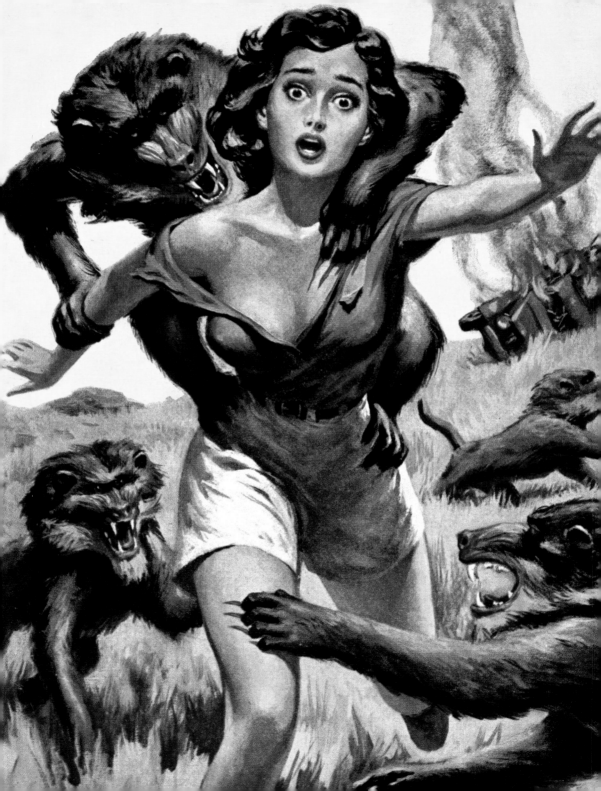

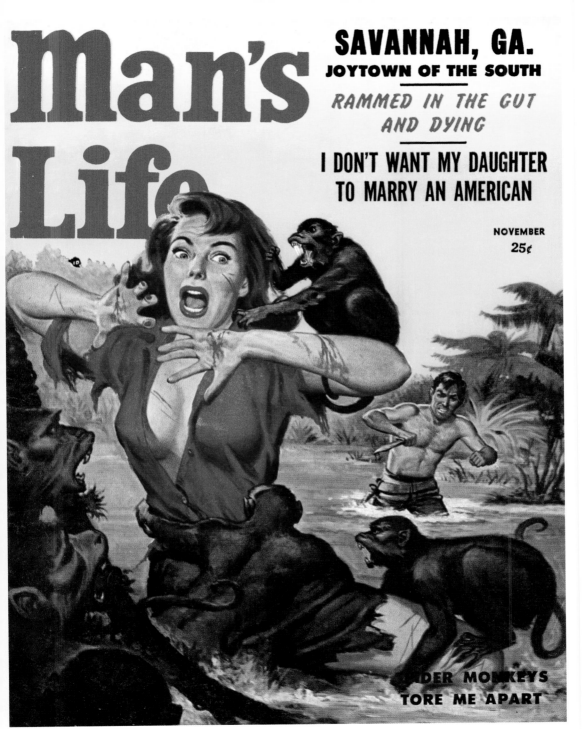

MAN'S LIFE, 11/1957, Will Hulsey
◄ **MAN'S LIFE**, 3/1959, Clarence Doore

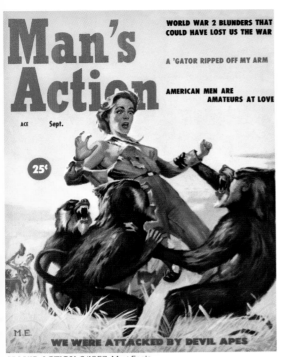

MAN'S ACTION, 9/1957, Mort Engle

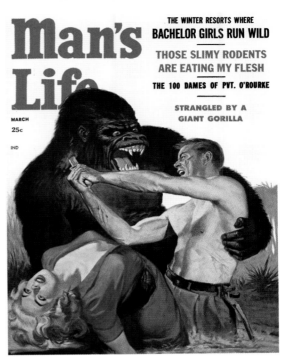

MAN'S LIFE, 3/1958, Will Hulsey

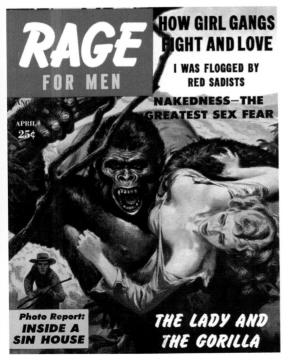

RAGE FOR MEN, 4/1957, Clarence Doore
◀ **SAFARI**, 2/1956, M. L. Bower

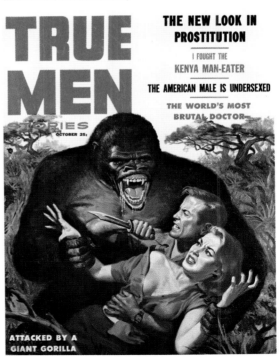

TRUE MEN STORIES, 10/1956, Will Hulsey

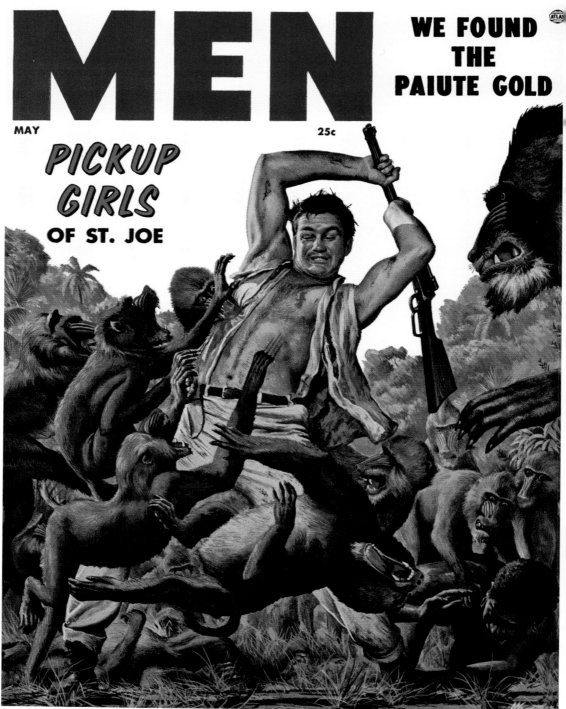

MEN, 5/1955, Mort Künstler

SAFARI, 3/1957, Douglas Allen, oil, 33 x 48 cm ▶

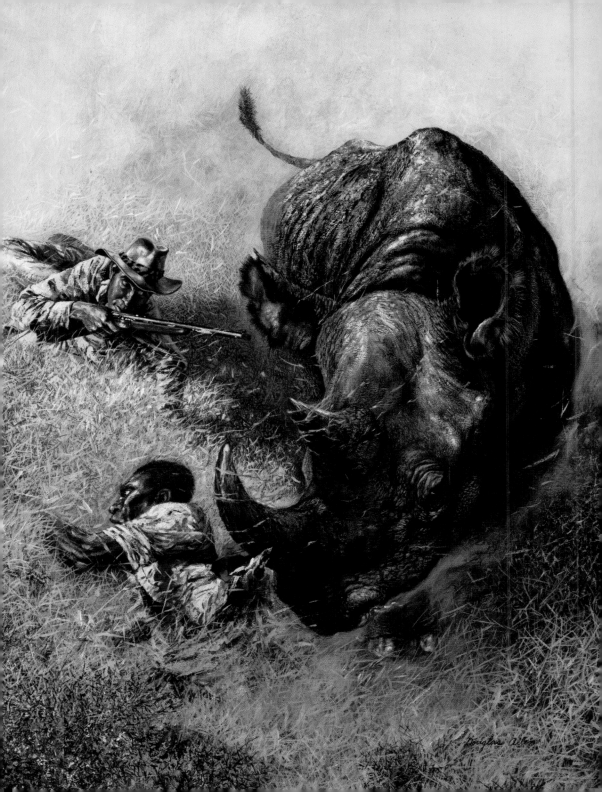

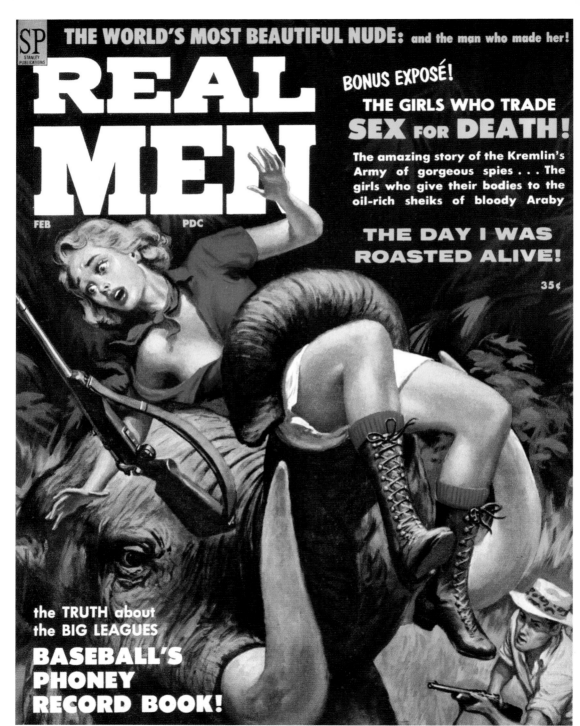

THE WORLD'S MOST BEAUTIFUL NUDE: and the man who made her!

SP STANLEY PUBLICATIONS

REAL MEN

FEB PDC

BONUS EXPOSÉ!

THE GIRLS WHO TRADE
SEX FOR DEATH!

The amazing story of the Kremlin's Army of gorgeous spies . . . The girls who give their bodies to the oil-rich sheiks of bloody Araby

THE DAY I WAS ROASTED ALIVE!

35¢

the TRUTH about the BIG LEAGUES

BASEBALL'S PHONEY RECORD BOOK!

REAL MEN, 2/1959, Clarence Doore

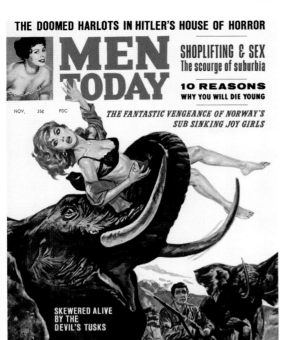

MEN TODAY, 11/1963, Norm Eastman

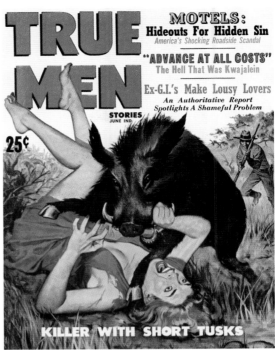

TRUE MEN STORIES, 6/1959, Will Hulsey

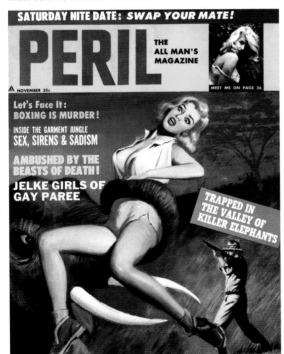

PERIL, 11/1962

PERIL, 5/1958
MAN'S DARING ACTION, 6/1959, Clarence Doore ▶▶

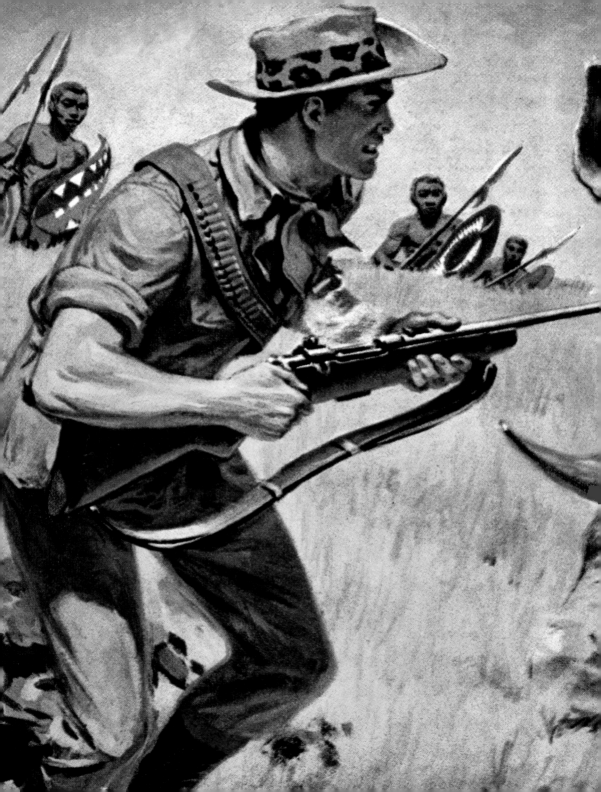

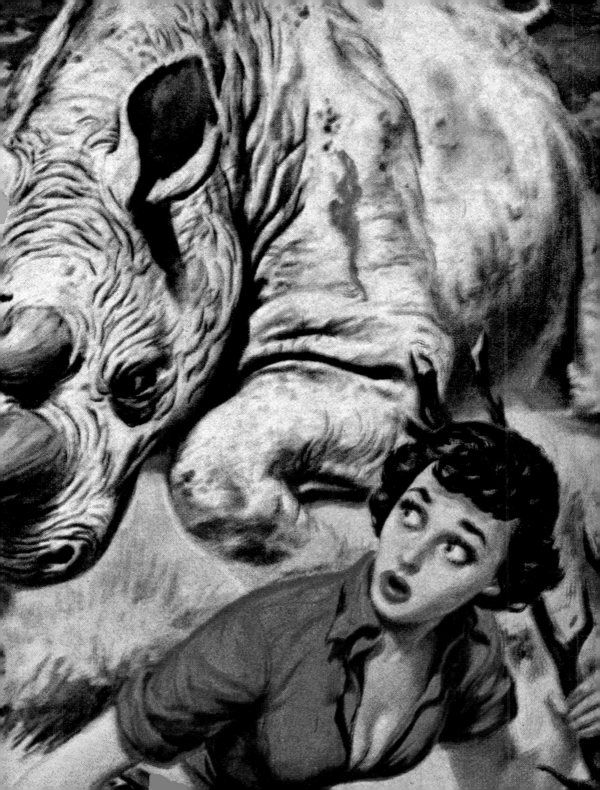

Man's Life

MARCH 25¢

Denver's Problem:
SHE-WOLVES ON THE PRO

Shove The Butt
Down His Throat!

THE AMERICAN MALE
LOSING HIS MANHOO

The Bloody Mess Was Me

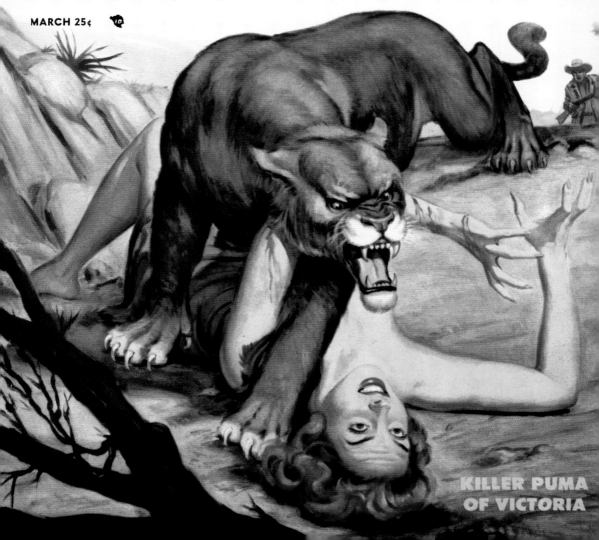

**KILLER PUMA
OF VICTORIA**

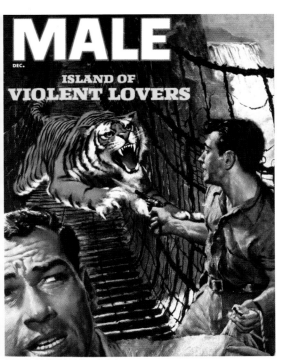

MALE, 12/1954, Robert Schulz

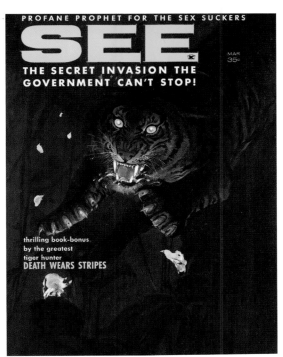

SEE, 3/1960, Maurice Thomas

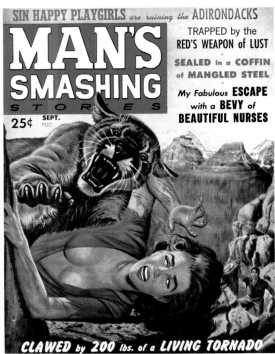

MAN'S SMASHING STORIES, 9/1959
◀ **MAN'S LIFE**, 3/1957

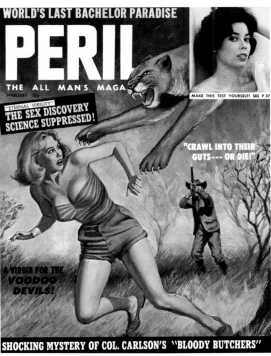

PERIL, 2/1961

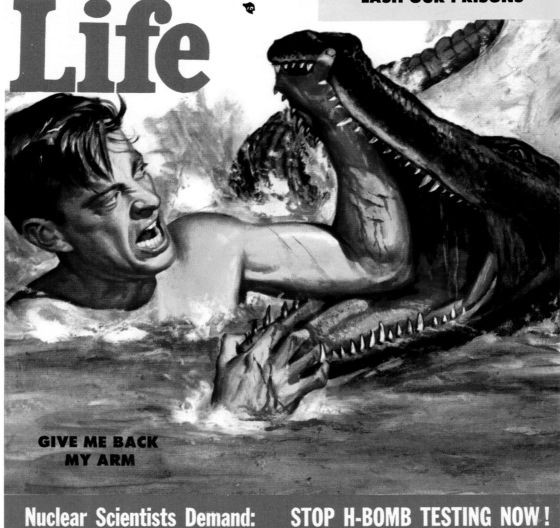

Man's Life

JANUARY 25c

GIVE ME BACK
MY ARM

Nuclear Scientists Demand: STOP H-BOMB TESTING NOW!
The World Could Be Blasted Off Its Axis! see page 12

MAN'S LIFE, 1/1957, Will Hulsey

CHAMPION, 9/1959, Clarence Doore ▶

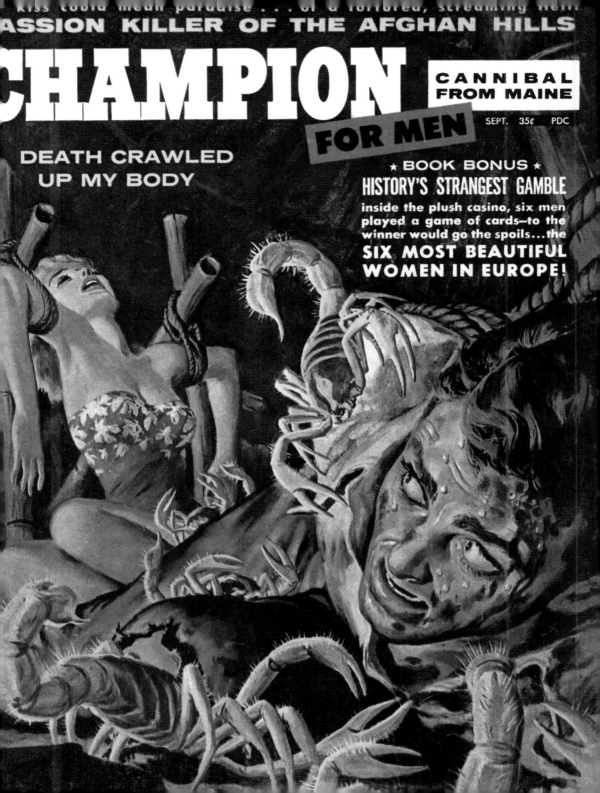

kiss could mean paradise . . . of a tortured, streaming hell

ASSION KILLER OF THE AFGHAN HILLS

CHAMPION

FOR MEN

SEPT. 35¢ PDC

CANNIBAL FROM MAINE

DEATH CRAWLED UP MY BODY

★ BOOK BONUS ★

HISTORY'S STRANGEST GAMBLE

inside the plush casino, six men played a game of cards—to the winner would go the spoils...the

SIX MOST BEAUTIFUL WOMEN IN EUROPE!

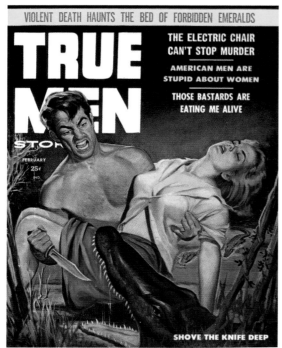

TRUE MEN STORIES, 2/1958, Will Hulsey

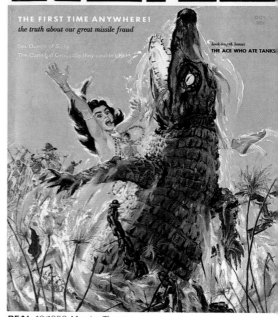

REAL, 10/1959, Maurice Thomas

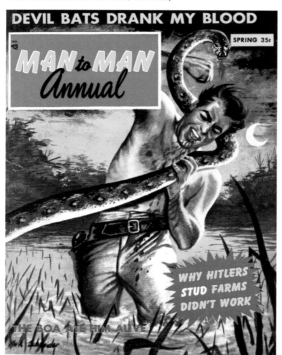

MAN TO MAN ANNUAL, Spring/1958, Mark Schneider

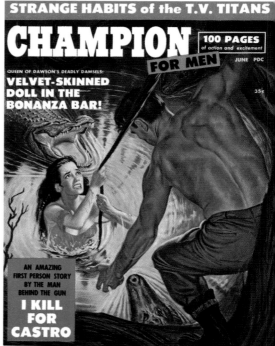

CHAMPION, 6/1959

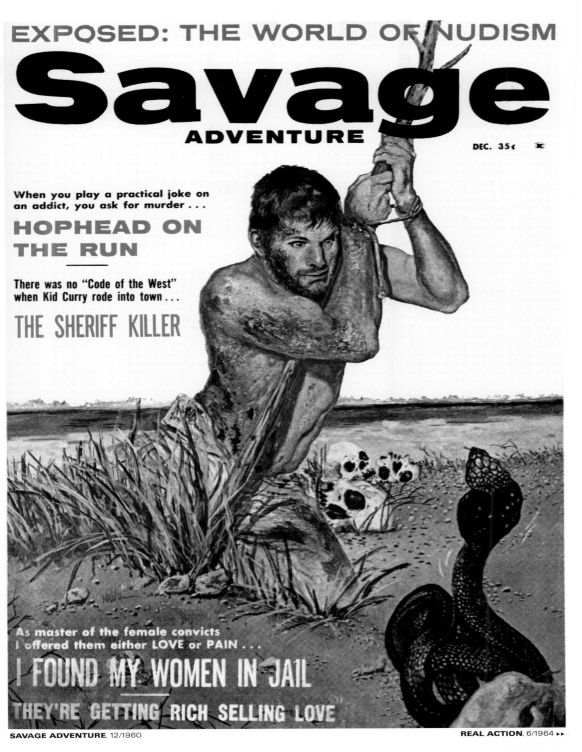

EXPOSED: THE WORLD OF NUDISM

Savage
ADVENTURE

DEC. 35¢

When you play a practical joke on
an addict, you ask for murder . . .

HOPHEAD ON
THE RUN

There was no "Code of the West"
when Kid Curry rode into town . . .

THE SHERIFF KILLER

As master of the female convicts
I offered them either LOVE or PAIN . . .

I FOUND MY WOMEN IN JAIL

THEY'RE GETTING RICH SELLING LOVE

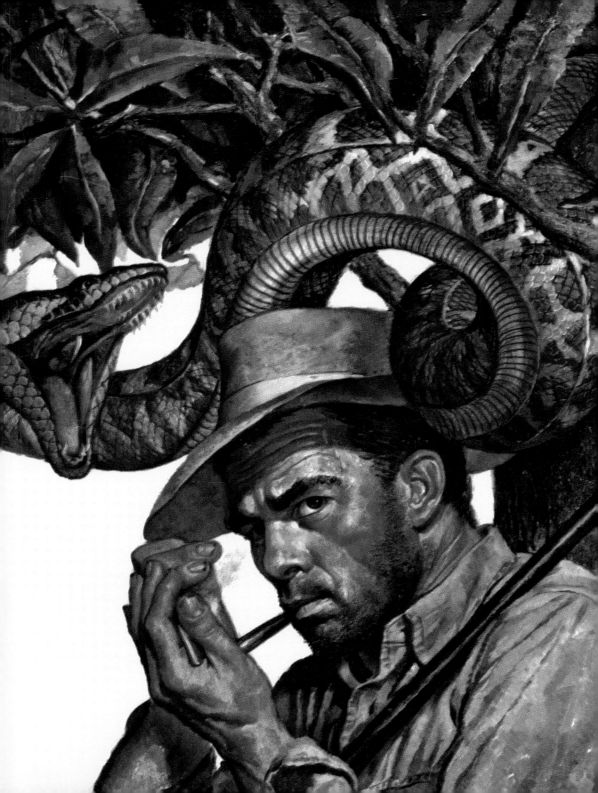

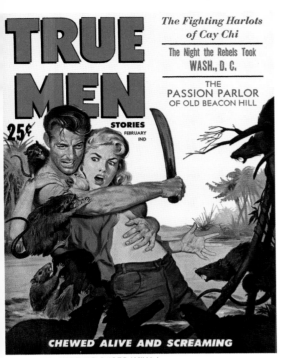

TRUE MEN STORIES, 2/1959, Will Hulsey

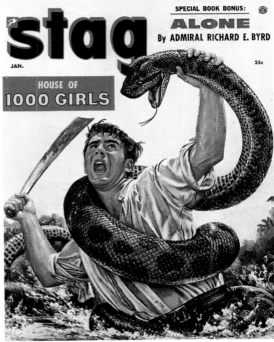

STAG, 1/1955, Mort Künstler

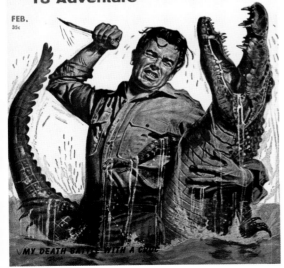

ESCAPE TO ADVENTURE, 2/1958, Rosa
◄ **VALOR FOR MEN**, 12/1958, Rafael DeSoto

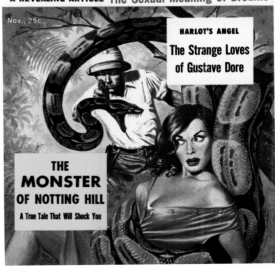

TRUE ADVENTURES, 11/1956, Walter Popp

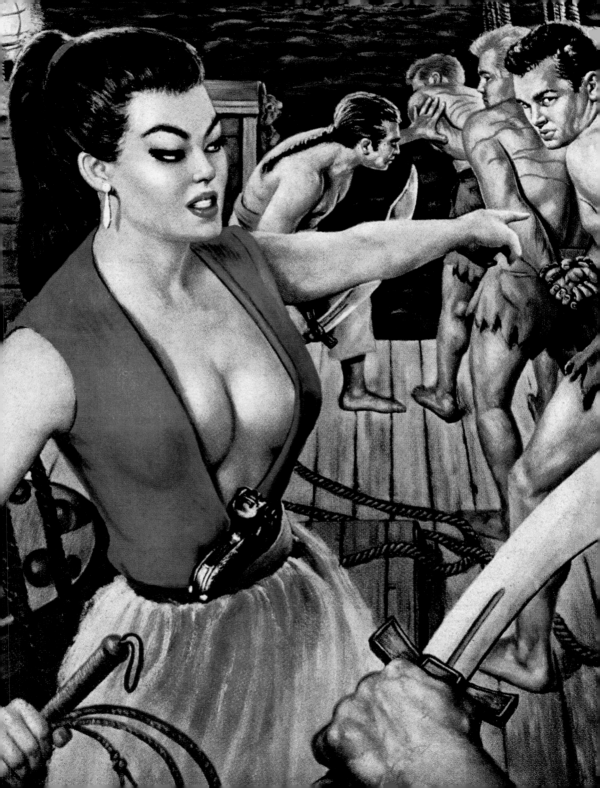

WILD RAMPAGE OF THE SEX-CRAZED PIRATE WOMEN

FROM THE HIGH SEAS TO HIGH NOON

From the time of ancient Greece, men have left home on quests to prove (and disseminate) their manhood, and both contemporary and historical journeys became a staple in men's adventure magazines. Covers depicted men on the road or high seas, finding lost civilizations, or making their fortunes in a number of exotic locales (conveniently populated by white women in peril, frequently tied to a stake, and occasionally staked to an anthill).

Many of the stories echoed classic pirate tales like *Treasure Island*, but, instead of Long John Silver, voluptuous pirate queens in skimpy attire ruled their crews with whip and steel in the best S&M manner. Initially, tame cover paintings of pirate or whaling ships at sea allowed the reader to appear as if he were perusing a magazine version of *Moby Dick*, when in reality he was engrossed in a spicy tale between the covers. By the sixties, no holds were barred. Suddenly, headlines like "Nympho Quartet vs. the Sex Beast of the Sea" or "28 Sex-Starved Men and a Girl on a Nightmare High-Seas Voyage" were accompanied by appropriately salacious covers and stories.

Beneath the waves, other wonders — and terrors — awaited. Judging by these covers, it was impossible for a man to slip into the ocean for even a casual bit of skin diving without encountering man-eating sharks, killer octopi, and sunken treasure. And, in case the promise of pirate gold was not a sufficient enticement, the seas were also strewn with bikini-clad damsels in distress.

Of course, nothing spices up an adventure like a good disaster

— in particular, a sinking ship. Disaster stories were a major sub-genre of men's adventure magazines. While sea disasters were the most common, air crashes and stranded travelers in the desert or snow also made for good subjects, especially if, like the Donner Party (which got stranded in the Californian Sierra Nevada in the winter of 1846), they ended up eating each other to stay alive.

Adventures of the historic variety tended toward stories of America's Wild West. Though most of the western pulp magazines had folded by the mid-fifties (along with their brethren in other genres), the western itself was thriving, with shows like *Gunsmoke* reaching an audience of millions via the new medium of television.

Western tales were a logical component of the eclectic mix of stories in men's adventure magazines. These versions of the west were not, however, built of the same wide-open spaces inhabited by Roy Rogers, Hopalong Cassidy, or the Lone Ranger. They were about brothels, Native Americans who kidnapped white women to torture and rape them, and bounty hunters who slept with the corpses of their victims.

At the other extreme from these nominally fact-based, western stories were cover yarns that truly stretched credibility. These included a surprising number of fantasies in which modern women were kidnapped by cavemen from long-lost, prehistoric tribes. Was it any wonder a real man was relieved to run into a band of sex-crazed female pirates on a wild rampage?

◄ **MAN'S DARING ACTION**, 8/1960, Charles Fracé
RAGE FOR MEN, 8/1963, Norm Eastman ►►

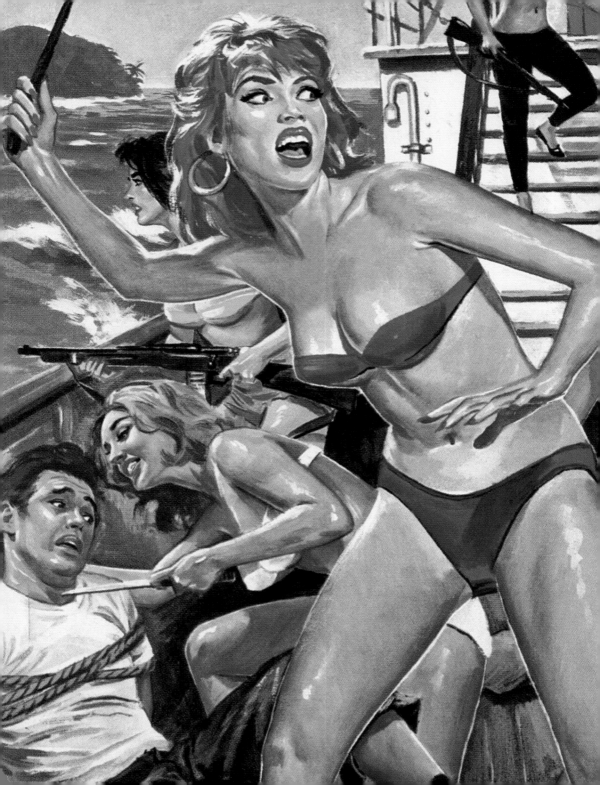

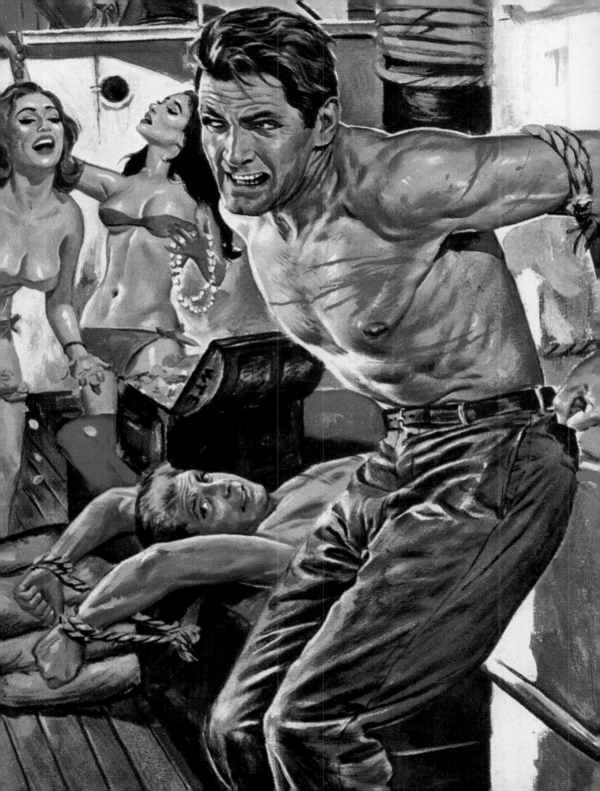

DER WÜSTE RITT DER SEXBESESSENEN PIRATINNEN.
VON HOHER SEE IN DEN WILDEN WESTEN

Nachweislich seit der Zeit der alten Griechen verließen Männer ihre Heimat, um ihre Männlichkeit unter Beweis zu stellen (und ihren Samen zu verbreiten), und sowohl zeitgenössische wie historische Reisen waren in den Abenteuerheftchen für Männer ständig zu finden. Auf den Titelbildern waren Männer auf Straßen oder auf hoher See abgebildet, die verschollene Zivilisationen entdecken oder in diversen exotischen Weltgegenden ihr Glück versuchen (wo es praktischerweise meist weiße Frauen in Lebensgefahr gibt, die an einen Marterpfahl gebunden sind, der eventuell auch noch in einem Ameisenhaufen steht).

Viele dieser Geschichten benutzten klassische Piratengeschichten wie *Die Schatzinsel* als Vorbild, aber statt Long John Silver herrschten hier dralle, notdürftig bekleidete Piratenköniginnen mit Peitsche und Stahl in bester S&M-Manier über ihre Mannschaft. Mit den harmlosen Einbandgrafiken von Piraten- oder Walfangschiffen konnten Leser anfangs noch so tun, als läsen sie eine Heftchenausgabe von *Moby Dick*, während sie sich in Wirklichkeit in schlüpfrige Geschichten vertieft hatten. Ab den Sechzigern war es damit jedoch vorbei. Plötzlich wurden Titel wie „Nymphomaninnenquartett gegen das Sexungeheuer des Meeres" oder „28 sexlüsterne Männer und ein Mädchen in einer Albtraumreise auf hoher See" von entsprechend obszönen Einbänden und Geschichten begleitet.

Natürlich macht nichts ein Abenteuer spannender als eine richtige Katastrophe – besonders ein sinkendes Schiff. Katastrophengeschichten stellten einen wichtigen Zweig der Abenteuerheftchen für Männer dar. Unglücke zu See waren am häufigsten, doch Flug-

zeugabstürze und in der Sand- oder Schneewüste verlorene Wanderer waren ebenfalls gutes Material, besonders wenn sie, wie bei der historischen „Donner Party" (eine Gruppe von Siedlern, die im Winter 1846 in der kalifornischen Sierra Nevada im Schnee festsaß), sich am Ende gegenseitig verspeisten, um am Leben zu bleiben.

Historische Abenteuer waren meist Geschichten aus dem amerikanischen Wilden Westen. Auch wenn Mitte der Fünfzigerjahre die meisten Western-Pulps vom Markt verschwunden waren (genau wie ihre Geschwister aus anderen Genres), erlebte der Western an sich jedoch eine Blütezeit und Fernsehserien wie *Rauchende Colts* erreichten mit dem neuen Medium Fernsehen ein Millionenpublikum.

Erzählungen aus dem Wilden Westen stellten einen logischen Bestandteil der bunten Mischung von Beiträgen in den Abenteuerheftchen für Männer dar. Diese Darstellungen des Westens beschworen jedoch nicht dieselben endlosen Landschaften, die von Roy Rogers, Hopalong Cassidy oder dem Lone Ranger durchritten wurden. Sie handelten von Bordellen, Indianern, die weiße Frauen entführten, marterten und vergewaltigten, und Kopfgeldjägern, die mit den Leichen ihrer Opfer schliefen.

Am gegenüberliegenden Ende der Skala dieser zumindest in gewisser Weise Tatsachen gestützter Westernstorys befanden sich die Titelgeschichten, mit denen die Leichtgläubigkeit ihrer Leser ernstlich herausgefordert wurde. Dazu gehörten eine erstaunliche Anzahl von Fantasien, in denen moderne Frauen von Höhlenbewohnern lang untergegangen gewähnter Urzeitstämme entführt wurden. Wen konnte es da wundern, wenn ein wahrer Mann erleichtert war, wenn er sich nur einer Horde sexbesessener Piratinnen beim wüsten Ritt gegenüber sah?

MEN, 9/1955, Jim Bentley

REAL MEN, 12/1958, Vic Prezio ▶

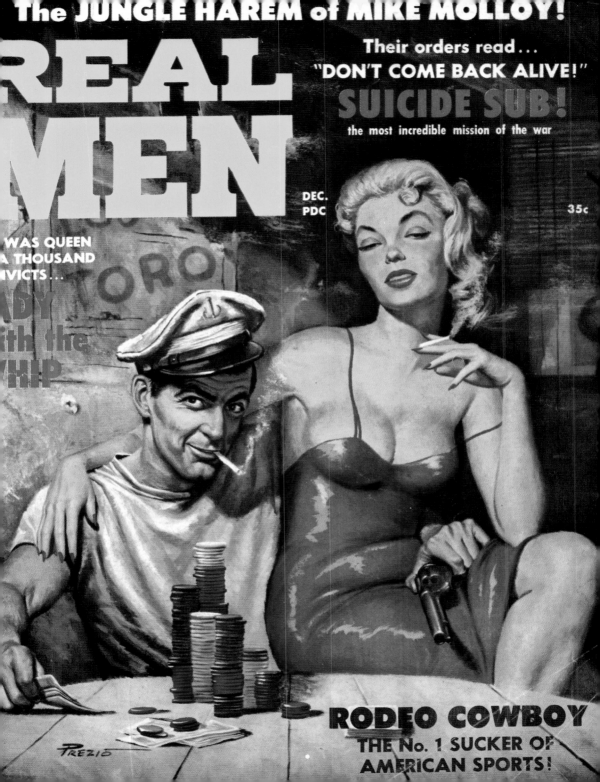

The JUNGLE HAREM of MIKE MOLLOY!

REAL MEN

Their orders read...
"DON'T COME BACK ALIVE!"
SUICIDE SUB!
the most incredible mission of the war

DEC.
PDC

35c

...WAS QUEEN
A THOUSAND
VICTS...

DY
th the
HIP

RODEO COWBOY
THE No. 1 SUCKER OF
AMERICAN SPORTS!

PREZIO

FURY, 6/1958, Tom Beecham

LA FRENESIE DES FEMMES-PIRATES ASSOIFFEES DE SEXE. DE LA HAUTE MER AU MIDI BRULANT

Depuis la plus haute Antiquité grecque, les hommes quittent leur foyer pour prouver (et répandre) leur virilité, et les voyages, modernes ou anciens, ont constitué un des thèmes favoris des magazines d'aventures pour hommes. Les couvertures montrent des héros cheminant sur une route, ou voguant en haute mer, découvrant des civilisations perdues ou faisant fortune dans quelque contrée exotique (comme par hasard peuplée de femmes blanches en péril souvent attachées à un pieu et parfois à une termitière).

Nombre de ces histoires font écho à des récits de piraterie classiques comme l'*Île au Trésor*, mais au lieu de Long John Silver, on a droit à de voluptueuses reines de pirates légèrement vêtues qui dirigent leurs marins à coups de fouet et de pistolet dans la pure tradition SM. Au départ, des couvertures plutôt sages de pirates ou de baleiniers fendant l'écume faisaient passer leur lecteur pour un innocent amateur de récits à la *Moby Dick*, alors qu'il était captivé par l'histoire salace que contenait son pulp. Dans les années soixante, ces biais n'avaient plus cours et les gros titres se firent soudainement très crus : « Les quatre nymphos et l'insatiable monstre marin » ou encore « 28 frustrés pour une seule fille, cauchemar en haute mer », étaient accompagnés de couvertures et histoires salaces ad hoc.

Bien sûr, rien de tel qu'un bon désastre pour corser une aventure de ce genre, l'idéal restant le naufrage. Les récits de catastrophes sont un des sous-groupes les plus remarquables des magazines d'aventures pour hommes. Si les naufrages restent les plus courants, les crashs aériens et autres récits de voyageurs perdus dans le désert, ou dans la neige, font aussi d'excellents sujets, surtout si, comme dans le cas du convoi Donner (qui fut bloqué l'hiver 1846 en Californie sur les hauteurs de la Sierra Nevada), les protagonistes finissent par se dévorer les uns les autres pour survivre.

Les aventures à thème historique avaient souvent pour cadre l'Ouest mythologique des pionniers. Au milieu des années cinquante, la plupart des pulps de western avaient disparu (tout

comme leurs homologues des autres genres), alors que le genre cinématographique du western était en plein essor comme l'attestent des émissions télé telle *Gunsmoke*, qui touchaient des millions de téléspectateurs.

Ce décor western constitue un ingrédient logique de l'insolite cocktail de sexe et de violence, le filon des magazines d'aventures pour hommes. Ces versions de l'Ouest ne présentent cependant pas les immenses espaces sauvages familiers aux lecteurs de Roy Rogers, Hopalong Cassidy ou the Lone Ranger. Il y est plutôt question de saloons-bordels, d'Indiens kidnappant des femmes blanches pour les torturer et les violer, et de chasseurs de primes dormant à côté du cadavre de leurs victimes.

A l'autre extrême de ces récits soi-disant basés sur des faits, on trouve des récits de fiction qui mettent au défi la crédulité du lecteur. Et notamment une impressionnante quantité de récits dans lesquels on voit des femmes modernes kidnappées par des hommes des cavernes appartenant à des tribus que la civilisation n'a pas atteintes. Dans un tel contexte, faut-il s'étonner qu'un homme ordinaire soit soulagé de tomber sur une bande de femmes pirates assoiffées de sexe ?

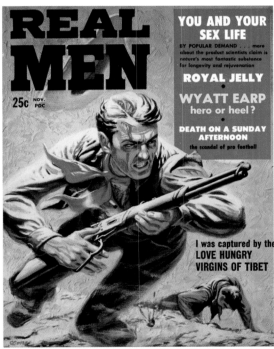

REAL MEN, 11/1957, Clarence Doore

ADVENTURE

STILL ONLY 25¢

DECEMBER

THE MAN'S MAGAZINE OF EXCITING FICTION AND FACT

A. CONAN DOYLE'S
GREAT PHOTO DRAMA
THE SHARKS OF BIR ALI

HOW MUCH DO YOU KNOW ABOUT WOMEN IN LOV
The Truth About Woman's Sex Habits
BY DR. A. J. BURSTELN

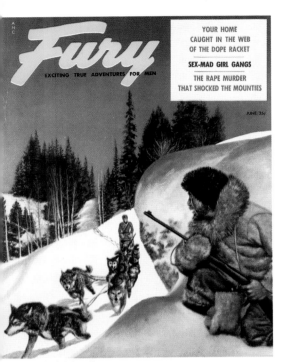

FURY, 6/1956, Robert Doares

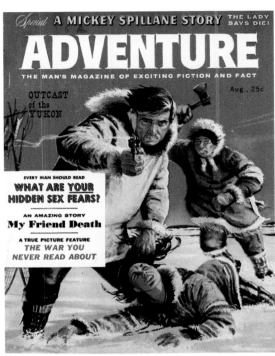

ADVENTURE, 8/1958, John Styga

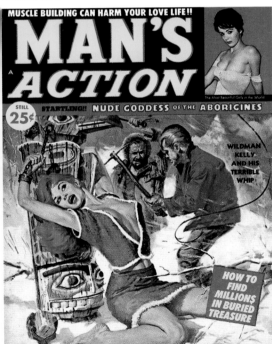

MAN'S ACTION, 3/1961
◄ **ADVENTURE**, 12/1962, Norman Saunders

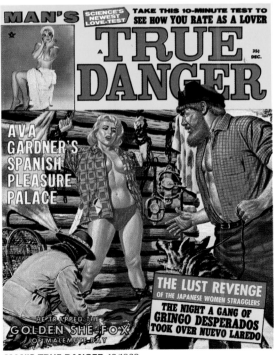

MAN'S TRUE DANGER, 12/1963

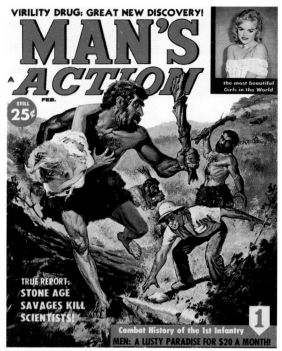

MAN'S ACTION, 2/1960, Basil Gogos

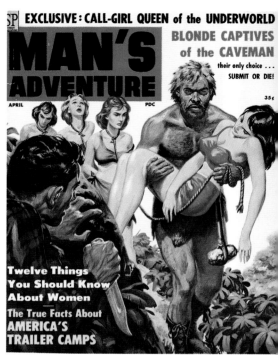

MAN'S ADVENTURE, 4/1959, Clarence Doore

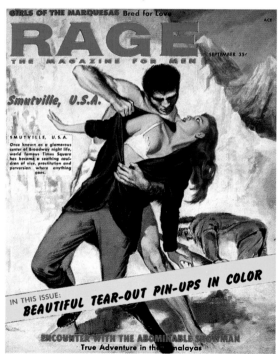

RAGE, 9/1960

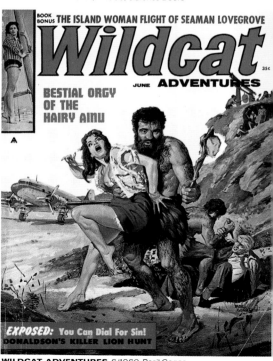

WILDCAT ADVENTURES, 6/1960, Basil Gogos

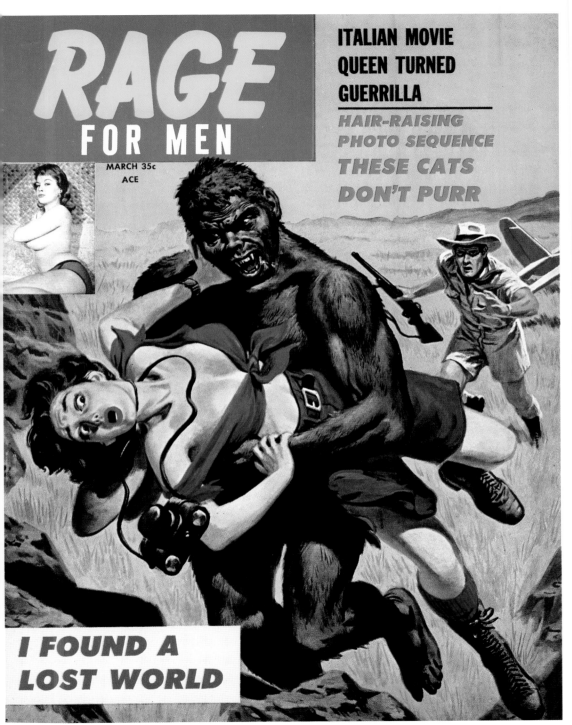

RAGE FOR MEN, 3/1961, Clarence Doore

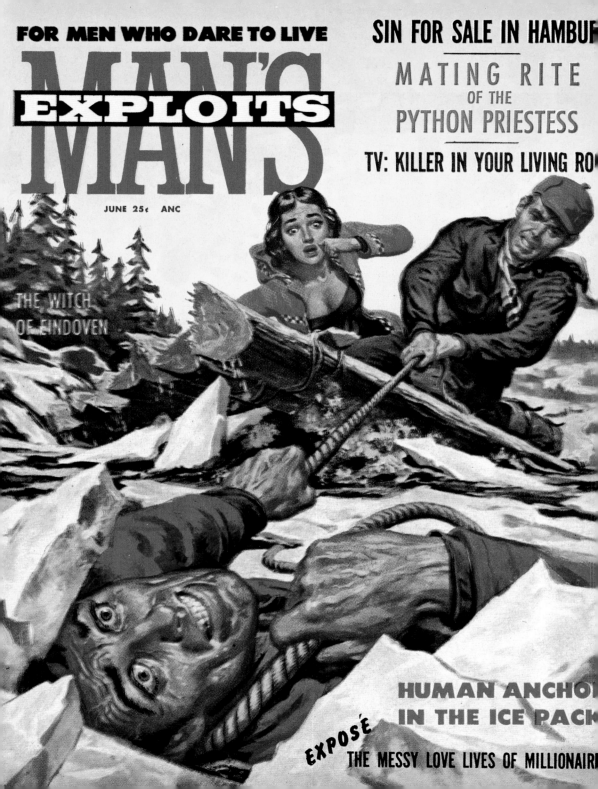

FOR MEN WHO DARE TO LIVE

MAN'S EXPLOITS

JUNE 25¢ ANC

SIN FOR SALE IN HAMBUR

MATING RITE
OF THE
PYTHON PRIESTESS

TV: KILLER IN YOUR LIVING RO

THE WITCH
OF EINDOVEN

HUMAN ANCHO
IN THE ICE PACK

EXPOSÉ
THE MESSY LOVE LIVES OF MILLIONAIR

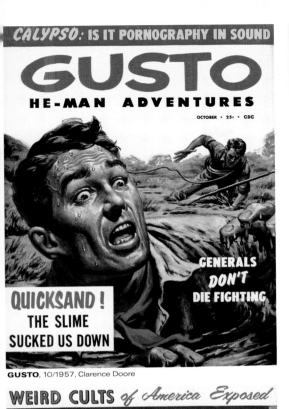

Clipping text within image 1:
CALYPSO: IS IT PORNOGRAPHY IN SOUND

GUSTO
HE-MAN ADVENTURES

OCTOBER · 25¢ · CDC

GENERALS DON'T DIE FIGHTING

QUICKSAND!
THE SLIME SUCKED US DOWN

GUSTO, 10/1957, Clarence Doore

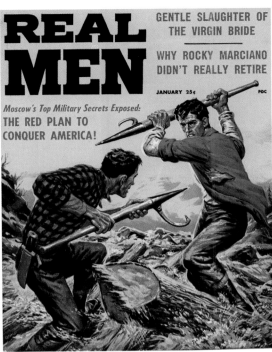

REAL MEN

GENTLE SLAUGHTER OF THE VIRGIN BRIDE

WHY ROCKY MARCIANO DIDN'T REALLY RETIRE

JANUARY 25¢ PDC

Moscow's Top Military Secrets Exposed:
THE RED PLAN TO CONQUER AMERICA!

REAL MEN, 1/1957, Clarence Doore

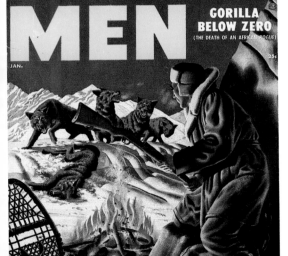

WEIRD CULTS *of America Exposed*

MEN

GORILLA BELOW ZERO
(THE DEATH OF AN AFRICAN ROGUE)

JAN. 25¢

MEN, 1/1955, Simon Greco
◄ **MAN'S EXPLOITS**, 6/1957, Clarence Doore

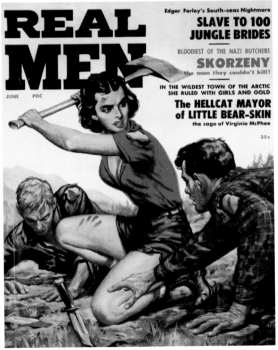

Real MEN

Edgar Farley's South-seas Nightmare
SLAVE TO 100 JUNGLE BRIDES

BLOODIEST OF THE NAZI BUTCHERS
SKORZENY
the man they couldn't kill!

IN THE WILDEST TOWN OF THE ARCTIC
SHE RULED WITH GIRLS AND GOLD
The HELLCAT MAYOR of LITTLE BEAR-SKIN
the saga of Virginia McPhee

JUNE PDC 35¢

REAL MEN, 6/1959, Clarence Doore

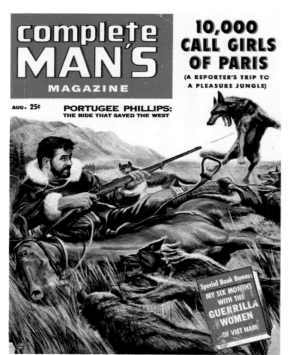

COMPLETE MAN'S MAGAZINE, 8/1957, Don Miller

MEN'S PICTORIAL, 2/1956, Mort Künstler

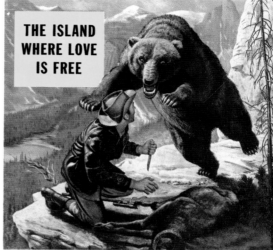

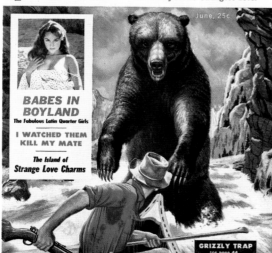

MEN'S PICTORIAL, 6/1956, Mort Künstler

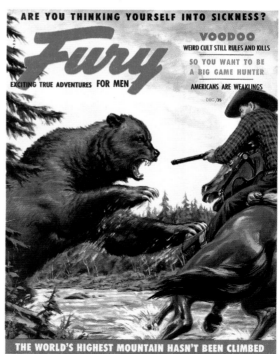

FURY, 12/1954, James Wearton

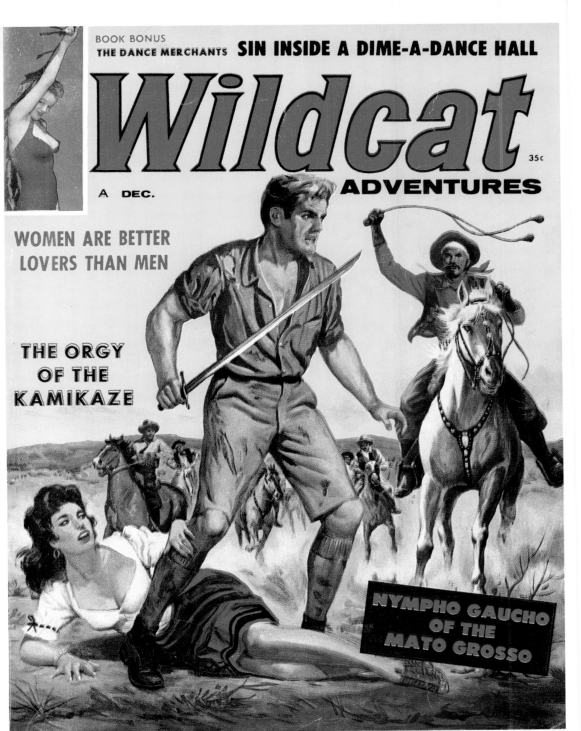

BOOK BONUS
THE DANCE MERCHANTS SIN INSIDE A DIME-A-DANCE HALL

Wildcat
ADVENTURES

A DEC. 35¢

WOMEN ARE BETTER
LOVERS THAN MEN

THE ORGY
OF THE
KAMIKAZE

NYMPHO GAUCHO
OF THE
MATO GROSSO

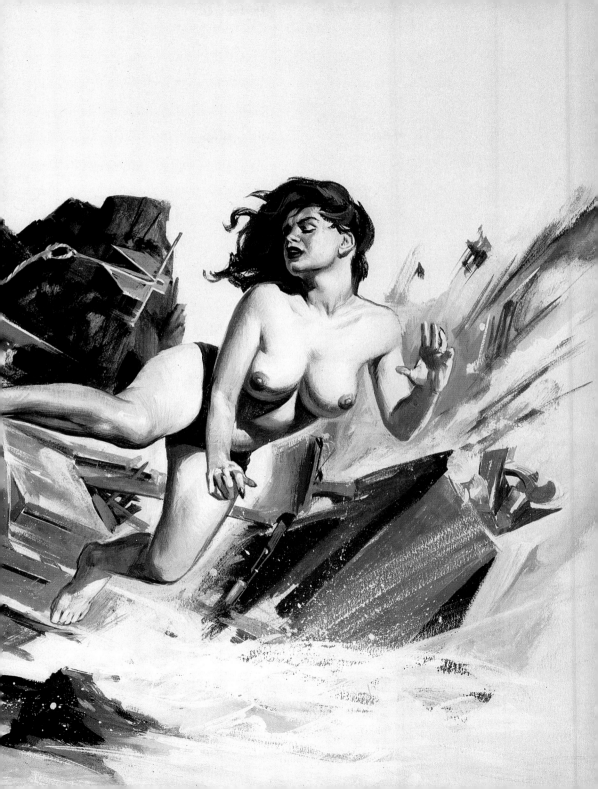

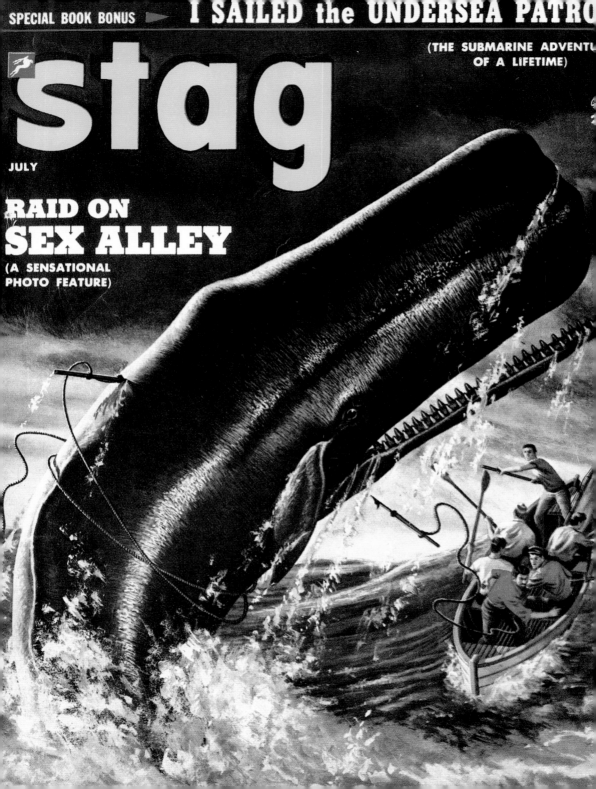

stag

JULY

RAID ON
SEX ALLEY

(A SENSATIONAL
PHOTO FEATURE)

REAL MEN, 5/1958, Clarence Doore

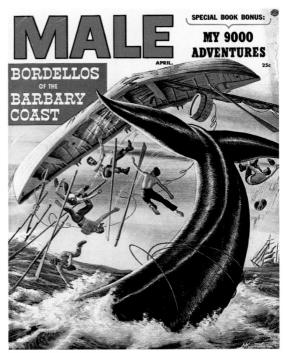

MALE, 4/1955, Mort Künstler

FURY, 8/1955, Clarence Doore
◄ STAG, 7/1954, Mort Künstler

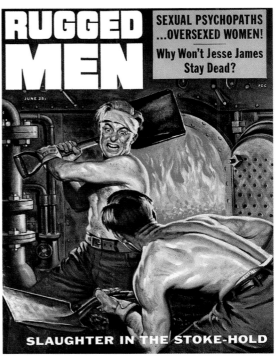

RUGGED MEN, 6/1956, Milton Luros
STAG, 9/1955, Mort Künstler ►►

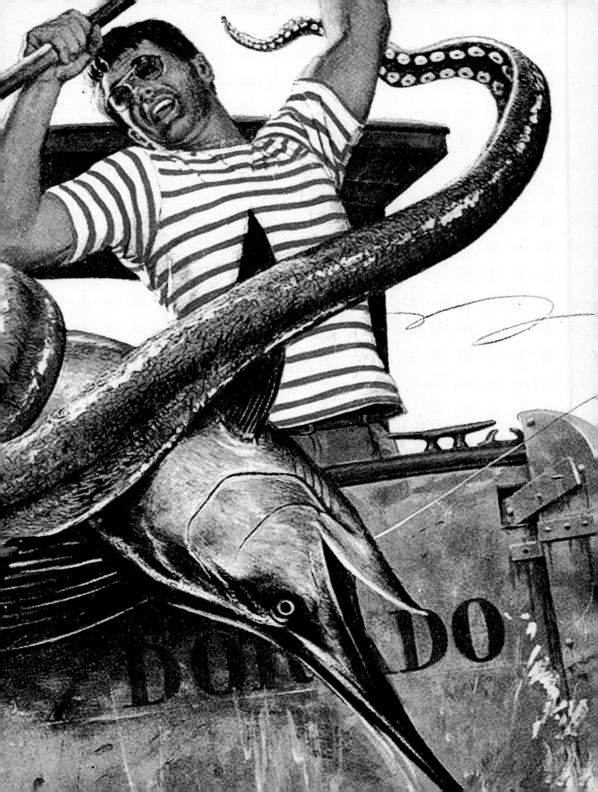

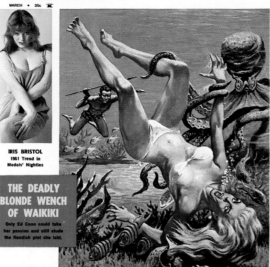

BOLD MEN!, 3/1961

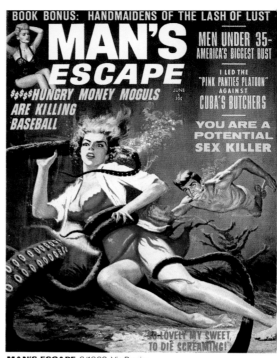

MAN'S ESCAPE, 6/1963, Vic Prezio

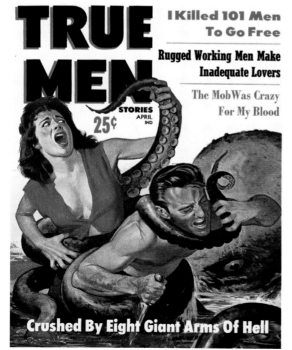

TRUE MEN STORIES, 4/1959, Will Hulsey

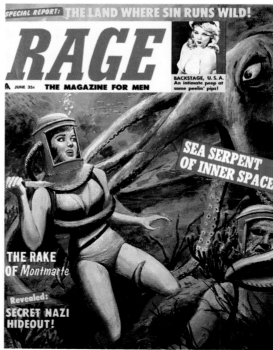

RAGE, 6/1962

MEN'S pictorial

The Price Of Her Sinning

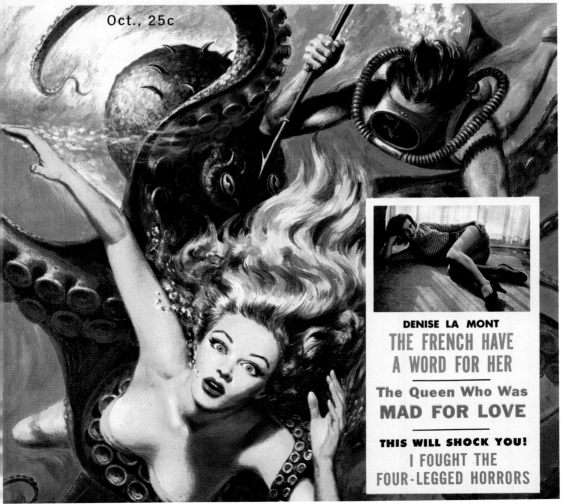

Oct., 25c

DENISE LA MONT
THE FRENCH HAVE A WORD FOR HER

The Queen Who Was
MAD FOR LOVE

THIS WILL SHOCK YOU!
I FOUGHT THE FOUR-LEGGED HORRORS

MEN'S PICTORIAL, 10/1956, Walter Popp

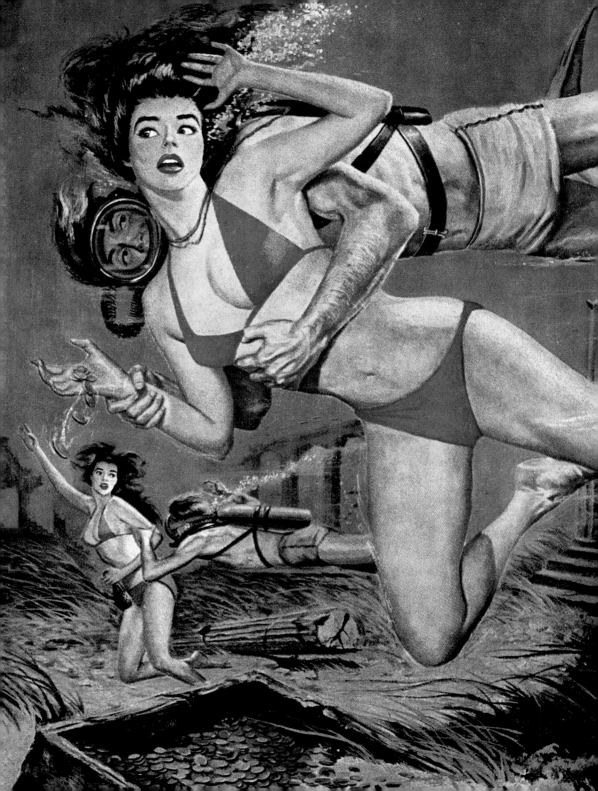

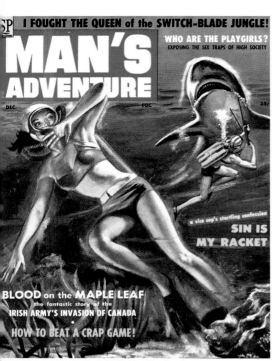

MAN'S ADVENTURE, 12/1958, Ray Sternbergh

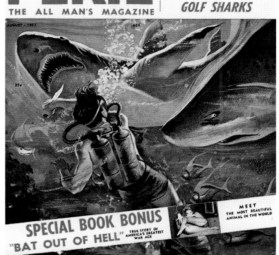

PERIL, 8/1957, Casey Jones

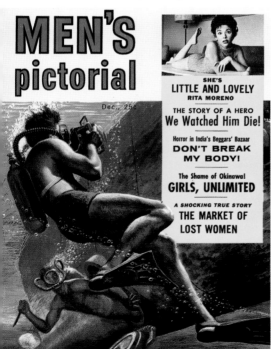

MEN'S PICTORIAL, 12/1956, Mort Künstler
ADVENTURE, 6/1961, Vic Prezio

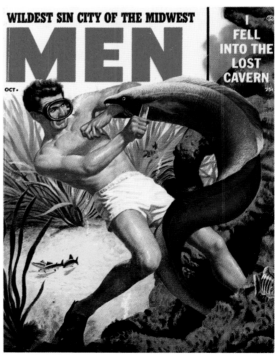

MEN, 10/1955, John Leone

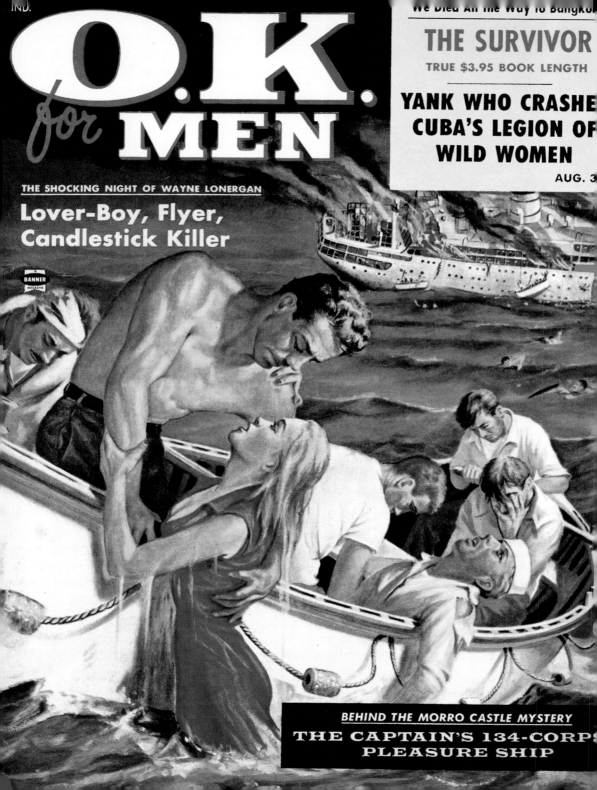

IND.

O. K.
for MEN

We Died All the Way To Bangkok

THE SURVIVOR
TRUE $3.95 BOOK LENGTH

YANK WHO CRASHE[D]
CUBA'S LEGION OF
WILD WOMEN

AUG. 3[]

THE SHOCKING NIGHT OF WAYNE LONERGAN

Lover-Boy, Flyer,
Candlestick Killer

BEHIND THE MORRO CASTLE MYSTERY
THE CAPTAIN'S 134-CORPS[E]
PLEASURE SHIP

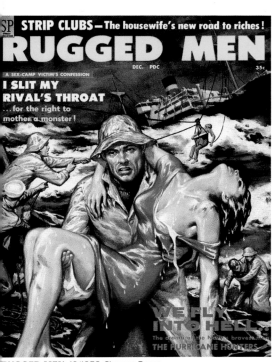

RUGGED MEN, 12/1958, Clarence Doore

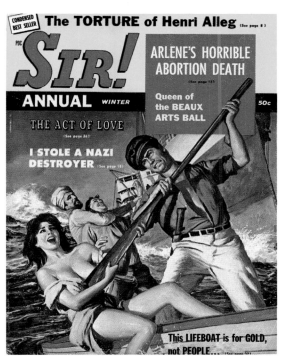

SIR! ANNUAL, Winter/1961

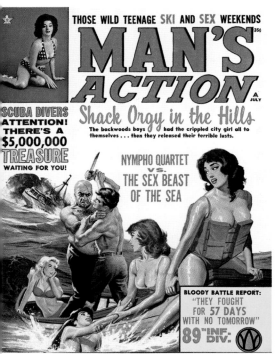

MAN'S ACTION, 7/1964, John Duillo
◄ **O.K. FOR MEN**, 8/1959, Lou Marchetti

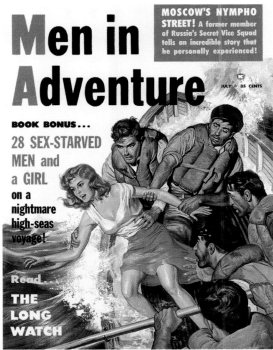

MEN IN ADVENTURE, 7/1959, Rafael DeSoto

SEA **ADVENTURES**

MAY 35¢

South Pacific Nightmare—
TRAPPED IN HELL'S HOLD

MASSACRE OFF ZANZIBAR—
THE DAY OUR DECKS RAN BLOOD

THE 14-DAY ORDEAL OF SEAMAN BOURGET

SEA ADVENTURES, 5/1959, John Leone **MAN'S ILLUSTRATED**, 1/1959, gouache, 33 x 36 cm ▶

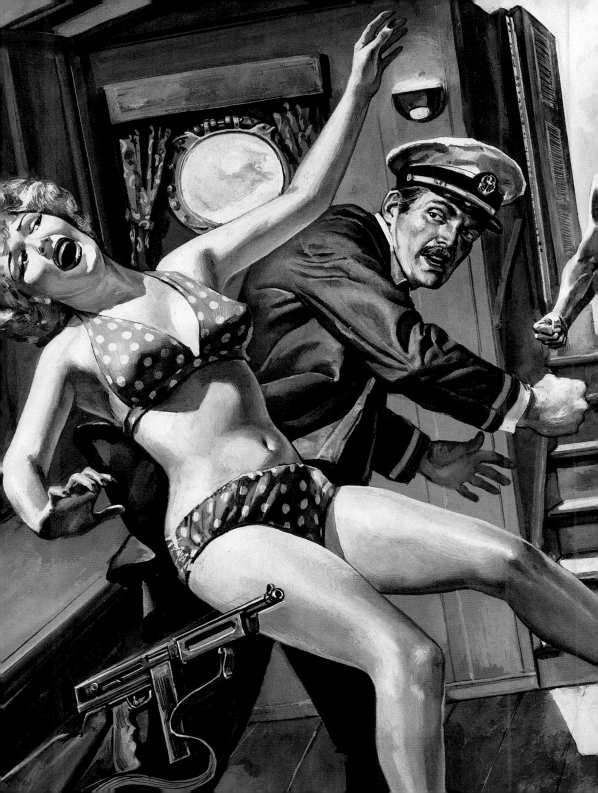

TRUE ACTION, 1/1959, Mort Künstler

UNTAMED, 6/1959, Ed Emsh

RUGGED MEN, 3/1959, Clarence Doore

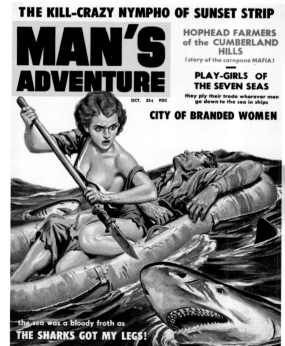

MAN'S ADVENTURE, 10/1959, Clarence Doore

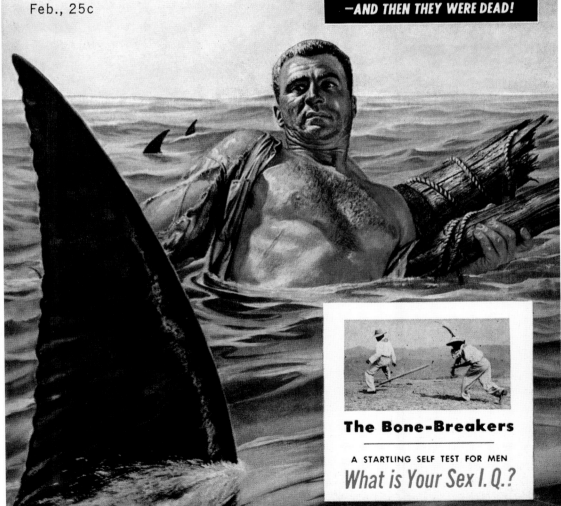

MEN'S
PICTORIAL

Feb., 25c

MEN'S PICTORIAL, 2/1958, Philip Ronfor

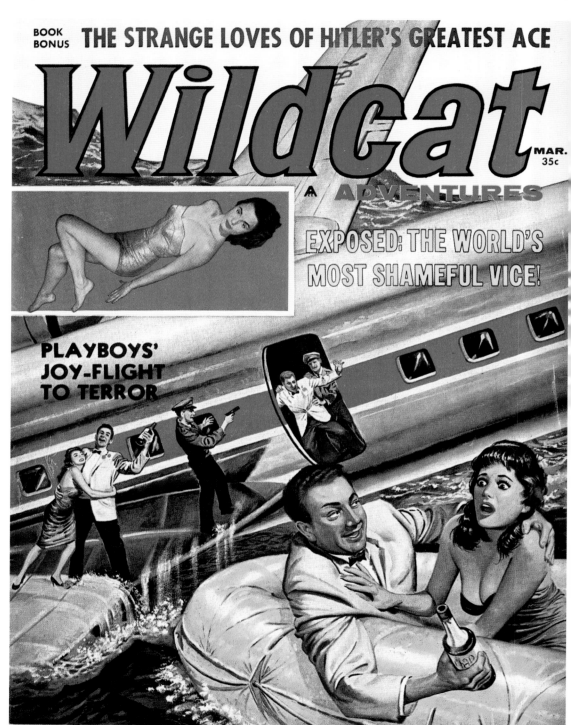

BOOK BONUS THE STRANGE LOVES OF HITLER'S GREATEST ACE

Wildcat

MAR. 35c

A ADVENTURES

EXPOSED: THE WORLD'S MOST SHAMEFUL VICE!

PLAYBOYS' JOY-FLIGHT TO TERROR

WILDCAT ADVENTURES, 3/1960

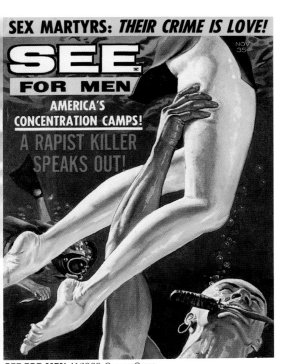

SEE FOR MEN, 11/1962, George Gross

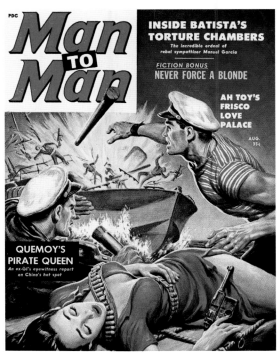

MAN TO MAN, 8/1959, Clarence Doore

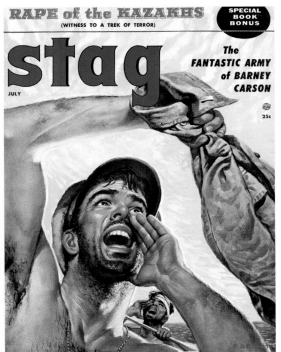

STAG, 7/1956, Rafael DeSoto

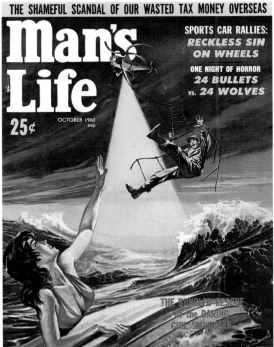

MAN'S LIFE, 10/1960

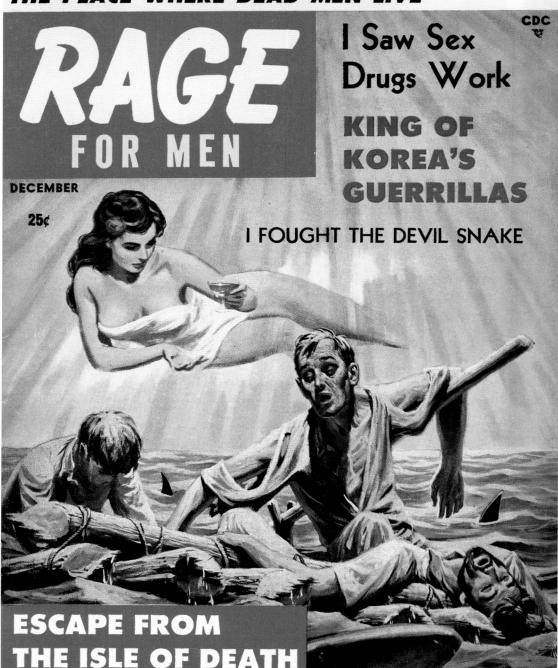

RAGE
FOR MEN

CDC

I Saw Sex
Drugs Work

**KING OF
KOREA'S
GUERRILLAS**

DECEMBER

25¢

I FOUGHT THE DEVIL SNAKE

ESCAPE FROM
THE ISLE OF DEATH

RAGE FOR MEN, 12/1957, Clarence Doore

SEE, 1/1960, Leo Ramon Summers ▸

THE PREGNANT INNOCENTS:
sterilization's secret scandal

SEE

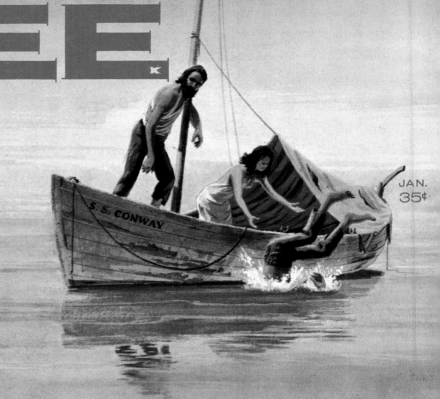

JAN.
35¢

E MAN
HO ATE HIMSELF

EFFIELD'S
CREDIBLE
X CULT

Y LIFE BEHIND
E GUN
unforgettable
k-bonus by
MES D. HORAN
thor of
D. A.'s MAN

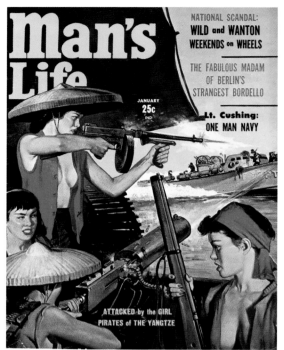

MAN'S LIFE, 1/1959, Will Hulsey

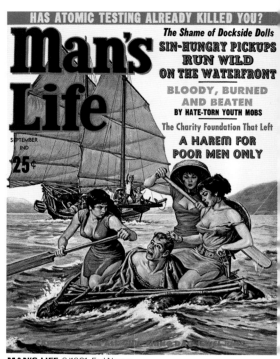

MAN'S LIFE, 9/1961, Earl Norem

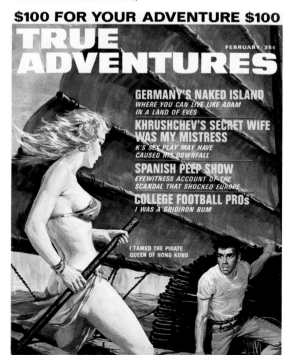

TRUE ADVENTURES, 2/1965, Robert Schulz

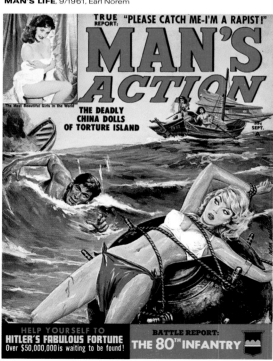

MAN'S ACTION, 9/1962, Norm Eastman

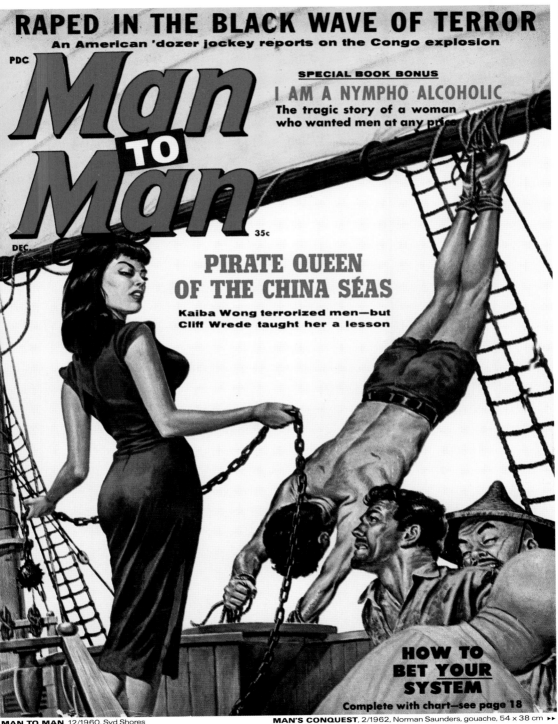

RAPED IN THE BLACK WAVE OF TERROR
An American 'dozer jockey reports on the Congo explosion

PDC

Man TO Man

DEC.

35c

SPECIAL BOOK BONUS
I AM A NYMPHO ALCOHOLIC
The tragic story of a woman
who wanted men at any price

PIRATE QUEEN
OF THE CHINA SÉAS
Kaiba Wong terrorized men—but
Cliff Wrede taught her a lesson

HOW TO
BET YOUR
SYSTEM
Complete with chart—see page 18

MAN TO MAN, 12/1960, Syd Shores

MAN'S CONQUEST, 2/1962, Norman Saunders, gouache, 54 x 38 cm ▶▶

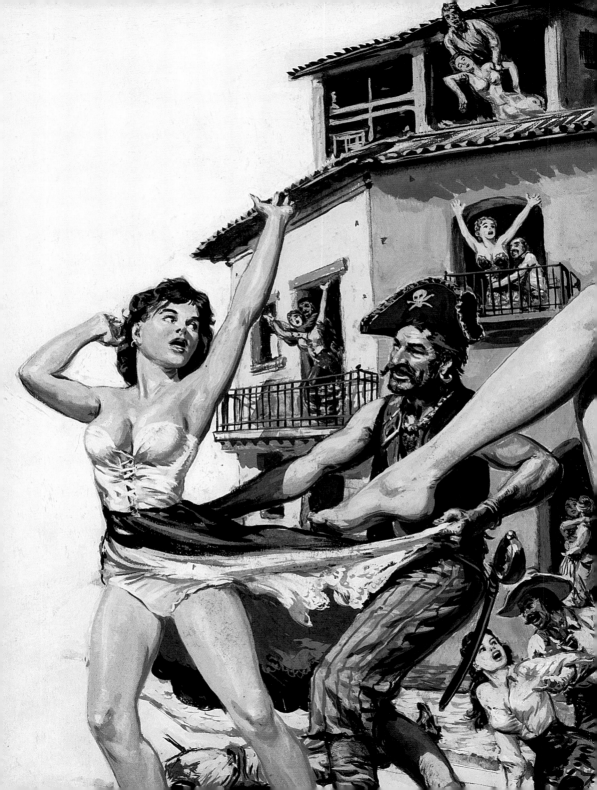

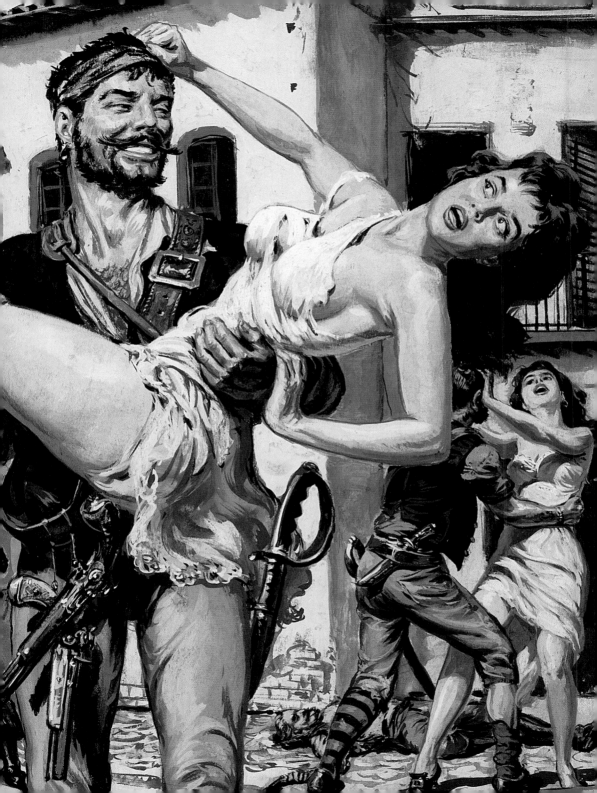

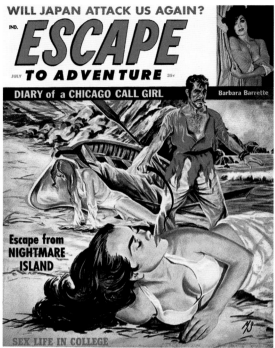

ESCAPE TO ADVENTURE, 7/1961, Mark Schneider

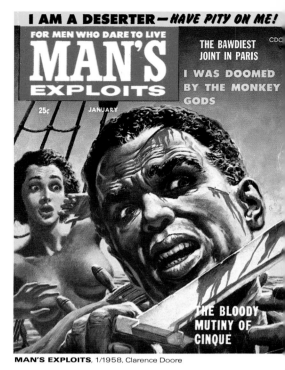

MAN'S EXPLOITS, 1/1958, Clarence Doore

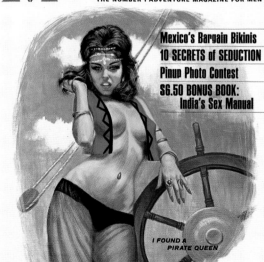

ADVENTURE, 6/1966, Mel Crair

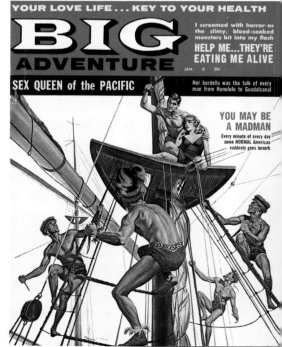

BIG ADVENTURE, 1/1961, Vic Prezio
SEE FOR MEN, 3/1957 ▸

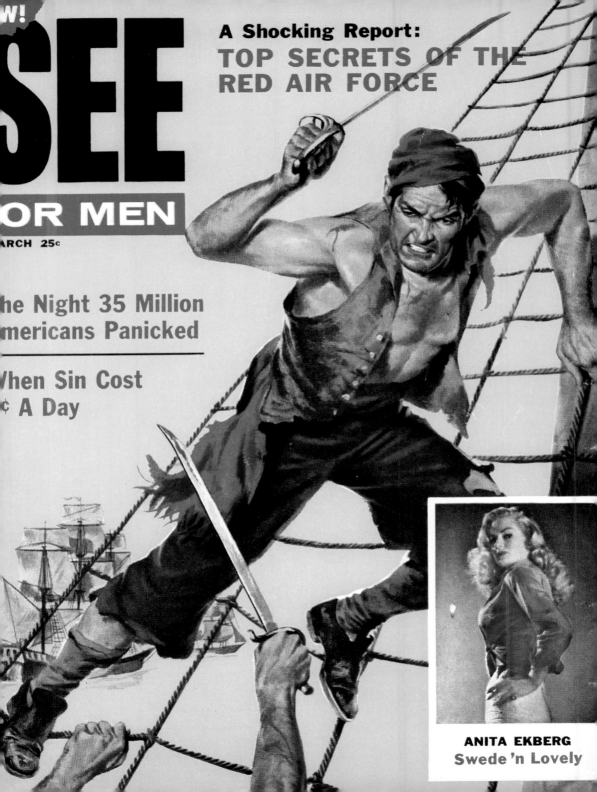

W!

SEE
OR MEN

ARCH 25c

A Shocking Report:
TOP SECRETS OF THE RED AIR FORCE

he Night 35 Million
mericans Panicked

Vhen Sin Cost
¢ A Day

ANITA EKBERG
Swede 'n Lovely

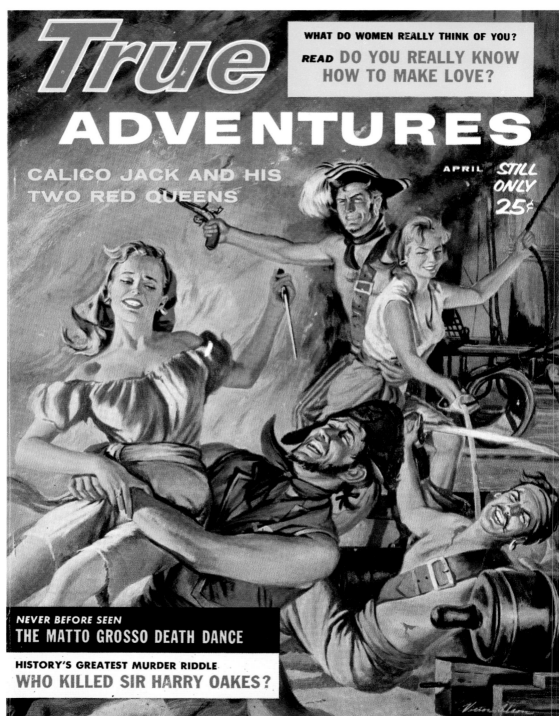

True
ADVENTURES

CALICO JACK AND HIS
TWO RED QUEENS

APRIL STILL ONLY 25¢

NEVER BEFORE SEEN
THE MATTO GROSSO DEATH DANCE

HISTORY'S GREATEST MURDER RIDDLE
WHO KILLED SIR HARRY OAKES?

TRUE ADVENTURES, 4/1960, Victor Olson

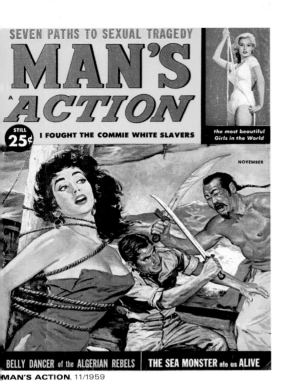

MAN'S ACTION, 11/1959

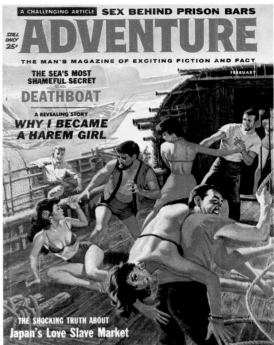

ADVENTURE, 2/1961, Jack Rickard

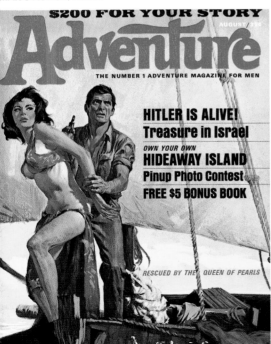

ADVENTURE, 8/1965, Roger Kastel

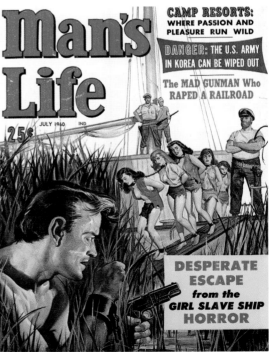

MAN'S LIFE, 7/1960, Will Hulsey
REAL FOR MEN, 11/1955, Rafael DeSoto, oil, 72 x 46 cm ▸▸

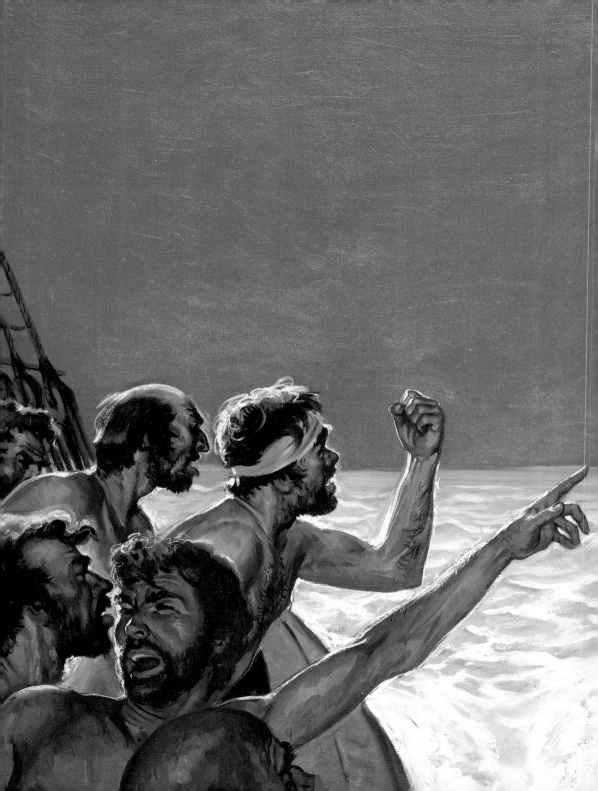

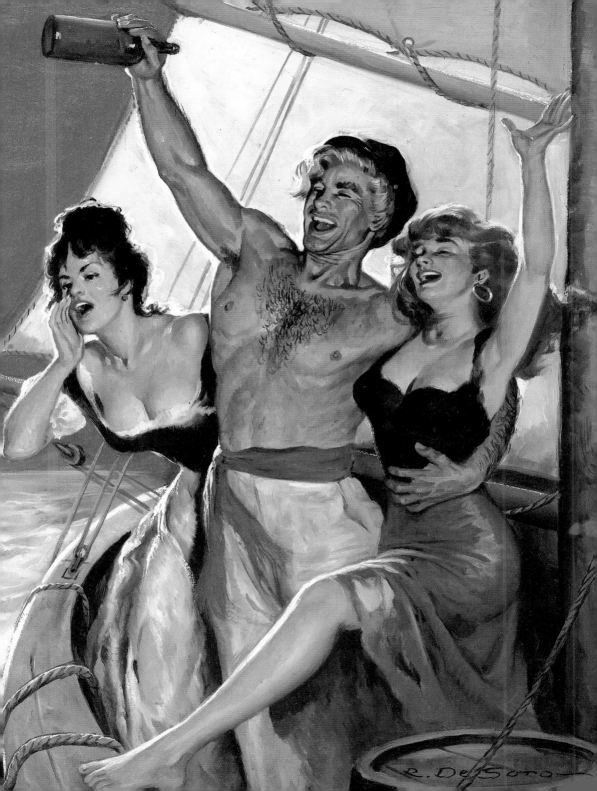

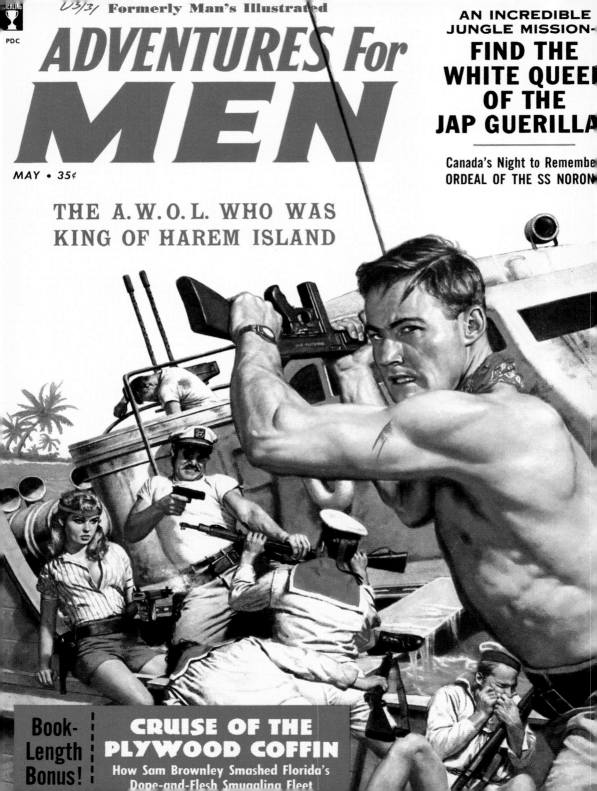

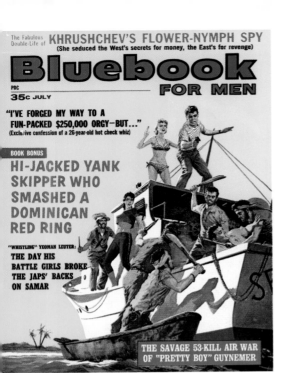

BLUEBOOK, 7/1963, Robert Schulz

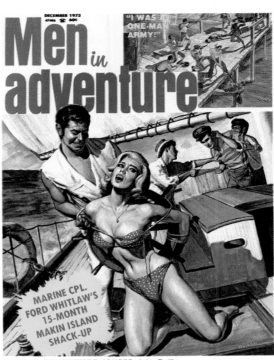

MEN IN ADVENTURE, 12/1973, John Duillo

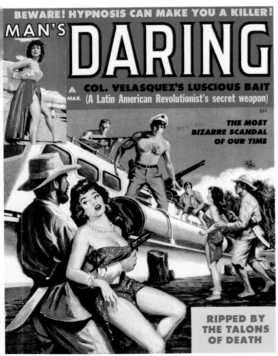

MAN'S DARING, 3/1960
◀ **ADVENTURES FOR MEN**, 5/1959, Stan Borack

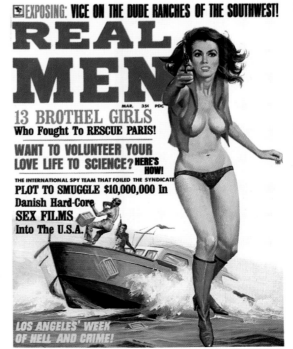

REAL MEN, 3/1969

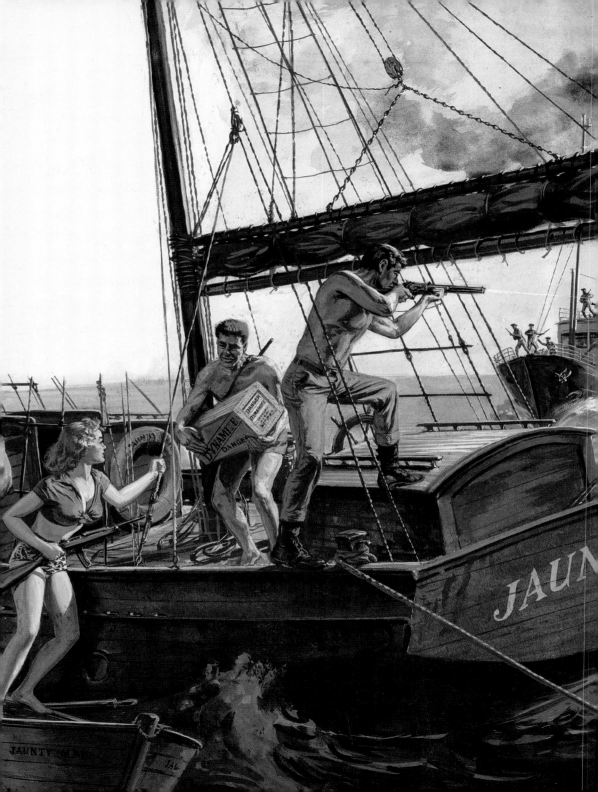

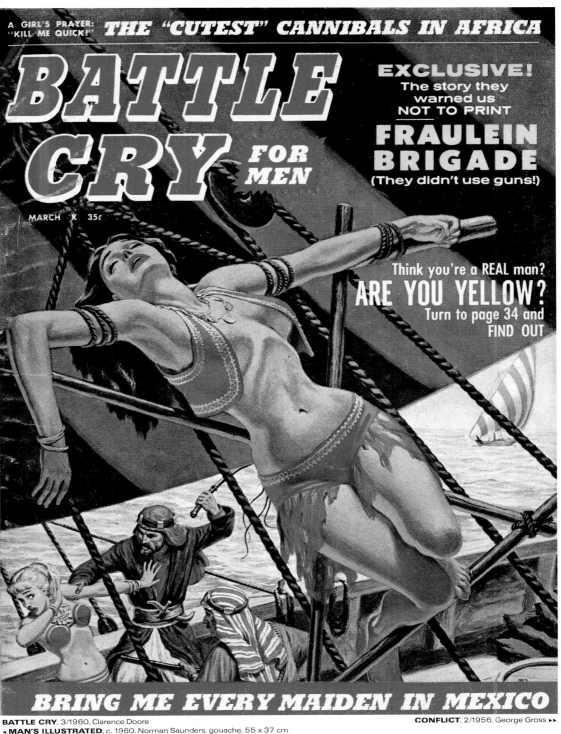

BATTLE CRY, 3/1960, Clarence Doore
◄ MAN'S ILLUSTRATED, c. 1960, Norman Saunders, gouache, 55 x 37 cm

CONFLICT, 2/1956. George Gross ▸▸

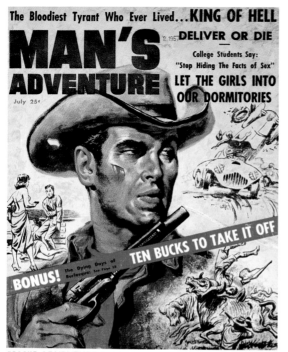

MAN'S ADVENTURE, 7/1957, Clarence Doore

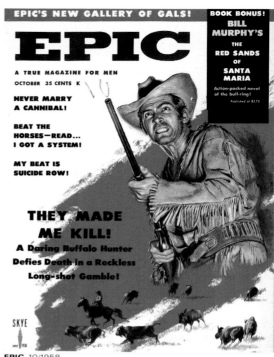

EPIC, 10/1958

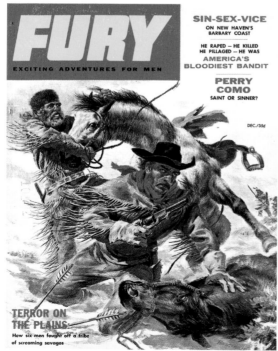

FURY, 12/1957, Tom Beecham

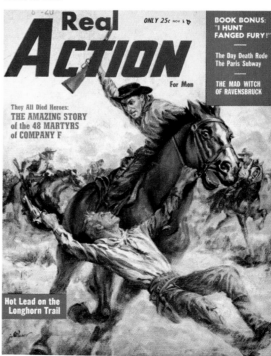

REAL ACTION, 11/1957

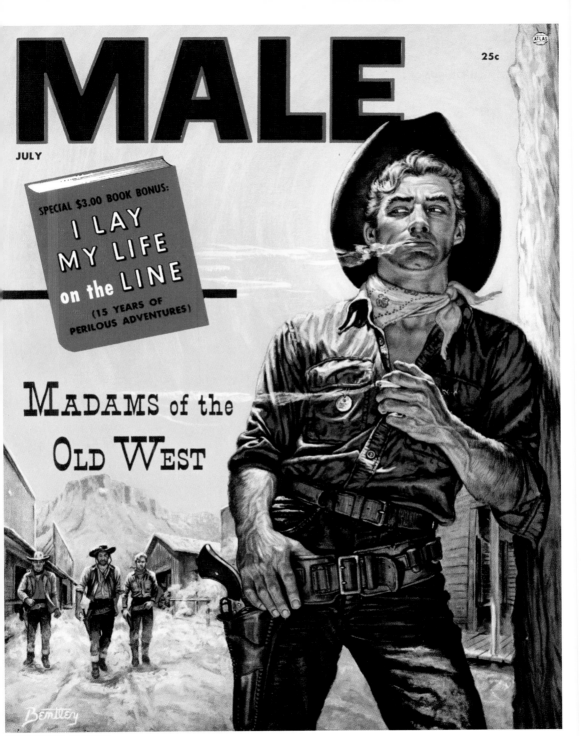

MALE, 7/1955, Jim Bentley

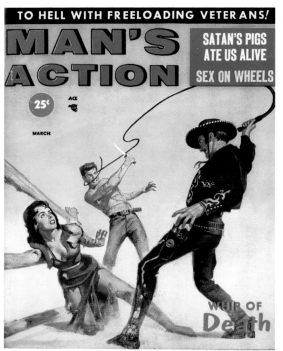

MAN'S ACTION, 3/1958

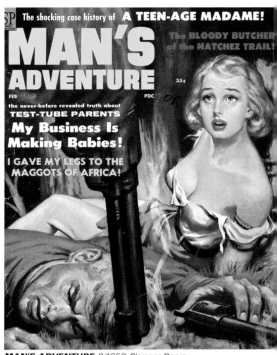

MAN'S ADVENTURE, 2/1959, Clarence Doore

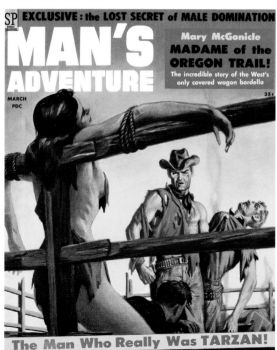

MAN'S ADVENTURE, 3/1959, Clarence Doore

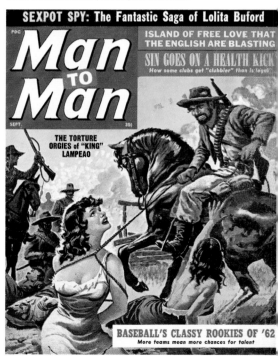

MAN TO MAN, 9/1962, Leo Morey
MAN'S LIFE, 1/1960, Will Hulsey ▶

CITY OF BANNED BOOKS
OPEN SIN — BOSTON, MASS.

BLOW *THE TROOP TRAIN*
BRIDGE TO HELL!

man's
Life

JANUARY
IND.

25¢

TERROR OF THE
ALL GIRL POSSE AND
THEIR NECKTIE PARTIES

EXCLUSIVE! The LUSTS and LOVES of PERON

REAL MEN

THE DAY THEY DROP THE BOMB
—
Confession of a Paid Killer

PDC

MARCH 25¢

REAL MEN, 3/1956, Milton Luros

SAVAGE, 3/1959, Louis Sher

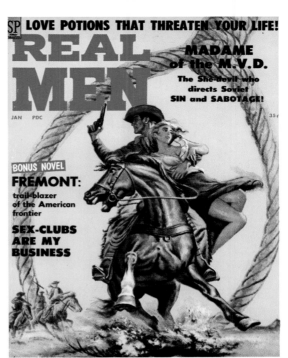

REAL MEN, 1/1959, Vic Prezio

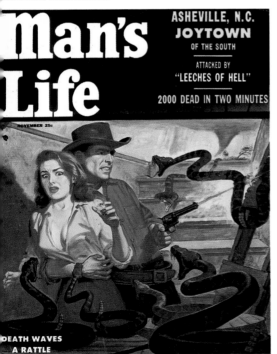

MAN'S LIFE, 11/1956, Will Hulsey

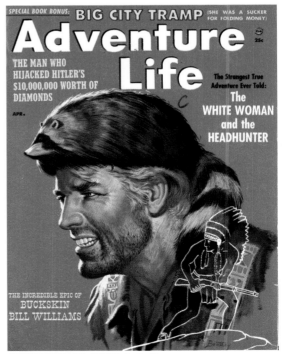

ADVENTURE LIFE, 4/1957, Jim Bentley
publication unknown, c. 1960, Samson Pollen, oil, 59 x 54 cm ▶▶

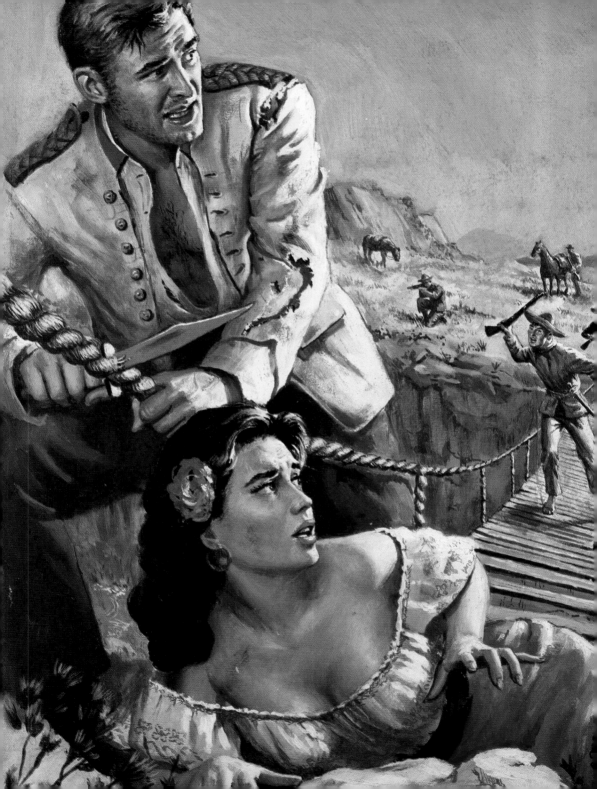

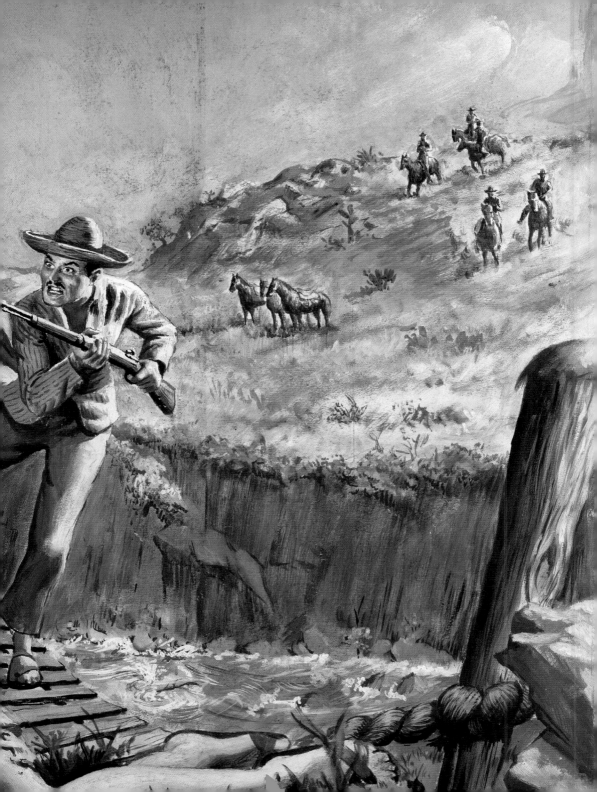

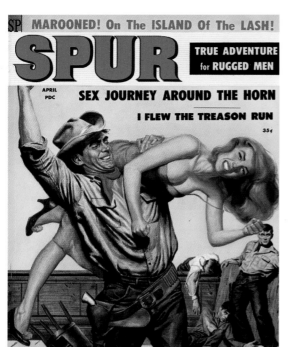

SPUR, 4/1959, Vic Prezio

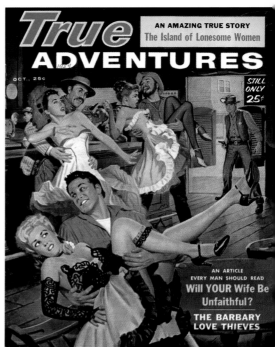

TRUE ADVENTURES, 10/1959, Joe Little

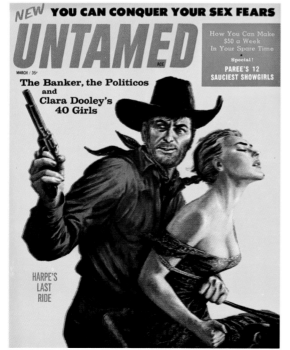

UNTAMED, 3/1960, Ed Emsh

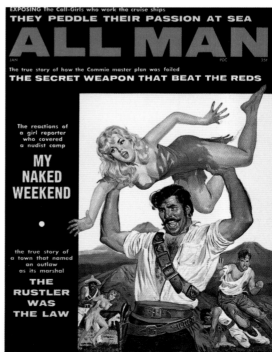

ALL MAN, 1/1961, Rafael DeSoto
MAN'S CONQUEST, 3/1957, Leo Ramon Summers, oil, 66 x 56 cm ▶

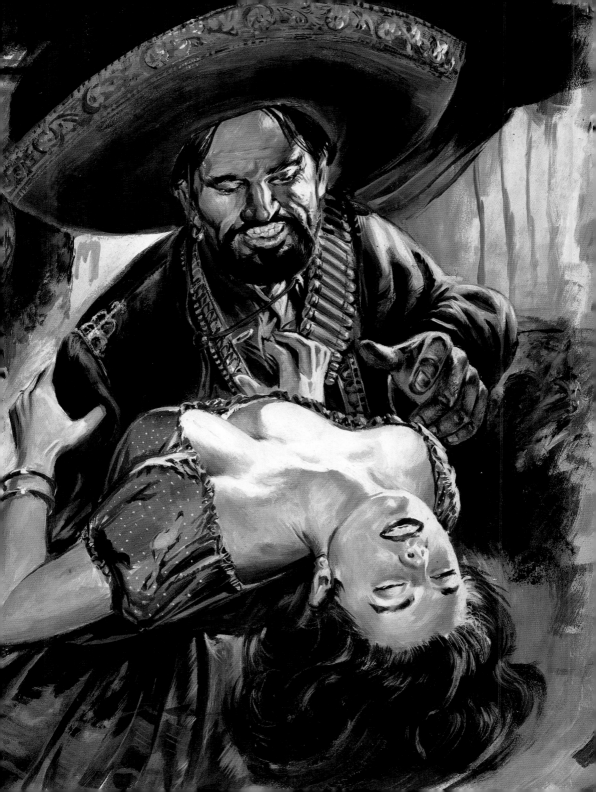

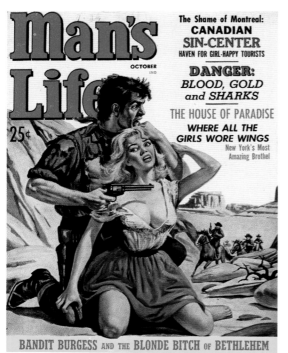

MAN'S LIFE, 10/1959

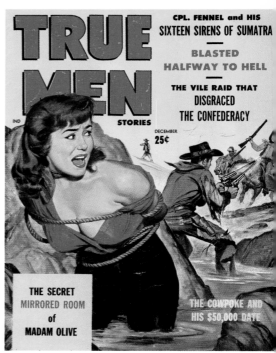

TRUE MEN STORIES, 12/1958, Will Hulsey

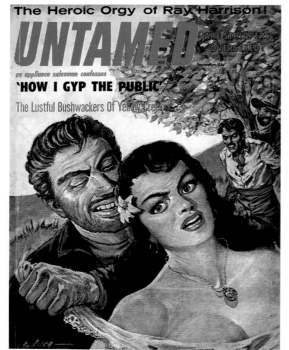

UNTAMED, 9/1959, Leo Morey

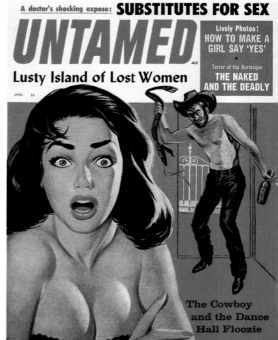

UNTAMED, 4/1959, Armand Weston
MAN'S LIFE, 5/1960, Will Hulsey ▶

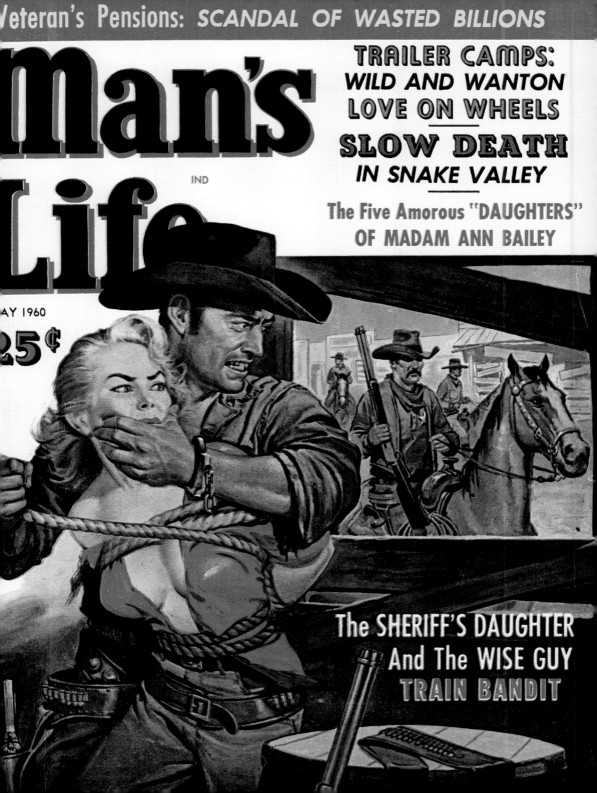

Man's Life

IND

MAY 1960

25¢

TRAILER CAMPS:
WILD AND WANTON
LOVE ON WHEELS

SLOW DEATH
IN SNAKE VALLEY

The Five Amorous "DAUGHTERS"
OF MADAM ANN BAILEY

The SHERIFF'S DAUGHTER
And The WISE GUY
TRAIN BANDIT

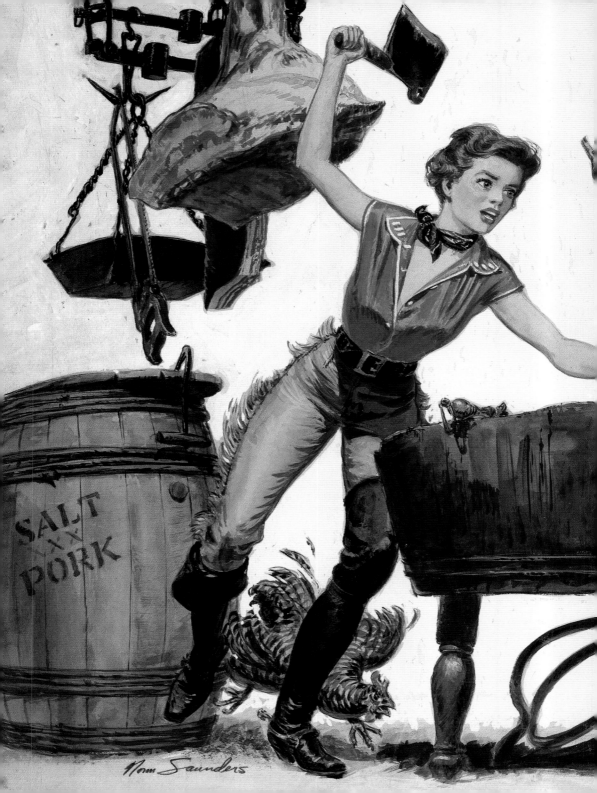

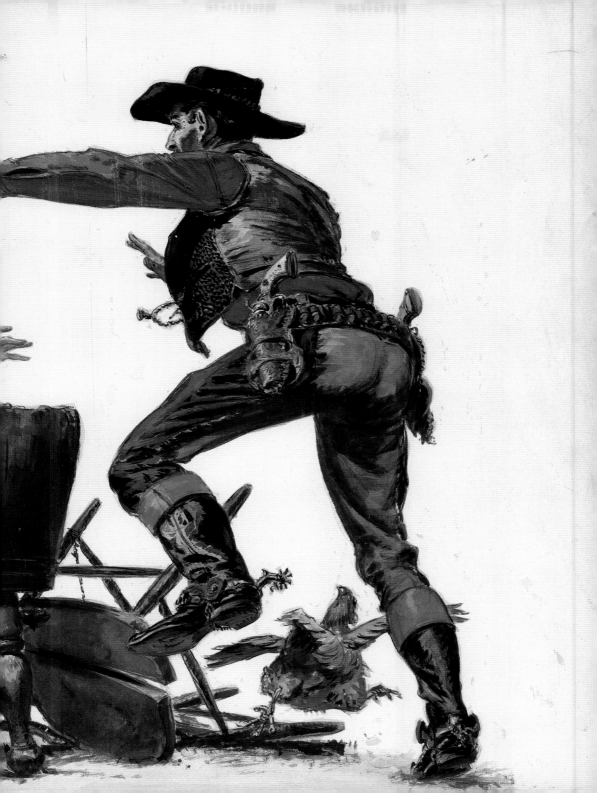

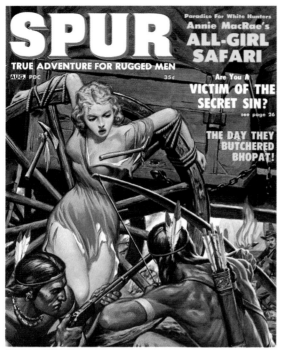

SPUR, 8/1959, Clarence Doore

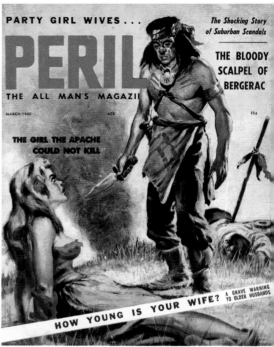

PERIL, 3/1960

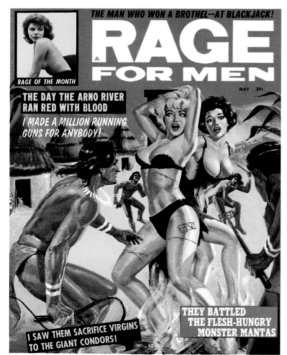

RAGE FOR MEN, 5/1963
◄◄ REAL FOR MEN, 11/1955, Norman Saunders, gouache, 79 x 51 cm

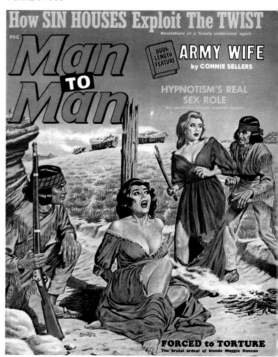

MAN TO MAN, 8/1962, Syd Shores

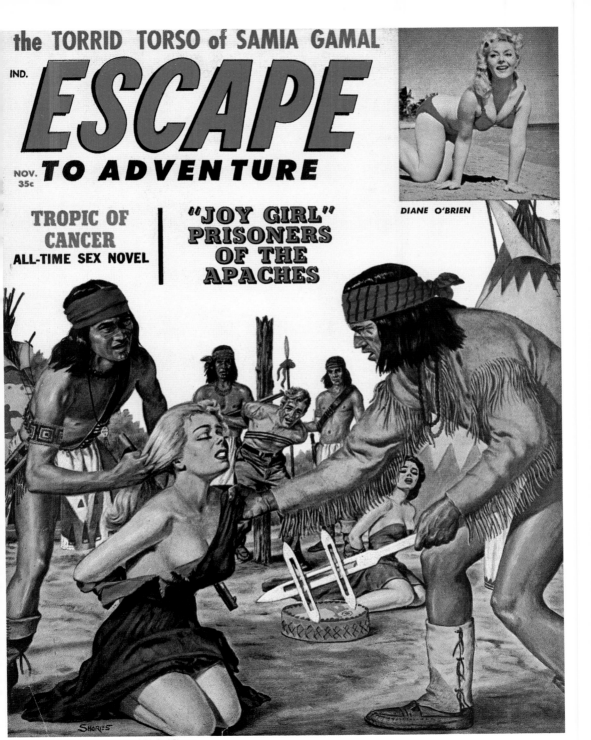

the TORRID TORSO of SAMIA GAMAL

IND.

ESCAPE

NOV.
35c

TO ADVENTURE

DIANE O'BRIEN

TROPIC OF CANCER
ALL-TIME SEX NOVEL

"JOY GIRL" PRISONERS OF THE APACHES

SHORES

ESCAPE TO ADVENTURE, 11/1961, Syd Shores

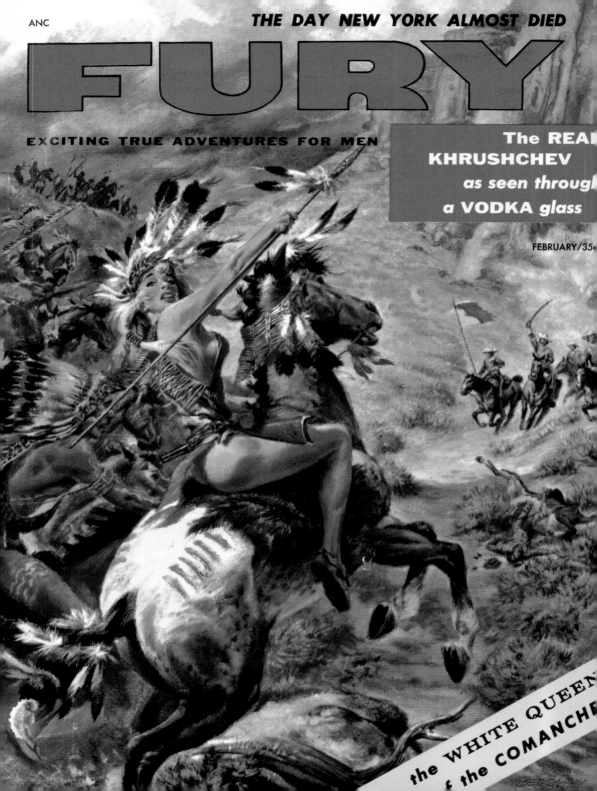

THE DAY NEW YORK ALMOST DIED

FURY

EXCITING TRUE ADVENTURES FOR MEN

The REAl
KHRUSHCHEV
as seen through
a VODKA glass

FEBRUARY/35¢

the WHITE QUEEN
f the COMANCHE

REAL LIFE ADVENTURES, 12/1957

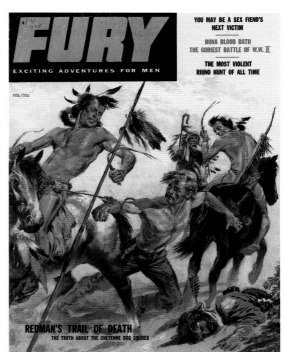

FURY, 2/1958, Tom Beecham

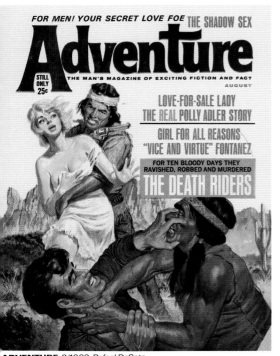

ADVENTURE, 8/1963, Rafael DeSoto
◄ **FURY**, 2/1957, Tom Beecham

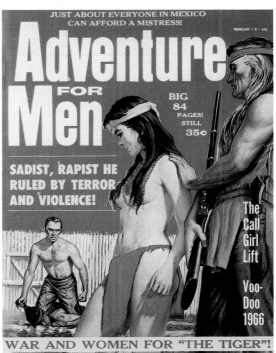

ADVENTURE FOR MEN, 2/1967, H. W. Johnson

CHAPTER 3

I WATCHED THE FIRE DANCE OF HUMAN SACRIFICE

THE NATIVES WERE GETTING RESTLESS

Exotic locales required men's adventure magazines to interpret the cultures of other peoples in their uniquely sweaty, all-American way, which held to a nineteenth-century, colonial ideal. Not surprisingly, this involved the most outrageous and offensive stereotypes imaginable: in the magazines' world, the inhabitants of these far-off lands were likely to be bloodthirsty savages with an unquenchable yen for white women. Cover paintings portrayed native men as dark with "Negro" features, while native women almost invariably appeared as Caucasians with Coppertone® tans. Especially where non-Caucasian cultures were concerned, the exaggerated racial prejudices common in the sweats – and in the America of half a century ago – are unimaginable by today's standards.

Tahitians and Polynesians fared better than most ethnic groups. Anthropologist Margaret Mead's ethnographic study *Coming of Age in Samoa* had depicted island natives as having freer sex lives than Americans, and Hollywood sarong epics of the thirties had portrayed a cuddly, sensual stereotype of innocent pagans. Thus, the sweats published stories of American soldiers or explorers stranded on islands rife with sexually liberated Polynesian women without the usual mayhem – witness "The Island Paradise of Sgt. Hart," "The Island of Lonesome Girls," and "Pete Kelly's Native Mistress." Other stories dealt with the darker side of island life: headhunters, attempts to separate island women from their white lovers, and oversexed island girls who required bizarre seduction rituals before doing the horizontal hula.

South Sea Stories devoted itself exclusively to adventures set on the islands, remaining in print for several years. Was the magazine created due to the popularity of such stories, or as an opportunity to run topless photos of young, "native" women? Whatever the case, few of the females pictured were from any island, except perhaps New York's Staten Island. They were usually ethnic strippers with exotic-sounding stage names.

Surprisingly, African-Americans – ordinarily the subject of the most extreme, negative, racial stereotyping in American popular culture – were little seen in the sweats. This might have resulted from the increased activity of the civil rights movement in America in the fifties and sixties. With the exception of the occasional story about boxer Joe Louis, the men's adventure field depicted few African-Americans, although Africans were a completely different matter. Cannibalism was a favorite subject, with articles on African (or island) tribes that ate their enemies being particularly common.

Throughout the fifties, the Mau Mau, a secret, insurgent organization in Kenya, waged a somewhat bloody war against the British colonists. The Brits' careful documentation of these attacks and atrocities meant that scores of free – and very graphic – photos of decapitated bodies, victims with machete wounds, and corpses left in the jungle to rot were made available to the Western media.

Such photos perfectly fulfilled the grisly criteria for he-man magazines, and almost every publication ran Mau Mau stories in the fifties. These yarns complemented standard B-movie-style

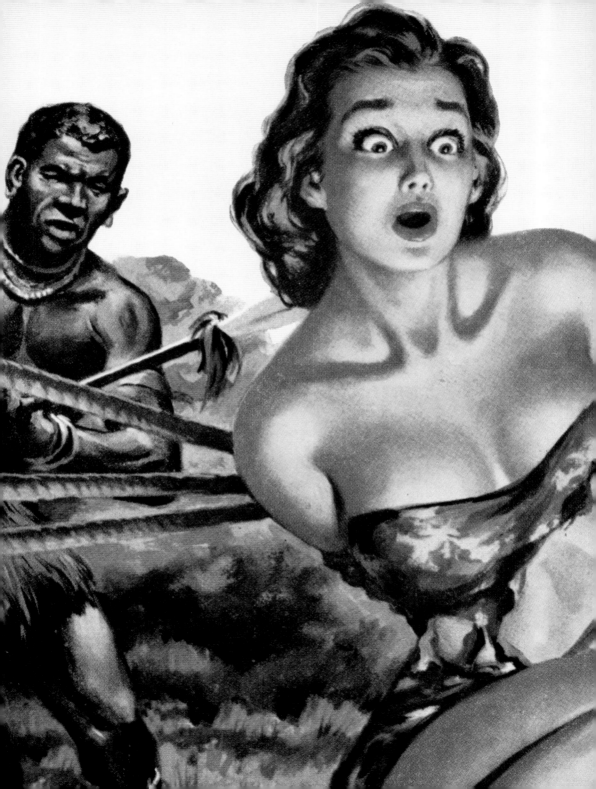

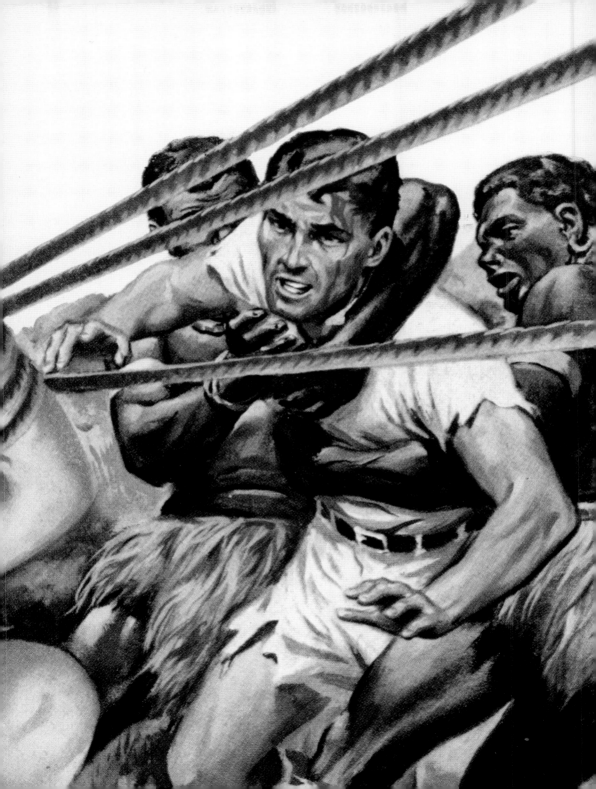

jungle stories of brave white explorers — though, in the men's adventure magazines, such explorers might be beautiful, white women, wearing short shorts and bikini tops, who find themselves tied to skull-topped posts.

Africans also appeared as hunters and guides in the various safari adventure stories, usually in full native dress — very much playing the role of noble savage.

Arabs, on the other hand, were spared any such air of nobility, being largely limited to roles as slave traders and lascivious heads of harems. When they were not kidnapping or buying women to satiate the deviant lusts of sheiks, they were depicted as sexual sadists torturing young women for their own pleasure. While some stories harked back to the French Foreign Legion maintaining order in its own inimitably sadistic way, the more extreme covers were supposedly based on recent events. The B-movie world of the sweats had little, if anything, to do with what was actually happening in the Middle East in the postwar period, however, as countries like Egypt gained their independence and became increasingly modern.

The men's adventure magazines, as late as the early seventies, remained a warped, nostalgic venue for America's most ridiculous, racial stereotyping.

ICH SAH DEN FEUERTANZ DES MENSCHEN-OPFERS. DIE EINGEBORE-NEN WERDEN UNRUHIG

Exotische Schauplätze erforderten die Interpretation fremder Kulturen, was die Abenteuerheftchen für Männer auf eine unnachahmlich verschwitzte, typisch amerikanische Art und Weise taten, die dem kolonialen Ideal des 19. Jahrhunderts verpflichtet war. Dass dieses mit Klischees der unglaublichsten und übelsten Art einherging, kann nicht verwundern: In der Welt der Schundheftchen waren die Bewohner ferner Länder blutrünstige Wilde mit einem unstillbaren Verlangen nach weißen Frauen. Auf den Covern wurden die männlichen Eingeborenen als dunkelhäutig mit „negriden" Zügen dargestellt, während die Eingeborenenfrauen stets wie Weiße mit Coppertone®-Bräune aussahen. Die rassistischen Vorurteile, die in den Sweats — und im Amerika der Fünfzigerjahre — gegen nicht weiße Völker vorherrschten, wären heute unvorstellbar.

Den Bewohnern Tahitis und Polynesiens erging es etwas besser als den meisten an-

MAN'S ACTION, 9/1959, Clarence Doore

deren ethnischen Gruppen. In der ethnografischen Studie *Kindhe* *und Jugend in Samoa* behauptete die Völkerkundlerin Margare Mead, dass die Südsee-Eingeborenen ein ungehemmteres Ge schlechtsleben hätten als die Amerikaner, und die „Sarong-Eper aus dem Hollywood der Dreißiger hatten ebenfalls das kuschelige sinnliche Stereotyp unschuldiger Heiden verbreitet. Aus diese Grund brachten die Abenteuerhefte jede Menge Geschichte amerikanischer Soldaten oder Entdecker, die als Schiffbrüchig auf Inseln gerieten, auf denen es vor sexuell emanzipierten Poly nesierinnen nur so wimmelte; diese Geschichten kamen ohne da übliche Gemetzel aus. Als Beispiele mögen „Das Inselparadies de Sgt. Hart", „Die Insel einsamer Mädchen" und „Pete Kellys Einge borenenfrau" genügen. Andere Geschichten widmeten sich de Schattenseiten des Südseelebens: Kopfjäger, Versuche, die Süd seefrauen von ihren weißen Geliebten zu trennen, und sexhung rige Mädels, die bizarre Verführungsrituale verlangten, bevor si zum horizontalen Hula übergingen.

South Sea Stories widmete sich ausschließlich Südseeaben teuern und erschien mehrere Jahre lang. O die Zeitschrift aufgrund der Beliebthe dieser Geschichten entstand oder ma nur die Gelegenheit ausnutzen wollte Bilder junger „Eingeborenenfrauen oben ohne zu zeigen, weiß man nich Jedenfalls stammten nur wenige de abgebildeten Frauen von irgendeiner Inse außer vielleicht von Staten Island in Nev York. Für gewöhnlich waren es braunhäutige Stripteasetänzerinnen mit exotisch klingende Künstlernamen.

Überraschenderweise tauchten Afroamerika ner — die in der sonstigen amerikanische Populärkultur Gegenstand der negativsten und am stärksten rassistischen Darstellung ware — in den Sweats nur selten auf. Dies wa vielleicht das Ergebnis der verstärkten Akti vitäten der amerikanischen Bürgerrechts bewegung in den Fünfziger- und Sechzige jahren. Abgesehen von vereinzelten Berichte über den Boxer Joe Louis wurden in den Män nerabenteuern nur wenige Afroamerikaner por trätiert. Bei Afrikanern sah die Sache allerdings völ lig anders aus. Kannibalismus war ein beliebte Thema und insbesondere Artikel über afrikani sche (oder polynesische) Stämme, die ihre Feinde auffraßen, tauchten immer wieder auf.

In den Fünfzigerjahren führten die Mau Mau, eine geheimbündlerische Befreiungsbe wegung in Kenia, einen recht blutigen Krieg gegen die britischen Kolonialherren. Die genaue Dokumentation ihrer Grausamkei ten durch die Briten bedeutete, dass der westlichen Medien große Mengen kos tenloser — und äußerst blutrünstiger Fotos von enthaupteten Leichnamen Verletzten mit Machetenwunder und im Dschungel verrottender Toten zur Verfügung standen.

Diese Fotos erfüllten die Kri terien für einen Beitrag in der

SOUTH SEA STORIES, c. 1960 Mark Schneider, mixed media 44 x 51 cm ▶

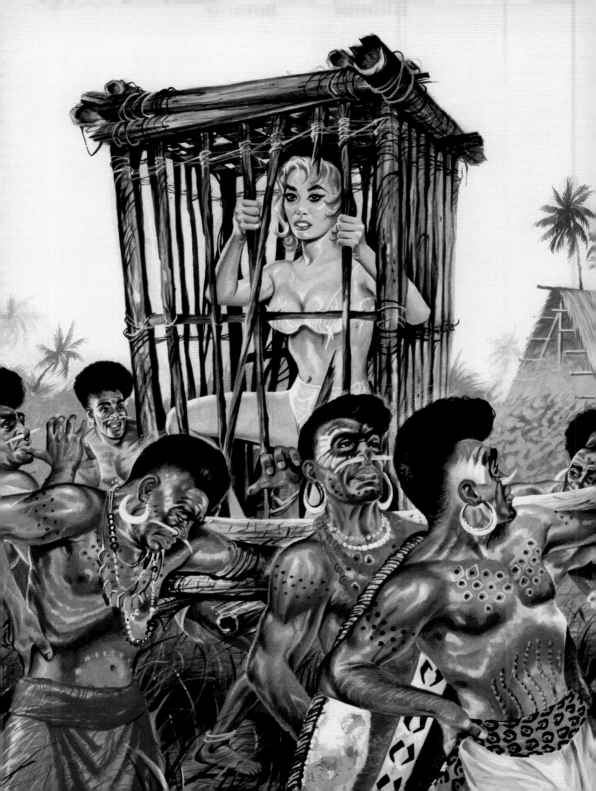

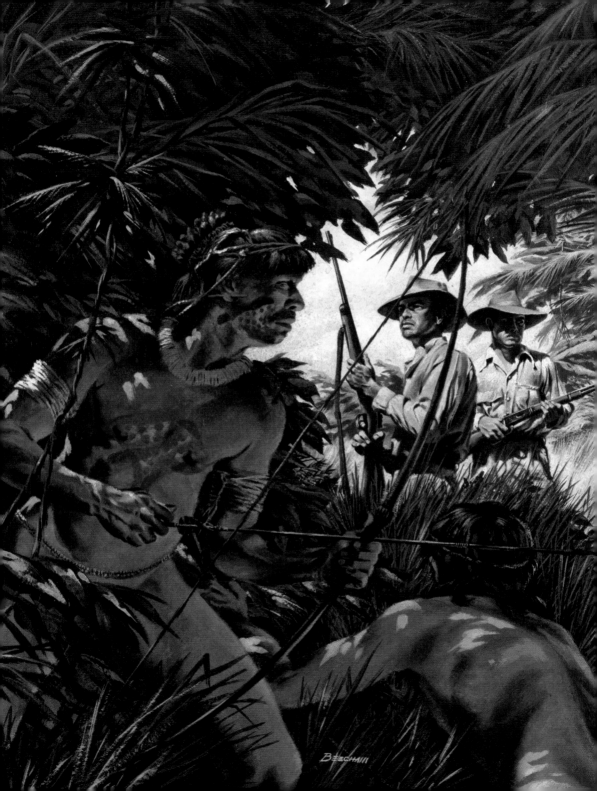

Machomänner-Magazinen auf geradezu perfekte Art und Weise und in den Fünfzigern waren in fast allen Serien Mau-Mau-Storys zu finden. Diese Schaudergeschichten stellten eine hervorragende Ergänzung für die gewohnten, an B-Filme erinnernde Urwaldabenteuer furchtloser weißer Entdecker dar – auch wenn diese Entdecker in den Abenteuerheftchen oft schöne weiße Frauen in Shorts und Bikinioberteilen waren, die festgebunden an einem schädelgekrönten Pfahl endeten. Davon abgesehen traten Afrikaner auch als Jäger und Führer in Safarigeschichten auf, wo sie meist in vollen Eingeborenenregalia die Rolle des edlen Wilden spielten.

Araber hingegen wurden nie als solch noble Mienen dargestellt, sondern blieben ganz auf die Rolle als Sklavenhändler und Haremsvorstände beschränkt. Wenn sie gerade nicht damit beschäftigt waren, Frauen zur Befriedigung der perversen Gelüste ihres Scheichs zu kaufen oder zu entführen, quälten sie junge Frauen zu ihrem eigenen Vergnügen auf sexuell sadistische Weise. Während manche dieser Storys auf die französische Fremdenlegion zurückgingen, die unnachahmlich sadistisch für Ruhe und Ordnung gesorgt hatte, stützten sich die extremsten Schlagzeilen angeblich auf jüngere Ereignisse. Die B-Film-Welt der Sweats hatte jedoch wenig oder nichts mit den tatsächlichen Ereignissen im Nahen Osten der Nachkriegszeit zu tun, als Länder wie Ägypten unabhängig wurden und eine starke Modernisierung erlebten.

Die Abenteuerheftchen für Männer blieben bis in die Siebzigerjahre ein verquerer, nostalgischer Tummelplatz für die absurdesten rassistischen Vorurteile Amerikas.

J'AI ASSISTE A LA DANSE SACREE DU SACRIFICE HUMAIN. PAS UN INSTANT DE REPIT POUR LES AUTOCHTONES

La fascination de l'exotique suppose que les magazines d'aventures pour hommes interprètent les cultures des autres peuples. Ils révèlent un regard d'une naïveté et d'un chauvinisme insignes, héritier d'une vision du monde coloniale remontant au XIXᵉ siècle. Comme on peut s'y attendre, cette interprétation véhicule des stéréotypes aussi agressifs qu'outranciers : dans le monde des magazines, les habitants de ces contrées éloignées sont en général des sauvages assoiffés de sang et irrésistiblement attirés par les femmes blanches. Les illustrations de couvertures montrent des « indigènes » au teint foncé et aux traits négroïdes, alors que les femmes sont presque toujours de type caucasien et de teint Coppertone®. Dès qu'il s'agit de présenter des cultures non-caucasiennes, l'outrance des préjugés raciaux courants dans l'univers des pulps – et dans l'Amérique d'il y a cinquante ans – atteint des sommets inimaginables aujourd'hui.

Les Tahitiens et les Polynésiens s'en sortent mieux que la plupart des groupes ethniques. Dans Adolescence à Samoa (1928, l'anthropologue Margaret Mead avait décrit les indigènes des îles comme ayant une vie sexuelle plus libre que les Américains, et les films hollywoodiens à grand spectacle des années trente avaient popularisé le stéréotype du personnage païen et innocent, tendre et sensuel. C'est pourquoi quand les pulps proposent des histoires de soldats ou d'explorateurs américains en rade sur une île polynésienne, ils dépeignent des myriades de femmes sexuellement libérées, sans les scènes de violence habituelles – témoin « l'Île

paradisiaque du Sergent Hart », « l'Île des filles solitaires », ou « la Maîtresse indigène de Pete Kelly ». D'autres histoires révèlent en revanche les aspects inquiétants de la vie des insulaires : chasseurs de têtes, tentatives de séparer les femmes indigènes de leurs amants blancs, femmes des îles obsédées de sexe accomplissant, avant de se livrer à la bagatelle, d'étranges rituels de séduction.

Le succès de South Sea Stories, exclusivement voué aux récits se déroulant sur lesdites îles dura plusieurs années. Est-ce la popularité du genre qui entraîna sa création ou permettait-il surtout de montrer des photos de jeunes femmes « indigènes » aux seins nus ? Quoi qu'il en soit, les femmes qui y étaient représentées étaient rarement des insulaires, à l'exception de celles demeurant à Staten Island, banlieue de New York. Il s'agissait en général de strip-teaseuses de cabaret aux pseudonymes résolument exotiques.

Bizarrement, les pulps mettaient rarement en scène des Afro-américains, pourtant victimes habituelles de stéréotypes raciaux d'une extrême violence dans la culture populaire américaine. Peut-être faut-il y voir le résultat de l'activisme du mouvement pour les droits civiques américain dans les années cinquante et soixante. A l'exception de l'histoire atypique du boxeur Joe Louis, les magazines d'aventures pour hommes montraient peu d'afro-américains. Les Africains étaient montrés sous un jour beaucoup moins favorable : le cannibalisme, en particulier était un des sujets favoris de ces magazines et les récits de tribus africaines, insulaires ou non, dévorant leurs ennemis n'étaient pas rares.

Dans les années cinquante, la Mau Mau, une organisation secrète de rebelles kenyans, déclencha contre les coloniaux anglais une campagne d'une grande férocité. La documentation détaillée recueillie par les autorités britanniques sur les attaques et les atrocités des Mau Mau draina vers les médias occidentaux une quantité impressionnante de photos très expressives de corps décapités, de victimes de blessures à la machette et autres cadavres à demi décomposés abandonnés dans la jungle.

De tels clichés correspondaient aux critères grand-guignolesques des magazines pour hommes et presque tous les numéros de ces magazines présentaient, dans les années cinquante, des histoires de Mau Mau. Ces feuilletons complétaient les histoires de série B d'explorateurs blancs perdus dans la jungle, bien que dans les magazines d'aventures pour hommes de tels explorateurs prissent souvent les traits de belles femmes blanches en shorts courts et bikinis attachées à un poteau de torture. Dans divers récits de safaris, les Africains incarnent des personnages de chasseurs et de guides, dans la tenue de rigueur de l'indigène, la variante positive du sauvage plein de noblesse.

Les Arabes n'avaient pas droit à ce traitement avantageux : on les cantonnait à des rôles de marchands d'esclaves et d'intendants lascifs régnant sur de vastes harems. Quand ils ne kidnappaient ni n'achetaient de femmes pour assouvir les désirs pervers de leur cheik, ils étaient présentés comme des sadiques torturant de jeunes femmes pour leur plaisir. D'autres histoires mettent en scène des soldats de la légion étrangère maintenant l'ordre avec leur brutalité et leur cruauté légendaires. Mais les couvertures les plus violentes s'inspiraient soi-disant d'événements récents ; le monde de série B des pulps à sensation n'avait rien à voir avec l'histoire du Proche Orient de l'après-guerre où des pays comme l'Egypte accédaient à l'indépendance et se modernisaient.

Les magazines d'aventures pour hommes, restèrent jusque dans les années soixante-dix, le porte-voix nostalgique et nauséabond des stéréotypes raciaux les plus éhontés de l'Amérique.

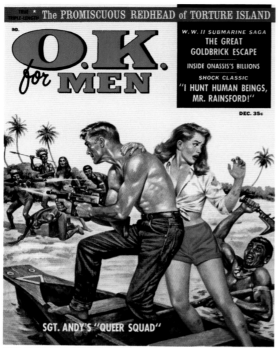

O.K. FOR MEN, 12/1958, Lou Marchetti

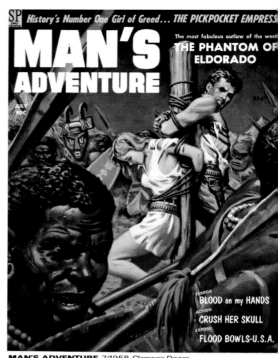

MAN'S ADVENTURE, 7/1958, Clarence Doore

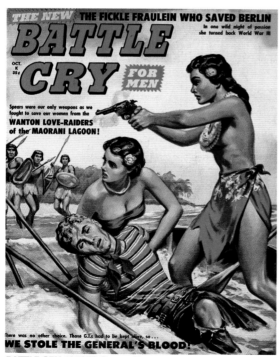

BATTLE CRY, 10/1959, Clarence Doore

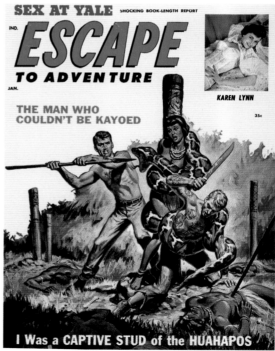

ESCAPE TO ADVENTURE, 1/1961, Clarence Doore

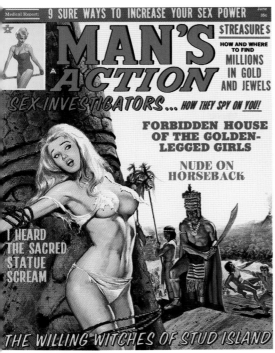

MAN'S ACTION, 6/1969, John Duillo

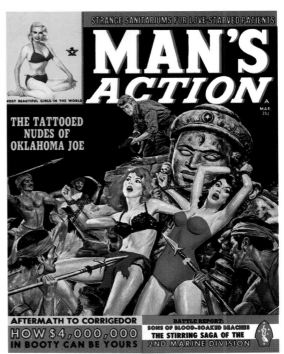

MAN'S ACTION, 3/1963, Norm Eastman

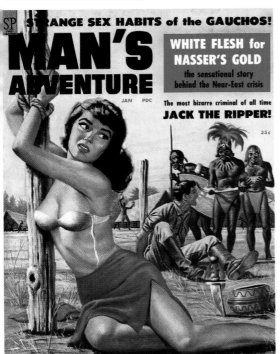

MAN'S ADVENTURE, 1/1959, Vic Prezio

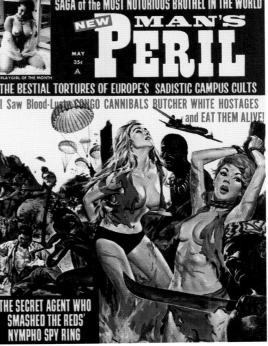

MAN'S PERIL, 5/1965, Norm Eastman
ESCAPE TO ADVENTURE, 1/1960, Vic Donahue ▶▶

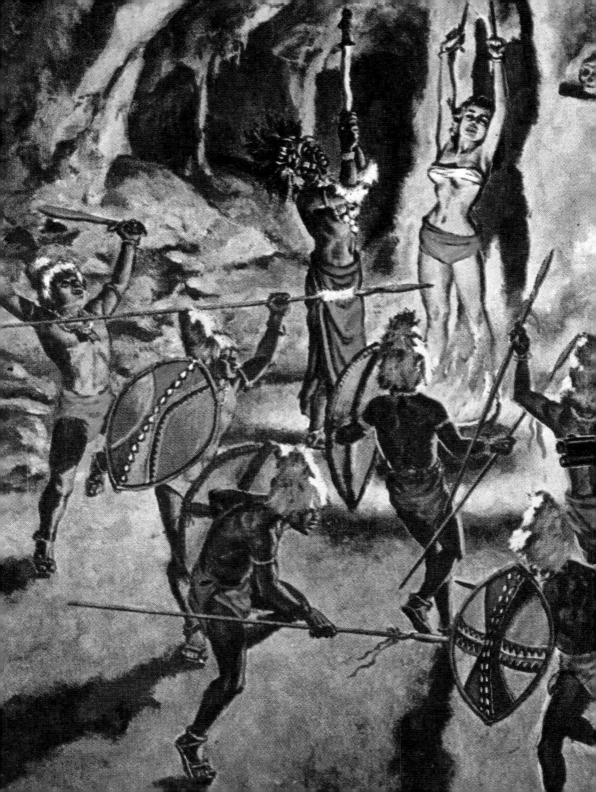

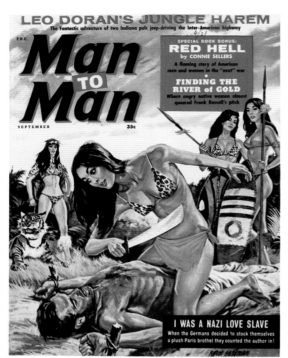

MAN TO MAN, 9/1960, Norm Eastman

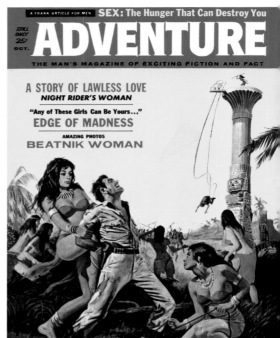

ADVENTURE, 10/1960, George Eisenberg

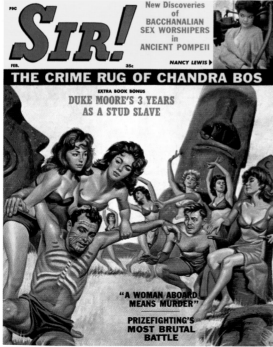

SIR!, 2/1961

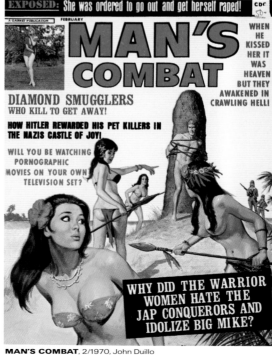

MAN'S COMBAT, 2/1970, John Duillo
TRUE ADVENTURES, 6/1961, Norm Eastman ▶

True ADVENTURES

STILL
ONLY
25¢

THE LURE THAT CAN
DESTROY YOU
**ROADSIDE
SEX TRAPS**

An Amazing True Story
**NATAL'S
GIRL MAD
MONSTER**

HAVE WE LOST THE RACE FOR SPACE?
**THE REDS' NEXT CONQUEST—
THE MOON?**

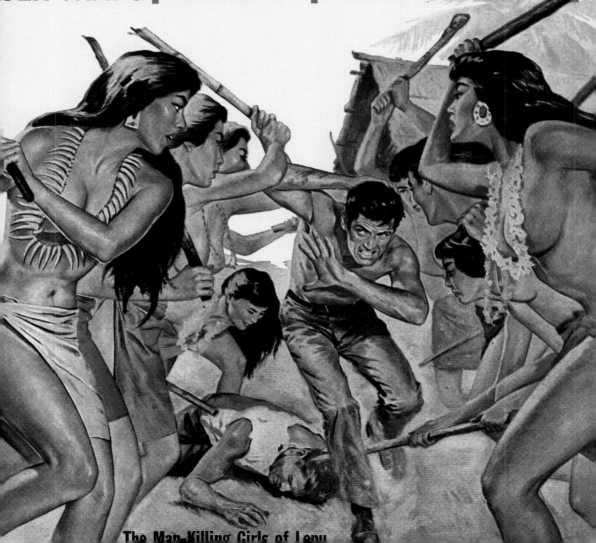

The Man-Killing Girls of Lenu

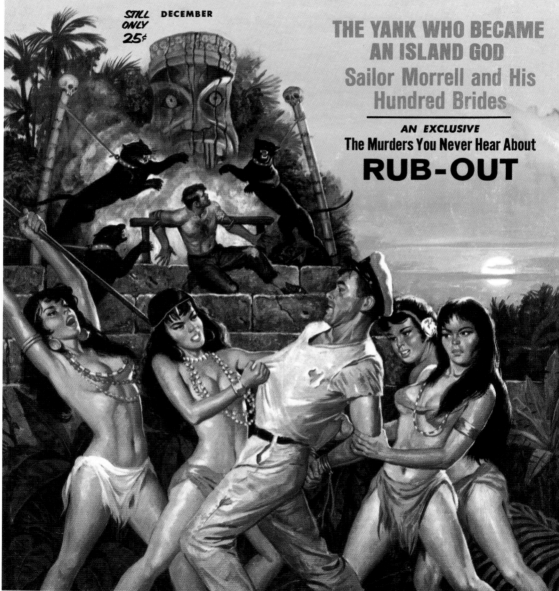

ADVENTURE, 12/1961, Rafael DeSoto

ALL MAN, 5/1959, Clarence Doore ▶

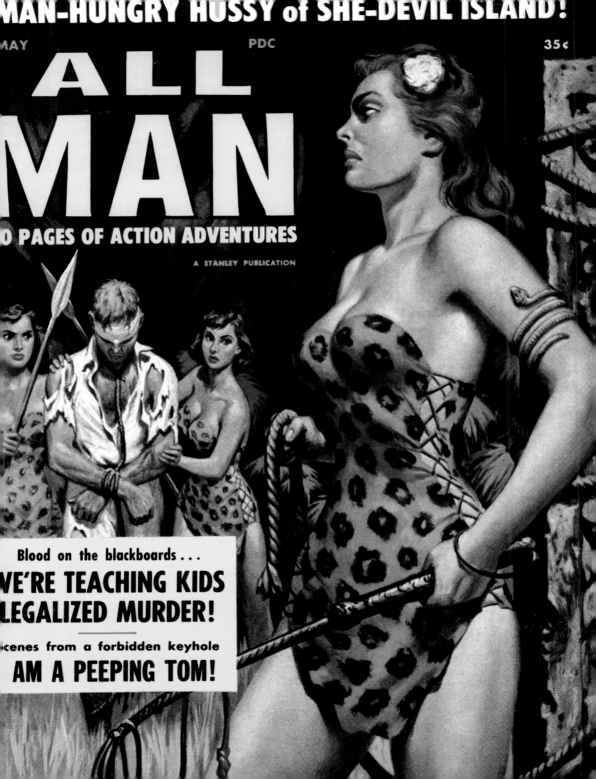

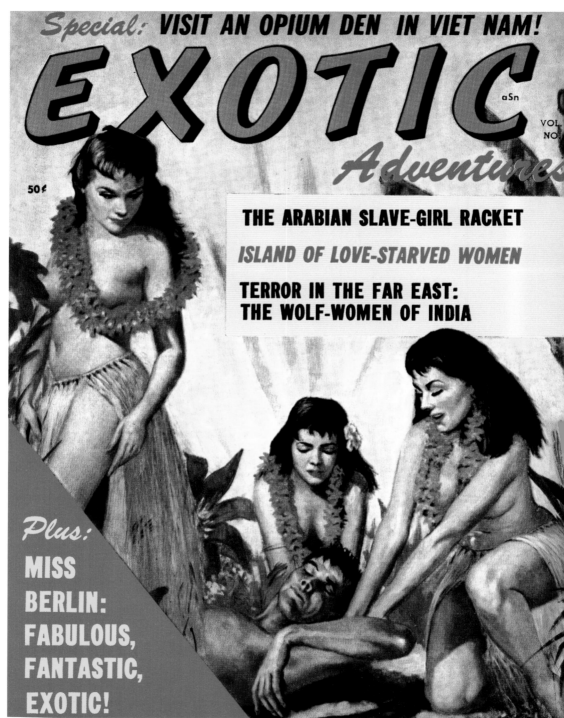

Special: **VISIT AN OPIUM DEN IN VIET NAM!**

EXOTIC
aSn

VOL.
NO.

Adventures

50¢

THE ARABIAN SLAVE-GIRL RACKET

ISLAND OF LOVE-STARVED WOMEN

**TERROR IN THE FAR EAST:
THE WOLF-WOMEN OF INDIA**

Plus:
**MISS
BERLIN:
FABULOUS,
FANTASTIC,
EXOTIC!**

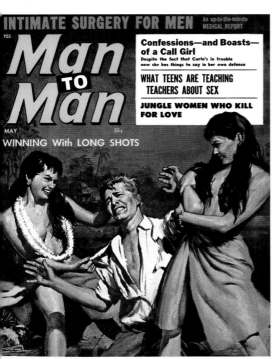

MAN TO MAN, 5/1963

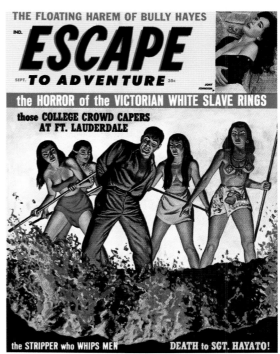

ESCAPE TO ADVENTURE, 9/1961

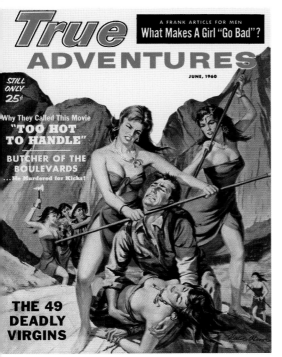

TRUE ADVENTURES, 6/1960, Victor Olson

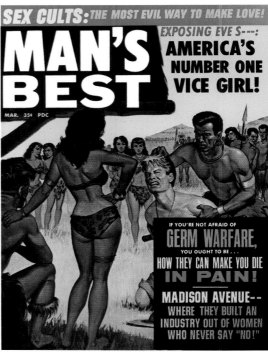

MAN'S BEST, 3/1967
TRUE MEN'S STORIES, 11/1962, Earl Norem, gouache, 58 x 27 cm ▶▶

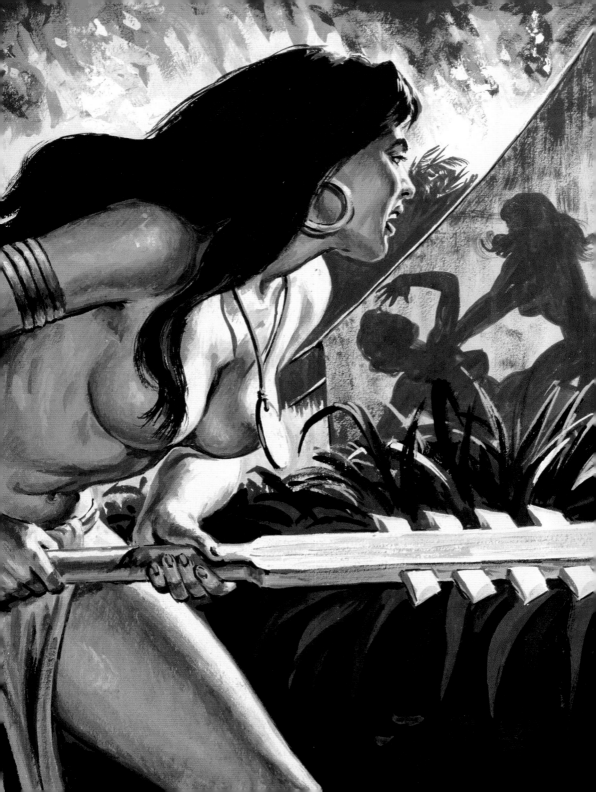

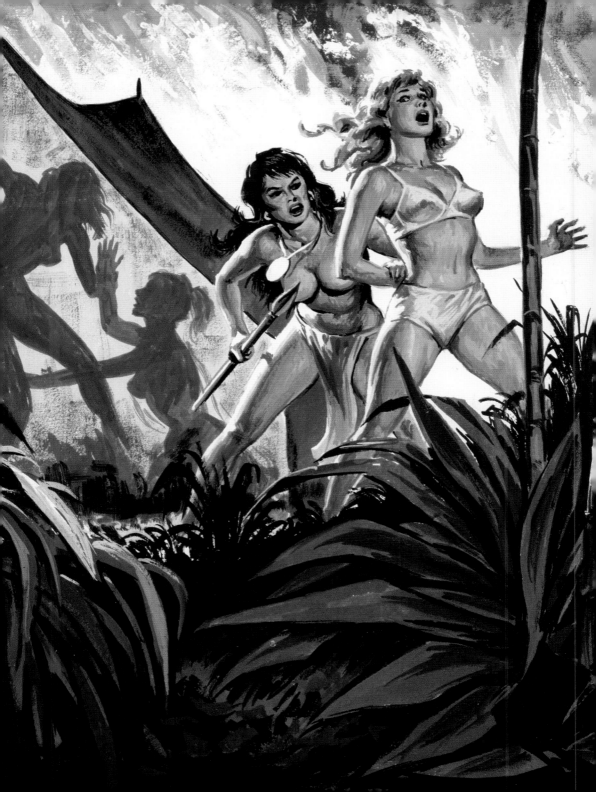

MARTIN O'HARE'S HOUSE
OF FORBIDDEN WOMEN
in the "Valley of Paradise" fifty tortured
females found a living hell!

MURDER IS MY JOB!
a guard at a South African leper colony
tells the world's most horrifying story

SEPT. PDC 35¢

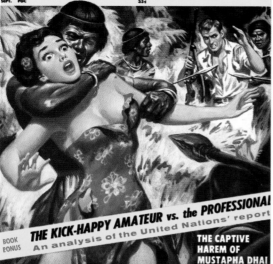

BOOK
BONUS
THE KICK-HAPPY AMATEUR vs. the PROFESSIONAL
An analysis of the United Nations' report

THE CAPTIVE
HAREM OF
MUSTAPHA DHAI

MAN'S ADVENTURE, 9/1959, Clarence Doore

NYMPHO QUEENS WHO RULE THE DREADED MAFIA

MAN'S PERIL

PLAYGIRL of the MONTH

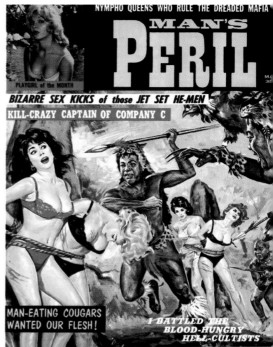

BIZARRE SEX KICKS of those JET SET HE-MEN

KILL-CRAZY CAPTAIN OF COMPANY C

MAN-EATING COUGARS
WANTED OUR FLESH!

I BATTLED THE
BLOOD-HUNGRY
HELL-CULTISTS

MAN'S PERIL, 5/1963, Norm Eastman

PDC

Man
TO
Man

CONDENSED BEST SELLER

THE TORTURE
of HENRI ALLEG
The most frightening true story of brutality ever printed
— first published as "The Question" — see page 16

$100 A NIGHT VICE DEN
The great — even royalty — were counted
among the customers at Minna's "house"

OCT. 35¢

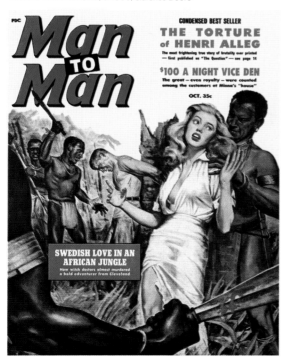

SWEDISH LOVE IN AN
AFRICAN JUNGLE
How witch doctors almost murdered
a bold adventurer from Cleveland

MAN TO MAN, 10/1959

WHY THEY BANNED SEX AT THE WORLD'S FAIR

ESCAPE

JULY
35¢ TO ADVENTURE

THE "MAN BURNERS" OF THE PLAINS

SEX DRUGS:
AMERICA'S SECRET
MULTI-MILLION
DOLLAR BUSINESS

BOOK REVIEW

SHOCK
BOOK
of the
YEAR

"THE
GRAPEVINE"
RIPS THE LID OFF
HOLLYWOOD
LESBIANS

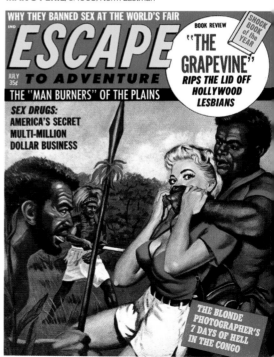

THE BLONDE
PHOTOGRAPHER'S
7 DAYS OF HELL
IN THE CONGO

ESCAPE TO ADVENTURE, 7/1964

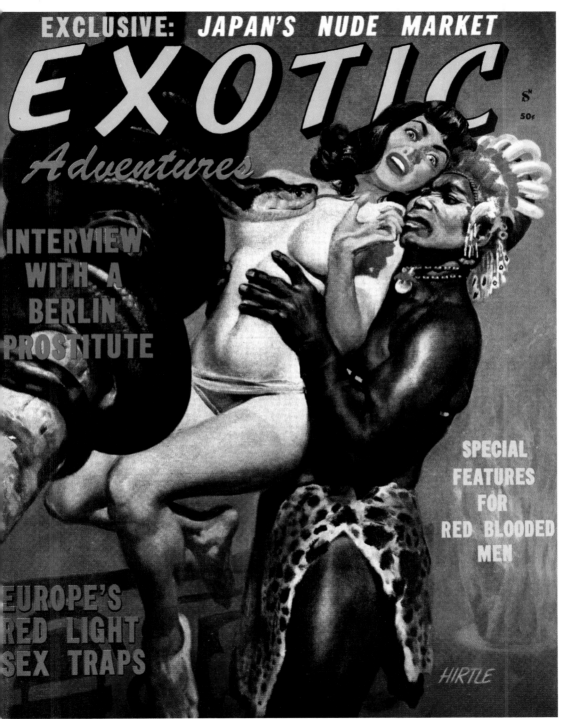

EXCLUSIVE: JAPAN'S NUDE MARKET

EXOTIC
Adventures

$^{S^N}$
50¢

INTERVIEW
WITH A
BERLIN
PROSTITUTE

SPECIAL
FEATURES
FOR
RED BLOODED
MEN

EUROPE'S
RED LIGHT
SEX TRAPS

HIRTLE

EXOTIC ADVENTURES, Vol. 1, No. 2/c. 1958, Hugh Hirtle **ESCAPE TO ADVENTURE**, 11/1958, Clarence Doore ▶▶

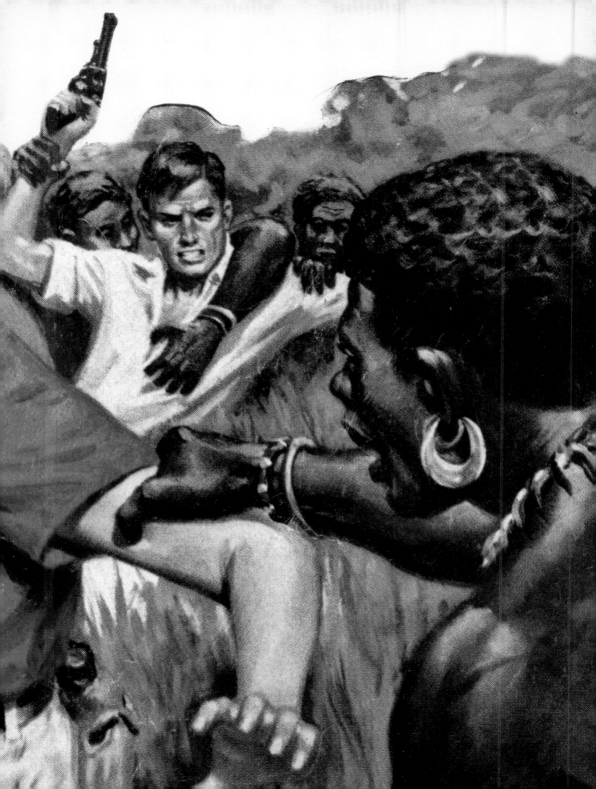

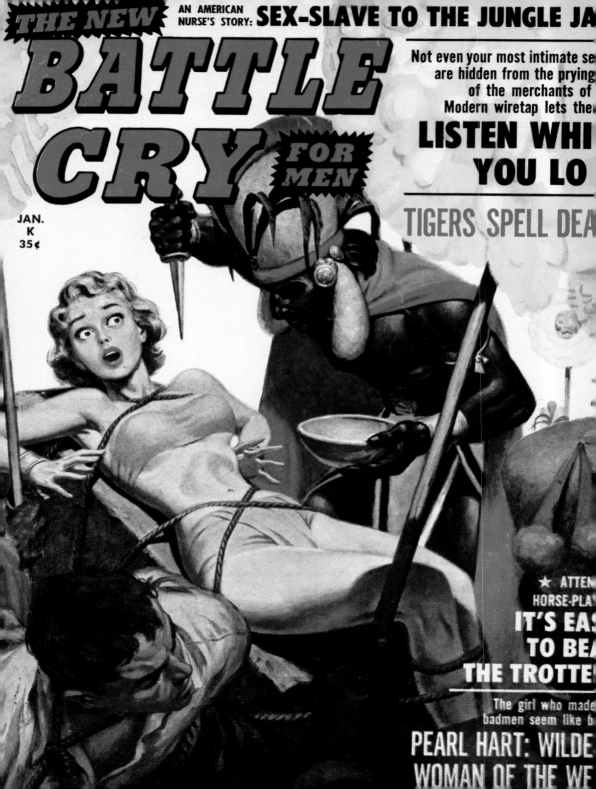

AN AMERICAN NURSE'S STORY: **SEX-SLAVE TO THE JUNGLE JA**

THE NEW
BATTLE
CRY FOR MEN

JAN.
K
35¢

Not even your most intimate se
are hidden from the prying
of the merchants of
Modern wiretap lets the

LISTEN WHI
YOU LO

TIGERS SPELL DEA

★ ATTEN
HORSE-PLA

IT'S EAS
TO BEA
THE TROTTE

The girl who made
badmen seem like b

PEARL HART: WILDE
WOMAN OF THE WE

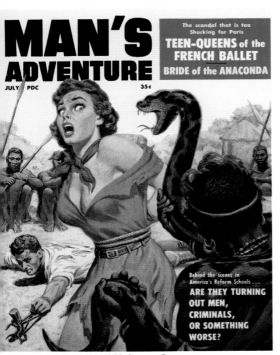

MAN'S ADVENTURE, 7/1959, Clarence Doore

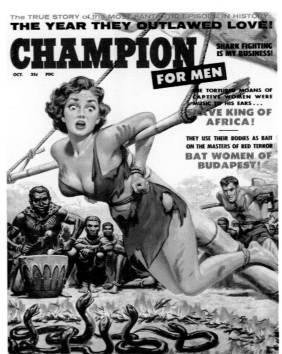

CHAMPION FOR MEN, 10/1959, Clarence Doore

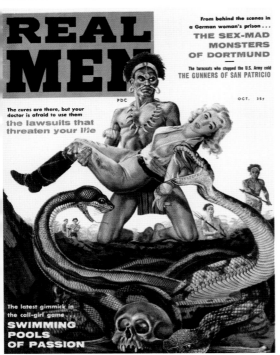

REAL MEN, 10/1960
◄ **BATTLE CRY**, 1/1960, Clarence Doore

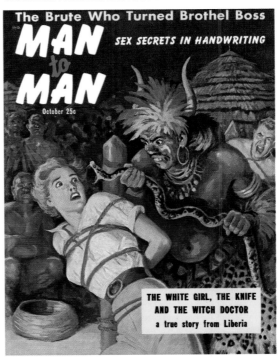

MAN TO MAN, 10/1958
BLUEBOOK, 10/1963, gouache, 61 × 41 cm ►►

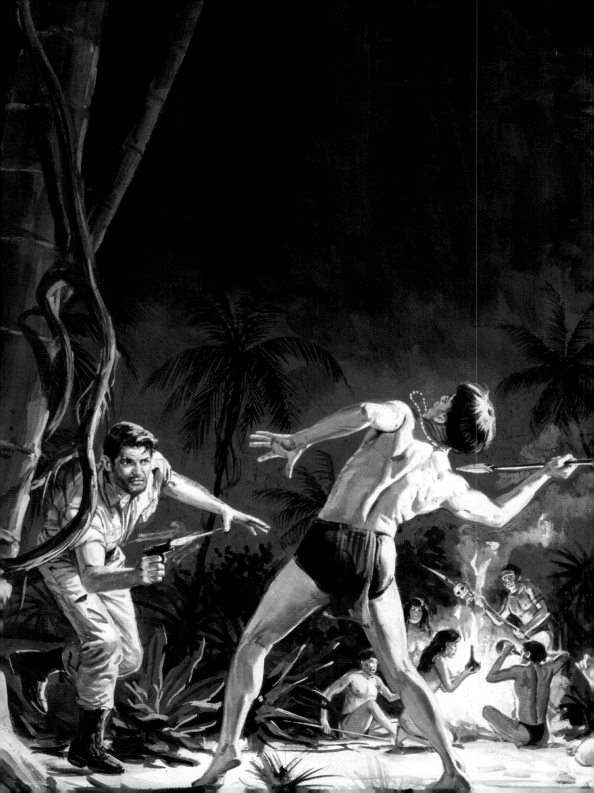

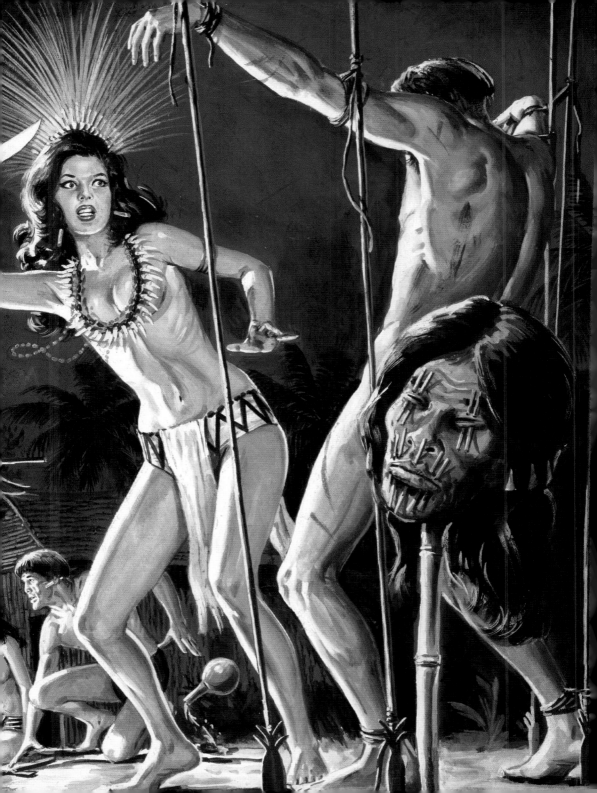

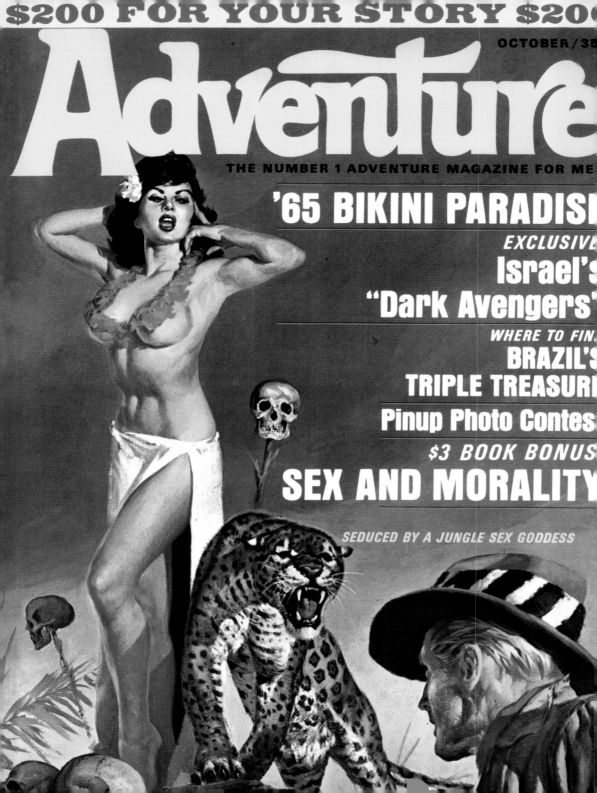

$200 FOR YOUR STORY $200

OCTOBER/35

Adventure

THE NUMBER 1 ADVENTURE MAGAZINE FOR ME

'65 BIKINI PARADISE

EXCLUSIVE
Israel's
"Dark Avengers"

WHERE TO FIN.
BRAZIL'S
TRIPLE TREASURE

Pinup Photo Contes

$3 BOOK BONUS

SEX AND MORALITY

SEDUCED BY A JUNGLE SEX GODDESS

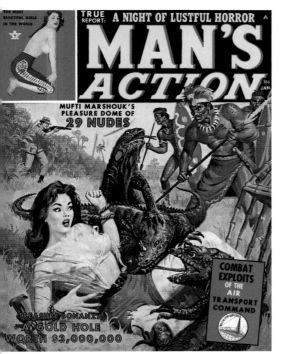

MAN'S ACTION, 1/1963

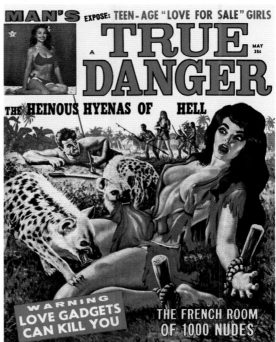

MAN'S TRUE DANGER, 5/1964

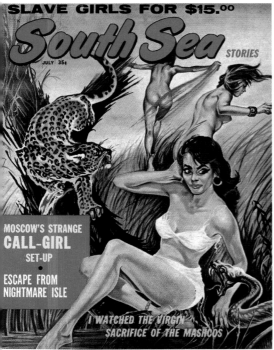

SOUTH SEA STORIES, 7/1963, Mark Schneider
◄ **ADVENTURE**, 10/1965, Basil Gogos

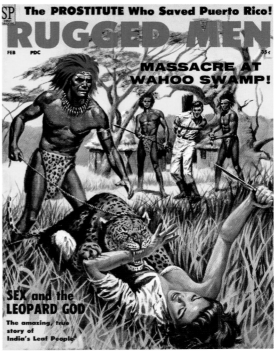

RUGGED MEN, 2/1959, Robert Stanley

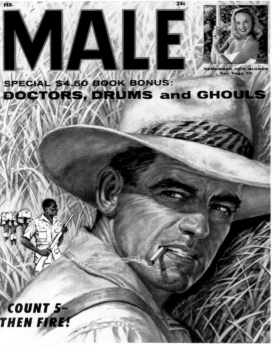

MALE, 2/1956, Jim Bentley

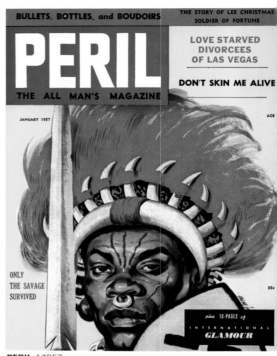

PERIL, 1/1957

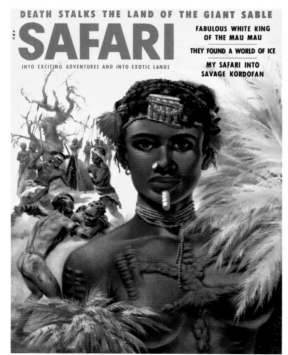

SAFARI, 1/1956, Tom Beecham

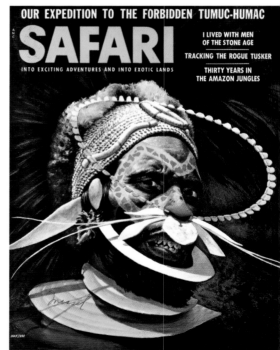

SAFARI, 7/1956, Robert Doares
MAN TO MAN, 6/1959 ▶

FURY, 10/1954, Clarence Doore

STAG, 6/1958, James Bama

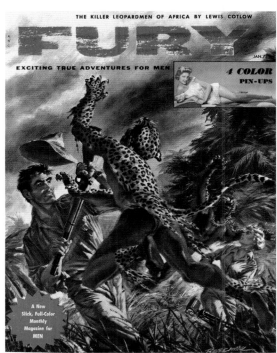

FURY, 1/1957, Tom Beecham

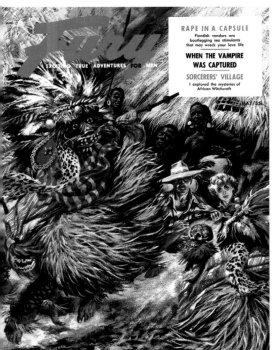

FURY, 5/1956, Tom Beecham

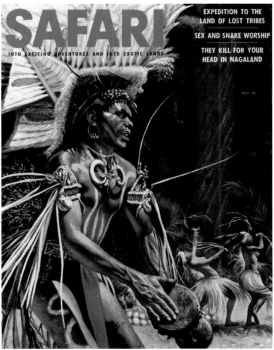

SAFARI, 11/1956, Robert Doares

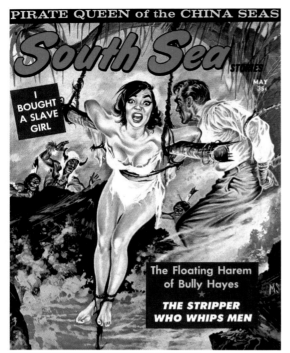

SOUTH SEA STORIES, 5/1963, Mark Schneider

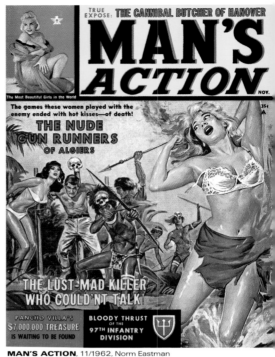

MAN'S ACTION, 11/1962, Norm Eastman

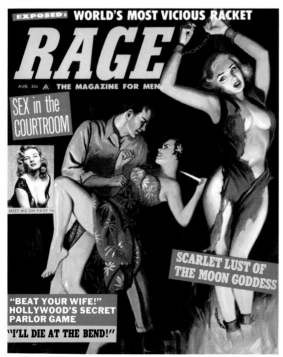

RAGE, 8/1962

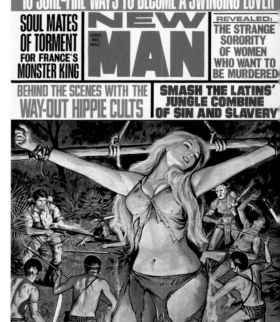

NEW MAN, 6/1970
REAL, 10/1962, Shannon Sternweiss ▶

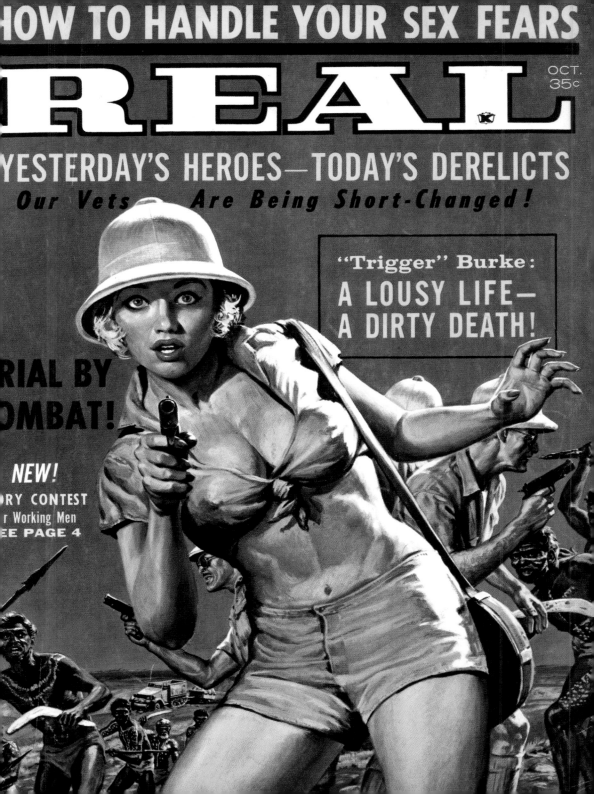

HOW TO HANDLE YOUR SEX FEARS

REAL

OCT.
35c

YESTERDAY'S HEROES—TODAY'S DERELICTS
Our Vets Are Being Short-Changed!

"Trigger" Burke:
A LOUSY LIFE—
A DIRTY DEATH!

RIAL BY
OMBAT!

NEW!
ORY CONTEST
r Working Men
EE PAGE 4

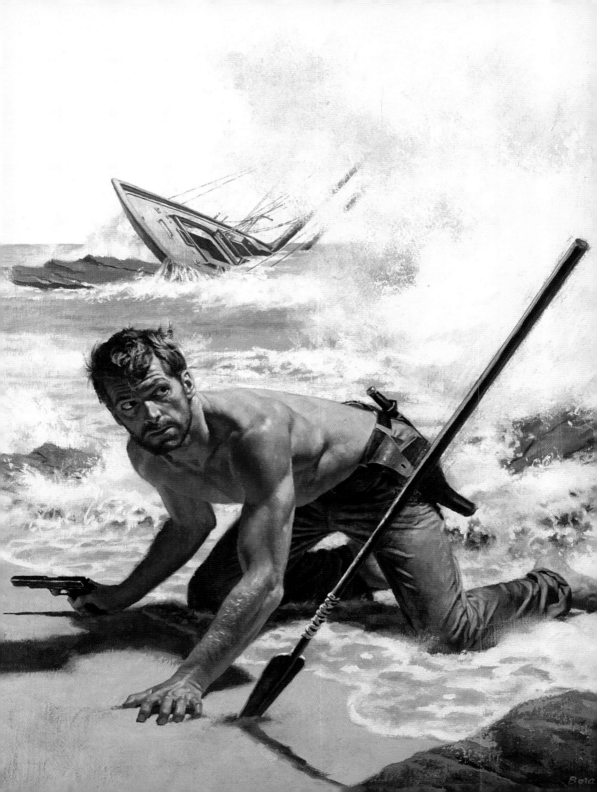

THE VICE-QUEENS HAD GIVEN THEIR LAST WARNING: "GET OUT OF TOWN, OR DIE!"

THE DAY THE BAWDS WENT CRAZY FOR BLOOD!

ALL MAN

The TRUE story of the most depraved monster in history
THE MAN WHO INVENTED PAIN

JAN. 35¢ PDC

SAVAGE DEMON
and the
KILLER CAT

SKIN, SIN and SWINDLE — the inside facts about NUDISM!

ALL MAN, 1/1960, Clarence Doore

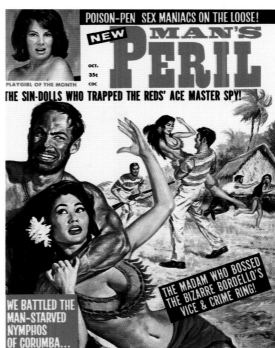

POISON-PEN SEX MANIACS ON THE LOOSE!

NEW **MAN'S PERIL**

OCT. 35¢ CDC

PLAYGIRL OF THE MONTH

THE SIN-DOLLS WHO TRAPPED THE REDS' ACE MASTER SPY!

WE BATTLED THE MAN-STARVED NYMPHOS OF CORUMBA...

THE MADAM WHO BOSSED THE BIZARRE BORDELLO'S VICE & CRIME RING!

MAN'S PERIL, 10/1965, Norm Eastman

HOW AMERICAN GENERALS ALMOST LOST WORLD WAR II

Man's Life

SEPTEMBER IND

25¢

PHONY MODEL AGENCIES:
THE HATBOX CALL GIRL RACKET
THE "GLAMOUR" CAREER THAT LEADS TO SIN!

MURDER IS A SCREWBALL HOBBY
BERSERK KILLERS ATTACK THE CORPSE!

THE PARIS JOY HOUSE
Of The MONEY-MAD SPY
A HAREM WAS USED TO OBTAIN INTERNATIONAL SECRETS!

SAVAGE-BAIT
ON THE ISLE OF
NO RETURN

MAN'S LIFE, 9/1960, Earl Norem
ADVENTURE TRAILS, 1/1957, Stan Borack, oil, 31 x 38 cm

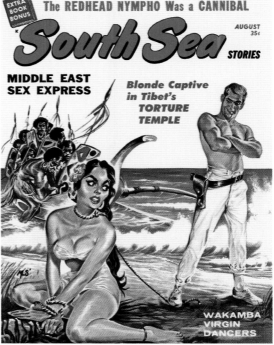

EXTRA BOOK BONUS

The REDHEAD NYMPHO Was a CANNIBAL

South Sea STORIES

AUGUST 35¢

MIDDLE EAST SEX EXPRESS

Blonde Captive in Tibet's **TORTURE TEMPLE**

WAKAMBA VIRGIN DANCERS

SOUTH SEA STORIES, 8/1961, Mark Schneider

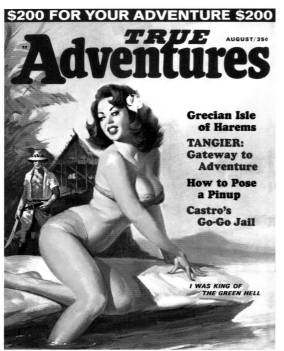

$200 FOR YOUR ADVENTURE $200

TRUE Adventures

AUGUST/35¢

Grecian Isle
of Harems

TANGIER:
Gateway to
Adventure

How to Pose
a Pinup

Castro's
Go-Go Jail

*I WAS KING OF
THE GREEN HELL*

TRUE ADVENTURES, 8/1966, Basil Gogos

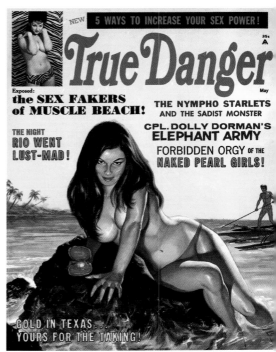

NEW **5 WAYS TO INCREASE YOUR SEX POWER!**

True Danger

35¢
May

Exposed:
the SEX FAKERS
of MUSCLE BEACH!

THE NYMPHO STARLETS
AND THE SADIST MONSTER

THE NIGHT
RIO WENT
LUST-MAD!

CPL. DOLLY DORMAN'S
ELEPHANT ARMY

FORBIDDEN ORGY OF THE
NAKED PEARL GIRLS!

GOLD IN TEXAS...
YOURS FOR THE TAKING!

TRUE DANGER, 5/1968

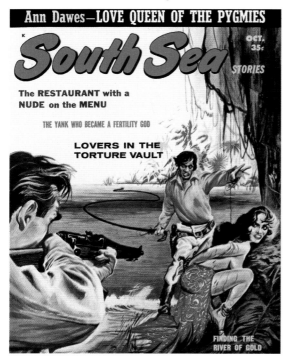

Ann Dawes—LOVE QUEEN OF THE PYGMIES

South Sea

OCT.
35¢

STORIES

The RESTAURANT with a
NUDE on the MENU

THE YANK WHO BECAME A FERTILITY GOD

LOVERS IN THE
TORTURE VAULT

FINDING THE
RIVER OF GOLD

SOUTH SEA STORIES, 10/1961, Mark Schneider

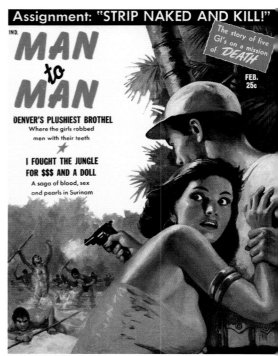

Assignment: "STRIP NAKED AND KILL!"

IND.

MAN to MAN

The story of five
GI's on a mission
of DEATH

FEB.
25¢

DENVER'S PLUSHIEST BROTHEL
Where the girls robbed
men with their teeth

I FOUGHT THE JUNGLE
FOR $$$ AND A DOLL
A saga of blood, sex
and pearls in Surinam

MAN TO MAN, 2/1959
ADVENTURE, 2/1966, Vic Prezio ▶

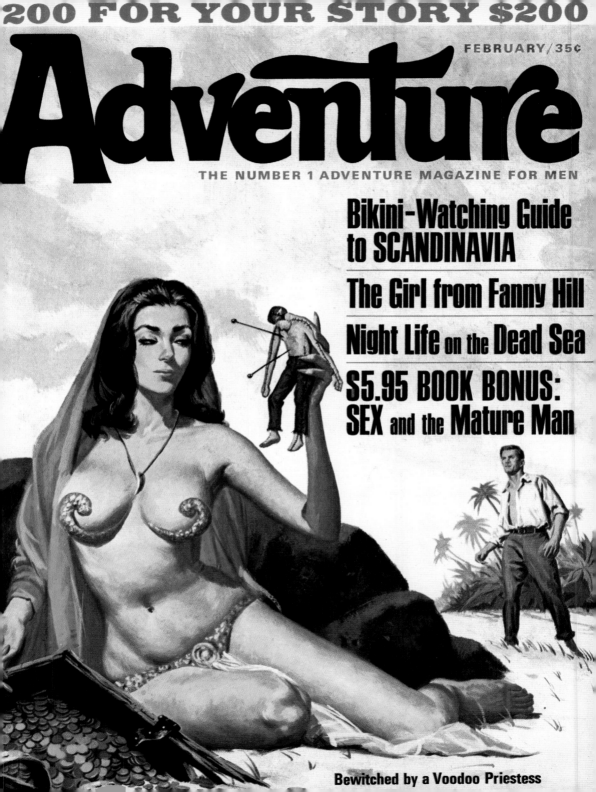

$200 FOR YOUR STORY $200

FEBRUARY/35¢

Adventure

THE NUMBER 1 ADVENTURE MAGAZINE FOR MEN

Bikini-Watching Guide to SCANDINAVIA

The Girl from Fanny Hill

Night Life on the Dead Sea

$5.95 BOOK BONUS: SEX and the Mature Man

Bewitched by a Voodoo Priestess

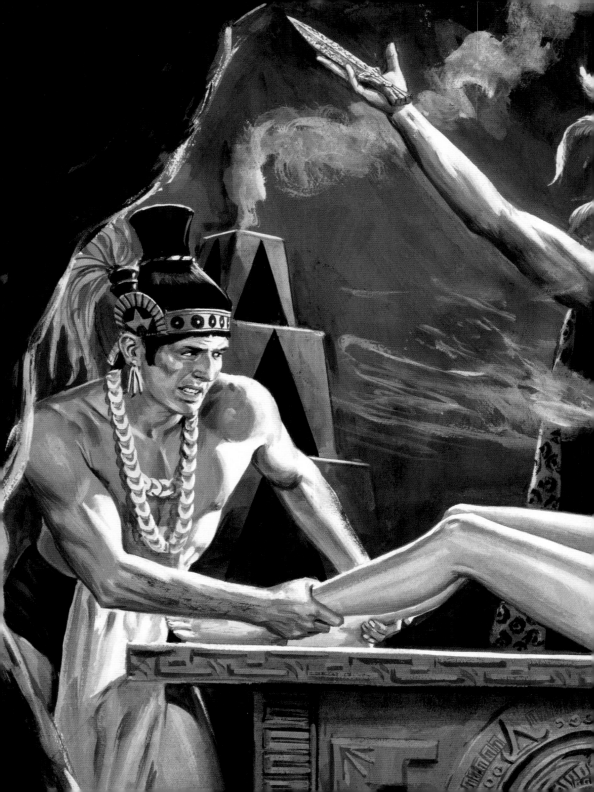

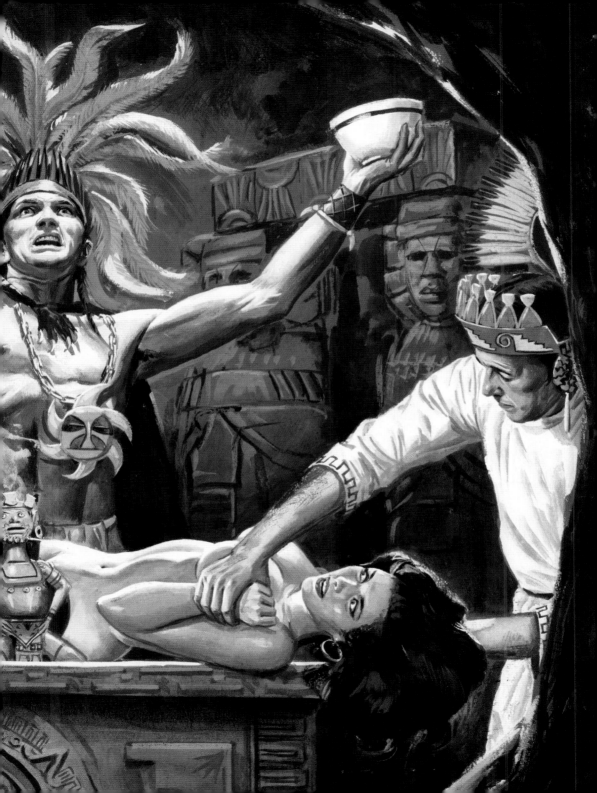

CHAMPION FOR MEN, 11/1959, Clarence Doore

TRUE ADVENTURES, 10/1961, Vic Prezio

MAN'S ACTION, 5/1958
◄◄ BLUEBOOK, 12/1963, gouache, 56 x 38 cm

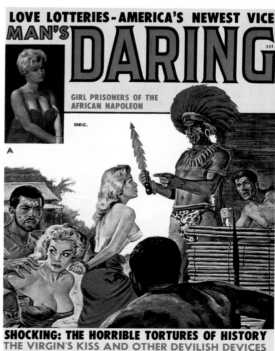

MAN'S DARING, 12/1960, Norm Eastman

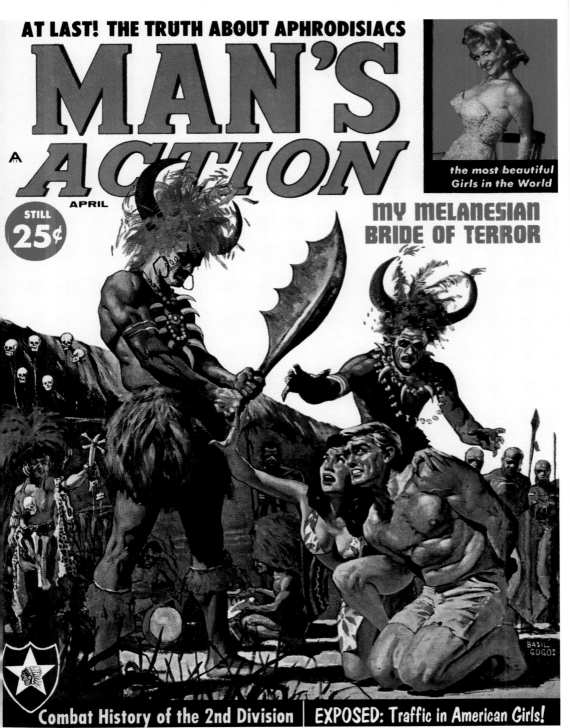

AT LAST! THE TRUTH ABOUT APHRODISIACS

MAN'S ACTION

A

APRIL

STILL 25¢

the most beautiful
Girls in the World

MY MELANESIAN BRIDE OF TERROR

Combat History of the 2nd Division | EXPOSED: Traffic in American Girls!

MAN'S ACTION, 4/1960, Basil Gogos

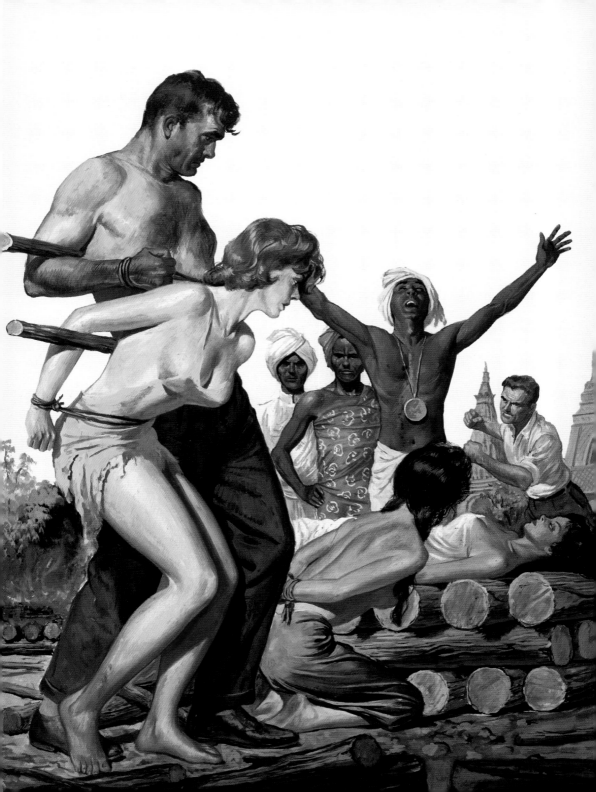

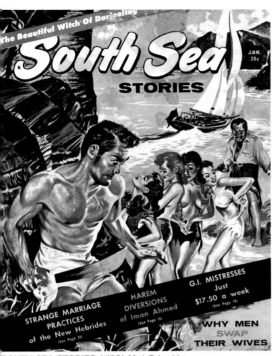

SOUTH SEA STORIES, 1/1961, Mark Schneider

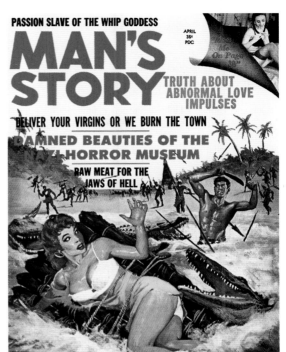

MAN'S STORY, 4/1962

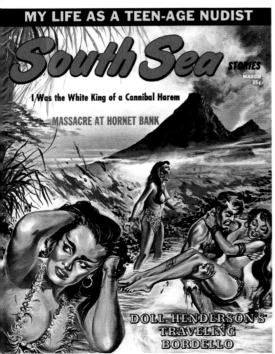

SOUTH SEA STORIES, 3/1962, Mark Schneider
◄ ADVENTURE, 8/1962, Rafael DeSoto, gouache, 40 x 52 cm

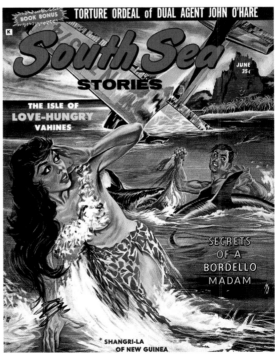

SOUTH SEA STORIES, 6/1961, Mark Schneider
REAL FOR MEN, 4/1956, Rafael DeSoto, oil, 64 x 41 cm ►►

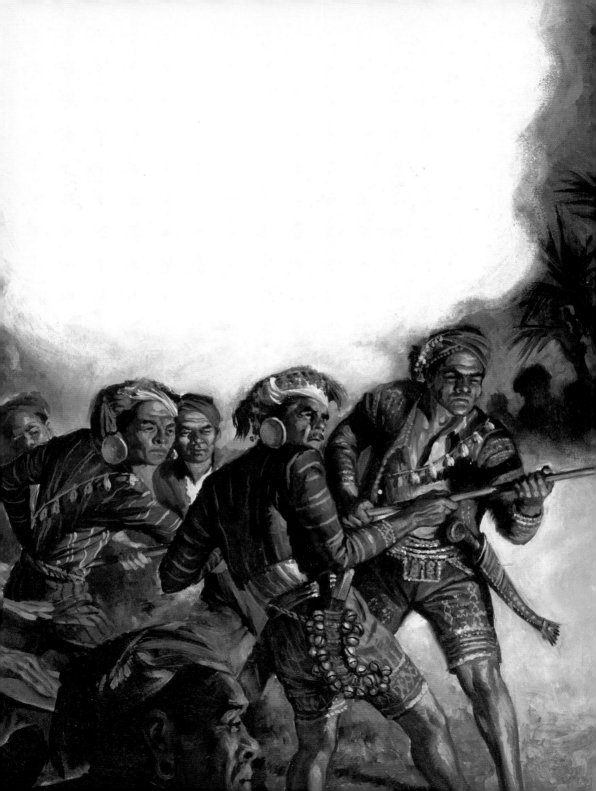

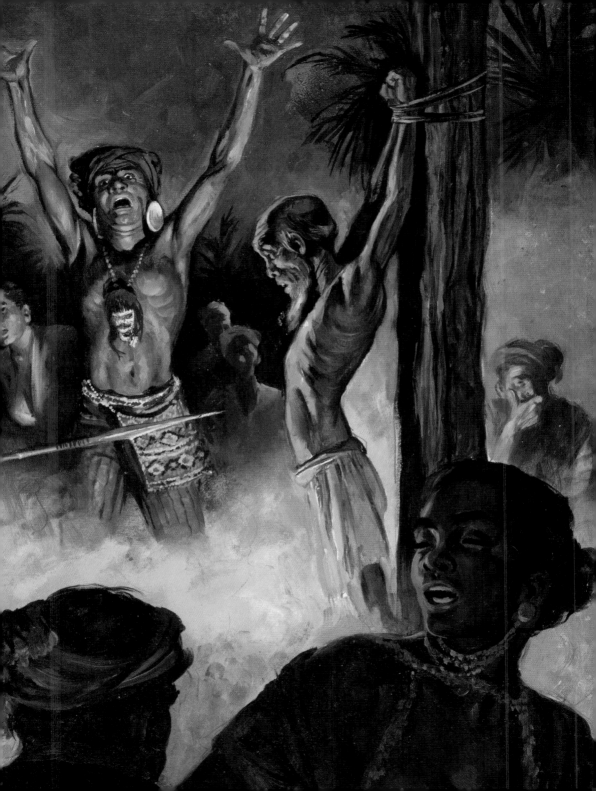

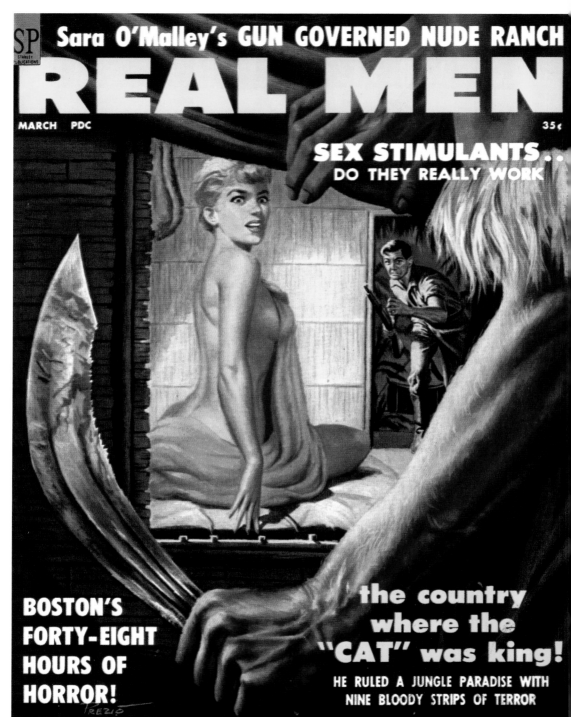

REAL MEN, 3/1959, Vic Prezio

SPORT LIFE, 12/1956, Rafael DeSoto

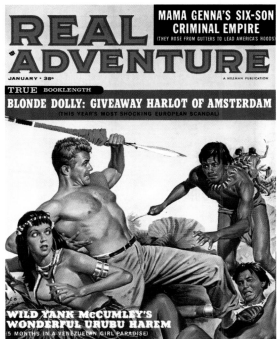

REAL ADVENTURE, 1/1961, John Kuller

REAL ADVENTURE, 11/1957, Stan Borack

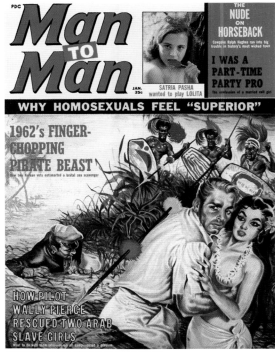

MAN TO MAN, 1/1963, Mark Schneider

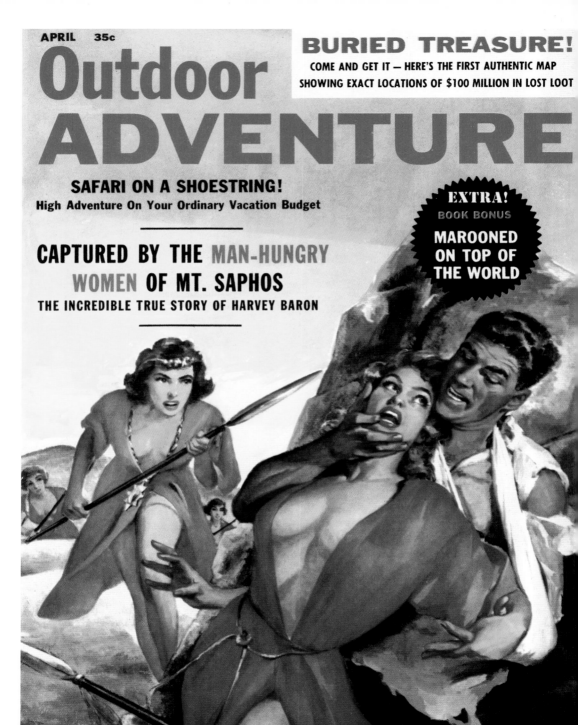

APRIL 35c

Outdoor
ADVENTURE

BURIED TREASURE!
COME AND GET IT — HERE'S THE FIRST AUTHENTIC MAP
SHOWING EXACT LOCATIONS OF $100 MILLION IN LOST LOOT

SAFARI ON A SHOESTRING!
High Adventure On Your Ordinary Vacation Budget

CAPTURED BY THE MAN-HUNGRY WOMEN OF MT. SAPHOS
THE INCREDIBLE TRUE STORY OF HARVEY BARON

EXTRA!
BOOK BONUS
MAROONED ON TOP OF THE WORLD

OUTDOOR ADVENTURES, 4/1959, Mel Philips

REAL MEN, 3/1957, Clarence Doore ▶

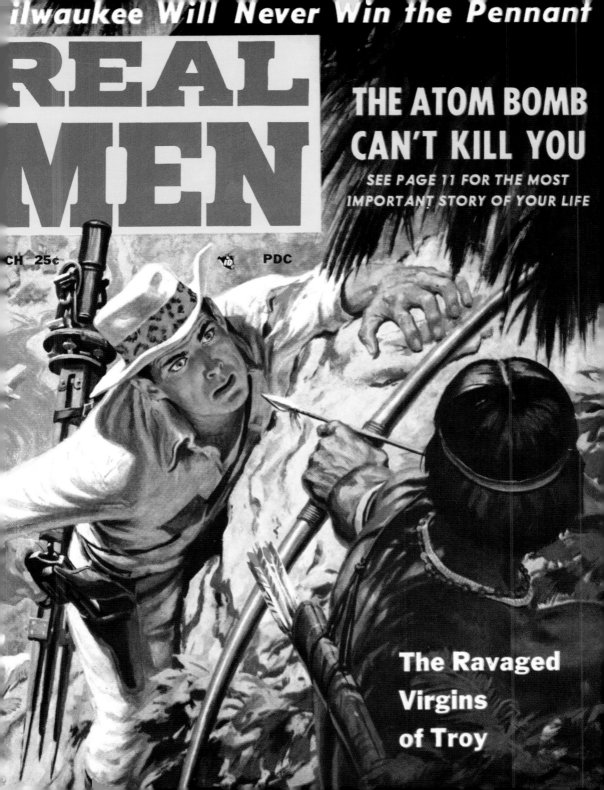

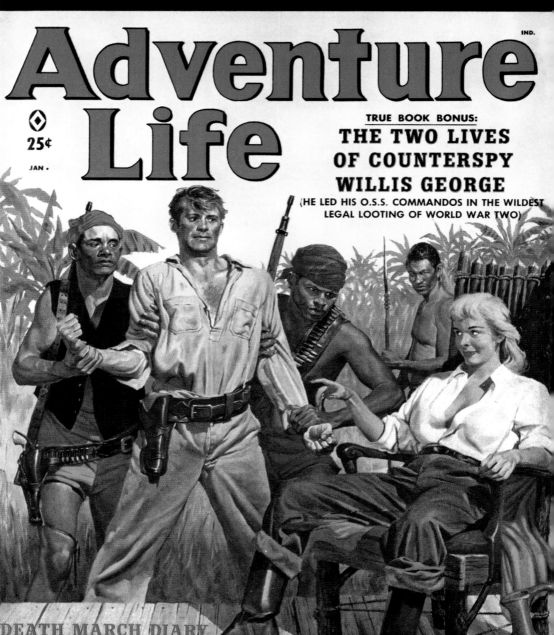

THE BLONDE GANG MOLL OF AFRICA'S JUNGLE BANDITS

Adventure Life

IND.

◆ 25¢

JAN.

TRUE BOOK BONUS:
THE TWO LIVES OF COUNTERSPY WILLIS GEORGE
(HE LED HIS O.S.S. COMMANDOS IN THE WILDEST LEGAL LOOTING OF WORLD WAR TWO)

DEATH MARCH DIARY OF CAPTAIN SCOTT

ADVENTURE LIFE, 1/1959, Rafael DeSoto

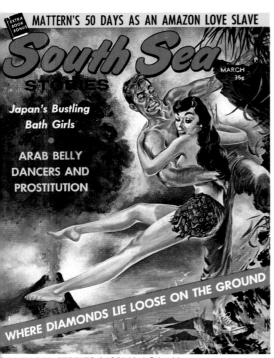

MATTERN'S 50 DAYS AS AN AMAZON LOVE SLAVE

EXTRA BOOK BONUS

South Sea
STORIES
MARCH 35¢

Japan's Bustling
Bath Girls

ARAB BELLY
DANCERS AND
PROSTITUTION

WHERE DIAMONDS LIE LOOSE ON THE GROUND

SOUTH SEA STORIES, 3/1961, Mark Schneider

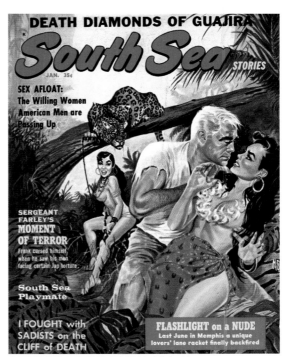

DEATH DIAMONDS OF GUAJIRA

South Sea
STORIES
JAN. 35¢

SEX AFLOAT:
The Willing Women
American Men are
Passing Up

SERGEANT
FARLEY'S
MOMENT
OF TERROR
Frank cursed himself
when he saw his men
facing certain Jap torture.

South Sea
Playmate

I FOUGHT with
SADISTS on the
CLIFF of DEATH

FLASHLIGHT on a NUDE
Last June in Memphis a unique
lovers' lane racket finally backfired

SOUTH SEA STORIES, 1/1963, Mark Schneider

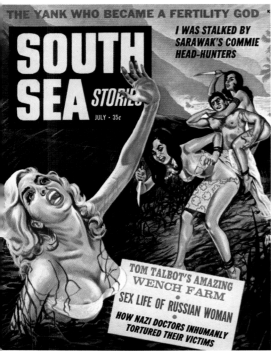

THE YANK WHO BECAME A FERTILITY GOD

SOUTH SEA STORIES
JULY · 35¢

I WAS STALKED BY
SARAWAK'S COMMIE
HEAD-HUNTERS

TOM TALBOT'S AMAZING
WENCH FARM
SEX LIFE OF RUSSIAN WOMAN
HOW NAZI DOCTORS INHUMANLY
TORTURED THEIR VICTIMS

SOUTH SEA STORIES, 7/1964, Mark Schneider

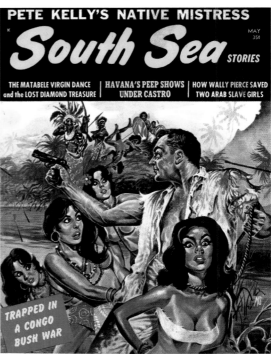

PETE KELLY'S NATIVE MISTRESS

South Sea
STORIES
MAY
35¢

THE MATABELE VIRGIN DANCE
and the LOST DIAMOND TREASURE | HAVANA'S PEEP SHOWS
UNDER CASTRO | HOW WALLY PIERCE SAVED
TWO ARAB SLAVE GIRLS

TRAPPED IN
A CONGO
BUSH WAR

SOUTH SEA STORIES, 5/1964, Mark Schneider
MAN'S CONQUEST, 6/1960, Norman Saunders, gouache, 54 x 38 cm ▶▶

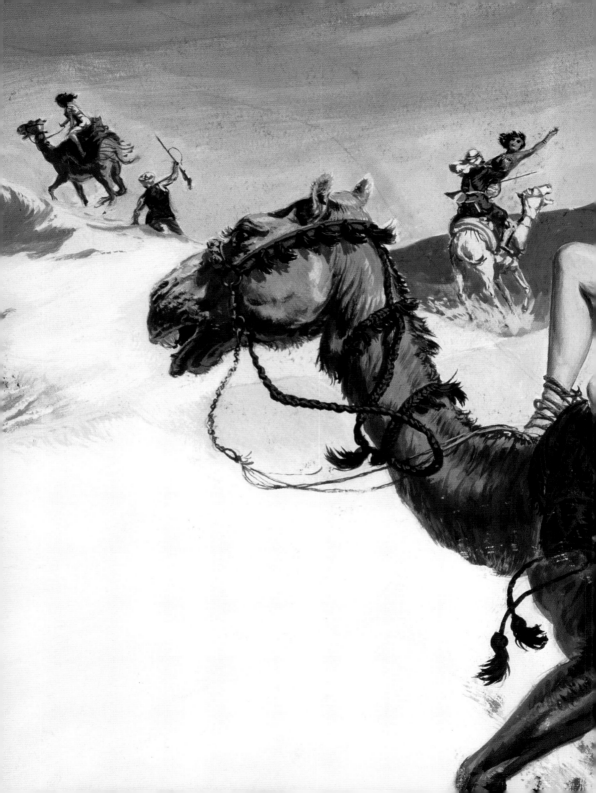

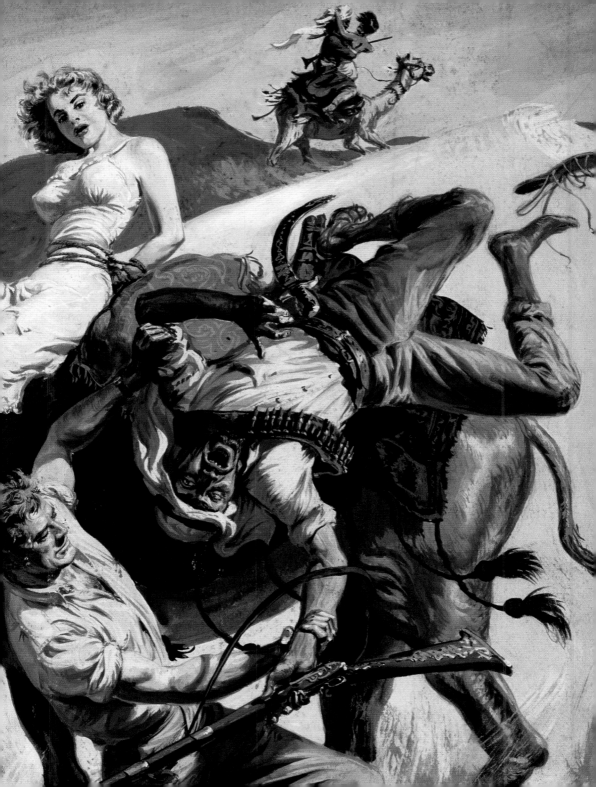

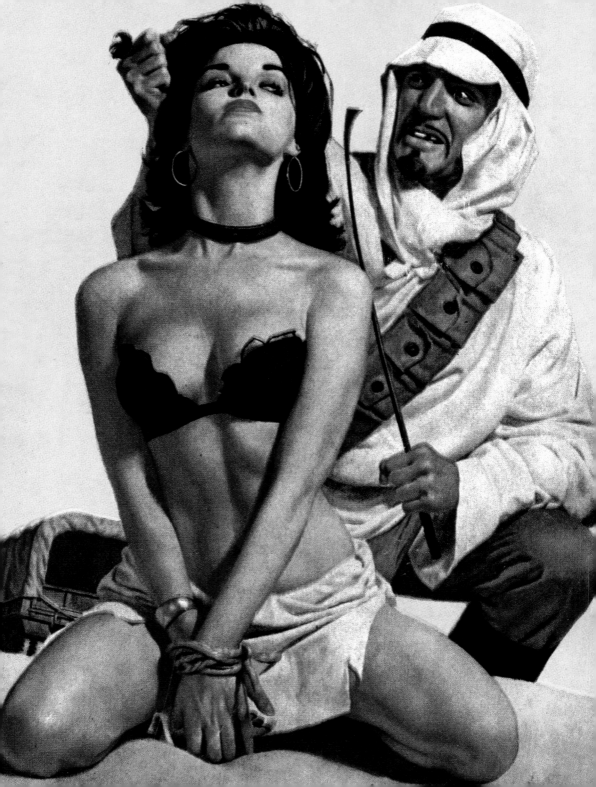

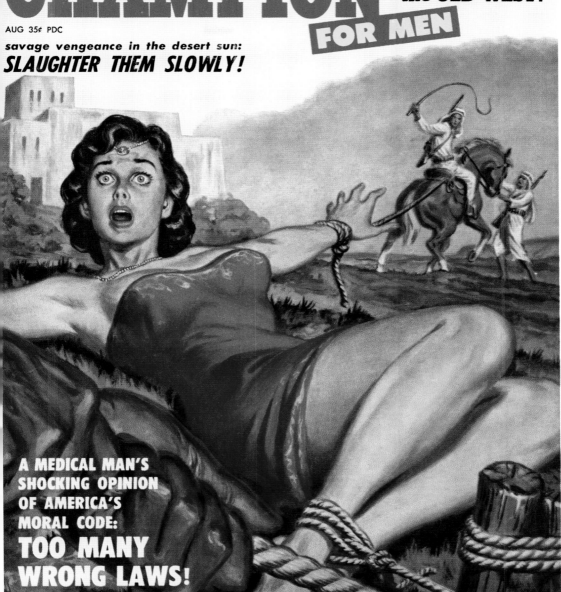

IRIS PARKER'S PLAY CABIN IN THE SKY see page 17

CHAMPION

SPECIAL BONUS:
RARE GUNS of the OLD WEST!

AUG 35¢ PDC

FOR MEN

savage vengeance in the desert sun:
SLAUGHTER THEM SLOWLY!

A MEDICAL MAN'S
SHOCKING OPINION
OF AMERICA'S
MORAL CODE:
TOO MANY
WRONG LAWS!

CHAMPION FOR MEN, 8/1959, Clarence Doore
◀ **BLUEBOOK**, 11/1962, Stan Borack

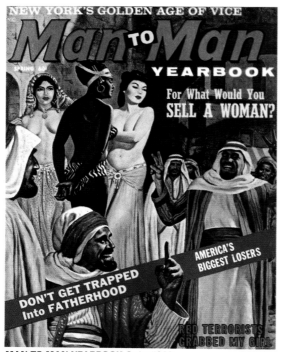

MAN TO MAN YEARBOOK, Spring/1963

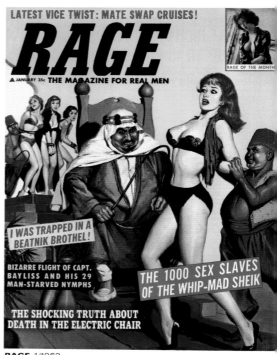

RAGE, 1/1963

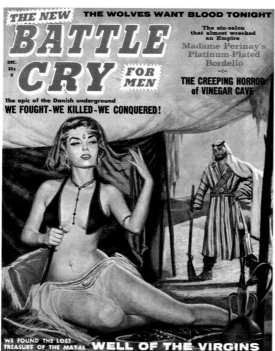

BATTLE CRY, 12/1959

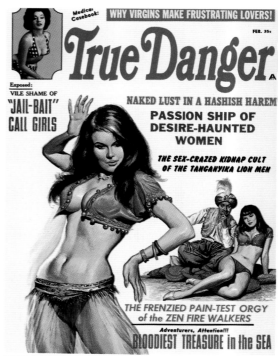

TRUE DANGER, 2/1968
MAN'S LIFE, 3/1960, Will Hulsey ▶

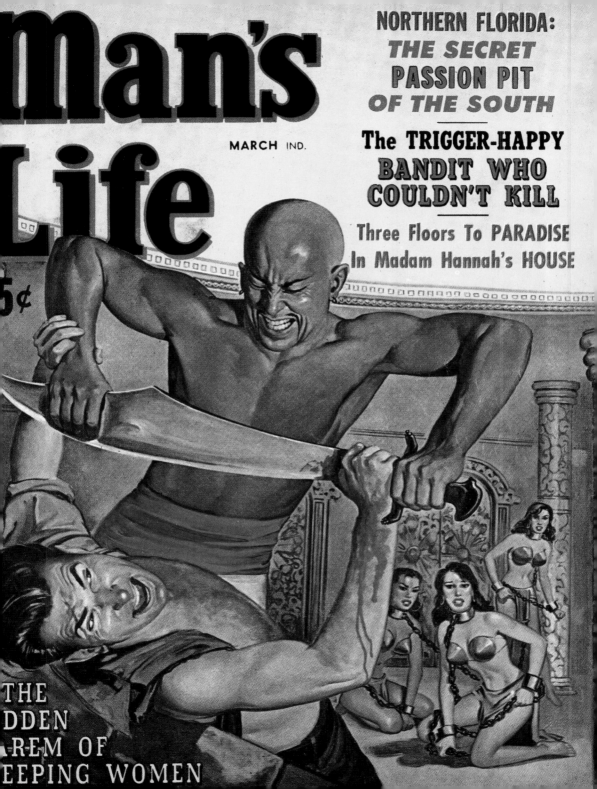

Man's Life

MARCH IND.

5¢

NORTHERN FLORIDA: THE SECRET PASSION PIT OF THE SOUTH

The TRIGGER-HAPPY BANDIT WHO COULDN'T KILL

Three Floors To PARADISE In Madam Hannah's HOUSE

THE
DDEN
REM OF
EEPING WOMEN

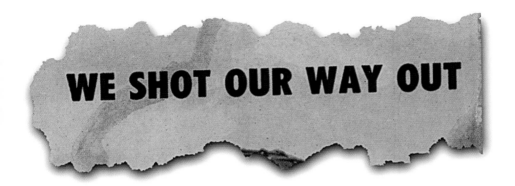

WE SHOT OUR WAY OUT

LIFE AND DEATH ON THE FRONT LINES

The target audience for men's adventure magazines consisted primarily of soldiers on active duty, veterans returned from military service, and men who wanted to join the service, but had not.

So it comes as no surprise that a major theme was war. While World War II was covered most often, wars of all types, of every era, were he-man magazine fodder, from the Mongol raids of Genghis Khan to the most obscure conflicts of the twentieth century.

Declassified photos enabled the sweats to differentiate their World War II "articles" from those of the average "news magazine" that did not cater to tough, manly, blue-collar readers. Many in the men's adventure audience had been there and were strong enough to look at the true, grisly face of war. Those who had not were either preparing to enter the military or wanted the vicarious experience of combat — military censorship during World War II had withheld publication of many unpleasant details, especially combat photos, from the American public.

Focusing on World War II also addressed the problem of distribution on military bases. The United States military tried to maintain strict control over what the troops saw relating to current wars; this was especially true in Korea. So telling heroic stories about World War II was far more acceptable than serving up tales of Korea or, later, Vietnam. The latter would provoke close scrutiny and possibly the return of the magazines from PXs (post exchange stores) if the stories offended military censors.

Contemporary conflicts also provided the challenge of authen-

ticity. Stories had to be accurate enough to convince readers — often GIs in battle zones — that the stories were real, while still being gripping enough to attract an audience outside the military.

The sexual undertone in many of the stories was a unique contribution to the popular literature of war. The sexual awakening of young soldiers, brought about, in part, by the intensity of war and the eminent reality of death, was emphasized in men's magazines of the era. Accordingly, many of the stories had a strong sexual context, ranging from real stories of heroines at the front to the odd "joy girl" or hooker who risked "unspeakable horrors" (her virginity long since sacrificed) to defeat the Nazis, "Japs," or "Ruskies."

The sexual context often involved rape (or implied rape), with the abused woman finding solace in sex with her savior soldier. Usually the war disrupted the relationship, and the single sexual encounter did not lead to an ongoing relationship (much less marriage), thus reinforcing the conservative cultural division of the time between the loose woman with whom one dallied and the good woman one married. This fantasy rationalized many soldiers' experiences, from encounters with the whores who worked in base "service" facilities to one-night stands with refugee women behind the lines who swapped sex for needed food.

The popularity of war stories led to numerous sweat magazines devoted solely to this subject. World War II predominated, most probably because it was a war the United States had won. *Battlefield*, a relaunch of a Martin Goodman comic book, was

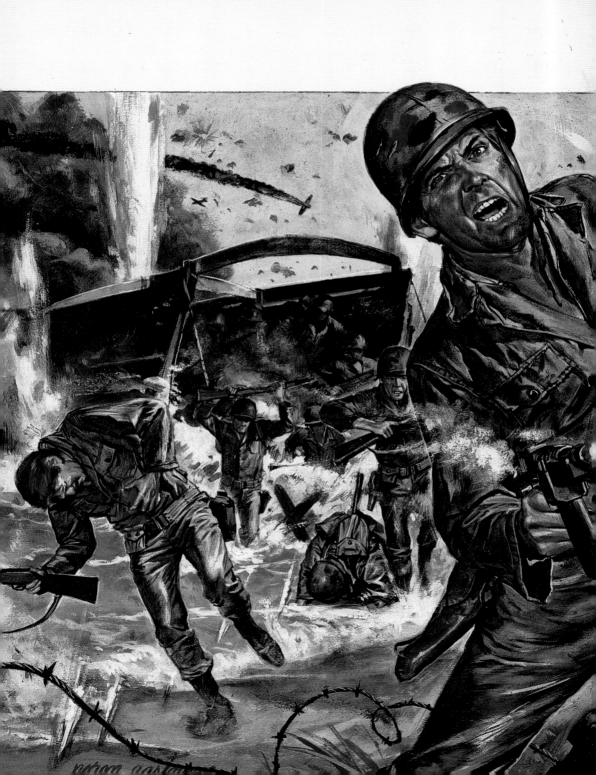

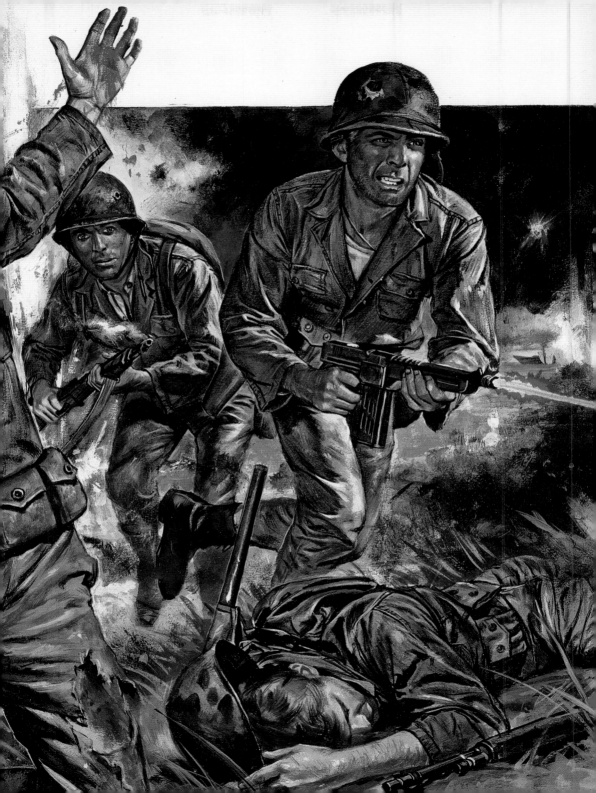

created to meet the demand for more "true war" stories. It was soon joined by *Real War* (which included a science-fiction issue on the future war in space), *Men in Combat*, and Charlton Publications' *War Story*. Joy-girl guerrillas and hooker heroines got their own magazine — *Women in War* — and *War Criminals* provided a bimonthly dose of concentration camp atrocities and the torture of naked women.

The Civil War centennial of the sixties summoned a host of stories about obscure aspects of that conflict; not just the great battles, but Lincoln's assassination, female confederate spies, and the deplorable conditions in various prisons and prison camps. Probably the most repeated story was that of the young woman who posed as a soldier in the Union army for months, though in the men's adventure version it was tough to tell how the busty, statuesque blonde in a tight, tattered uniform got away with this.

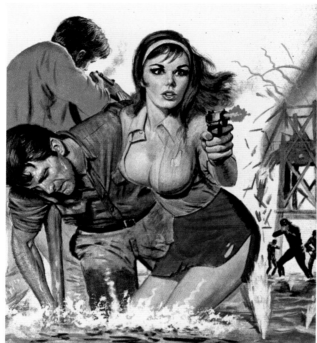

MEN TODAY, 11/1970

WIR SCHOSSEN UNS DEN WEG FREI. LEBEN UND STERBEN AN DER FRONT

Das Zielpublikum der Abenteuerheftchen bestand vorwiegend aus Soldaten im aktiven Dienst, aus dem Militärdienst ausgeschiedenen Kriegsteilnehmern und Männern, die gern in der Armee gedient hätten. Insofern überrascht es nicht, dass Krieg zu den Hauptthemen gehörte. Die meisten Artikel handelten vom Zweiten Weltkrieg, aber Kriege aller Art, von den Mongolenfeldzügen unter Dschingis Khan bis zu den obskursten Konflikten des 20. Jahrhunderts, waren begehrtes Lesefutter.

Von der Regierung freigegebene Fotos waren das Material, mit dem die Sweats sich mit ihren „Berichten" über den Zweiten Weltkrieg von denen die durchschnittlichen Nachrichtenmagazins abhoben, die nicht primär an hartgesottenen Burschen und Arbeiter gerichtet waren. Viele der Leser der Männerabenteuer waren selbst dabei gewesen und stark genug, um sich dem wahren, grässlichen Angesicht des Krieges zu stellen. Die, die den Krieg noch nicht aus eigener Erfahrung kannten, wollten entweder zum Militär oder zumindest indirekt miterleben, was echte Soldaten gesehen hatten. (Während des Zweiten Weltkrieges hatte die Militärzensur verhindert, dass viele unerfreuliche Details, insbesondere Bilder vom Schlachtfeld, an die Öffentlichkeit drangen.)

Die Konzentration auf den Zweiten Weltkrieg löste auch das Problem des Heftchenverkaufs in den Militärstützpunkten. Die amerikanische Heeresführung versuchte, alle Informationen streng zu kontrollieren, die Soldaten über aktuelle Kriege zu Gesicht bekamen; das galt insbesondere für den Koreakrieg. Die Veröffentlichung heldenhafter Geschichten aus dem Zweiten Weltkrieg stieß auf sehr viel weniger Widerstand von Seiten der Zensur als die von Storys aus Korea oder später Vietnam. Aktuelle Themen dieser Art provozierten eine genaue Überprüfung und sogar eine eventuelle Beschlagnahmung der Heftchen in den PX-Läden der Armeestützpunkte, wenn die Militärzensur Anstoß an ihnen nahm.

Zeitgenössische Konflikte erforderten außerdem eine gewisse Authentizität. Die Artikel mussten so weit stimmen, dass die Leser — oft Soldaten im Kampfeinsatz — von ihrer Echtheit überzeugt waren, und gleichzeitig packend genug sein, um das Publikum außerhalb des Militärs anzusprechen.

Der sexuelle Unterton in vielen der Geschichten war ein Beitrag zur populären Kriegsliteratur, der sonst so nicht zu finden war. Das sexuelle Erwachen junger Soldaten, das von der Intensität des Krieges und der Allgegenwart des Todes gefördert wurde, spielte in den Männermagazinen dieser Epoche eine große Rolle. Viele der Storys hatten einen stark sexualisierten Kontext, der von wahren Berichten von Heldinnen an der Front bis zu vereinzelten Freudenmädchen reichten, die „unaussprechliches Grauen" riskierten (die Jungfräulichkeit war bereits bei langem geopfert worden), um die Nazis, „Japsen" oder „Ruskis" zu besiegen.

In der sexuellen Nebenhandlung ging es oft um vergewaltigte Frauen (bzw. um angedeutete Vergewaltigungen), die Trost im Sex mit ihrem soldatischen Retter fanden. Das Verhältnis wurde dann meist durch die Kriegswirren auseinander gerissen, so dass es bei der einen intimen Begegnung blieb, aus der nie eine längerfristige Beziehung oder gar eine Ehe wurde. Diese Art der Darstellung bekräftigte die konservative Trennung zwischen dem losen Frauenzimmer, mit dem man anbändelte, und der tugendhaften Frau, die man heiratete. Diese Fantasien verarbeiteten die Erfahrungen vieler Soldaten, von der Begegnung mit den Huren in den „Versorgungsstützpunkten" der Armeelager bis hin zu One-Night-Stands mit Flüchtlingsfrauen, die hinter den Schützengräben Sex gegen dringend benötigte Nahrungsmittel tauschten.

Die große Beliebtheit der Kriegsgeschichten führte dazu, dass sich eine Vielzahl von Abenteuermagazinen ausschließlich diesem

BATTLE CRY, 3/1961, Vic Prezio ▶

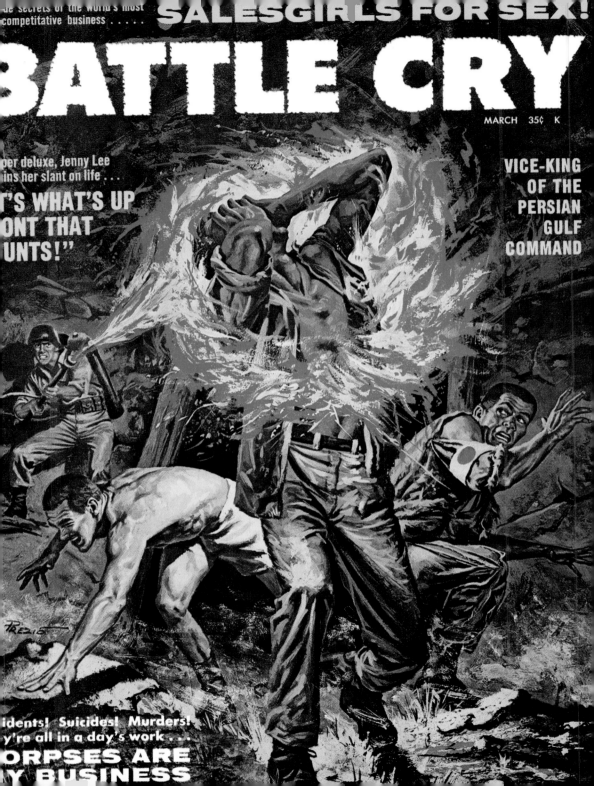

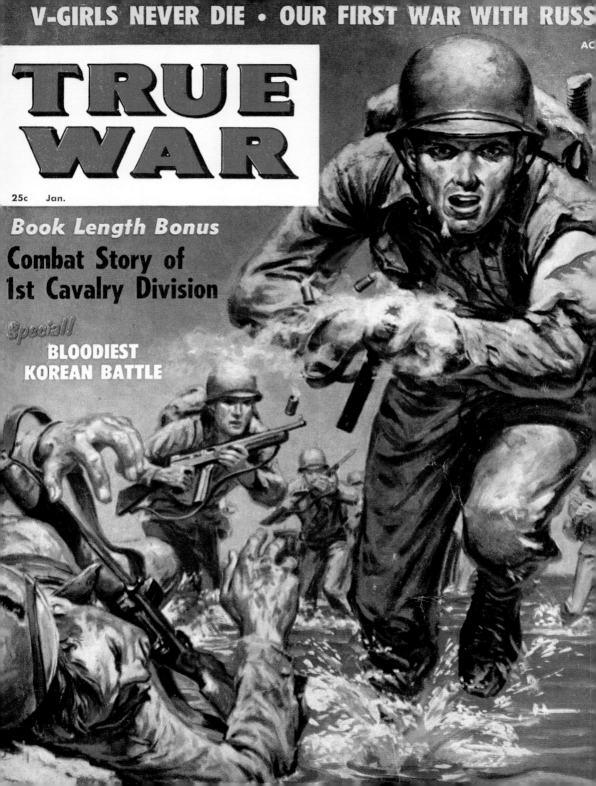

TRUE WAR

25c Jan.

Book Length Bonus

Combat Story of 1st Cavalry Division

Special!

BLOODIEST KOREAN BATTLE

hema widmeten. Der Zweite Weltkrieg war das Hauptthema, wahrscheinlich, weil die USA aus diesem Krieg siegreich hervorgegangen waren. *Battlefield*, die Neuauflage eines Martin-Goodman-Comics, wurde geschaffen, um die Nachfrage nach noch mehr „wahren Berichten von der Front" zu befriedigen. Ihm folgte bald *Real War* (das u. a. eine Science-Fiction-Ausgabe über den Krieg der Zukunft im Weltall brachte), *Men in Combat* und das von Charlton Publications herausgegebene *War Story*. Freudennädchen-Guerrillas und heldenhafte Huren bekamen ihre eigene Heftchenreihe – *Women in War* –, während *War Criminals* alle 14 Tage eine gehörige Dosis Konzentrationslagerqualen und Folter nackter Frauen lieferte.

Das 100-jährige Jubiläum des amerikanischen Bürgerkriegs beschwor in den Sechzigerjahren Unmengen von Historien über unbekannte Aspekte dieses Konflikts herauf, nicht über die großen Schlachten, sondern auch über den Mord an Lincoln, Spioninnen der Konföderierten und die erschreckenden Zustände in diversen Gefängnissen und Kriegsgefangenenlagern. In der vermutlich am häufigsten reproduzierten Handlung ging es um eine junge Frau, die sich monatelang als Soldat der Union ausgab, auch wenn es in den Männerheftchen nur schwer vorstellbar war, wie die vollbusigen, stattlichen Blondinen in hautengen, zerfetzten Uniformen das fertig brachten.

IL SE FRAYAIENT UN CHEMIN A LA MITRAILLETTE. VIE ET MORT SUR LES LIGNES DE FRONT

Le public-cible des magazines d'aventures pour hommes se composait essentiellement de militaires professionnels, d'anciens combattants libérés de leurs obligations militaires et d'hommes qui auraient voulu servir dans l'armée mais n'avaient pas pu.

Rien de surprenant donc, à ce qu'un des thèmes essentiels de ces magazines ait été la guerre. La plupart du temps, il s'agissait de la Seconde Guerre mondiale, mais toutes les sortes de guerres, de toutes les époques, alimentaient les histoires des magazines pour hommes, des guerres-éclair de Gengis Khan, aux plus obscurs conflits du XXe siècle.

Les photos déclassifiées qu'ils publiaient permettaient aux pulps de ce type de distinguer leurs articles sur la Guerre de ceux des grands magazines d'actualité qui ne s'adressaient pas à un public de lecteurs ouvriers machos et frustes. Nombre de ces lecteurs avaient fait la guerre et ils étaient assez durs pour regarder en face le vrai visage, atroce, de celle-ci. Et quant à ceux qui ne l'avaient pas faite, soit ils se préparaient à entrer dans l'armée, soit ils voulaient expérimenter par procuration ce qu'avaient connu les vrais soldats. (La censure militaire avait interdit la révélation au public américain de nombreux détails jugés fâcheux, à commencer par les photos de combats.)

Cette prédominance de la Seconde Guerre mondiale posait aussi le problème de la distribution des journaux sur les bases militaires. L'armée américaine essayait de garder un strict contrôle sur les lectures de ses soldats concernant les guerres en cours – et particulièrement sur la campagne de Corée. Si bien que les récits des prouesses militaires américaines pendant la Seconde Guerre était beaucoup plus acceptables que les mêmes sur la Corée, ou, plus

tard, le Vietnam. Les magazines qui publiaient des histoires prenant pour cadre le Vietnam étaient examinés à la loupe et risquaient, s'ils irritaient les censeurs, un pur et simple retour à l'envoyeur.

Les descriptions des conflits de l'époque devaient en outre présenter un minimum d'authenticité : elles devaient être assez précises pour convaincre de leur réalité les GI du front et assez palpitantes pour captiver des lecteurs civils.

Les sous-entendus sexuels présents dans beaucoup de ces histoires en font une contribution unique à la littérature populaire sur la guerre. L'éveil sexuel des jeunes soldats, causé en partie par l'intensité de la guerre et en partie par l'obsédante réalité de la mort, est un thème constant des magazines pour hommes de l'époque. En conséquence, nombre de ces histoires ont une forte connotation sexuelle, qu'il s'agisse d'histoires vraies d'héroïnes au front ou de filles de joie atypiques risquant « d'indicibles supplices » (leur virginité depuis longtemps sacrifiée) pour vaincre les nazis, les « Japs » ou les « Ruskofs ».

Les histoires de femmes violées sont légion, ainsi que la happy end qui veut que celles-ci trouvent souvent le réconfort dans les bras du soldat-sauveur. En général la fin de la guerre signifie cependant la fin de la relation, et le rapport sexuel ne débouche pas sur une liaison proprement dite – encore moins sur le mariage. Ce scénario renforce donc la division culturelle conventionnelle de l'époque entre la femme à la dérive avec qui l'on copule et la femme « bien » que l'on épouse. Cette vision de la femme n'est d'ailleurs qu'une justification rationnelle de nombreuses expériences de soldats, qu'il s'agisse de passes avec des prostituées aux alentours des bases ou d'intimité d'une nuit avec des réfugiées qui troquaient leurs faveurs contre un peu de nourriture.

La popularité de ces histoires de guerre a poussé bon nombre de magazines à se cantonner dans ce genre. Et on peut penser que la Seconde Guerre mondiale y prédominait surtout parce que les Etats-Unis l'avaient remportée. *Battlefield*, reprise d'un illustré de Martin Goodman, fut créé pour répondre à la demande de magazines de « véritables » histoires de guerre. Il fut bientôt imité par *Real War* (avec notamment un numéro de science fiction sur la future guerre dans l'espace), *Men in Combat*, et une publication du groupe Charlton, *War Story*. Les filles de joie recyclées dans la guérilla et les autres prostituées héroïques eurent leur propre magazine, *Women in War*, tandis que *War Criminals* offrait une dose bimensuelle de camps de concentration avec leurs atrocités mais surtout les tortures de femmes dénudées.

Dans les années soixante, le centenaire de la Guerre de Sécession suscita son lot d'histoires sur les obscurs aspects du conflit, et pas seulement les grandes batailles : l'assassinat de Lincoln, les espionnes nordistes et les terribles conditions de vie des détenus dans les prisons ou les camps.

L'histoire qui revint le plus souvent fut celle de la jeune femme qui servit pendant des mois comme soldat dans l'armée sudiste, bien qu'à lire la version des magazines pour hommes on ne comprenne pas très bien comment cette superbe blonde aux formes suggestives ait pu, étroitement sanglée dans son uniforme, se faire passer pour un militaire…

◄ **TRUE WAR**, 1/1957, Clarence Doore

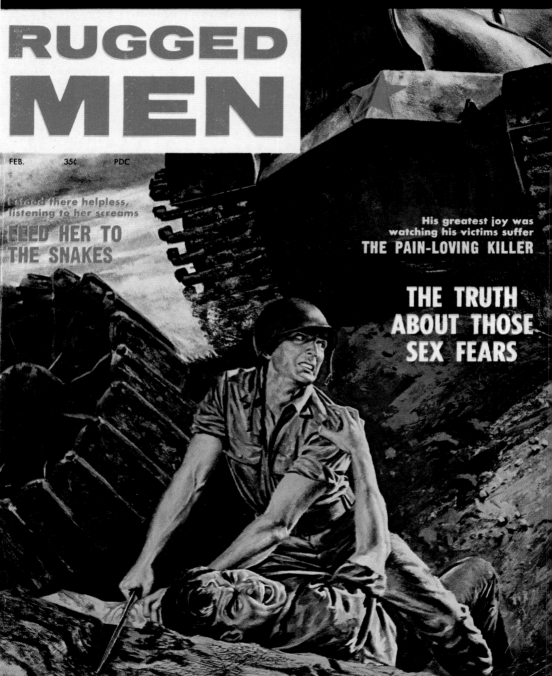

RUGGED MEN

FEB. 35¢ PDC

I stood there helpless, listening to her screams

FEED HER TO THE SNAKES

His greatest joy was watching his victims suffer

THE PAIN-LOVING KILLER

THE TRUTH ABOUT THOSE SEX FEARS

RUGGED MEN, 2/1961, Vic Prezio

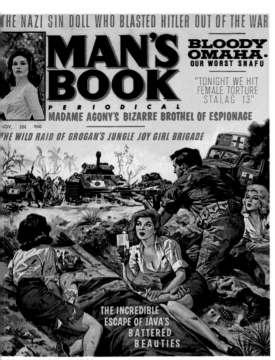

THE NAZI SIN DOLL WHO BLASTED HITLER OUT OF THE WAR

MAN'S BOOK
P E R I O D I C A L

BLOODY OMAHA- OUR WORST SNAFU

"TONIGHT WE HIT FEMALE TORTURE STALAG 13"

MADAME AGONY'S BIZARRE BROTHEL OF ESPIONAGE

THE WILD RAID OF GROGAN'S JUNGLE JOY GIRL BRIGADE

THE INCREDIBLE ESCAPE OF JAVA'S BATTERED BEAUTIES

MAN'S BOOK, 11/1962

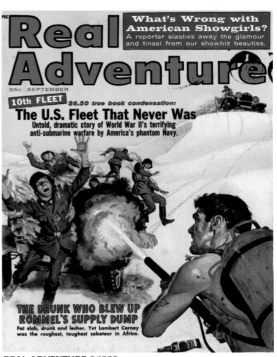

Real Adventure

What's Wrong with American Showgirls?
A reporter slashes away the glamour and tinsel from our showbiz beauties.

35c SEPTEMBER

10th FLEET $6.50 true book condensation:

The U.S. Fleet That Never Was
Untold, dramatic story of World War II's terrifying anti-submarine warfare by America's phantom Navy.

THE DRUNK WHO BLEW UP ROMMEL'S SUPPLY DUMP
Fat slob, drunk and lecher. Yet Lambert Carney was the roughest, toughest saboteur in Africa.

REAL ADVENTURE, 9/1963

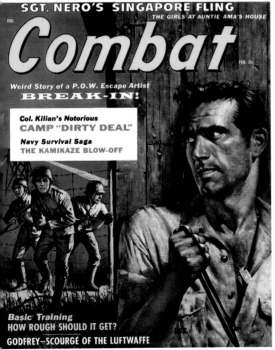

SGT. NERO'S SINGAPORE FLING
THE GIRLS AT AUNTIE AMA'S HOUSE

Combat
FEB. 35c

Weird Story of a P.O.W. Escape Artist
BREAK-IN!

Col. Kilian's Notorious
CAMP "DIRTY DEAL"

Navy Survival Saga
THE KAMIKAZE BLOW-OFF

Basic Training
HOW ROUGH SHOULD IT GET?

GODFREY—SCOURGE OF THE LUFTWAFFE

COMBAT, 2/1959

THE SYMPTOMS OF A SEX FIEND—A Medical Exclusive

IMPACT
BOLD TRUE ACTION FOR MEN

THE NAKED MAIDEN-WARRIORS of SAN ITO

World War II's Most Amazing Battle!

SLAUGHTER ON FIVE-MILE STRETCH
The Shocking, True Story Behind America's Deadliest Highway

STERLING MAGAZINE
JUNE · 25c

SCHULZ

Bloodbath at Kasserine Pass

IMPACT, 6/1957, Robert Schulz
STAG, 10/1959, Mort Künstler ▶▶

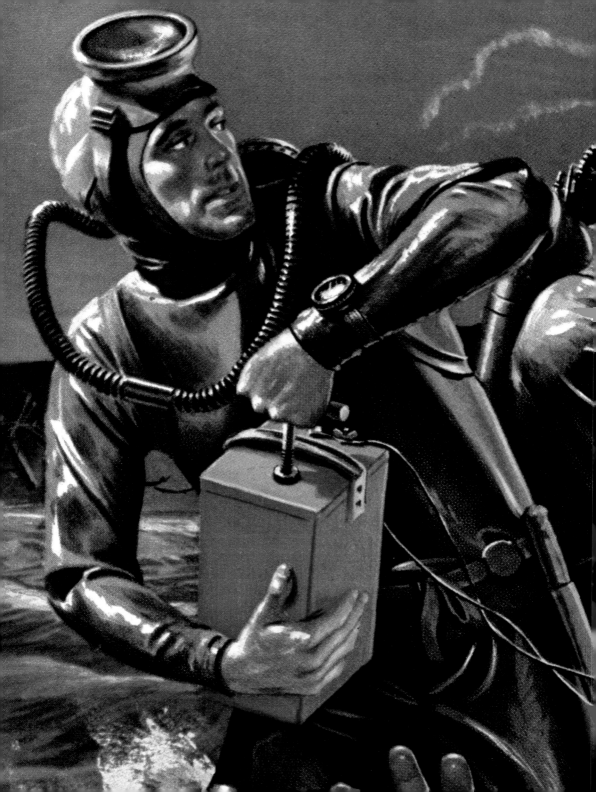

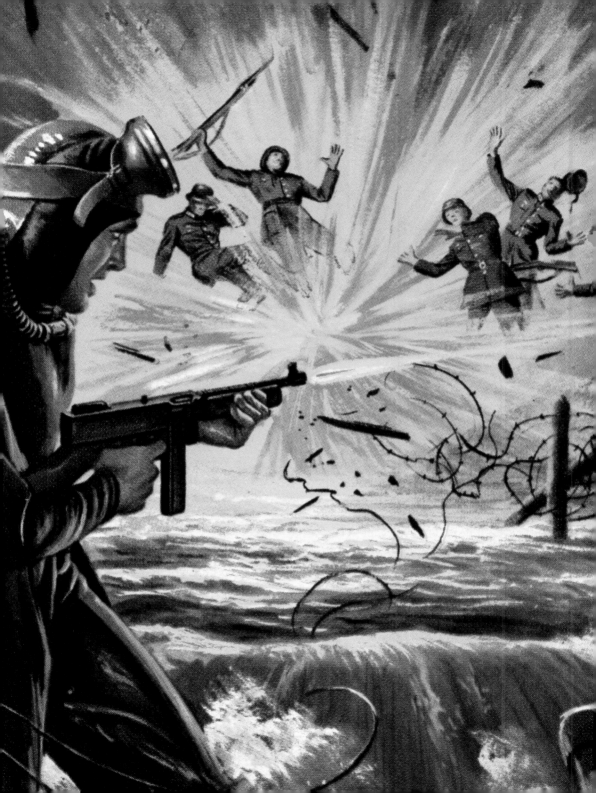

"I TOOK 910 DAYS TO ESCAPE"

(THE FANTASTIC SPY WHO CONNED THE GESTAPO)

IND.

25¢

Adventure Life

TIMOTHY BRIGGS: **CAPTIVE SAILOR OF TASMANIA'S AMAZON WOMEN**

(THEY FORCED HIM TO MARRY AN ENTIRE TRIBE)

MAR.

THE GENERAL'S LONE WOLF PATROL

TWO BOOKLENGTH BONUSES

35¢ 40¢ IN CANADA

IND. ◆

U.S. AGENT'S DESPERATE S.O.S.

"All Cuba Is Hunting Me... Will Fight On..." *Plus*

AUG.

MALE

GIRL FROM HONG KONG'S "HOT STREET"

THOSE SHOCKING HOUSING DEVELOPMENT SEX PARTIES

ORDERS TO A U.S. COMMANDO TEAM
Destroy That Bloody Bridge At Coblentz!

BLISTERING EXPOSE
RAW DEAL DETROIT GIVES CAR BUYERS

MALE, 8/1964, Mort Künstler

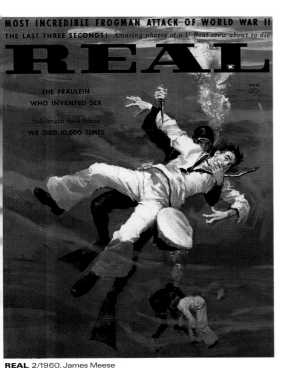

MOST INCREDIBLE FROGMAN ATTACK OF WORLD WAR II

THE LAST THREE SECONDS! *Amazing photos of a U-Boat crew about to die*

REAL

FEB 35¢

THE FRAULEIN
WHO INVENTED SEX

full-length book bonus

WE DIED 10,000 TIMES

REAL, 2/1960, James Meese

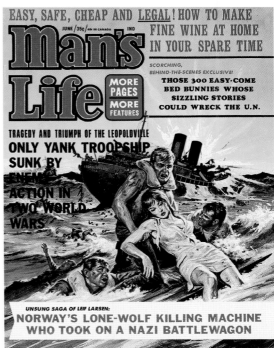

EASY, SAFE, CHEAP AND LEGAL! HOW TO MAKE FINE WINE AT HOME IN YOUR SPARE TIME

JUNE / 35¢ / 40¢ IN CANADA IND

man's Life

MORE PAGES
MORE FEATURES

SCORCHING,
BEHIND-THE-SCENES EXCLUSIVE!
THOSE 300 EASY-COME
BED BUNNIES WHOSE
SIZZLING STORIES
COULD WRECK THE U.N.

TRAGEDY AND TRIUMPH OF THE LEOPOLDVILLE
ONLY YANK TROOPSHIP SUNK BY ENEMY ACTION IN TWO WORLD WARS

UNSUNG SAGA OF LEIF LARSEN:
NORWAY'S LONE-WOLF KILLING MACHINE WHO TOOK ON A NAZI BATTLEWAGON

MAN'S LIFE, 6/1965, Earl Norem

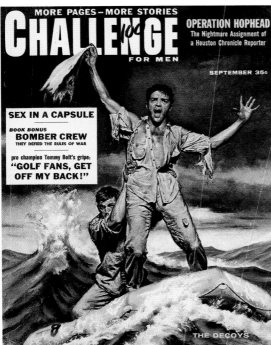

MORE PAGES - MORE STORIES

CHALLENGE
FOR MEN

OPERATION HOPHEAD
The Nightmare Assignment of
a Houston Chronicle Reporter

SEPTEMBER 35¢

SEX IN A CAPSULE

BOOK BONUS
BOMBER CREW
THEY DEFIED THE RULES OF WAR

pro champion Tommy Bolt's gripe:
"GOLF FANS, GET OFF MY BACK!"

THE DECOYS

CHALLENGE FOR MEN, 9/1958

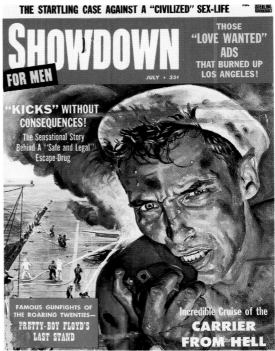

THE STARTLING CASE AGAINST A "CIVILIZED" SEX-LIFE STERLING

SHOWDOWN
FOR MEN

JULY • 35¢

THOSE
"LOVE WANTED"
ADS
THAT BURNED UP
LOS ANGELES!

"KICKS" WITHOUT CONSEQUENCES!
The Sensational Story
Behind A "Safe and Legal"
Escape-Drug

FAMOUS GUNFIGHTS OF
THE ROARING TWENTIES—
PRETTY-BOY FLOYD'S LAST STAND

Incredible Cruise of the
CARRIER FROM HELL

SHOWDOWN FOR MEN, 7/1958, George Gross

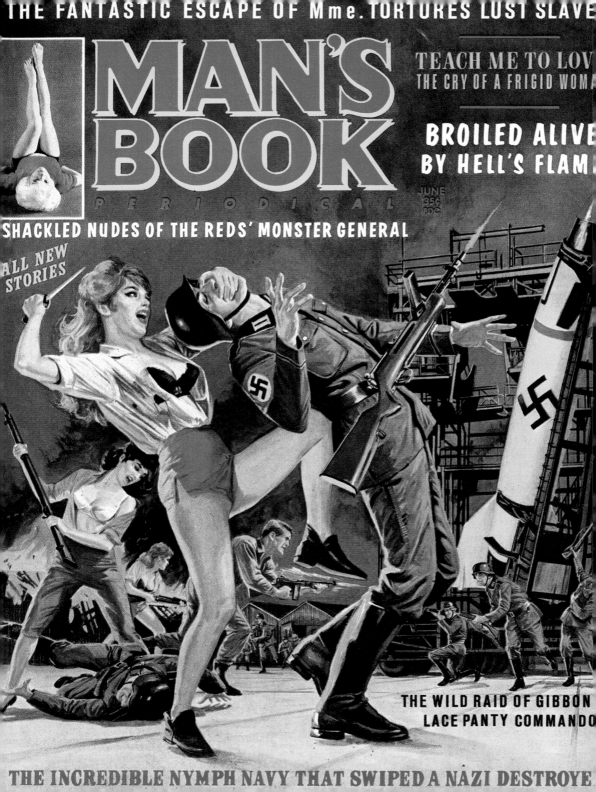

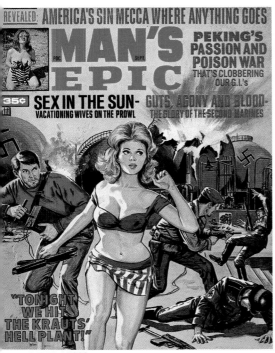

MAN'S EPIC, 9/1969

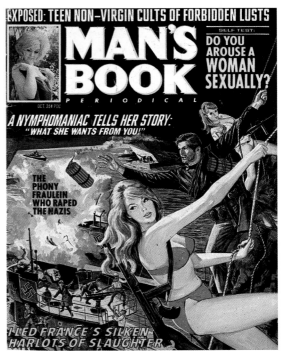

MAN'S BOOK, 10/1968

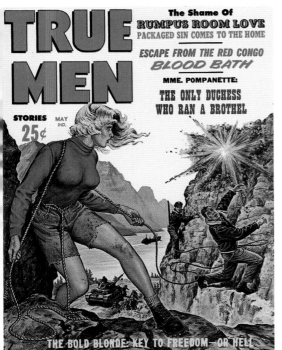

TRUE MEN STORIES, 5/1961, Earl Norem
◀ MAN'S BOOK, 6/1963

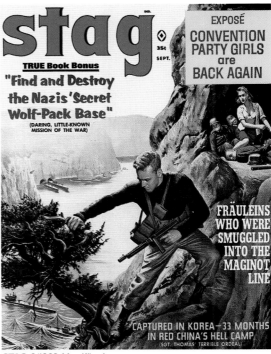

STAG, 9/1962, Mort Künstler
MAN'S BOOK, 1/1964 ▶▶

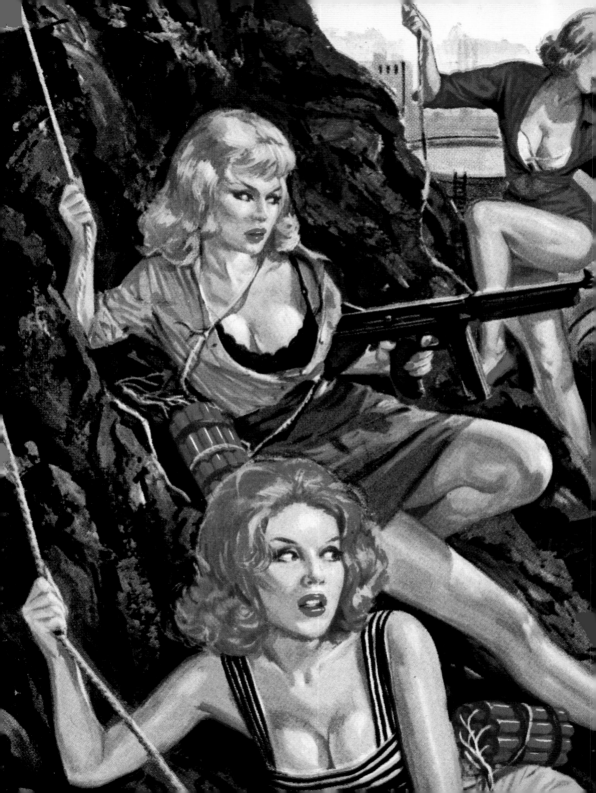

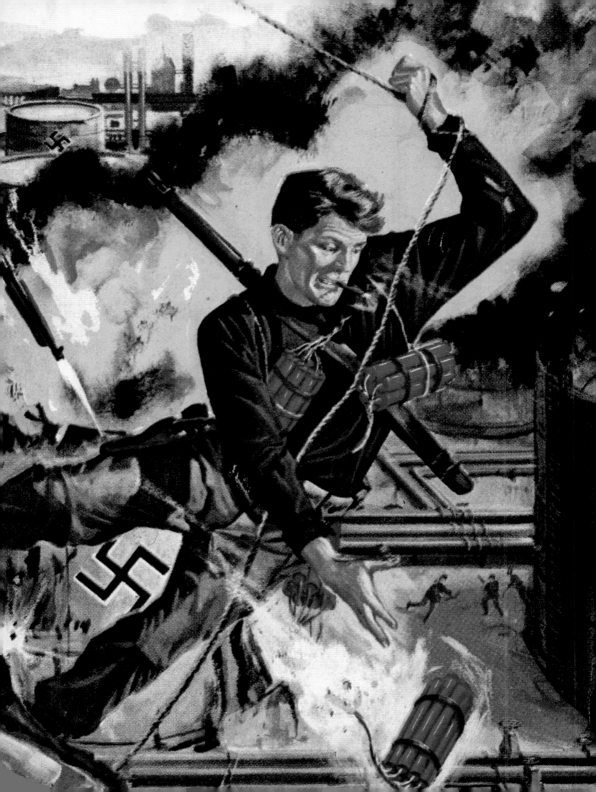

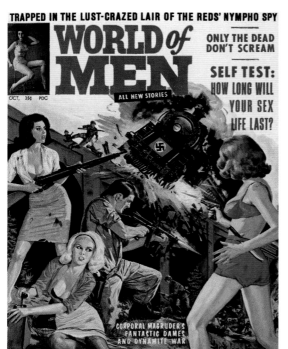

WORLD OF MEN, 10/1963

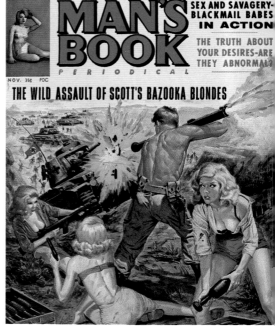

MAN'S BOOK, 11/1963

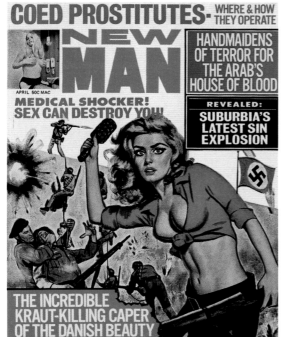

NEW MAN, 4/1970

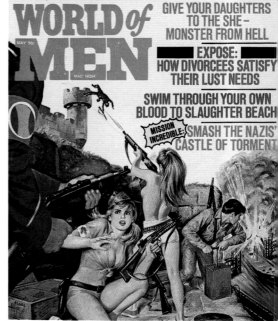

WORLD OF MEN, 5/1972
publication unknown, c. 1965, Earl Norem, mixed media, 48 x 61 cm ▶

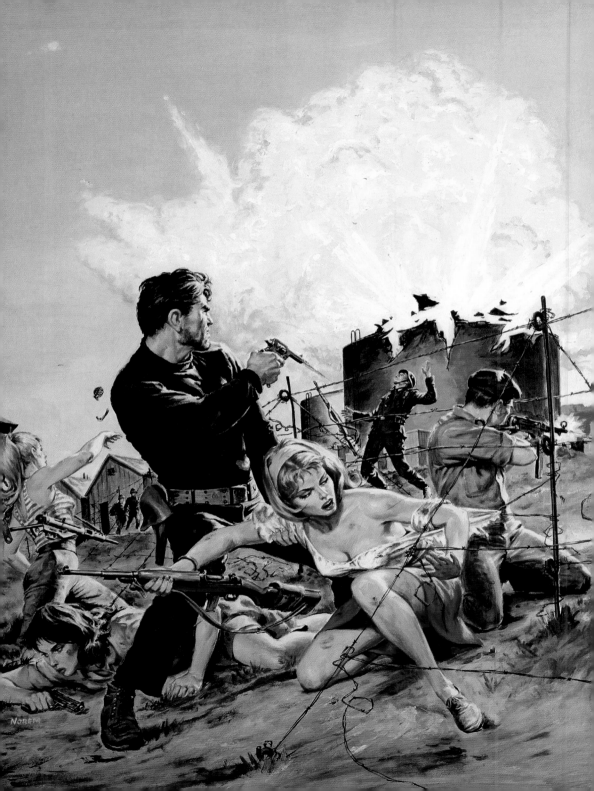

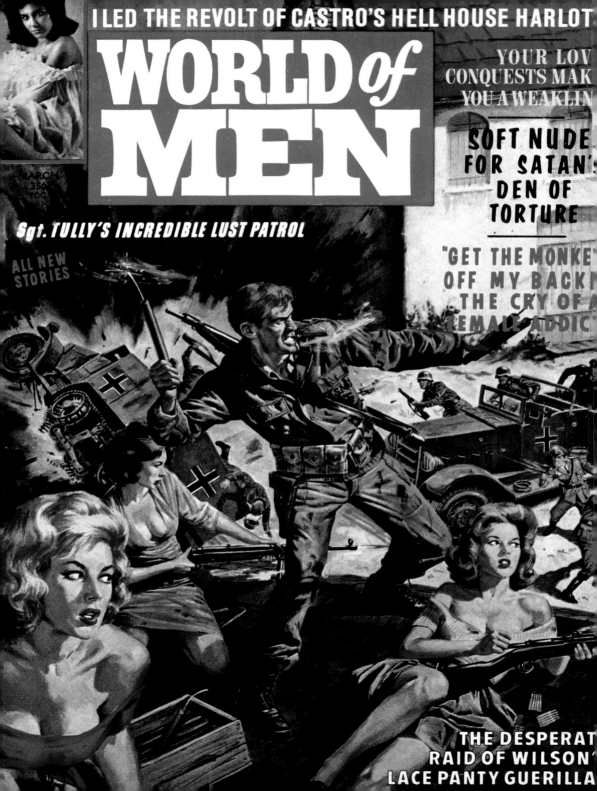

I LED THE REVOLT OF CASTRO'S HELL HOUSE HARLOT

WORLD *of* MEN

MARCH
35¢
7DC

Sgt. TULLY'S INCREDIBLE LUST PATROL

ALL NEW
STORIES

YOUR LOV
CONQUESTS MAK
YOU A WEAKLIN

**SOFT NUDE
FOR SATAN'
DEN OF
TORTURE**

"GET THE MONKE
OFF MY BACK!
THE CRY OF
FEMALE ADDIC

**THE DESPERAT
RAID OF WILSON
LACE PANTY GUERILLA**

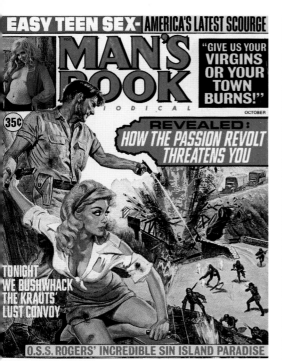

MAN'S BOOK, 10/1969

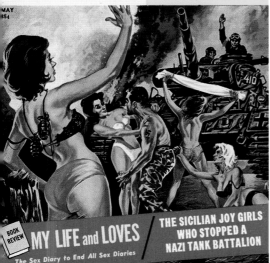

ESCAPE TO ADVENTURE, 5/1964, Mark Schneider
WORLD OF MEN, 3/1963

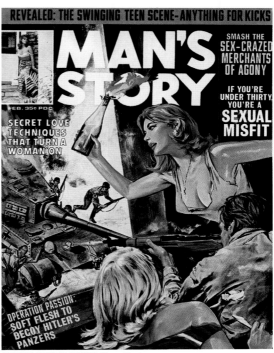

MAN'S STORY, 2/1969, Norm Eastman

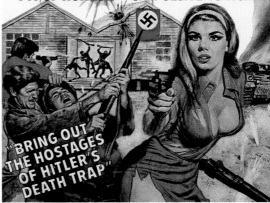

MEN TODAY, 3/1969
MAN'S ILLUSTRATED, 5/1963, gouache, 41 x 61 cm ▶▶

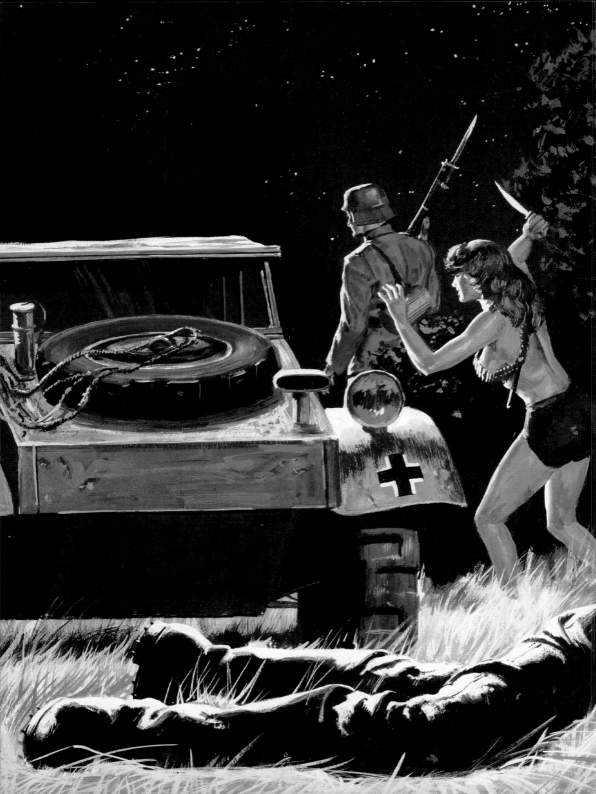

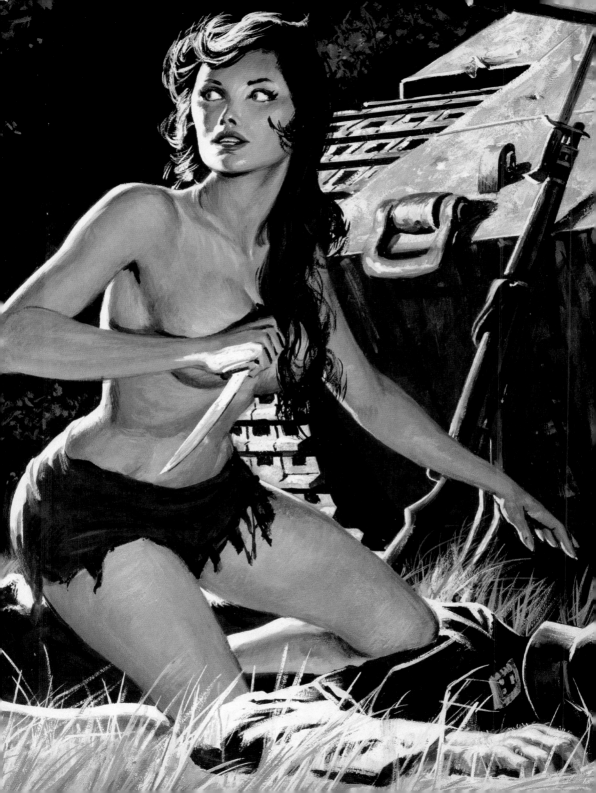

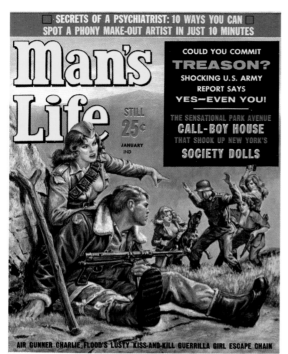

MAN'S LIFE, 1/1963, Earl Norem

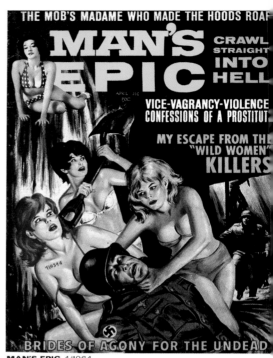

MAN'S EPIC, 4/1964

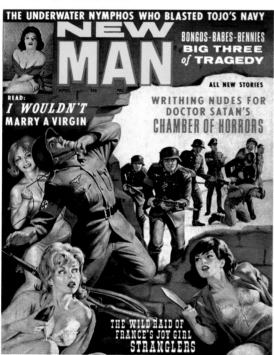

NEW MAN, 4/1963

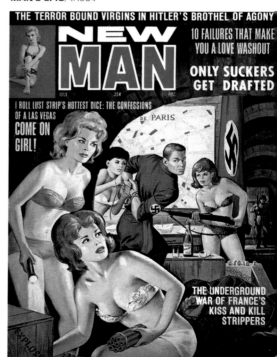

NEW MAN, 7/1964

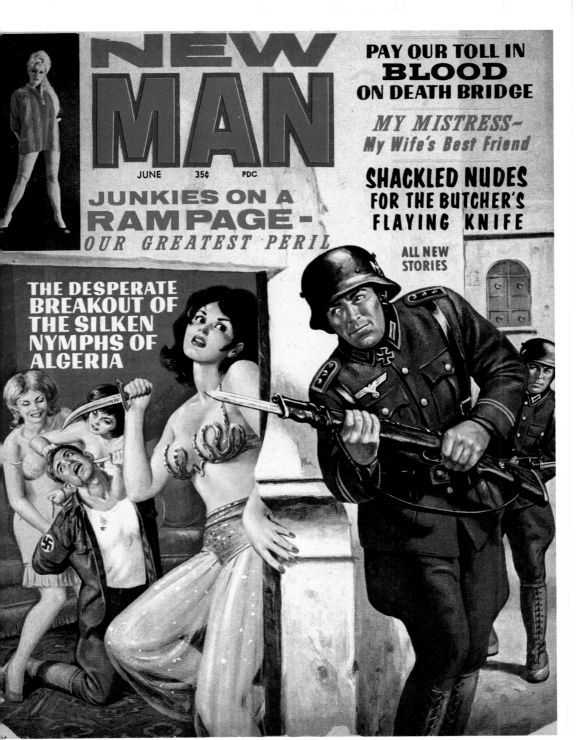

NEW MAN

JUNE 35¢ PDC

JUNKIES ON A RAMPAGE—
OUR GREATEST PERIL

PAY OUR TOLL IN
BLOOD
ON DEATH BRIDGE

MY MISTRESS—
My Wife's Best Friend

SHACKLED NUDES
FOR THE BUTCHER'S FLAYING KNIFE

ALL NEW
STORIES

THE DESPERATE BREAKOUT OF THE SILKEN NYMPHS OF ALGERIA

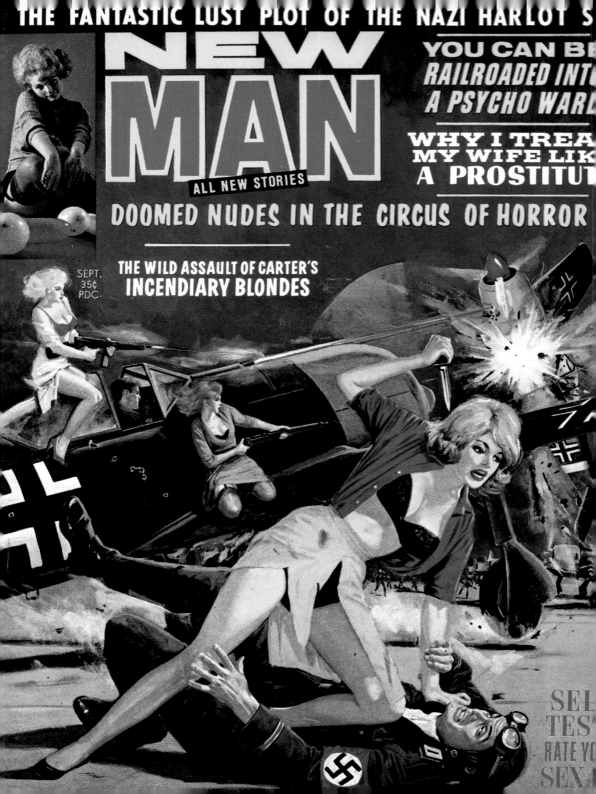

THE FANTASTIC LUST PLOT OF THE NAZI HARLOT S

NEW MAN

ALL NEW STORIES

YOU CAN BE
RAILROADED INT
A PSYCHO WARL

WHY I TREA
MY WIFE LIK
A PROSTITUT

DOOMED NUDES IN THE CIRCUS OF HORROR

SEPT.
35¢
PDC.

THE WILD ASSAULT OF CARTER'S
INCENDIARY BLONDES

SEL
TES
RATE YO
SEX

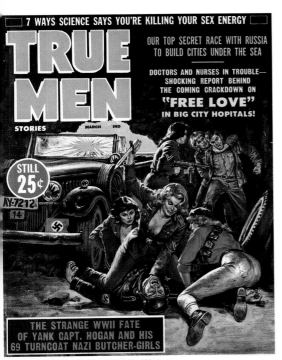

TRUE MEN STORIES, 3/1963, Earl Norem

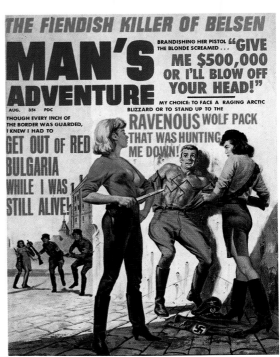

MAN'S ADVENTURE, 8/1966

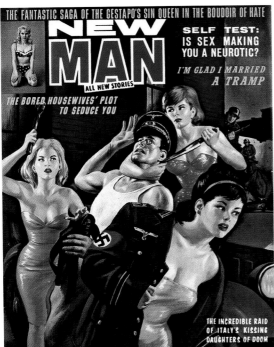

NEW MAN, 11/1963
◄ **NEW MAN**, 9/1963

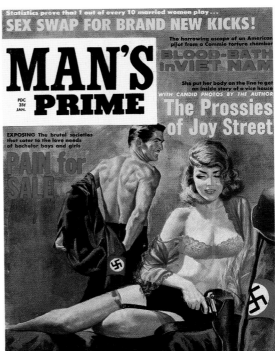

MAN'S PRIME, 1/1965

TRUE STORY OF A MAN WHO HAD ALL THE WOMEN HE WANTED

"I MAKE SEX MOVIES!"

MAN'S ADVENTURE

DEC. 35¢ PDC

A FORMER VICE COP EXPOSES THE RACKET

YOU CAN BE SET UP FOR BLACKMAIL!

Only the dead could arouse her passion

She Loved A Rotting Corpse

"NOT EVEN THE WALL COULD STOP ME

I ESCAPED FROM EAST BERLIN!"

MAN'S ADVENTURE, 12/1964

NEW MAN, 9/1965, Norman Saunders, gouache, 48 x 33 cm ▶

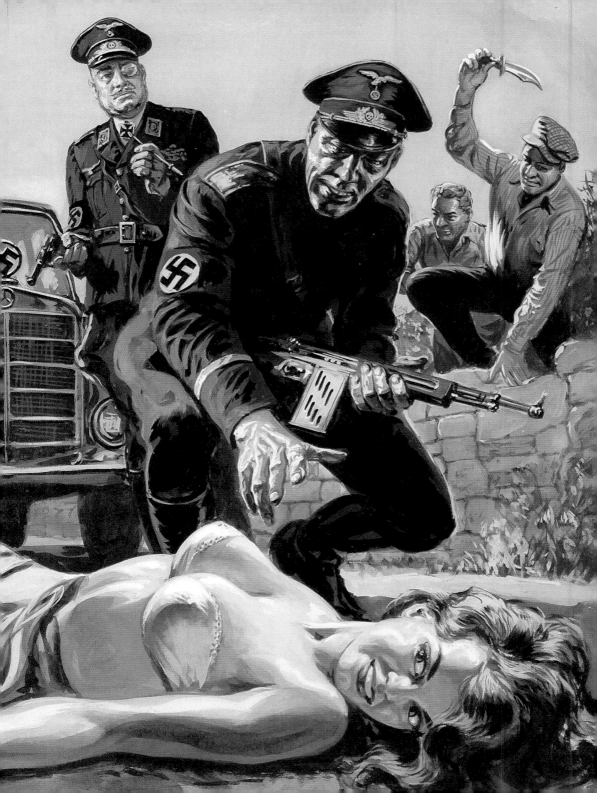

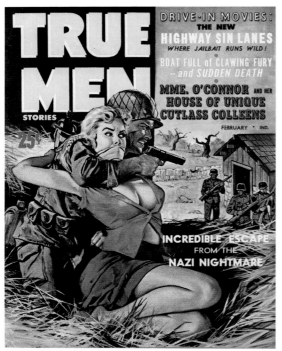

TRUE MEN STORIES, 2/1960, Will Hulsey

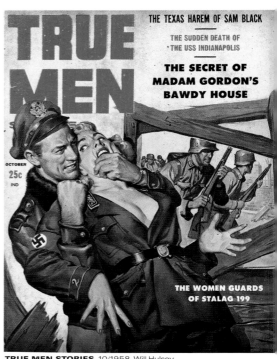

TRUE MEN STORIES, 10/1958, Will Hulsey

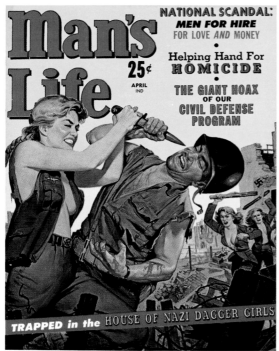

MAN'S LIFE, 4/1960, Will Hulsey

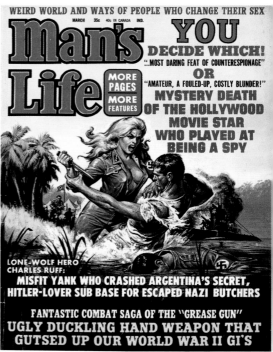

MAN'S LIFE, 3/1965, Earl Norem

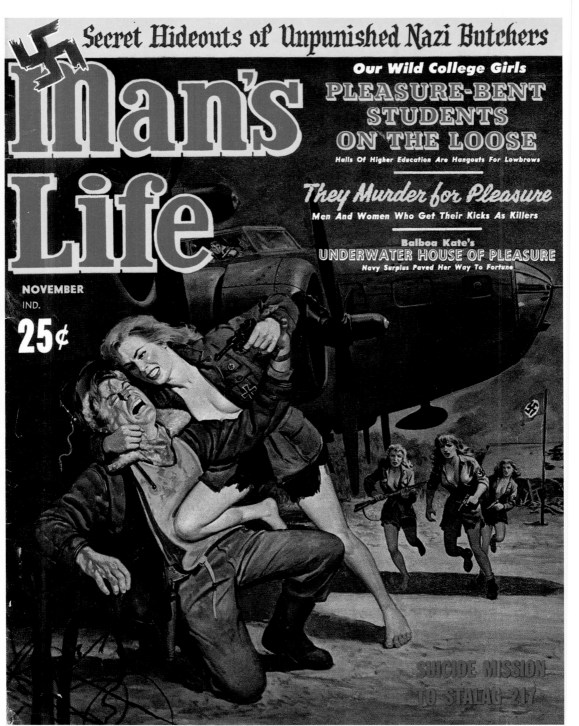

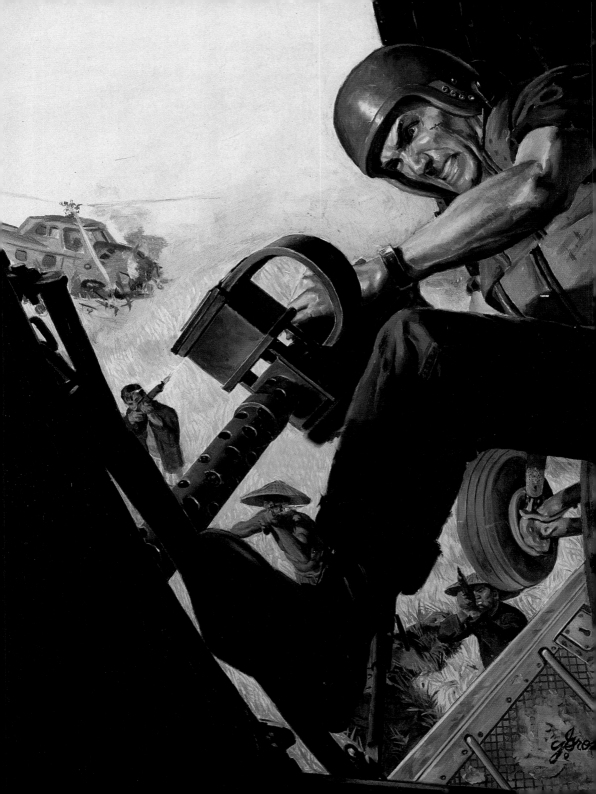

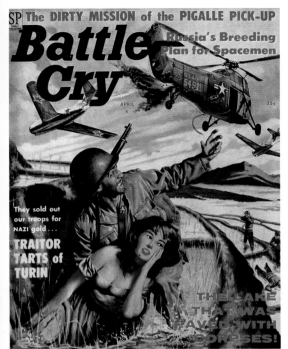

BATTLE CRY, 4/1959, Vic Prezio

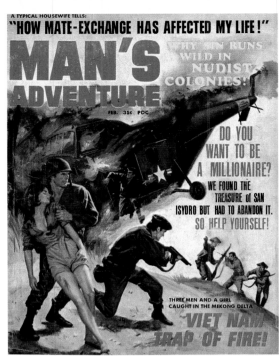

MAN'S ADVENTURE, 2/1967

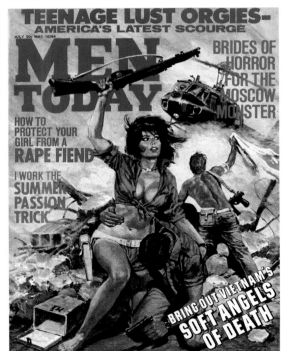

MEN TODAY, 7/1972, Sommer
◄ **MAN'S ILLUSTRATED**, 9/1965, George Gross, oil, 31 x 41 cm

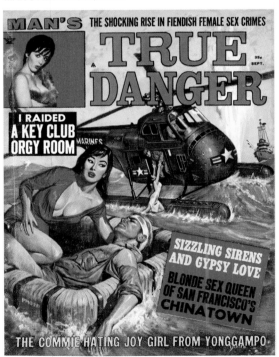

MAN'S TRUE DANGER, 9/1964, John Duillo
REAL COMBAT STORIES, 4/1965 ▶▶

SPECIAL Book Bonus ESCAPE FROM HELL ◆

"...CASABLANCA'S MOST INFAMOUS WOMAN...N. AFRICA'S MOST HUNTED MAN...
CAUGHT IN THE VIOLENCE OF ALGERIA...SHOCKING...SENSATIONAL..." *THE RECORDER*

FEB •

stag

IND.

35¢ 40¢ IN CANADA

THE GI WHO
TRACKED DOWN
PARIS'
MADEMOISELLE
"UNDERGROUND"

THE DAY 3800 U.S. BOMBERS
TOOK ON THE ENTIRE
LUFTWAFFE
(GREATEST ALL-OUT AIR FORCE GAMBLE)

**Call Girls
on Wheels**
THEY FOLLOW
THE FLEET

STAG, 2/1963, Mort Künstler

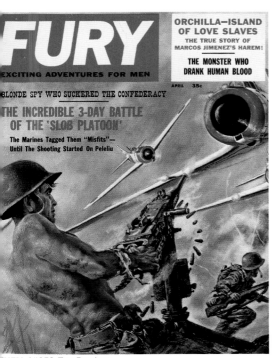

FURY, 4/1959, Tom Beecham

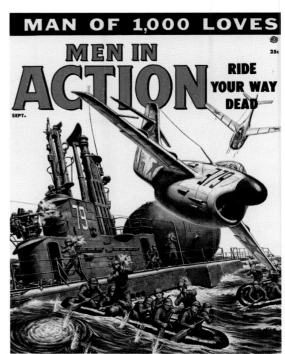

MEN IN ACTION, 9/1955, Clarence Doore

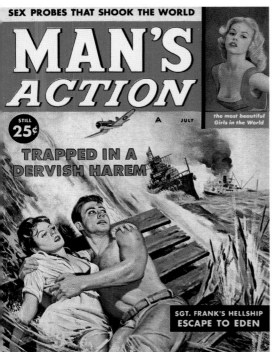

MAN'S ACTION, 7/1959

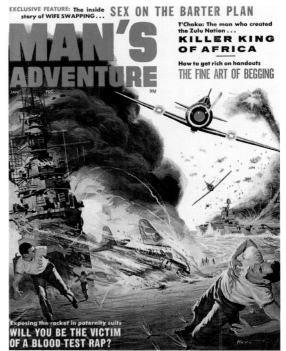

MAN'S ADVENTURE, 1/1962, Vic Prezio

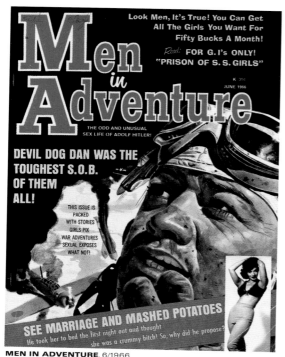

MEN IN ADVENTURE, 6/1966

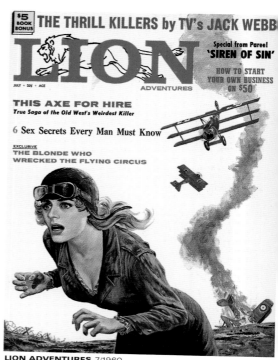

LION ADVENTURES, 7/1960

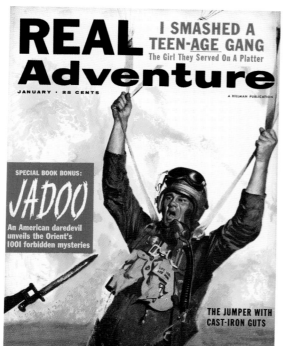

REAL ADVENTURE, 1/1958

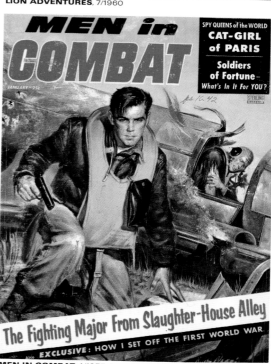

MEN IN COMBAT, 1/1957, Rudy Nappi
MAN'S EPIC, 11/1963 ▶

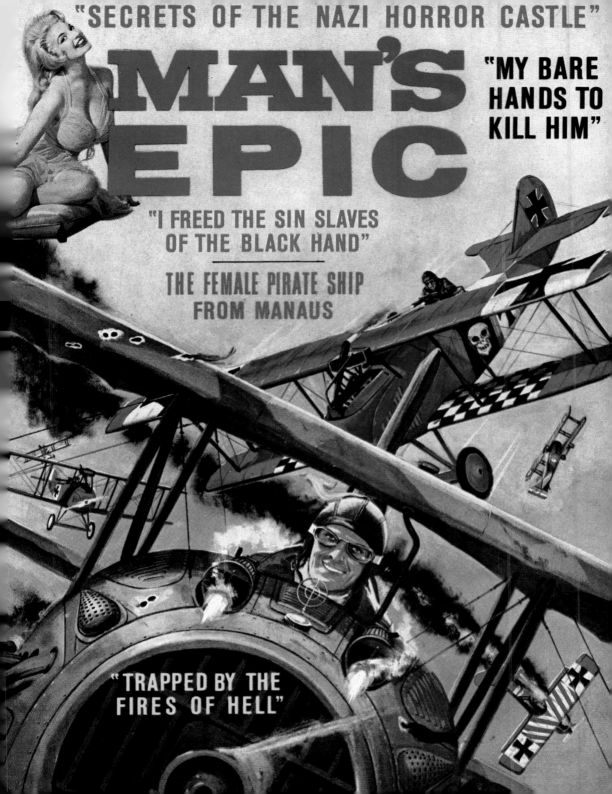

MAN'S LIFE, 2/1961, Will Hulsey

MAN'S LIFE, 1/1962, Will Hulsey

MAN'S LIFE, 8/1959, Will Hulsey

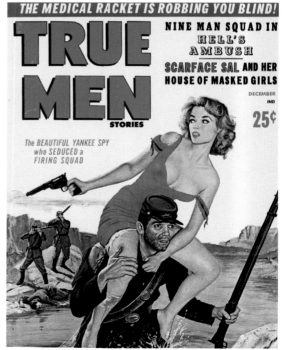

TRUE MEN STORIES, 12/1959, Will Hulsey
MAN'S LIFE, 11/1958, Will Hulsey, mixed media, 49 x 64 cm ▶

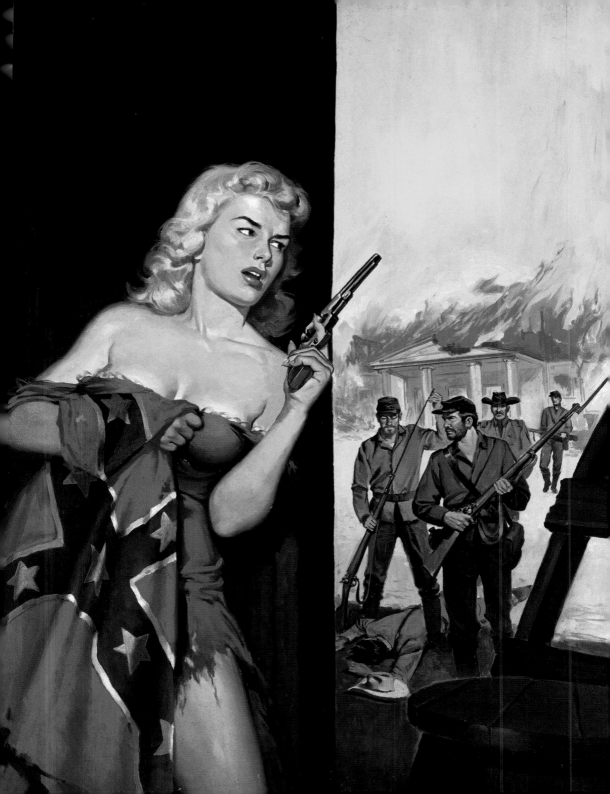

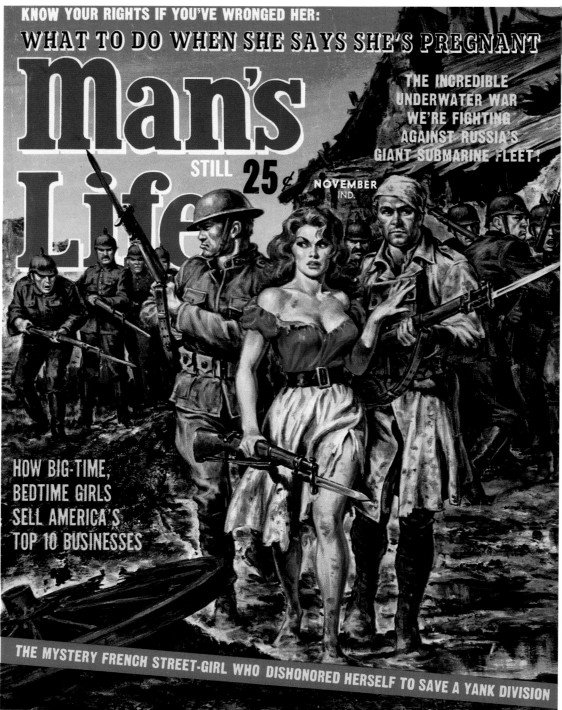

KNOW YOUR RIGHTS IF YOU'VE WRONGED HER:

WHAT TO DO WHEN SHE SAYS SHE'S PREGNANT

Man's Life

STILL 25¢

THE INCREDIBLE UNDERWATER WAR WE'RE FIGHTING AGAINST RUSSIA'S GIANT SUBMARINE FLEET!

NOVEMBER IND.

HOW BIG-TIME, BEDTIME GIRLS SELL AMERICA'S TOP 10 BUSINESSES

THE MYSTERY FRENCH STREET-GIRL WHO DISHONORED HERSELF TO SAVE A YANK DIVISION

MAN'S LIFE, 11/1962, Earl Norem

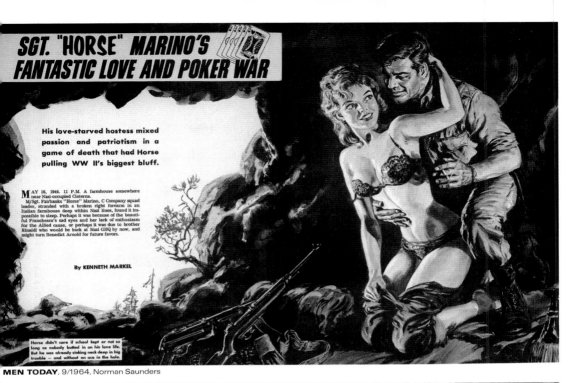

SGT. "HORSE" MARINO'S
FANTASTIC LOVE AND POKER WAR

His love-starved hostess mixed passion and patriotism in a game of death that had Horse pulling WW II's biggest bluff.

MAY 16, 1944. 11 P.M. A farmhouse somewhere near Nazi-occupied Cisterna. M/Sgt. Fairbanks "Horse" Marino, C Company squad leader, stranded with a broken right forearm in an Italian farmhouse deep within Nazi lines, found it impossible to sleep. Perhaps it was because of the beautiful Franchesca's sad eyes and her lack of enthusiasm for the Allied cause, or perhaps it was due to brother Rinaldi who would be back at Nazi GHQ by now, and might turn Benedict Arnold for future favors.

By KENNETH MARKEL

Horse didn't care if school kept or not so long as nobody butted in on his love life. But he was already sinking neck deep in big trouble — and without an ace in the hole.

MEN TODAY, 9/1964, Norman Saunders

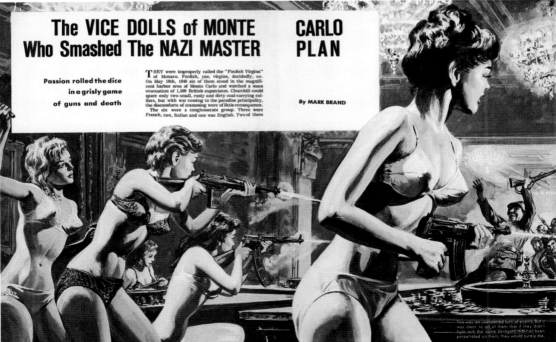

The VICE DOLLS of MONTE CARLO
Who Smashed The NAZI MASTER PLAN

Passion rolled the dice in a grisly game of guns and death

THEY were improperly called the "Foolish Virgins" of Monaco. Foolish, yes; virgins, decidedly, no. On May 10th, 1940 six of them stood in the magnificent harbor area of Monte Carlo and watched a mass evacuation of 1,500 British expatriates. Churchill could spare only two small, rusty and dirty coal-carrying colliers, but with war coming to the paradise principality, the discomforts of cramming were of little consequence.

The six were a conglomerate group. Three were French, two, Italian and one was English. Two of them

By MARK BRAND

This was an unexpected turn of events, but it was clear to all of them that if they didn't fight with the same savagery that had been perpetrated on them, they would surely die.

WORLD OF MEN, 1/1968, Norman Saunders

ANC

MEN in COMBAT

JULY • 25¢

STERLING
MAGAZINE

ROCK O
THE MARN

Story of the Fightin
Third Infantry Divisi

G.I. Heaven, 1957
ONE MAD NIGHT IN MUN

KILL-CRUISE of the
CAST-IRON FORTRESS

BLUEBOOK, 8/1965, Mel Crair, mixed media, 44 x 64 cm
◄ **MEN IN COMBAT**, 7/1957, Mort Künstler

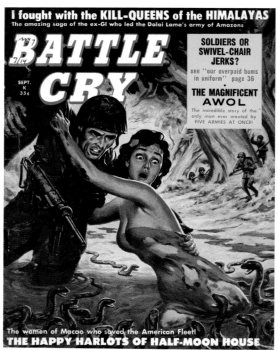

I fought with the KILL-QUEENS of the HIMALAYAS
The amazing saga of the ex-GI who led the Dalai Lama's army of Amazons

BATTLE CRY

SEPT.
K
35¢

SOLDIERS OR SWIVEL-CHAIR JERKS?
see "our overpaid bums in uniform" page 36

THE MAGNIFICENT AWOL
The incredible story of the only man ever wanted by FIVE ARMIES AT ONCE!

The women of Macao who saved the American Fleet!
THE HAPPY HARLOTS OF HALF-MOON HOUSE

BATTLE CRY, 9/1959, Clarence Doore

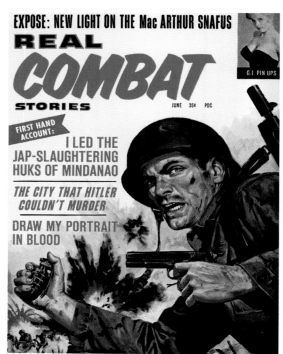

EXPOSE: NEW LIGHT ON THE MacARTHUR SNAFUS

REAL COMBAT STORIES

JUNE 35¢ PDC

G.I. PIN UPS

FIRST HAND ACCOUNT:
I LED THE JAP-SLAUGHTERING HUKS OF MINDANAO

THE CITY THAT HITLER COULDN'T MURDER

DRAW MY PORTRAIT IN BLOOD

REAL COMBAT, 6/1964

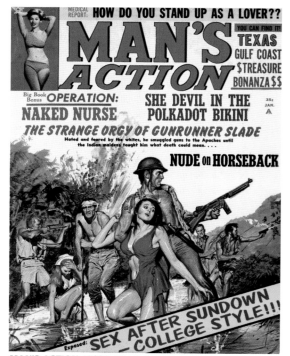

MEDICAL REPORT: HOW DO YOU STAND UP AS A LOVER??

MAN'S ACTION

TEXAS GULF COAST $TREASURE BONANZA $$

Big Book Bonus OPERATION: NAKED NURSE

SHE DEVIL IN THE POLKADOT BIKINI

35¢
JAN.
A

THE STRANGE ORGY OF GUNRUNNER SLADE
Hated and feared by the whites, he smuggled guns to the Apaches until the Indian maidens taught him what death could mean....

NUDE on HORSEBACK

Exposed: SEX AFTER SUNDOWN — COLLEGE STYLE!!!

MAN'S ACTION, 1/1968, John Duillo

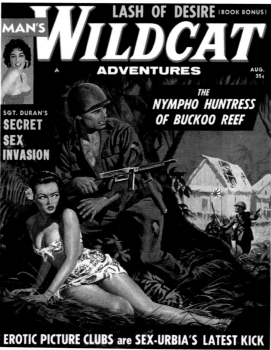

LASH OF DESIRE (BOOK BONUS)

MAN'S
WILDCAT ADVENTURES

AUG.
35¢

SGT. DURAN'S SECRET SEX INVASION

THE NYMPHO HUNTRESS OF BUCKOO REEF

EROTIC PICTURE CLUBS are SEX-URBIA'S LATEST KICK

WILDCAT ADVENTURES, 8/1959
MEN IN ADVENTURE, 5/1959, Rafael DeSoto, gouache, 45 x 58 cm ▶

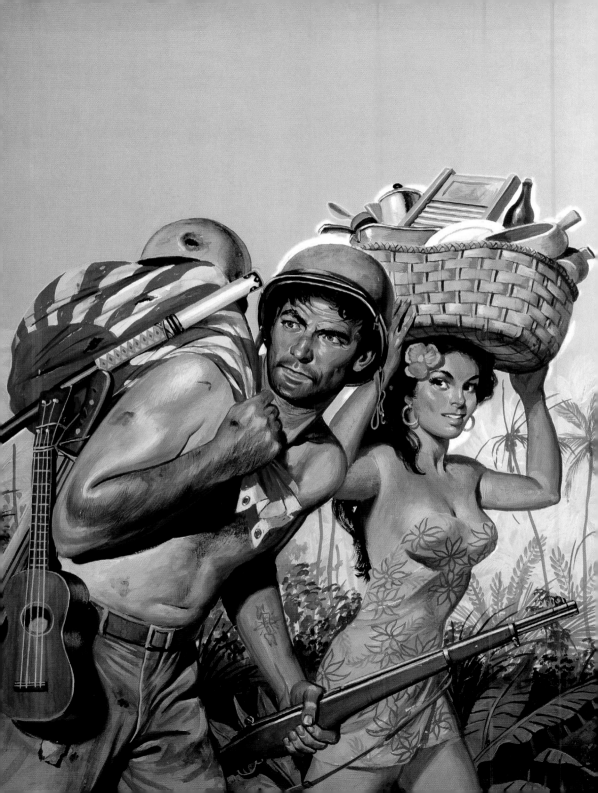

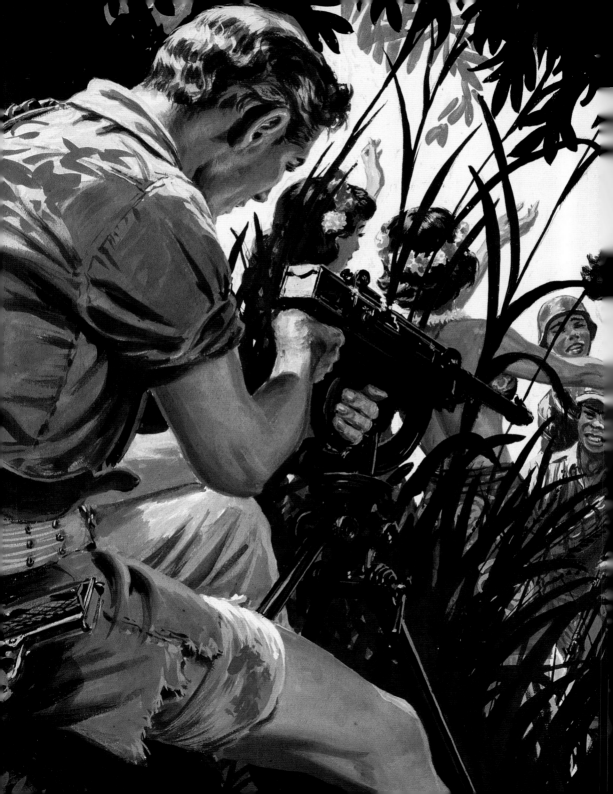

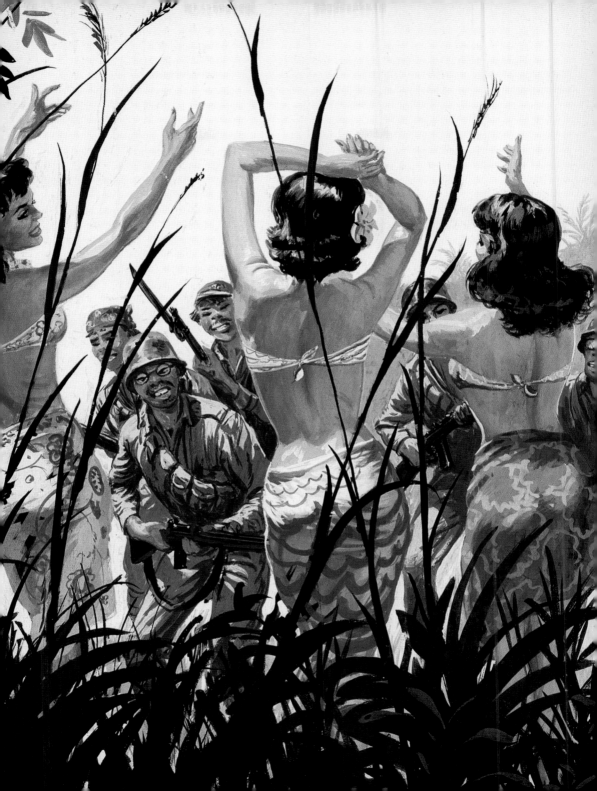

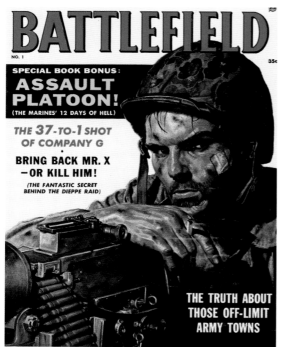

BATTLEFIELD, No. 1/1957, Charles Copeland

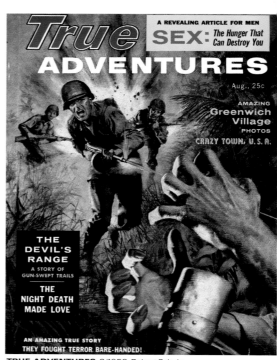

TRUE ADVENTURES, 8/1958, Robert Schulz

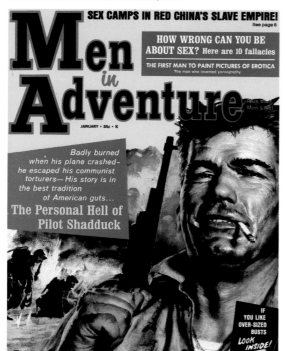

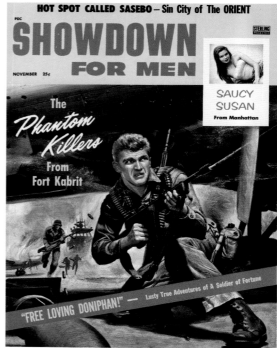

MEN IN ADVENTURE, 1/1967
◄◄ **ADVENTURES FOR MEN**, 8/1959, Norman Saunders, gouache, 45 x 47 cm

SHOWDOWN FOR MEN, 11/1957
STAG, 7/1959, Mort Künstler ►

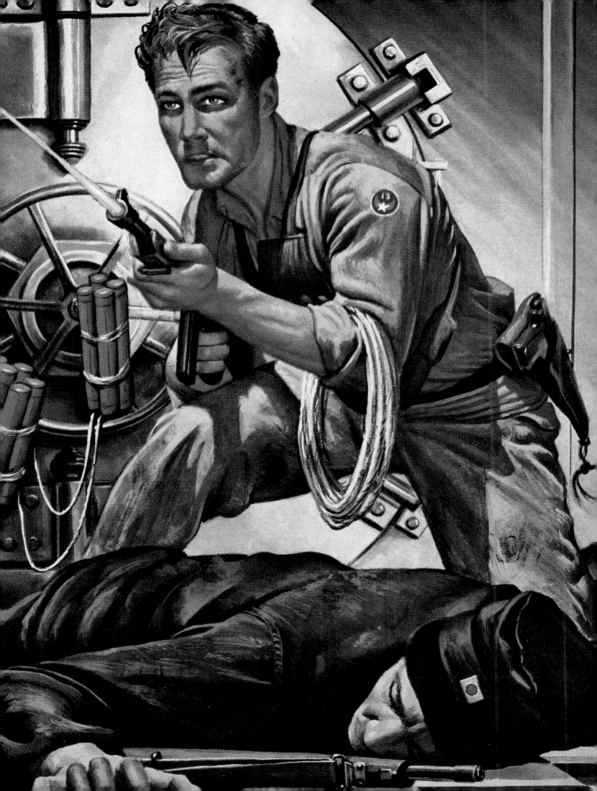

GUY
TRUE ADVENTURES

The $1500-a-Night Girls
MADAM DAISY'S
CHARLESTON FUN HOUSE

Saga of Slim Jim Gavin
THE GENERAL WHO
PARACHUTED
INTO HELL

THE WILD WEST'S
DAMNEDEST LIAR

JAN. • 35¢

Torture in the Arab Hoggar
CPL. POBEGUIN'S
4-MONTH SAHARA ORDEAL

World's Greatest Break-out Artist
THE 11 INCREDIBLE ESCAPES
OF A MASTER SPY

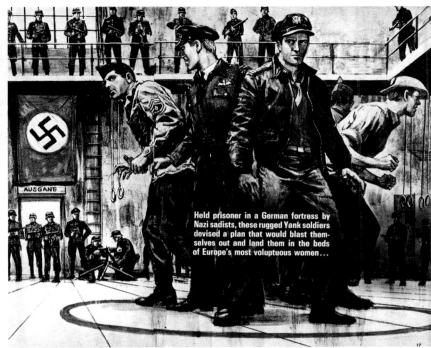

EXPLOSIVE BOOK BONUS

ESCAPE OR DIE!

"Unbelievable excitement . . . Sex-hungry frauleins . . ." —POST

By MARIO CLERI

ON CHRISTMAS Day, 1944, two German SS officers presented certain official documents to the Wehrmacht Commander of Stalag 21 in eastern Prussia, the prison camp used to hold the most dangerous of Allied war prisoners. The Wehrmacht Kommandant, a Colonel named Jarz, studied his documents and paled slightly. "I must protest," he said. "These orders are a direct violation of the Geneva convention. They are not military orders. They are criminal orders."

One of the SS officers drew his side-arm. "Colonel Jarz, one more word and I must place you under arrest as a traitor to the Fatherland. These orders will be obeyed. They will be carried out in the utmost secrecy. Do you understand?"

Colonel Jarz stared at the SS officer and then shrugged. "As you wish," he said. "But some day we may all hang for this dirty piece of work."

Thirty minutes later one of the prisoners in the camp was hustled out to the Kommandant's office. There he was turned over to the two SS officers who put him in a staff car that held four SS troopers. The prisoner was told he was being transferred to another camp but he knew something strange was afoot. However he was too closely guarded to attempt escape.

The staff car rolled out of the Stalag 21 gates. It went at full speed through the night on the road heading toward Berlin. When it had traveled about 20 miles, the SS men made their prisoner get out of the car and kneel beside the road. One of *(Continued on page 80)*

Art by Gil Cohen

Mabry looked around at the well armed Nazis before giving his men the signal.

Held prisoner in a German fortress by Nazi sadists, these rugged Yank soldiers devised a plan that would blast themselves out and land them in the beds of Europe's most voluptuous women . . .

17

TRUE ACTION, 2/1970, Gil Cohen

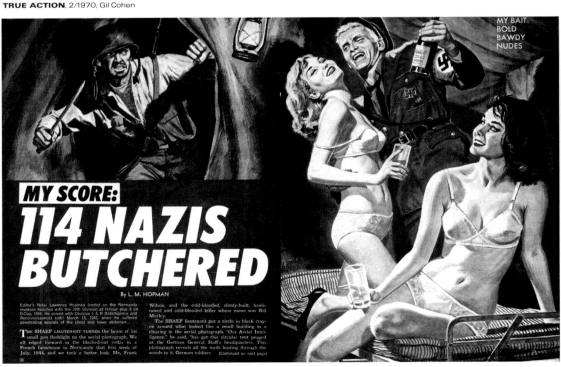

MY BAIT: BOLD BAWDY NUDES

MY SCORE: 114 NAZIS BUTCHERED

By L. M. HOPMAN

Editor's Note: Lawrence Hopman landed on the Normandy invasion beaches with the 29th Division at H-hour plus 8 on D-Day, 1944. He served with Division I & R (Intelligence and Reconnaissance) until March 15, 1945, when he suffered penetrating wounds of the chest and lower abdomen.

THE SHAEF LIEUTENANT TURNED the beam of his small pen flashlight on the aerial photograph. We all edged forward in the blacked-out cellar in a French farmhouse in Normandy that first week of July, 1944, and we took a better look. Me, Frank Wilson, and the cold-blooded, slimly-built, hawk-nosed and cold-blooded killer whose name was Bill Morley.

The SHAEF lieutenant put a circle in black crayon around what looked like a small building in a clearing in the aerial photograph. "Our Aerial Intelligence," he said, "has got this circular tent pegged as the German General Staff's headquarters. This photograph reveals all the trails leading through the woods to it. German soldiers *(Continued on next page)*

38

MAN'S DARING, 1/1966
◄ **GUY**, 1/1959

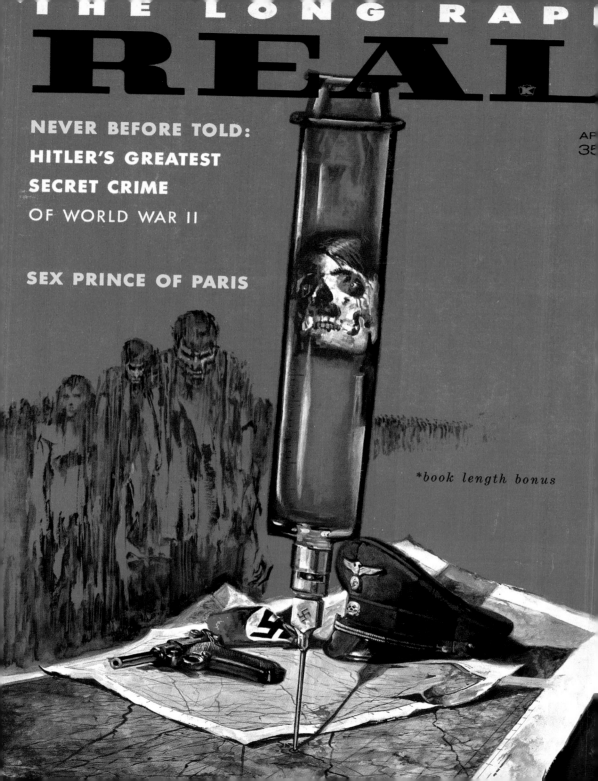

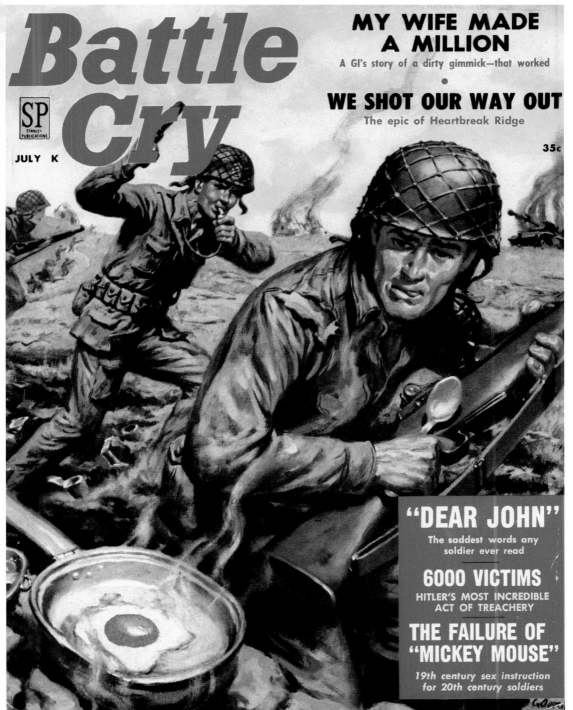

BATTLE CRY, 7/1958, Clarence Doore
◄ **REAL**, 4/1960

Battle Cry

SP
STANLEY
PUBLICATIONS

JULY K

MY WIFE MADE A MILLION
A GI's story of a dirty gimmick—that worked
•
WE SHOT OUR WAY OUT
The epic of Heartbreak Ridge

35c

"DEAR JOHN"
The saddest words any
soldier ever read

6000 VICTIMS
HITLER'S MOST INCREDIBLE
ACT OF TREACHERY

THE FAILURE OF "MICKEY MOUSE"
19th century sex instruction
for 20th century soldiers

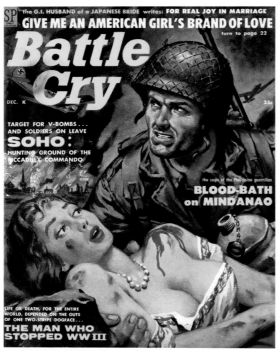

BATTLE CRY, 12/1958, Clarence Doore

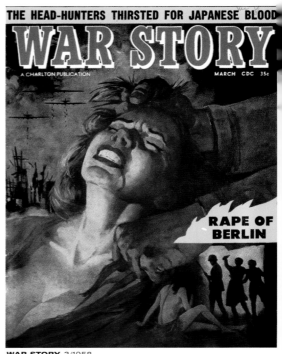

WAR STORY, 3/1958

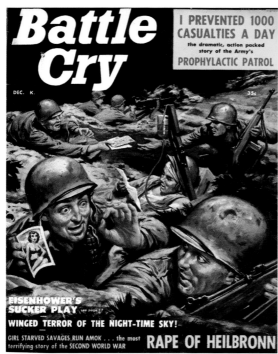

BATTLE CRY, 12/1957, Clarence Doore

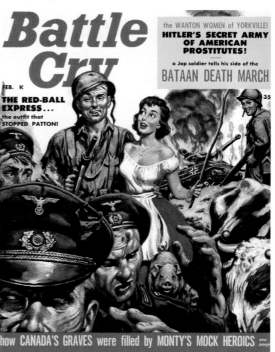

BATTLE CRY, 2/1958, Clarence Doore
BATTLE CRY, 10/1957, Clarence Doore ▶

Battle Cry

CT. 35¢ K

WHERE THE AMERICAN ARMY LEARNED ABOUT SEX!

We buried them alive...in
THE DEATH CAVES OF BIAK

the wildest celebration in history
THE DAY THAT PARIS FELL

HE CANADIAN CORVETTE: The Ship that Saved the Atlantic

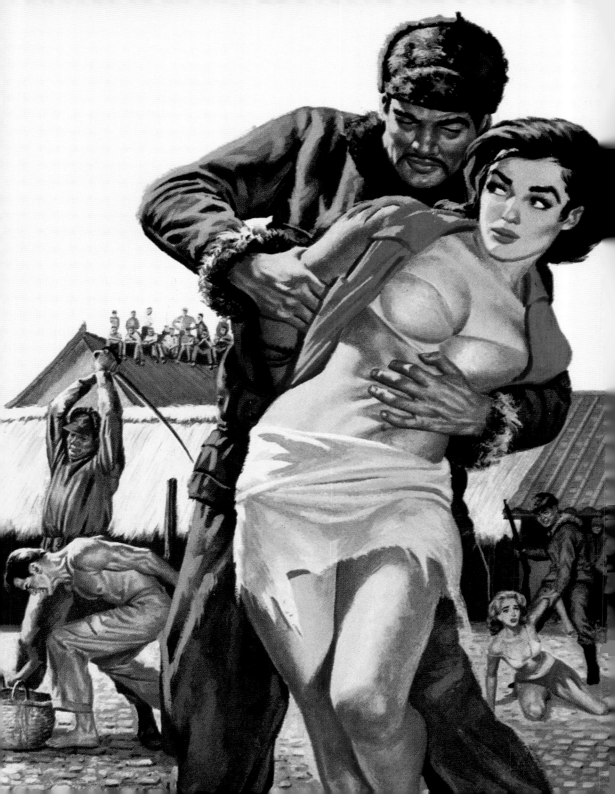

CHAPTER 5

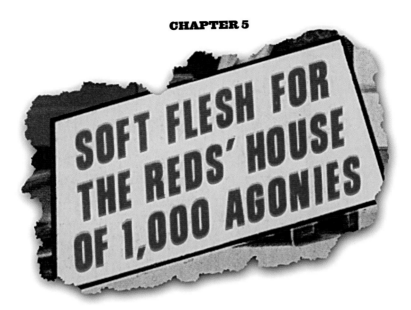

THE RED MENACE
AND THE YELLOW PERIL

The men's adventure magazines thrived during the Cold War and Vietnam War. As can be expected, the "Communist Menace" was a prime theme — from tales of Russian plans to poison America's water supplies to stories of fighting the Vietcong in tunnel hideaways.

Americans, it seems, were always on the lookout for a peril from the East. The early pulps had offered a horde of inscrutable Chinese à la Fu Manchu. After Pearl Harbor, menacing Japanese were de rigueur; by the fifties they were joined by Red Chinese and North Koreans, while the sixties saw the addition of Vietcong to the list of stock Asian villains. The men's adventure magazines used them interchangeably; whatever their particular ethnicity or nationality, these bad guys had it in for white women.

Communist conspiracies made for great jingoistic headlines like "Rake the Red Rats to Shreds" or "Soviet Slave Camp: Torture in Hell," but often did not inspire cover artists to their most outrageous work, as spies did not provide the extreme action images that sold men's magazines. This all changed with the Russian defeat of the Hungarian Revolution of 1956, which supplied numerous stories of joy girls battling the Russians or heroic harlots tortured in re-education camps.

True Adventures bore a Rafael DeSoto cover for "I Was a Red Torture Prisoner," depicting women in their underwear battling with communist guards. Atop the prison wall, a manly man is about to come to their rescue, having already killed the guard in the watchtower. The article inside, however, describes no such scene. Women are hardly mentioned in several grueling pages of descriptions of inhumane conditions supposedly faced by the writer when he was confined in communist prisons in Hungary.

Even stranger is the October 1964 *Men Today* cover story, "The Silk Panties Platoon Who Broke Castro's Blockade," depicting Cuban soldiers inflicting various tortures on beautiful women. Not only is the scene not recounted in the story, but there is no story about Cuba in that issue.

Since Russia occupied East Germany during the Cold War, such "true" stories as "Secrets of the East Berlin Torture Palace" are actually just rewritten Nazi torture stories with Russians replacing the traditional German commandants.

The turn-of-the-century concept of the "Yellow Peril" lived on in men's adventure magazines — whether World War II-era Japanese, the Red Chinese, or the Vietnamese, "Orientals" were depicted as devils and always as a threat. In 1942, right after Pearl Harbor, *True* magazine put out a one-shot, "Jap Blood Cults," outlining atrocities by the Japanese in China and Manchuria, which could have served as the model for men's adventure magazine World War II stories.

Historically, most Japanese atrocities — the murder of civilian populations and the drafting of local women into brothels to service Japanese troops — were committed against other Asian populations. These covers played on American-style racism, however, with the victim — usually a white European woman — suffering one

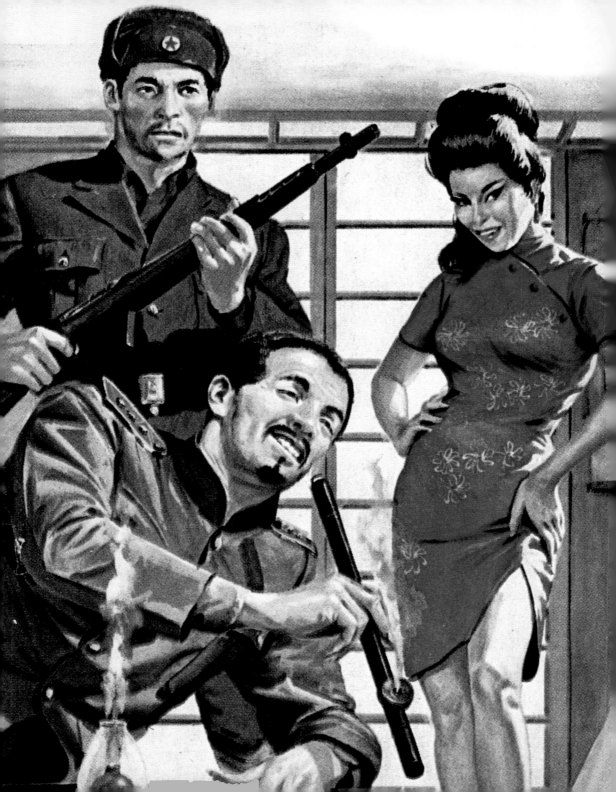

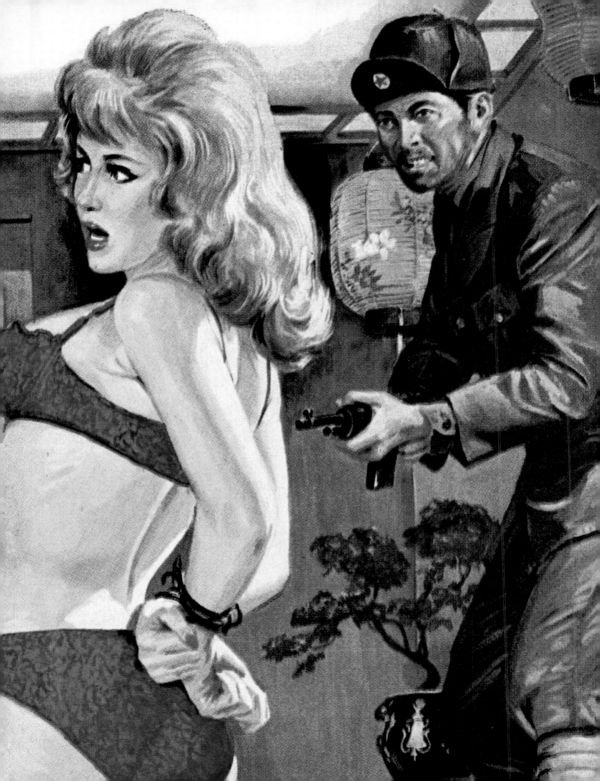

thousand cuts or hideous, gnawing mink torture. The same tended to be true of Red Chinese (and some Vietnamese) torture covers. Outside these war-related themes, stories frequently detailed Asian white slavery, drug rings, and pirates.

The Goodman magazines regularly featured cover stories set in Vietnam, often based on true events, but with the usual sweatmag enhancements. For instance, a story of American soldiers fighting the Vietcong underground, "Capt. Herb Thornton King of Our Heroic Cong-Busting 'Tunnel Rats'" (*Male*, July 1966), is scrupulously accurate regarding the details of booby traps and other perils in the tunnels. Midway through, however, the tale becomes ludicrous, as a GI enters a corridor filled with villagers being attacked by ferocious groundhogs released by the Cong.

Martin Goodman's approach to the war was in stark contrast with that of Hugh Hefner's *Playboy*, another postwar fantasy magazine for men. As early as 1966, Playmates were touring Vietnam, visiting hospitals and providing entertainment for the troops. At the same time, *Playboy* was running articles questioning the validity of the United States' involvement in the conflict and often arguing for diplomatic solutions to end the war. Goodman, on the other hand, was backing the war unconditionally with fictionalized stories of American soldiers in combat and reprints of some of the most erroneous propaganda released by the U.S. State Department and the Pentagon. While this obviously reflected the politics of each publisher or editor, it also revealed the magazines' audiences: the sweat mag's blue-collar conservative and *Playboy*'s college-educated liberal.

Men's adventure magazines loved to target Fidel Castro's Cuba, bombarding our isolated neighbor through extreme covers and stories. Ironically enough, prior to Castro's victory in 1959, many ran stories about the valiant revolutionaries fighting to overthrow Fulgencio Batista y Zaldívar and his oppressive regime. Once Castro won, however, the magazines took offense at his actions – not so much his summary execution of the worst of Batista's torturers, but his decision to go socialist and close many mob-owned Cuban brothels.

This political turnaround was not unique to men's adventure magazines. America not only gave shelter to Batista Cubans, but began training them to retake the country. Castro had also tossed out American organized crime, which controlled most vice and the casinos in Cuba. A reader did not need to go to the sweat magazines to find anti-Castro propaganda: one mainstream publisher issued a spy novel titled *Assassinate Castro*. Even President John F. Kennedy, a *Playboy* reader not likely to sample the sweat magazines, caught the anti-Castro bug; liberals were not immune.

ZARTES FLEISCH FÜRS ROTE HAUS DER 1.000 QUALEN. ROTE BEDROHUNG UND GELBE GEFAHR

Während des Kalten Krieges und des Vietnamkrieges boomte die Heftchenliteratur für Männer. Wie zu erwarten war die „kommunistische Bedrohung" ein großes Thema – von russischen Plänen zur Vergiftung des amerikanischen Trinkwassers zu Geschichten von Kämpfen gegen die Vietcong in unterirdischen Tunneln.

Man bekam den Eindruck, dass die Amerikaner aus dem Osten nichts als Bedrohung erwarteten. In den frühen Heftchen hatte es Horden finsterer Chinesen à la Fu Manchu gegeben. Nach Pearl Harbor ging nichts mehr ohne bedrohliche Japaner, denen sich in den Fünfzigern Rotchinesen und Nordkoreaner zugesellten, in den Sechzigern reihten sich die Vietcong in den Grundstock asiatischer Erzschurken ein. In den Abenteuerheftchen für Männer wurden sie ohne jeden Unterschied benutzt; aus welchem Land oder welcher ethnischen Gruppe sie kamen, spielte keine Rolle – diese bösen Kerle waren sowieso nur hinter weißen Frauen her.

Über kommunistische Verschwörungen ließen sich großartige chauvinistische Schlagzeilen texten, zum Beispiel „Schießt die roten Ratten zu Klump" oder „Sowjetisches Sklavenlager: Folter in der Hölle", sie inspirierten die Umschlagmaler aber nicht zu ihren grellsten Werken, da Spione nicht die Art extremer Actionszenen bieten konnten, mit denen sich die Abenteuerheftchen für Männer verkauften. Das änderte sich mit der Niederschlagung des Aufstandes in Ungarn 1956 schlagartig, über den unzählige Storys von gegen die Russen kämpfenden Freudenmädchen oder in Umerziehungslagern gequälten, heroischen Huren verfasst werden konnten.

True Adventures brachte einmal ein Cover von Rafael DeSoto für „Ich war ein Häftling in der Hand der roten Folterknechte", auf denen Frauen in Unterwäsche zu sehen waren, die gegen kommunistische Bewacher kämpfen. Über die Gefängnismauer hinweg eilt gerade ein wahrer Mann zu ihrer Rettung, der bereits den Soldaten im Wachturm getötet hat. Der Artikel im Heftinneren beschreibt allerdings keinerlei Szenen dieser Art. Frauen kommen auf den nächsten Seiten praktisch nicht vor, auf denen der Autor die unmenschlichen Bedingungen beschreibt, die er angeblich als Häftling im kommunistischen Gefängnis in Ungarn erduldet hatte.

Noch undurchsichtiger ist der Titel von *Men Today* vom Oktober 1964: „Die Seidenhöschen-Brigade, die Castros Blockade durchbrach", auf dem kubanische Soldaten zu sehen sind, die schöne Frauen quälen. Nicht nur diese Szene kommt im Inhalt nicht vor, sondern es findet sich auch im ganzen Heft nichts über Kuba.

So lange Russland Ostdeutschland während des Kalten Krieges besetzt hielt, wurden solche „wahren" Geschichten wie „Die Geheimnisse des Ostberliner Folterpalastes" aus umgeschriebenen Nazifoltergeschichten zusammengeschustert, in denen die ehemals deutschen Kommandanten durch Russen ersetzt wurden.

Die Idee von der „Gelben Gefahr", die der Jahrhundertwende entstammte, lebte in den Abenteuerheftchen für Männer weiter – ob sie nun Japaner während des Zweiten Weltkrieges, Rotchinesen oder Vietnamesen waren: „Orientalen" wurden immer als Teufel und als ständige Bedrohung dargestellt. Direkt nach dem Angriff auf Pearl Harbor 1942 brachte das Magazin *True* eine einmalige Ausgabe heraus, „Japanische Blutriten", in dem die Gräueltaten der Japaner in China und der Mandschurei geschildert wurden, die auch genauso gut im Zweiten Weltkrieg hätten spielen können.

Historisch betrachtet verübten die Japaner die meisten Gräueltaten – die Ermordung der Zivilbevölkerung und die Zwangsrekrutierung einheimischer Frauen in Bordelle für den Gebrauch japanischer Soldaten – an anderen asiatischen Völkern. Doch die Titelbilder waren immer im amerikanischen Rassismus verankert, weil meist eine weiße europäische Frau 1000 Messerstiche oder die schreckliche Folter nagender Nerze erdulden musste. Für die Einbände mit Rotchinesen (und zum Teil mit Vietnamesen) traf genau das Gleiche zu. Abgesehen von den kriegsbezogenen Geschichten gab es regelmäßig Beiträge über die Versklavung weißer Frauen durch Asiaten, über Drogenringe und Piraterie.

NEW MAN, 9/1965, Norman Saunders, gouache, 51 x 72 cm ▶

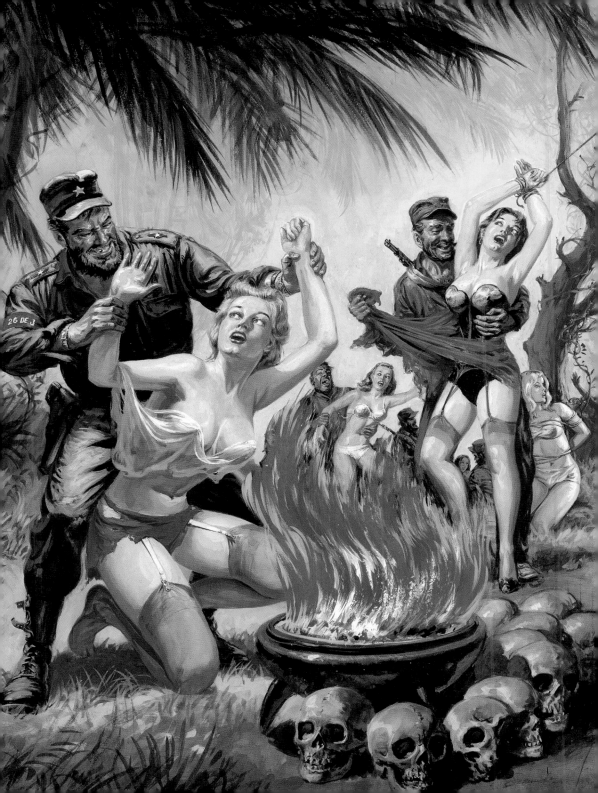

Die Goodman-Magazine brachten regelmäßig in Vietnam spielende Titelgeschichten, die sich oft auf wahre Begebenheiten stützten, aber mit den üblichen Übertreibungen der Abenteuermagazine angereichert waren. Ein Bericht über den Kampf amerikanischer Soldaten gegen die Vietcong unter der Erde, „Capt. Herb Thornton King von den heldenhaften Cong-Killern und ‚Tunnelratten'" (*Male*, Juli 1966), entspricht hinsichtlich der Einzelheiten wie Minenfallen und anderen Gefahren in den Tunneln peinlich genau der Realität. Mittendrin wird der Artikel jedoch plötzlich völlig albern, wenn ein amerikanischer Soldat einen Gang voller Dorfbewohnerinnen betritt, die von angriffslustigen Murmeltieren attackiert werden, die die Vietcong dort losgelassen haben.

Martin Goodmans Herangehensweise an den Krieg stand in völligem Gegensatz zu dem von Hugh Hefners *Playboy*, eine weitere Ausgeburt männlicher Nachkriegsfantasien. Bereits 1966 gingen die Playmates auf Tour durch Vietnam, wo sie Krankenhäuser besuchten und den Soldaten Unterhaltung boten. Zur gleichen Zeit waren im *Playboy* Artikel zu finden, in denen die Rechtmäßigkeit der amerikanischen Einmischung in den Konflikt hinterfragt und oft diplomatische Lösungen zur Beendigung des Krieges befürwortet wurden. Goodman stellte sich hingegen mit seinen weitgehend erfundenen Geschichten von amerikanischen Soldaten an der Front und dem Abdruck von völlig falscher Propaganda aus dem Außenministerium und dem Pentagon uneingeschränkt hinter den Krieg. Das brachte natürlich die politische Einstellung der Verleger zum Ausdruck, verriet aber auch viel über die Leserkreise der Zeitschriften: die konservativen Leser aus der Arbeiterschicht der Sweat Magazins und die liberalen *Playboy*-Leser mit Collegeabschluss.

Abenteuerheftchen für Männer knöpften sich gern Fidel Castros Kuba vor und bombardierten es mit himmelschreienden Einbänden und Storys. Ironischerweise hatten viele der gleichen Heftchen vor dem Sieg der kommunistischen Revolution 1959 Geschichten über die guten Rebellen gebracht, die gegen Fulgencio Batista y Zaldívar und sein diktatorisches Regime kämpften. Sobald Fidel Castro gewonnen hatte, nahmen sie jedoch Anstoß an seinen Handlungen – nicht so sehr daran, dass Batistas schlimmste Folterknechte in Massen hingerichtet wurden, sondern an seiner Entscheidung für den Sozialismus und der Schließung zahlreicher mafiaeigener kubanischer Puffs.

Nicht nur die Abenteuerheftchen für Männer drehten ihr politisches Fähnlein derart nach dem Wind. Die USA gewährten den Batista-Anhängern Asyl und bildeten sie zur Rückeroberung des Landes aus. Castro hatte auch das amerikanische organisierte Verbrechen, das die Prostitution und die Kasinos in Kuba zum

größten Teil kontrolliert hatte, aus dem Land geworfen. Man brauchte nicht zu den Sweats zu greifen, um Anti-Castro-Propaganda zu finden: Ein großer Verlag veröffentlichte den Spionageroman *Assassinate Castro* (*Tötet Castro*). Sogar Präsident John F. Kennedy, ein *Playboy*-Leser, der mit ziemlicher Sicherheit keine Heftchenliteratur gelesen hat, ließ sich von der castrofeindlichen Hysterie anstecken – auch Liberale waren nicht immun dagegen.

JOLIES MARTYRES POUR LE BUNKER COCO DES MILLE ET UN SUPPLICES. MENACE ROUGE ET PERIL JAUNE

Les magazines d'aventures pour hommes se sont développés durant la guerre froide et la guerre du Vietnam. Comme on pouvait s'y attendre, cette presse exploita à outrance le thème de la « menace communiste », qu'il s'agisse des plans soviétiques pour empoisonner les réserves d'eau potable ou d'histoires de combats contre les vietcongs dans des tunnels souterrains.

A croire que les Américains redoutèrent toujours un péril venant de l'Est. Les premiers pulps avaient d'ailleurs présenté toute une galerie de Chinois insondables à la Fu Manchu. Après Pearl Harbor, les Japonais menaçants étaient de rigueur. Dans les années cinquante, ils furent rejoints par les communistes chinois et coréens, liste de méchants asiatiques à laquelle vinrent s'ajouter, dans les années soixante, les Vietcongs. Dans les magazines d'aventures, les uns et les autres étaient interchangeables : quelle que fût leur origine ethnique ou leur couleur de peau, ces méchants-là étaient toujours très attirés par les femmes blanches.

La thématique du complot communiste inspirait des titres tonitruants, tel « Pulvérisez ces fumiers de rouges ! » ou encore « Camp d'esclaves soviétique : l'enfer des tortures »… Mais l'ennemi soviétique n'inspira pas aux dessinateurs leurs couvertures les plus délirantes, car l'espionnage ne donnait pas matière aux trépidantes images d'action qui faisaient vendre les magazines d'aventures pour hommes. Tout cela changea avec l'écrasement par les Soviétiques de la révolution hongroise de 1956, événement qui fournit une multitude d'histoires de filles de joie luttant contre les russes et de prostituées héroïques torturées dans des camps de rééducation.

True Adventures publia ainsi une couverture de Rafael DeSoto intitulée « J'ai été capturée et torturée par les Rouges », montrant des prisonnières en sous-vêtements aux prises avec des gardiens communistes. Au sommet du mur de la prison, on aperçoit un type baraqué sur le point de les secourir – il vient de tuer le gardien dans le mirador. Mais l'article, à

NEW MAN, 11/1964, Norman Saunders, gouache, 37 × 51 cm

l'intérieur, ne décrit nullement la scène annoncée. Il n'est pratiquement pas question de femmes dans les quelques pages de descriptions atroces des conditions de vie inhumaines prétendument vécues par l'auteur quand il était incarcéré dans les geôles communistes hongroises.

Plus étrange encore est la couverture d'octobre 1964 de *Men Today* « Le bataillon des filles de satin qui força le blocus américain de Cuba ». On y voit des soldats cubains infligeant des tortures variées, à de belles femmes. Cette scène n'appartient à aucune histoire du numéro en question et il n'y est pas question de Cuba.

Avec l'occupation de l'Allemagne de l'Est par les Soviétiques durant la guerre froide, ce type d'histoires « vraies », comme « les secrets du palais des tortures de Berlin Est » n'étaient que des histoires de tortures nazies récrites dans lesquelles les Russes remplaçaient les habituels commandants allemands.

La notion de « péril jaune », popularisée au début du XXe siècle, perdura dans les magazines d'aventures pour hommes, avec les Japonais durant la Seconde Guerre, plus tard les maoïstes ou les Vietnamiens : les « orientaux » étaient toujours dépeints comme des démons menaçants. En 1942, après Pearl Harbor, le magazine *True* publia une couverture clamant « Cultes sanguinaires japonais », qui détaillait les atrocités commises par les Japonais en Chine et en Mandchourie. Ce numéro aurait pu servir de modèle pour les histoires sur la Seconde Guerre des magazines d'aventures pour hommes de l'époque.

Historiquement, la plupart de ces exactions japonaises (les massacres des populations civiles et les rafles de femmes destinées aux bordels militaires de campagnes), étaient perpétrés contre d'autres Asiatiques. Mais ces couvertures flattaient le racisme américain. On y voyait en général une femme blanche de

BIG ADVENTURE, 6/1961, Basil Gogos

type européen au corps entièrement zébré de coups de couteau ou inexorablement rongé par un rat. Quant aux couvertures exhibant communistes chinois et vietnamiens, elles puisaient au même fantasme : on y voyait des blanches réduites en esclavage par des Asiatiques, des trafiquants de drogue et des pirates.

Les magazines Goodman faisaient souvent leur couverture sur des épisodes de la guerre au Vietnam, basés généralement sur des histoires vraies, mais avec les amplifications propres au genre. Par exemple, une histoire de soldats américains combattant les soldats vietcongs dans des souterrains devient « Le Capitaine Herb Thornton héros de l'héroïque traque des viets dans leurs « tunnels à rats » (*Male*, juillet 1966). Ce récit est d'une précision scrupuleuse en ce qui concerne les traquenards et autres dangers liés à cette guerre des tunnels. Ce qui n'empêche pas l'auteur, au

milieu de son histoire, d'inventer un épisode extravagant, où il fait entrer un GI dans une galerie grouillant de villageois attaqués par de féroces marmottes lâchées par les communistes.

Chez Martin Goodman, l'approche de la guerre s'oppose radicalement à celle de *Playboy*, le magazine de Hugh Hefner, autre grand catalyseur des fantasmes masculins de l'après-guerre. Dès 1966, les playmates parcouraient le Vietnam, rendaient visite aux soldats américains blessés dans les hôpitaux et animaient des soirées offertes aux militaires. Pourtant, au même moment, *Playboy* publiait régulièrement des articles qui critiquaient l'engagement américain dans ce conflit et plaidaient en faveur d'une issue diplomatique. Goodman, en revanche, soutenait inconditionnellement la guerre avec des histoires romancées de soldats américains au combat et relayait la propagande officielle du département d'Etat en imprimant ses « informations » les plus douteuses. Chaque éditeur ou rédacteur en chef réagit évidemment en fonction de ses opinions personnelles, mais leur ligne reflétait aussi les opinions de leur lectorat : conservatrices dans le cas des ouvriers adeptes de magazines à sensations, ou plus libérales pour les lecteurs de *Playboy*, en général passés par l'université.

Les magazines d'aventures pour hommes s'en prenaient aussi volontiers au régime castriste de Cuba, et cette petite île constitua un filon de couvertures et d'histoires rocambolesques. Assez paradoxalement, avant la victoire de la révolution castriste de 1959, nombre de ces mêmes magazines avaient publié des histoires sur les vaillants rebelles en lutte contre le régime dictatorial de Fulgencio Batista y Zaldívar. Pourtant, à peine Castro avait-il pris le pouvoir que le magazine dénigrait son action — pas tant les exécutions sommaires des pires tortionnaires de Batista, que sa décision d'opter pour le socialisme et de fermer la plupart des bordels cubains détenus par la mafia.

Ce virage politique ne fut pas réservé aux magazines d'aventures pour hommes. Non seulement l'Amérique accueillit les opposants cubains à Castro, mais elle entreprit de leur fournir un entraînement militaire pour les aider à reprendre le pouvoir. Castro avait aussi expulsé la mafia américaine qui contrôlait la plupart des casinos et la prostitution sur l'île. Les citoyens américains ordinaires n'avaient nul besoin de se plonger dans un pulp pour trouver de la propagande anticastriste : un éditeur grand public avait intitulé un roman policier *Tuez Fidel Castro !* Même le président Kennedy, lecteur de *Playboy* et peu porté sur les magazines bon marché fut contaminé par le virus anticastriste : les progressistes n'étaient pas immunisés.

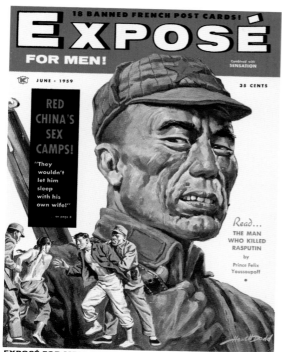

EXPOSÉ FOR MEN!, 6/1959, Howell Dodd

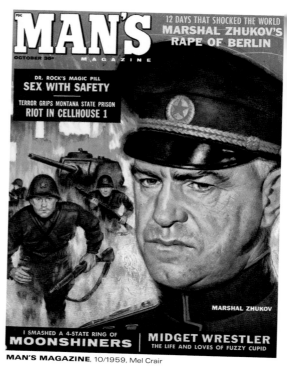

MAN'S MAGAZINE, 10/1959, Mel Crair

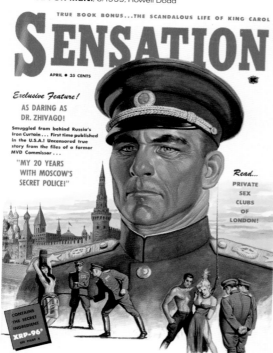

SENSATION, 4/1959, Rafael DeSoto

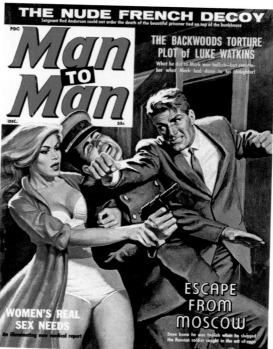

MAN TO MAN, 12/1961

TEN SEX SECRETS NO WOMAN TELLS

ADVENTURE

STILL ONLY 25¢

THE MAN'S MAGAZINE OF EXCITING FICTION AND FACT

OCTOBER

AN AMAZING TRUE ARTICLE
STRANGE AMERICAN LOVE CULTS

MISTRESS OF MURDER HILL

THE NIGHT RONNIE GEDEON DIED
THE MAD SCULPTOR AND THE "HOT NUMBER"

ADVENTURE, 10/1962, Vic Prezio

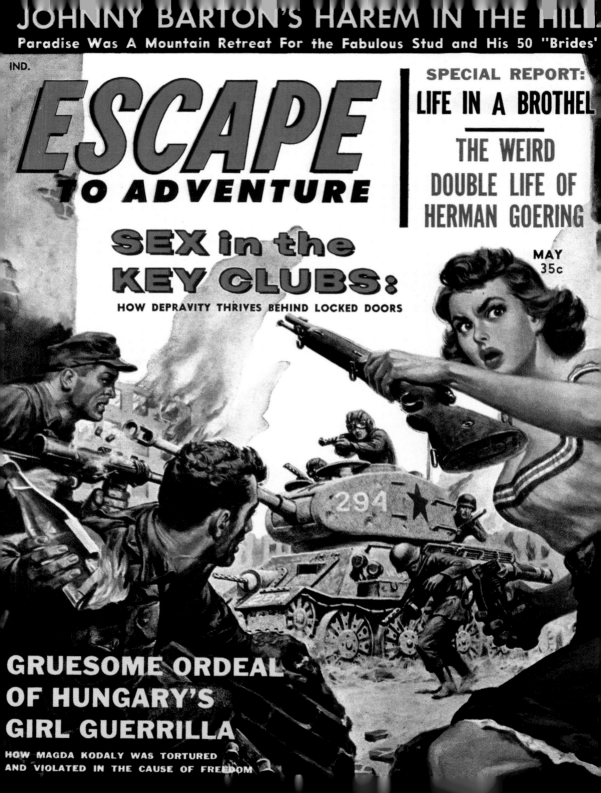

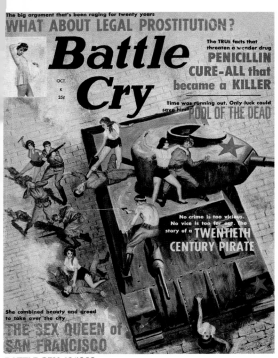

BATTLE CRY, 10/1963

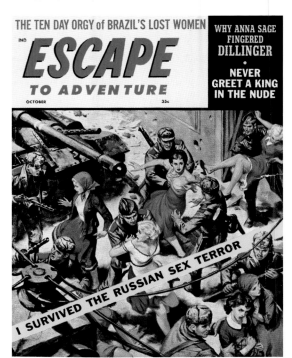

ESCAPE TO ADVENTURE, 10/1960, Clarence Doore

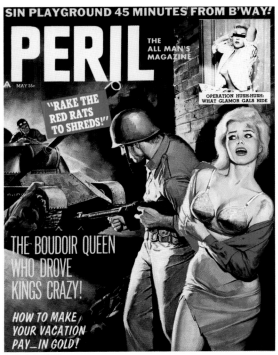

PERIL, 5/1962
◄ **ESCAPE TO ADVENTURE**, 5/1959, Clarence Doore

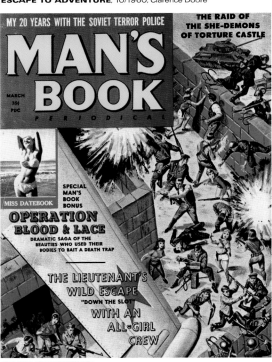

MAN'S BOOK, 3/1962

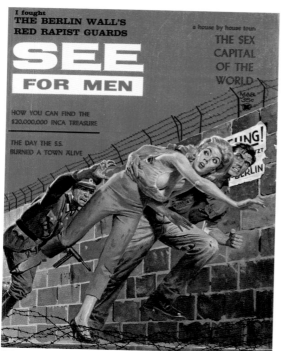

I fought
THE BERLIN WALL'S
RED RAPIST GUARDS

a house by house tour
THE SEX
CAPITAL
OF THE
WORLD

SEE
FOR MEN

HOW YOU CAN FIND THE
$20,000,000 INCA TREASURE

THE DAY THE S.S.
BURNED A TOWN ALIVE

SEE FOR MEN, 3/1963, George Gross

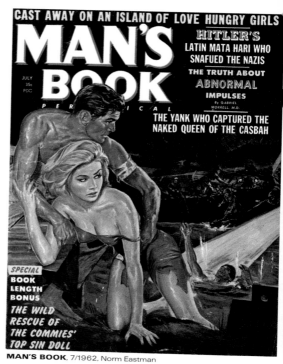

CAST AWAY ON AN ISLAND OF LOVE HUNGRY GIRLS

MAN'S
BOOK
PERIODICAL

JULY
35c
PDC

HITLER'S
LATIN MATA HARI WHO
SNAFUED THE NAZIS

THE TRUTH ABOUT
ABNORMAL
IMPULSES
By GABRIEL
MORRELL M.D.

THE YANK WHO CAPTURED THE
NAKED QUEEN OF THE CASBAH

SPECIAL
BOOK
LENGTH
BONUS
THE WILD
RESCUE OF
THE COMMIES'
TOP SIN DOLL

MAN'S BOOK, 7/1962, Norm Eastman

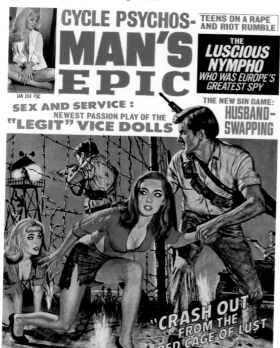

CYCLE PSYCHOS-
MAN'S
EPIC

TEENS ON A RAPE
AND RIOT RUMBLE

THE
LUSCIOUS
NYMPHO
WHO WAS EUROPE'S
GREATEST SPY

JAN 35¢ PDC

SEX AND SERVICE:
NEWEST PASSION PLAY OF THE
"LEGIT" VICE DOLLS

THE NEW SIN GAME:
HUSBAND-
SWAPPING

"CRASH OUT"
FROM THE
RED CAGE OF LUST

MAN'S EPIC, 1/1969

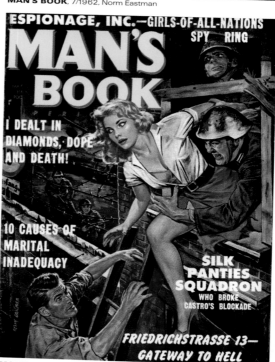

ESPIONAGE, INC.—GIRLS-OF-ALL-NATIONS
SPY RING

MAN'S
BOOK
PERIODICAL

I DEALT IN
DIAMONDS, DOPE
AND DEATH!

10 CAUSES OF
MARITAL
INADEQUACY

SILK
PANTIES
SQUADRON
WHO BROKE
CASTRO'S BLOCKADE

FRIEDRICHSTRASSE 13—
GATEWAY TO HELL

MAN'S BOOK, 5/1962, Norm Eastman
REAL MEN, 7/1964 ▶

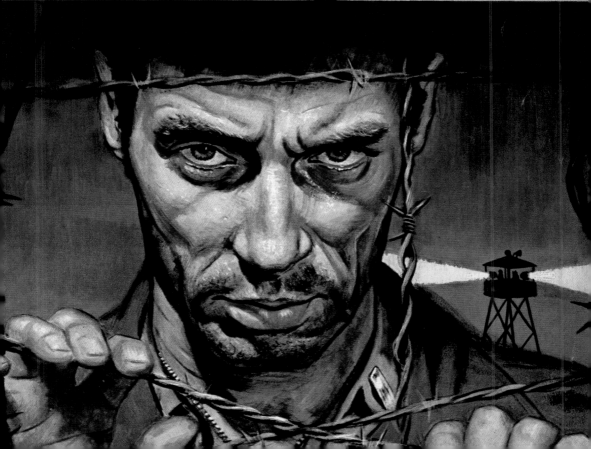

The modern way to pick a better mate.... **SEX ON TRIAL**

MAN'S BEST

SEPT. PDC 35¢

She ruled 100 love-mad women
with the kiss of her whip . . .

**THE NYMPHOS WERE
CRAZY FOR PAIN**

The quiet man who did his talking
with a blazing tommy-gun

**THE BLOODY
BUTCHER OF
KANSAS CITY**

EXPOSING the business
crooks who steal your
hard-earned cash . . .

**THE CUSTOMER
IS ALWAYS WRONG**

MAN'S BEST, 9/1961

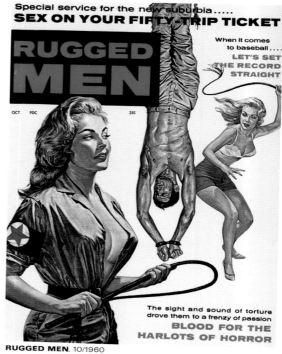

Special service for the new suburbia.....
SEX ON YOUR FIFTY-TRIP TICKET

RUGGED MEN

OCT. PDC 35¢

When it comes
to baseball
**LET'S SET
THE RECORD
STRAIGHT**

The sight and sound of torture
drove them to a frenzy of passion
**BLOOD FOR THE
HARLOTS OF HORROR**

RUGGED MEN, 10/1960

The untamed wilderness of the west where anything goes . . .
AMERICA'S NATIONAL PARK OF SEX

RUGGED MEN

DEC. PDC 35¢

The true story of a man who
was eaten alive . . . and lived . . .

**A LION DRANK
MY BLOOD!**

For 1000 years the Thugs have
been getting away with murder
HOLY KILLERS OF INDIA

Want to save money **NEXT SUMMER: LET'S GO CAMPING**
on your vacation?

THE MADAME AND THE BOUNTY KILLER

RUGGED MEN, 12/1960

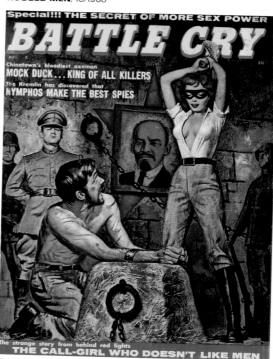

Special!!! THE SECRET OF MORE SEX POWER

BATTLE CRY

AUG. 35¢

Chinatown's bloodiest axeman
MOCK DUCK . . . KING OF ALL KILLERS

The Kremlin has discovered that
NYMPHOS MAKE THE BEST SPIES

The strange story from behind red lights
THE CALL-GIRL WHO DOESN'T LIKE MEN

BATTLE CRY, 8/1961
ALL MAN, 3/1961 ▶

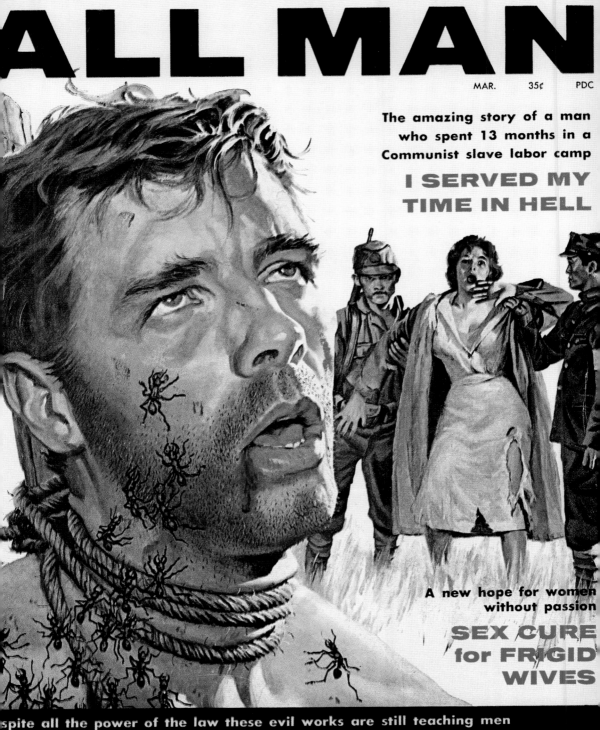

HE TRUTH ABOUT AMERICA'S ABORTION RACKET

ALL MAN

MAR. 35¢ PDC

The amazing story of a man
who spent 13 months in a
Communist slave labor camp

I SERVED MY
TIME IN HELL

A new hope for women
without passion

SEX CURE
for FRIGID
WIVES

spite all the power of the law these evil works are still teaching men
the art of torture **GUIDEBOOKS TO PAIN**

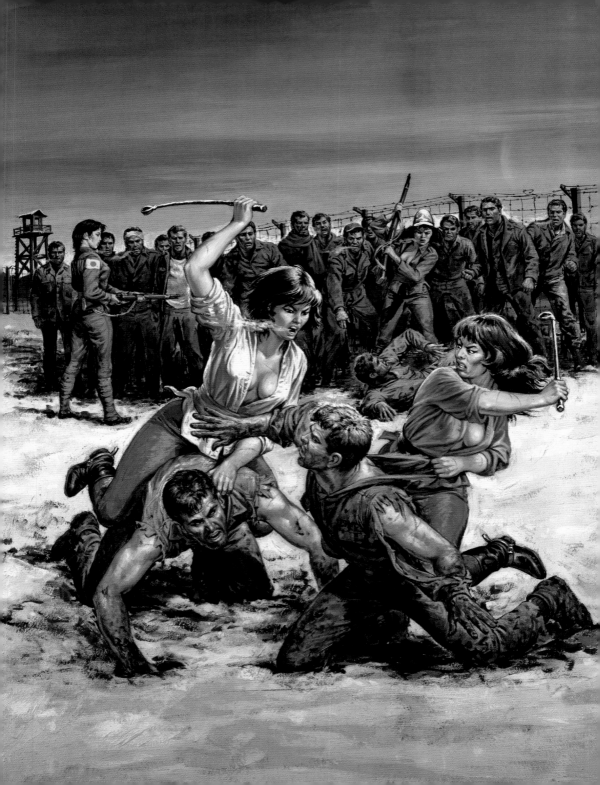

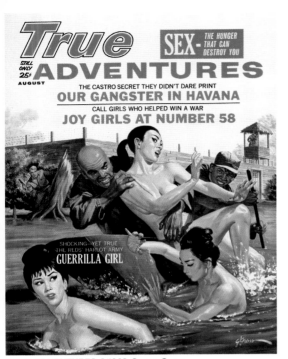

TRUE ADVENTURES, 8/1963, George Gross

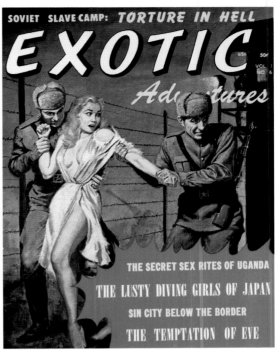

EXOTIC ADVENTURES, Vol. 1, No. 6/1959

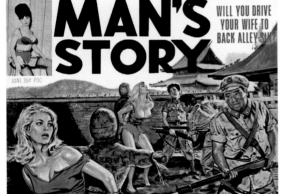

MAN'S STORY, 6/1966, Norm Eastman
◄ MAN'S LIFE, 5/1963, Earl Norem, mixed media, 55 x 72 cm

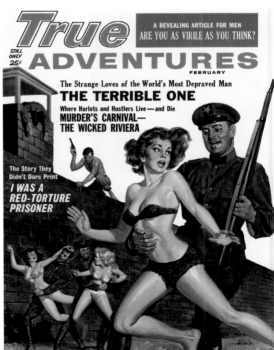

TRUE ADVENTURES, 2/1963, Rafael DeSoto

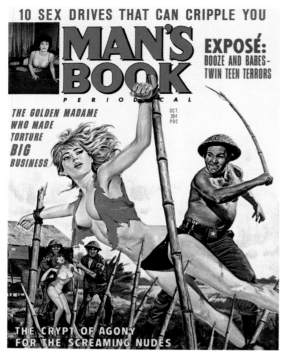

10 SEX DRIVES THAT CAN CRIPPLE YOU

MAN'S BOOK
PERIODICAL

OCT.
35¢
PDC

EXPOSÉ:
BOOZE AND BABES-
TWIN TEEN TERRORS

THE GOLDEN MADAME
WHO MADE
TORTURE
BIG
BUSINESS

THE CRYPT OF AGONY
FOR THE SCREAMING NUDES

MAN'S BOOK, 10/1965, Norm Eastman

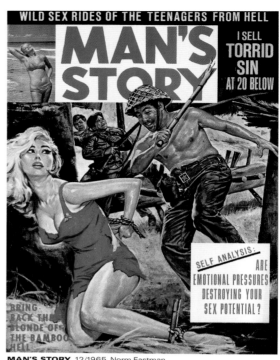

WILD SEX RIDES OF THE TEENAGERS FROM HELL

MAN'S
STORY

I SELL
TORRID
SIN
AT 20 BELOW

DEC. 35¢ PDC

SELF ANALYSIS:
ARE
EMOTIONAL PRESSURES
DESTROYING YOUR
SEX POTENTIAL?

BRING
BACK THE
BLONDE OF
THE BAMBOO
HELL

MAN'S STORY, 12/1965, Norm Eastman

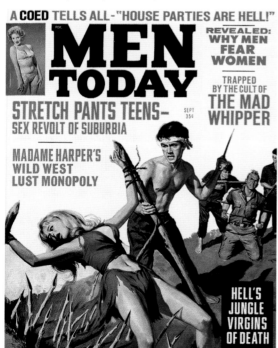

A COED TELLS ALL-"HOUSE PARTIES ARE HELL!"

MEN
TODAY

REVEALED:
WHY MEN
FEAR
WOMEN

TRAPPED
BY THE CULT OF
THE MAD
WHIPPER

STRETCH PANTS TEENS-
SEX REVOLT OF SUBURBIA

SEPT
35¢

MADAME HARPER'S
WILD WEST
LUST MONOPOLY

HELL'S
JUNGLE
VIRGINS
OF DEATH

MEN TODAY, 9/1967, John Duillo

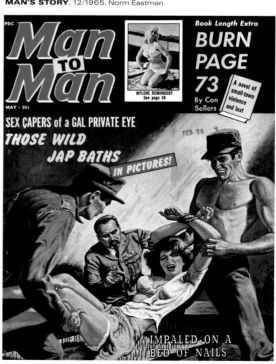

PDC

Man
TO
Man

MAY · 35¢

Book Length Extra
BURN
PAGE
73
By Con
Sellers

A novel of
small-town
violence
and lust

MYLENE DEMONGEOT
See page 26

SEX CAPERS of a GAL PRIVATE EYE
THOSE WILD
JAP BATHS
IN PICTURES!

FEB 20

IMPALED ON A
BED OF NAILS

MAN TO MAN, 5/1964

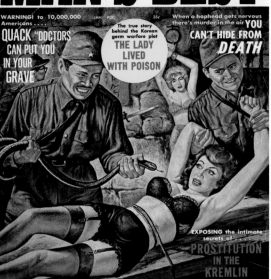

MAN'S BEST, 1/1963

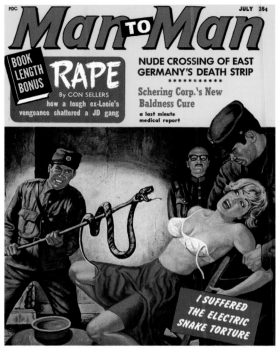

MAN TO MAN, 7/1964

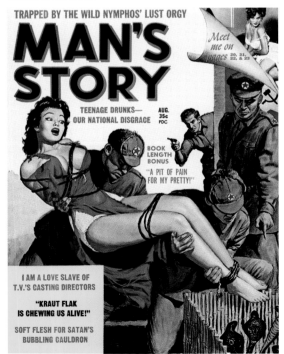

MAN'S STORY, 8/1961

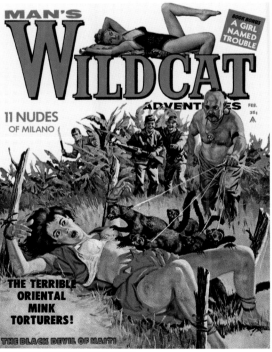

WILDCAT ADVENTURES, 2/1961

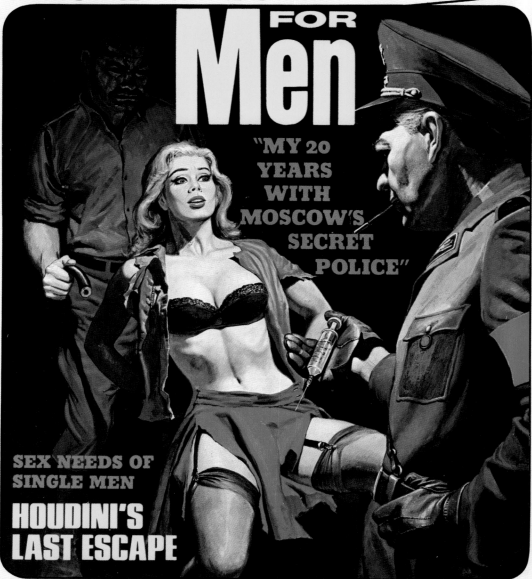

IF A GIRL'S A TEASE . . . SLAP HER FACE!

47197 March 1974 60¢

Adventure

GIANT SPECIAL ISSUE

FOR Men

"MY 20 YEARS WITH MOSCOW'S SECRET POLICE"

SEX NEEDS OF SINGLE MEN

HOUDINI'S LAST ESCAPE

ADVENTURE FOR MEN, 3/1974, John Duillo

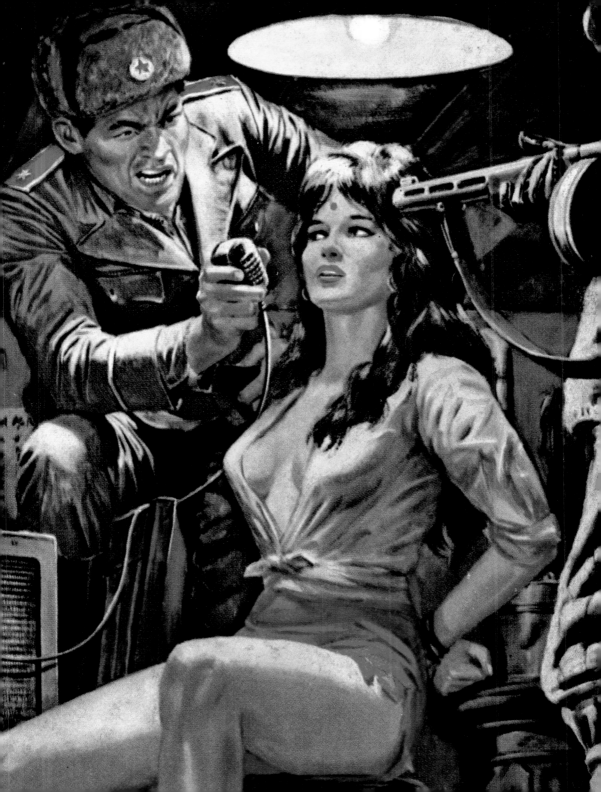

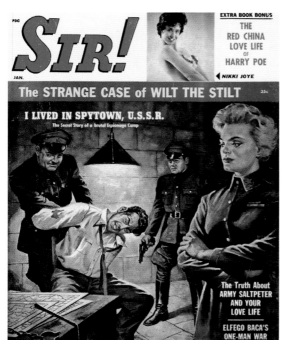

SIR!, 1/1961

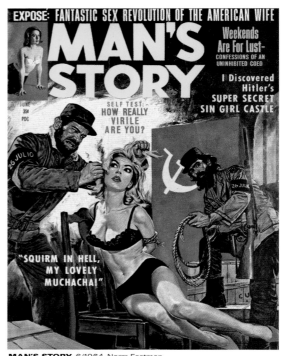

MAN'S STORY, 6/1964, Norm Eastman

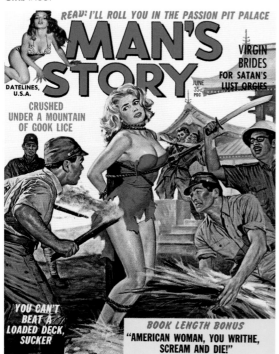

MAN'S STORY, 6/1961, Norm Eastman

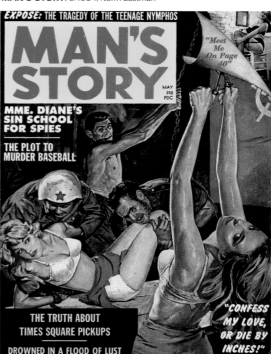

MAN'S STORY, 5/1962, Norm Eastman

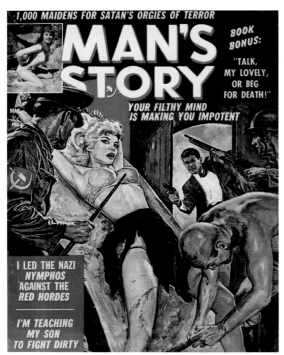

MAN'S STORY, 3/1961, Norm Eastman

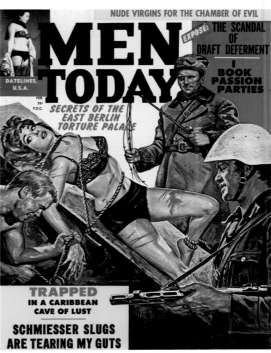

MEN TODAY, 2/1962, Norm Eastman

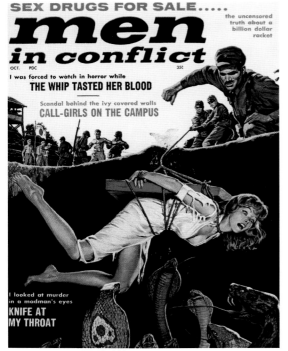

MEN IN CONFLICT, 10/1961

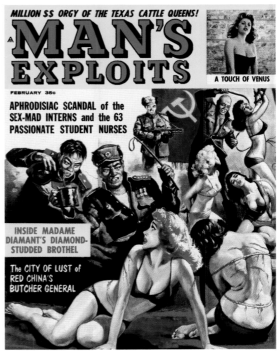

MAN'S EXPLOITS, 2/1963

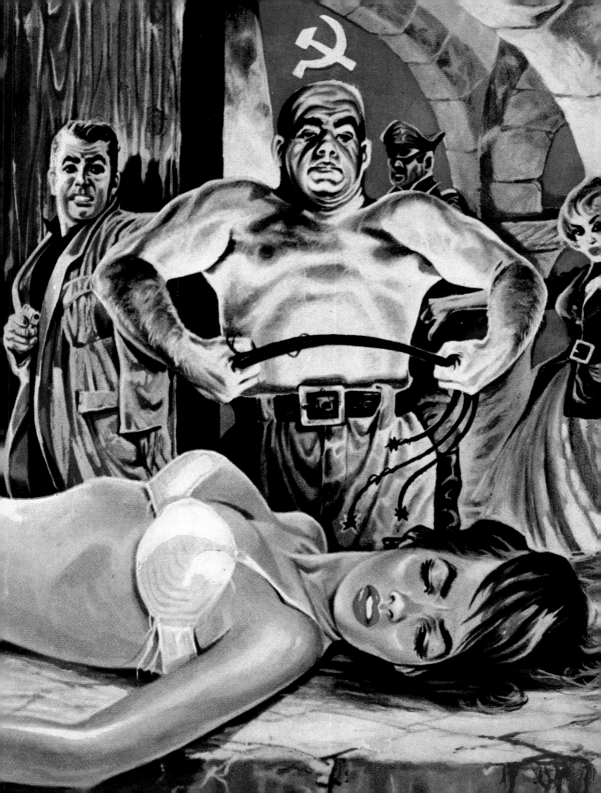

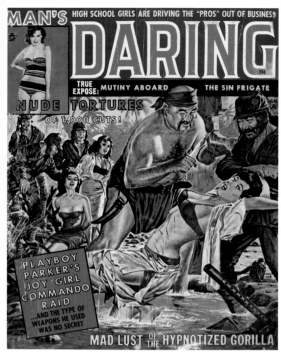

MAN'S DARING, 1/1963

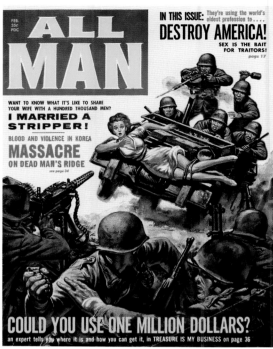

ALL MAN, 2/1960, Clarence Doore

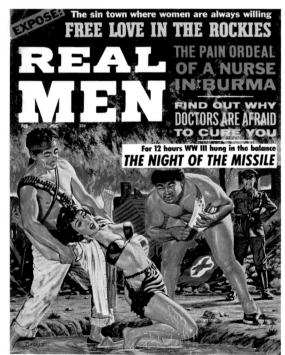

REAL MEN, 2/1965, Syd Shores
◄ MAN TO MAN, 2/1963, Mark Schneider

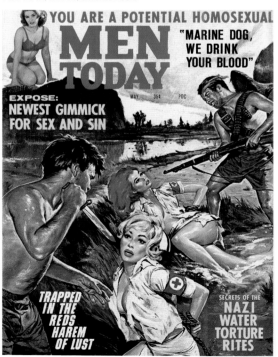

MEN TODAY, 5/1966

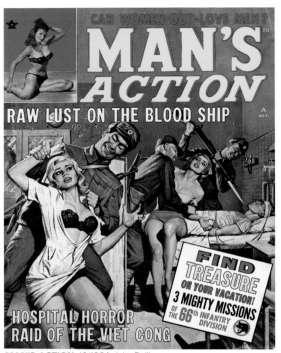

MAN'S ACTION, 10/1964, John Duillo

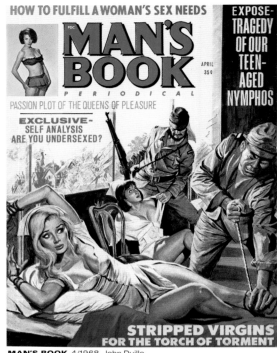

MAN'S BOOK, 4/1968, John Duillo

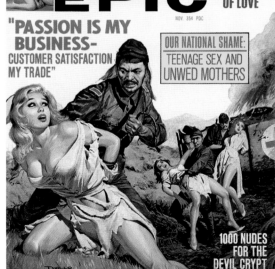

MAN'S EPIC, 11/1965, John Duillo

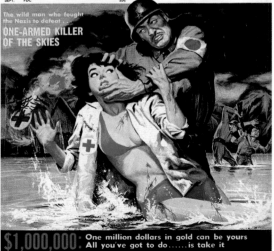

MAN'S ADVENTURE, 9/1961

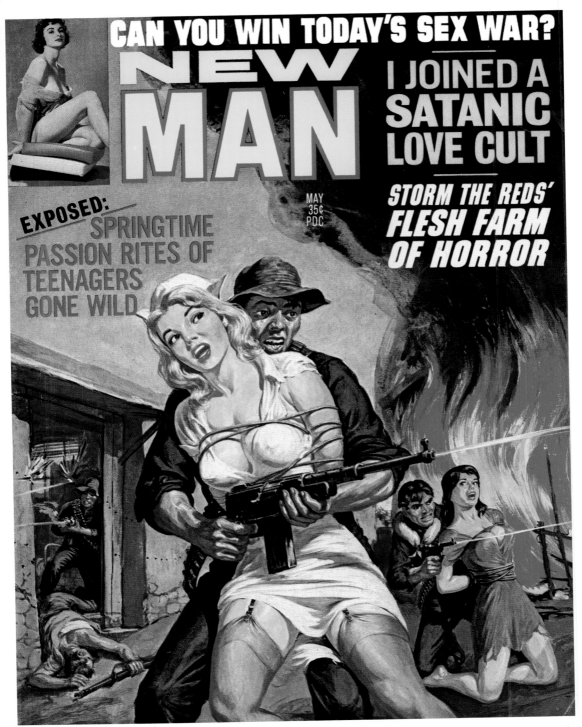

NEW MAN, 5/1966, Norman Saunders

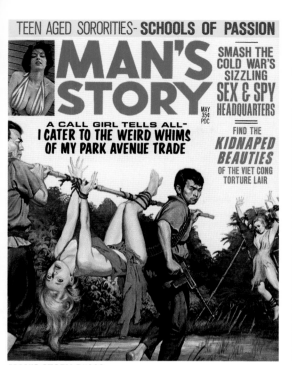

TEEN AGED SORORITIES- SCHOOLS OF PASSION

MAN'S STORY

MAY 35¢ PDC

SMASH THE COLD WAR'S SIZZLING SEX & SPY HEADQUARTERS

A CALL GIRL TELLS ALL-
I CATER TO THE WEIRD WHIMS OF MY PARK AVENUE TRADE

FIND THE KIDNAPED BEAUTIES OF THE VIET CONG TORTURE LAIR

MAN'S STORY, 5/1966

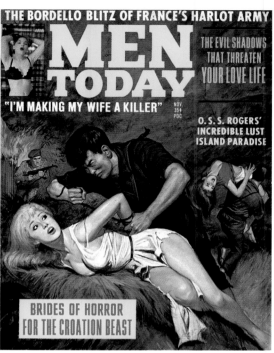

THE BORDELLO BLITZ OF FRANCE'S HARLOT ARMY

MEN TODAY

NOV 35¢ PDC

THE EVIL SHADOWS THAT THREATEN YOUR LOVE LIFE

"I'M MAKING MY WIFE A KILLER"

O. S. S. ROGERS' INCREDIBLE LUST ISLAND PARADISE

BRIDES OF HORROR FOR THE CROATION BEAST

MEN TODAY, 11/1966, John Duillo

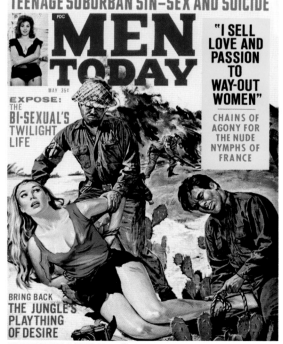

TEENAGE SUBURBAN SIN—SEX AND SUICIDE

MEN TODAY

MAY 35¢

EXPOSE: THE BI-SEXUAL'S TWILIGHT LIFE

"I SELL LOVE AND PASSION TO WAY-OUT WOMEN"

CHAINS OF AGONY FOR THE NUDE NYMPHS OF FRANCE

BRING BACK THE JUNGLE'S PLAYTHING OF DESIRE

MEN TODAY, 5/1968, Norm Eastman
◄ **MAN'S EPIC**, 12/1965, Norm Eastman, acrylic, 44 x 57 cm

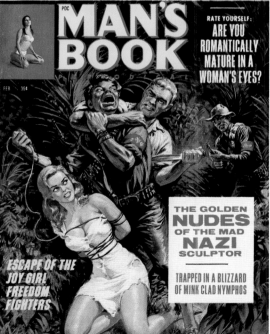

EXPOSED: WEEKEND PASSION - THE DISGRACE OF OUR COLLEGES

MAN'S BOOK

FEB 35¢

RATE YOURSELF: ARE YOU ROMANTICALLY MATURE IN A WOMAN'S EYES?

THE GOLDEN NUDES OF THE MAD NAZI SCULPTOR

TRAPPED IN A BLIZZARD OF MINK CLAD NYMPHOS

ESCAPE OF THE JOY GIRL FREEDOM FIGHTERS

MAN'S BOOK, 2/1967, Norman Saunders
WORLD OF MEN, 2/1966 ►►

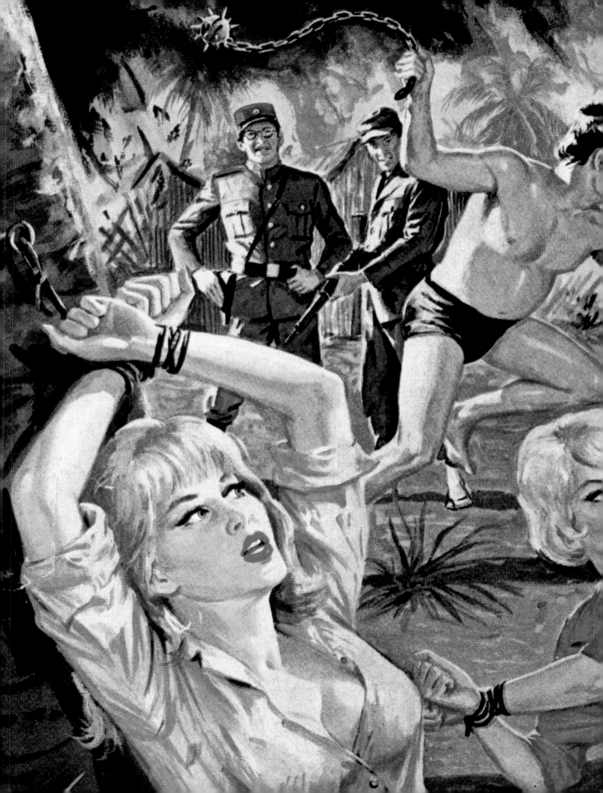

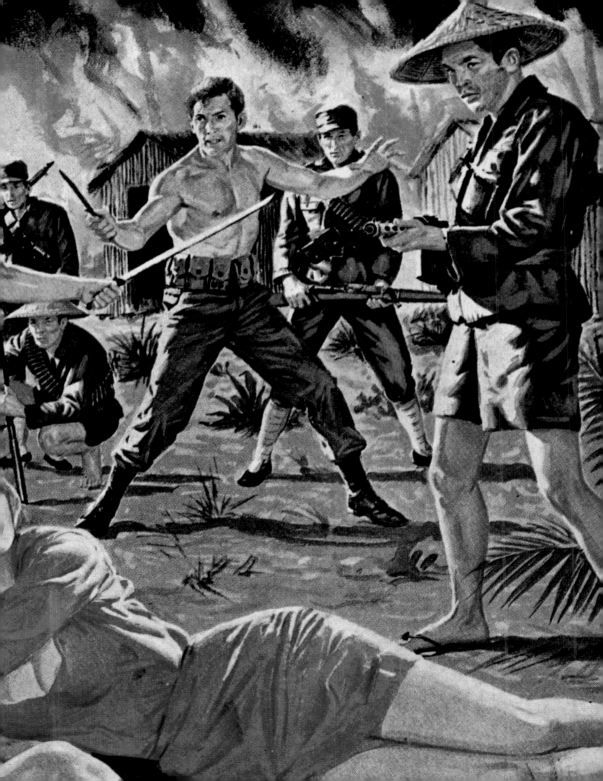

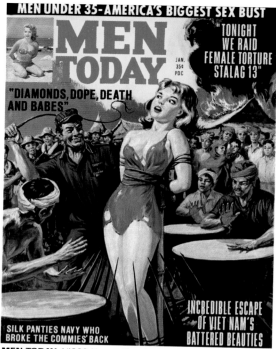

MEN TODAY, 1/1966, Norman Saunders

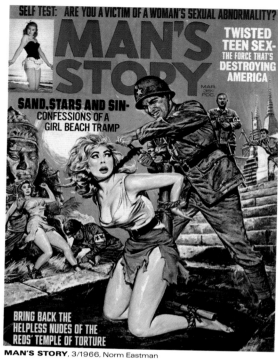

MAN'S STORY, 3/1966, Norm Eastman

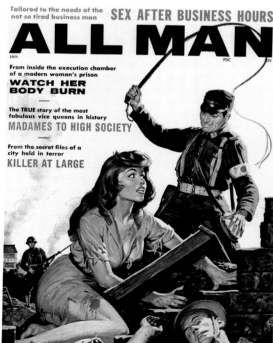

ALL MAN, 1/1962

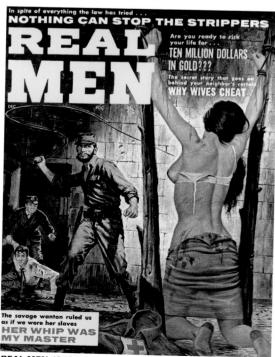

REAL MEN, 12/1961

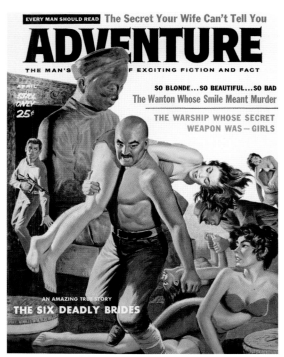

EVERY MAN SHOULD READ The Secret Your Wife Can't Tell You

ADVENTURE

THE MAN'S ~~OF~~ EXCITING FICTION AND FACT

APRIL
STILL
ONLY
25¢

SO BLONDE...SO BEAUTIFUL...SO BAD
The Wanton Whose Smile Meant Murder

THE WARSHIP WHOSE SECRET
WEAPON WAS—GIRLS

AN AMAZING TRUE STORY
THE SIX DEADLY BRIDES

ADVENTURE, 4/1960

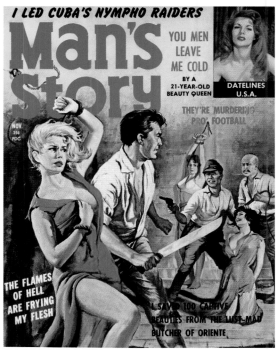

I LED CUBA'S NYMPHO RAIDERS

Man's Story

YOU MEN
LEAVE
ME COLD
BY A
21-YEAR-OLD
BEAUTY QUEEN

DATELINES
U.S.A.

THEY'RE MURDERING
PRO FOOTBALL

THE FLAMES
OF HELL
ARE FRYING
MY FLESH

I SAVED 100 CAPTIVE
BEAUTIES FROM THE LUST-MAD
BUTCHER OF ORIENTE

MAN'S STORY, 11/1960

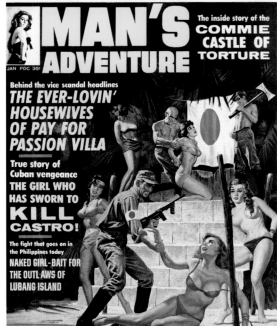

EXPOSING: THE ONE WAY MIRROR SEX RACKET

MAN'S
ADVENTURE

JAN PDC 35¢

The inside story of the
COMMIE
CASTLE OF
TORTURE

Behind the vice scandal headlines
THE EVER-LOVIN'
HOUSEWIVES
OF PAY FOR
PASSION VILLA

True story of
Cuban vengeance
THE GIRL WHO
HAS SWORN TO
KILL
CASTRO!

The fight that goes on in
the Philippines today
NAKED GIRL-BAIT FOR
THE OUTLAWS OF
LUBANG ISLAND

MAN'S ADVENTURE, 1/1965

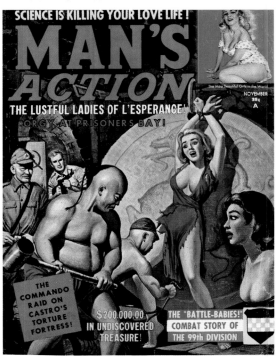

SCIENCE IS KILLING YOUR LOVE LIFE !

MAN'S
ACTION

NOVEMBER
35¢
A

THE LUSTFUL LADIES OF L'ESPERANCE
ORGY AT PRISONER'S BAY!

The Most Beautiful Girls in the World

THE
COMMANDO
RAID ON
CASTRO'S
TORTURE
FORTRESS!

$200,000.00
IN UNDISCOVERED
TREASURE!

THE "BATTLE-BABIES!"
COMBAT STORY OF
THE 99th DIVISION

MAN'S ACTION, 11/1961

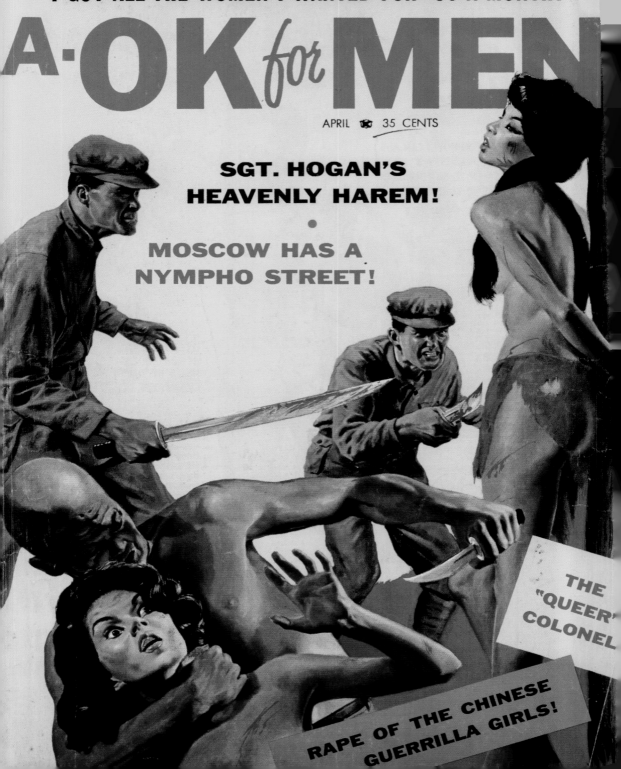

"I GOT ALL THE WOMEN I WANTED FOR $50-A-MONTH!"

A·OK for MEN

APRIL 35 CENTS

SGT. HOGAN'S HEAVENLY HAREM!

•

MOSCOW HAS A NYMPHO STREET!

THE "QUEER" COLONEL

RAPE OF THE CHINESE GUERRILLA GIRLS!

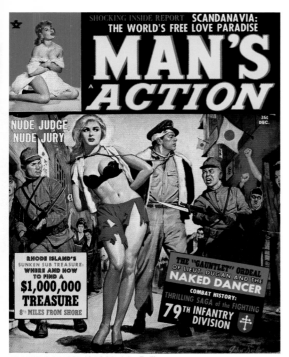

MAN'S ACTION, 12/1963, John Duillo

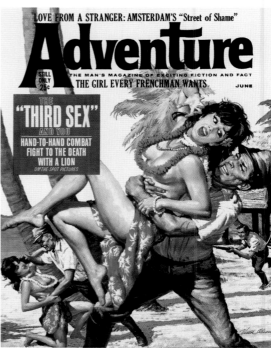

ADVENTURE, 6/1963, Victor Olson

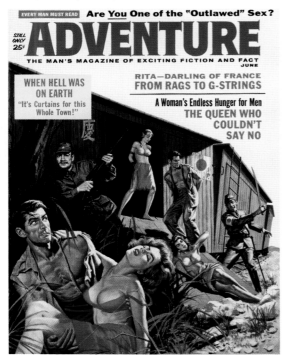

ADVENTURE, 6/1962, Vic Prezio
◄ **A-OK FOR MEN**, 4/1963

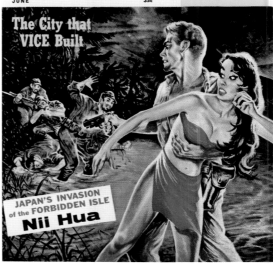

ESCAPE TO ADVENTURE, 6/1960, Mark Schneider

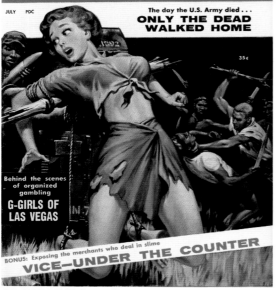

ALL MAN, 7/1962, Clarence Doore

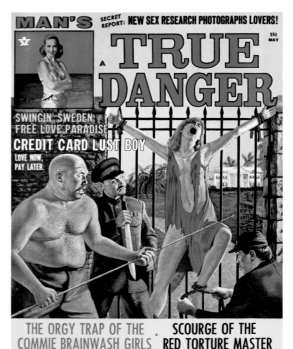

MAN'S TRUE DANGER, 5/1966

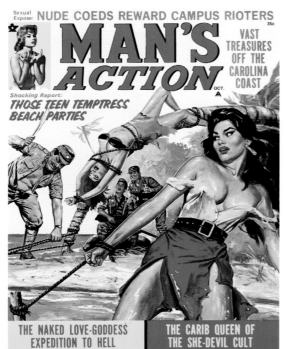

MAN'S ACTION, 10/1969, Norm Eastman

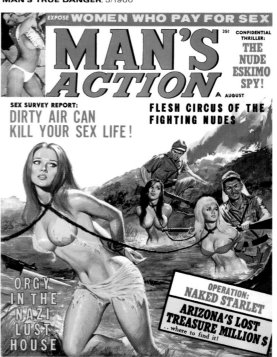

MAN'S ACTION, 8/1968, John Duillo

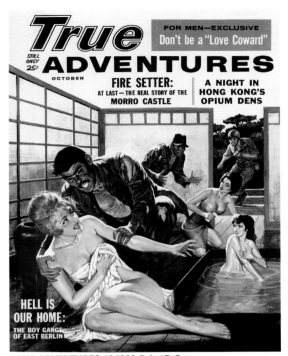

TRUE ADVENTURES, 10/1962, Rafael DeSoto

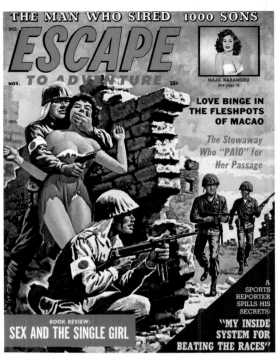

ESCAPE TO ADVENTURE, 11/1962

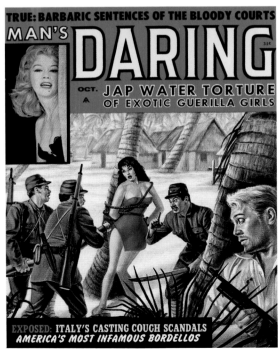

MAN'S DARING, 10/1960

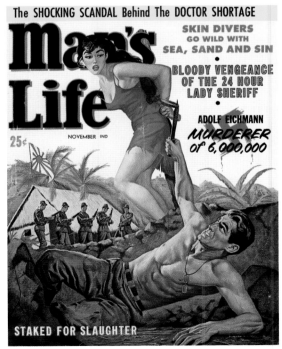

MAN'S LIFE, 11/1960, Vic Prezio

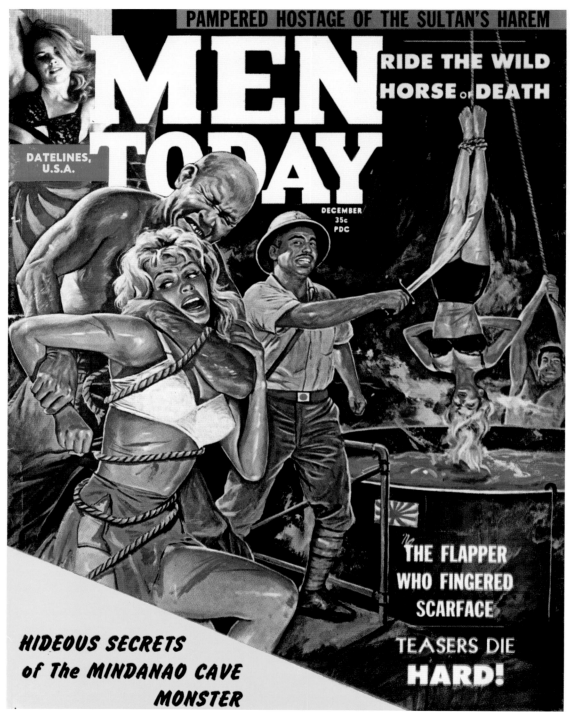

MEN TODAY

RIDE THE WILD
HORSE of DEATH

DATELINES,
U.S.A.

DECEMBER
35c
PDC

THE FLAPPER
WHO FINGERED
SCARFACE

TEASERS DIE
HARD!

*HIDEOUS SECRETS
of The MINDANAO CAVE
MONSTER*

MEN TODAY, 12/1961, Norm Eastman

MAN TO MAN, 3/1962 ▶

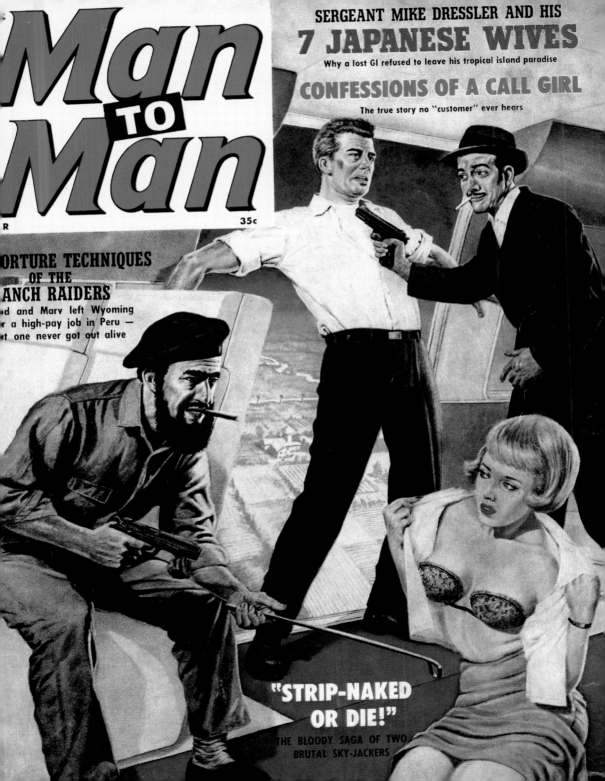

Man TO Man

35c

SERGEANT MIKE DRESSLER AND HIS
7 JAPANESE WIVES
Why a lost GI refused to leave his tropical island paradise

CONFESSIONS OF A CALL GIRL
The true story no "customer" ever hears

ORTURE TECHNIQUES
OF THE
ANCH RAIDERS
d and Marv left Wyoming
r a high-pay job in Peru —
t one never got out alive

"STRIP-NAKED
OR DIE!"
THE BLOODY SAGA OF TWO
BRUTAL SKY-JACKERS

TRUE ACTION, 2/1960

SEE FOR MEN, 7/1961, George Gross

MAN'S BEST, 3/1962

ESCAPE TO ADVENTURE, 11/1963

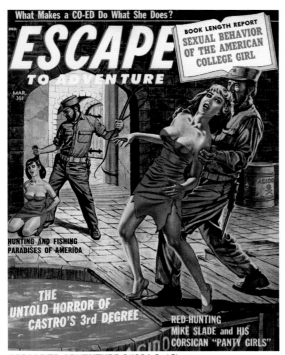

ESCAPE TO ADVENTURE, 3/1964, Syd Shores

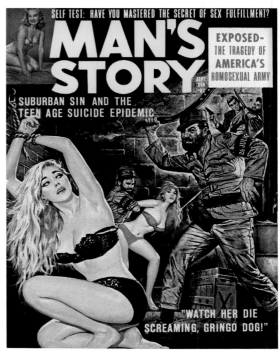

MAN'S STORY, 9/1965, Norm Eastman

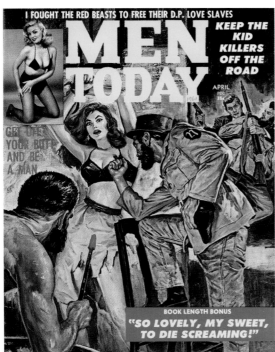

MEN TODAY, 4/1961, Norm Eastman

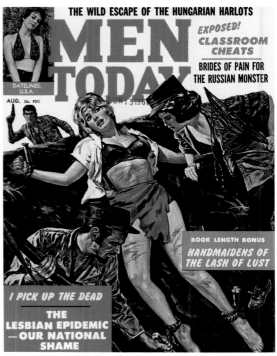

MEN TODAY, 8/1961, Norm Eastman
TRUE MEN STORIES, 8/1960, Will Hulsey ▶▶

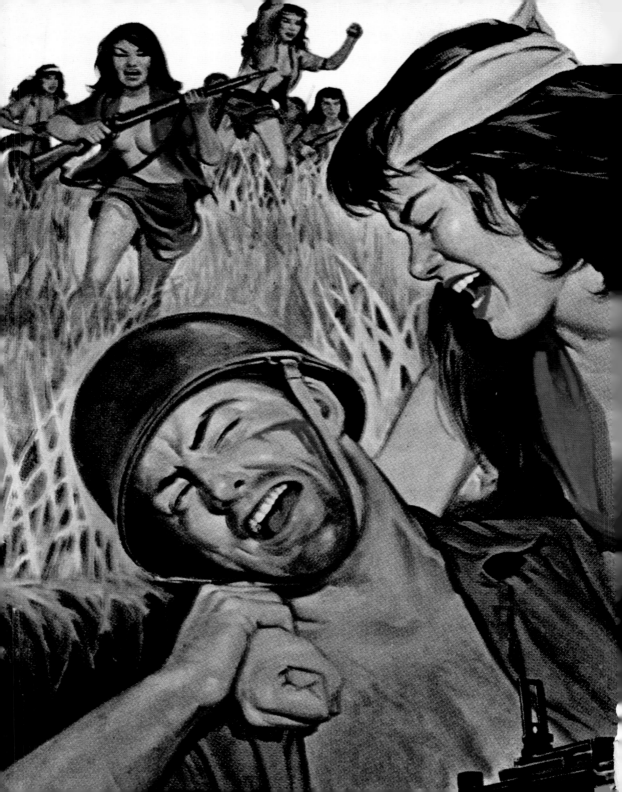

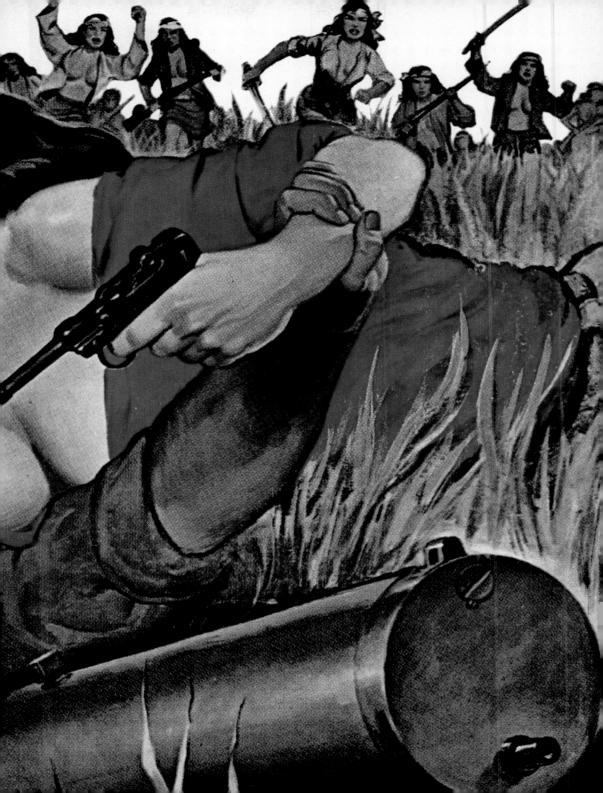

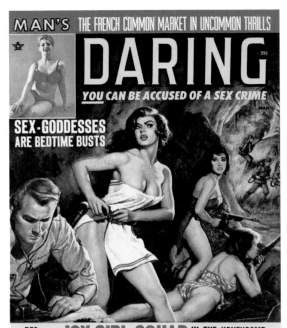

MAN'S DARING, 3/1964

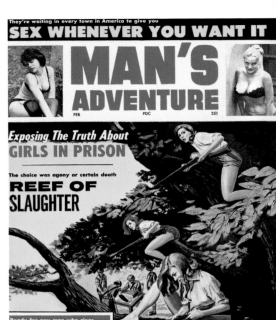

MAN'S ADVENTURE, 2/1964

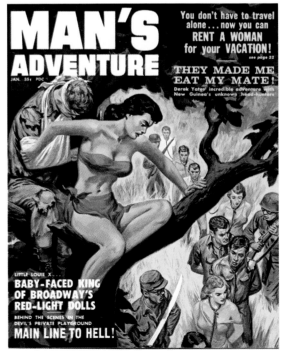

MAN'S ADVENTURE, 1/1960, Clarence Doore

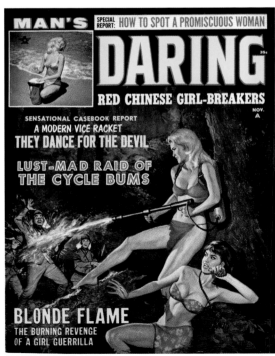

MAN'S DARING, 11/1965
BATTLE CRY, 11/1960, Rafael DeSoto ▶

true story behind the plush
ses that dot the countryside...

SEX IN THE SUBURBS!

BATTLE CRY

NOV. K 35¢

OVE SLAVES TO THE
EASTS OF TORTURE!

Christmas Eve
along the Yalu...

THE FROZEN WATERS of HELL!

EXCLUSIVE!!!
An ACTUAL
record in pictures
of an attempt to escape
the Iron Curtain...

DOGFIGHT TO SLAUGHTER

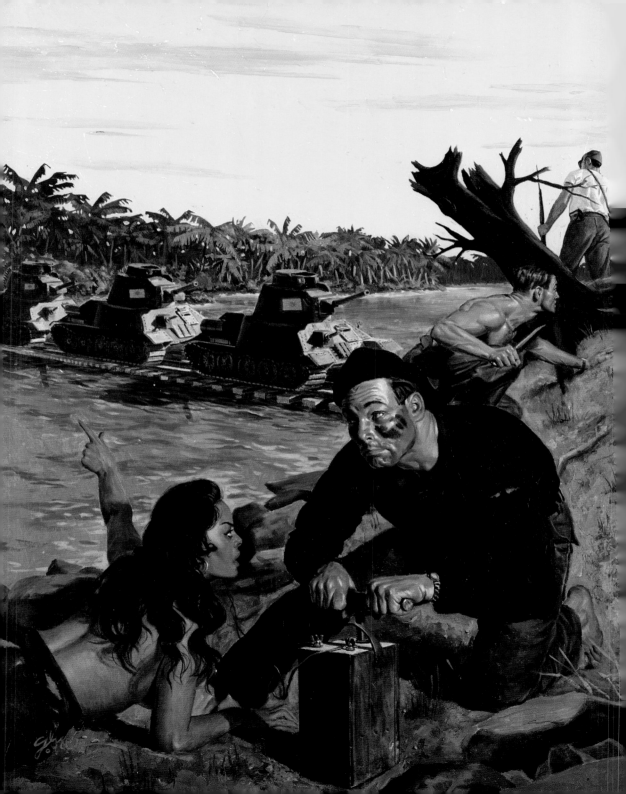

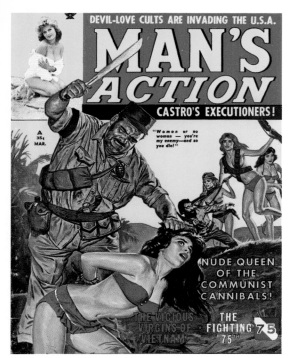

MAN'S ACTION, 3/1962, Norm Eastman

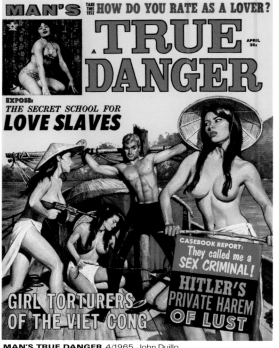

MAN'S TRUE DANGER, 4/1965, John Duillo

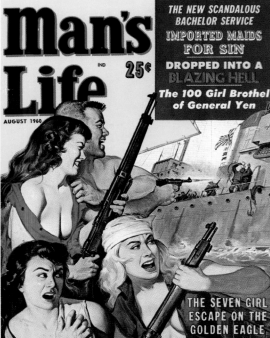

MAN'S LIFE, 8/1960, Will Hulsey
◄ **MAN'S CONQUEST**, 8/1959, George Gross, oil, 36 x 45 cm

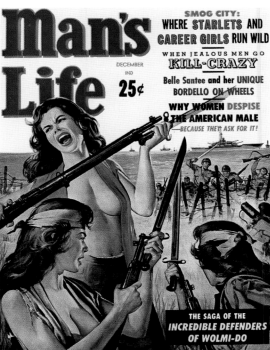

MAN'S LIFE, 12/1959, Will Hulsey

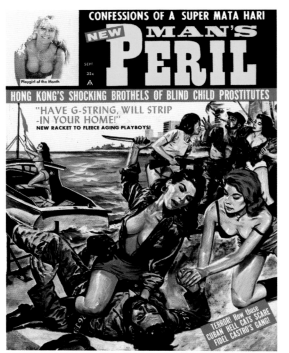

MAN'S PERIL, 9/1964, Norm Eastman

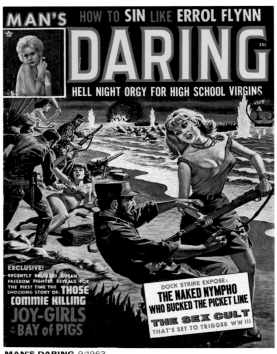

MAN'S DARING, 9/1963

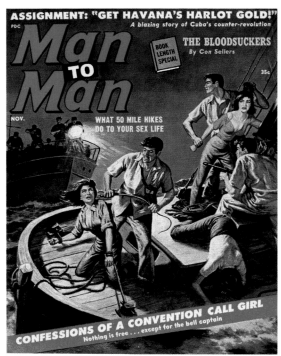

MAN TO MAN, 11/1963

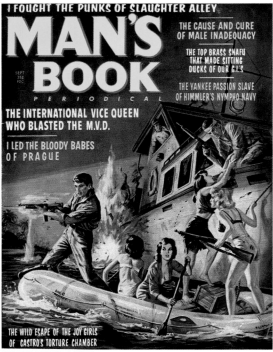

MAN'S BOOK, 9/1962

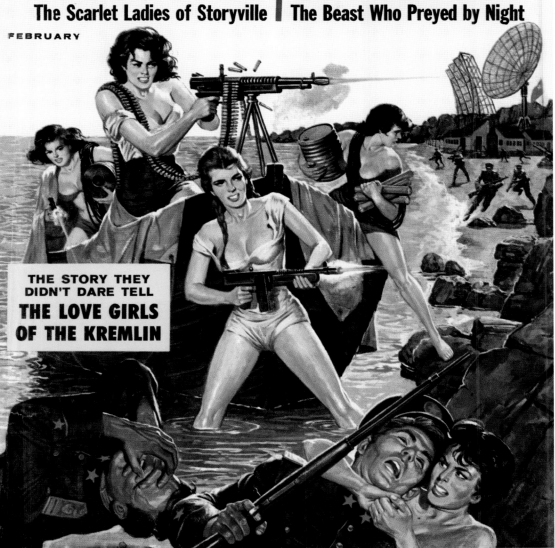

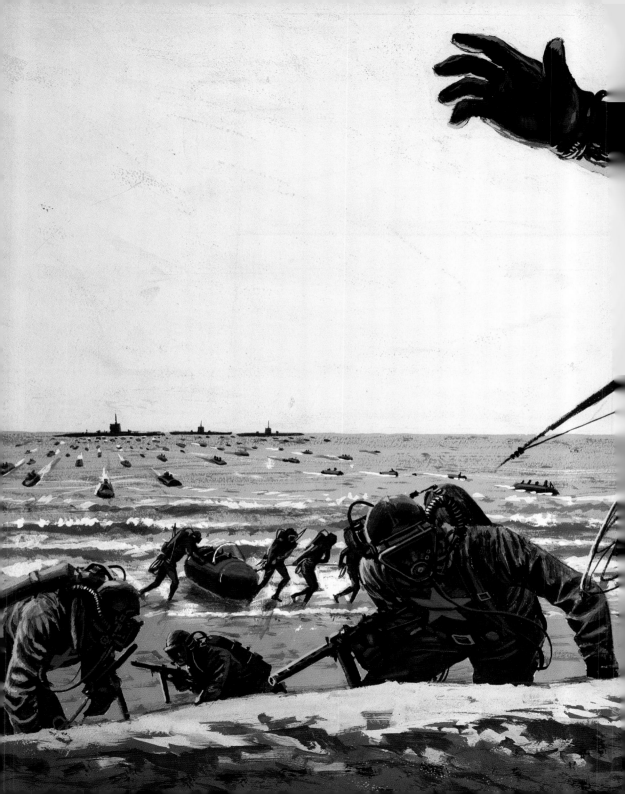

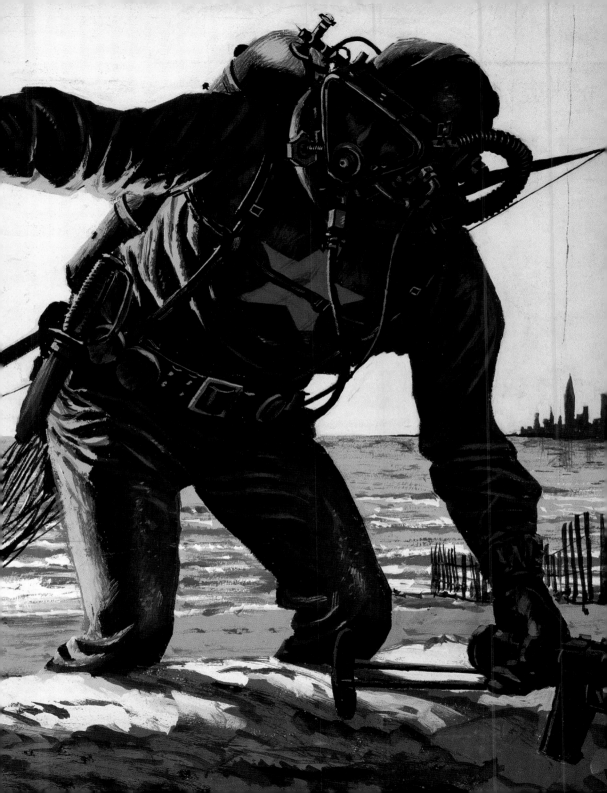

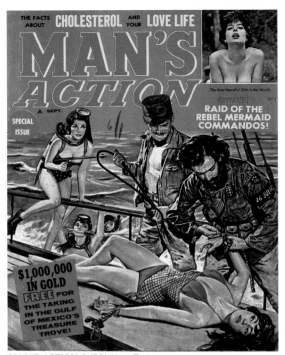

MAN'S ACTION, 9/1961, Norm Eastman

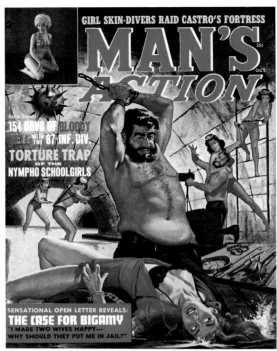

MAN'S ACTION, 10/1963

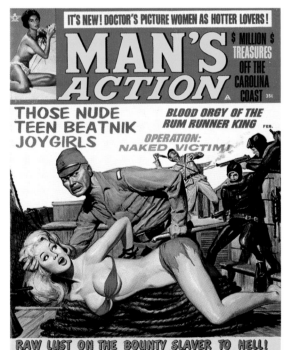

MAN'S ACTION, 2/1968, John Duillo

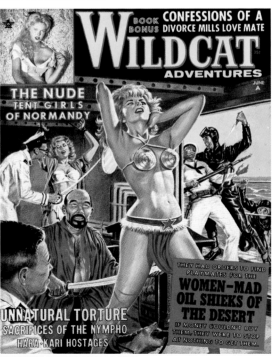

WILDCAT ADVENTURES, 6/1963

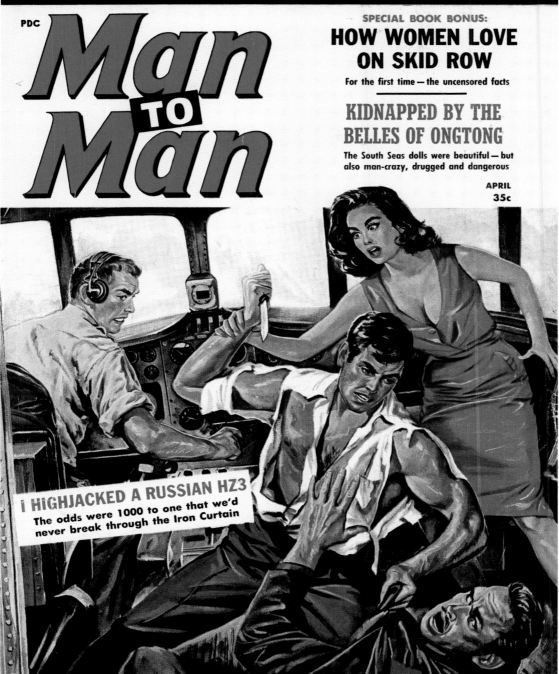

SATAN'S CIRCUS — WHERE THE DOLLS WALTZED NUDE

PDC

Man TO Man

SPECIAL BOOK BONUS:

HOW WOMEN LOVE ON SKID ROW

For the first time — the uncensored facts

KIDNAPPED BY THE BELLES OF ONGTONG

The South Seas dolls were beautiful — but also man-crazy, drugged and dangerous

APRIL
35c

I HIGHJACKED A RUSSIAN HZ3
The odds were 1000 to one that we'd never break through the Iron Curtain

MAN TO MAN, 4/1960, Norm Eastman

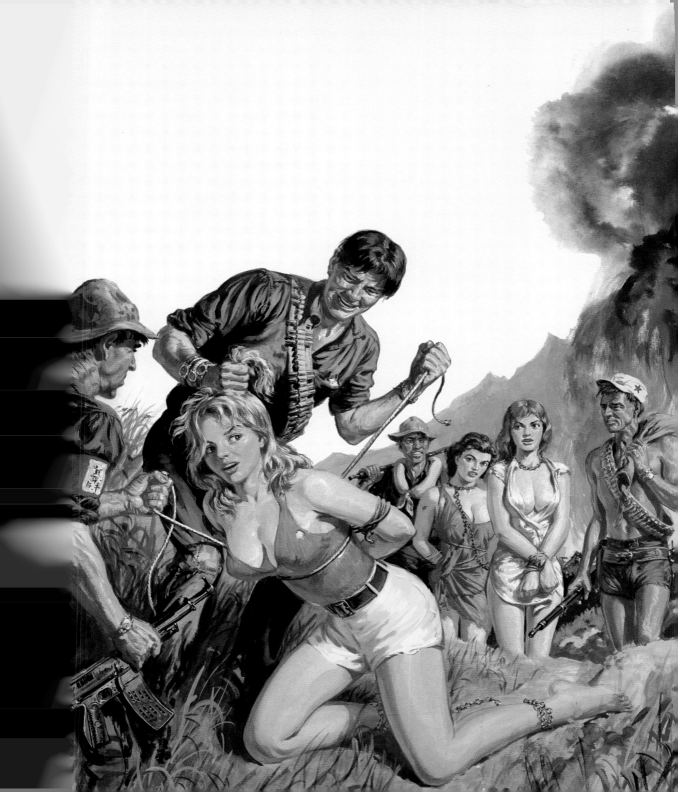

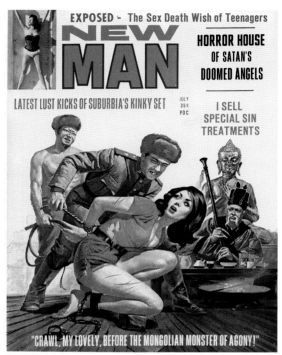

EXPOSED – The Sex Death Wish of Teenagers

NEW MAN

HORROR HOUSE OF SATAN'S DOOMED ANGELS

LATEST LUST KICKS OF SUBURBIA'S KINKY SET

JULY 35¢ PDC

I SELL SPECIAL SIN TREATMENTS

"CRAWL, MY LOVELY, BEFORE THE MONGOLIAN MONSTER OF AGONY!"

NEW MAN, 7/1966

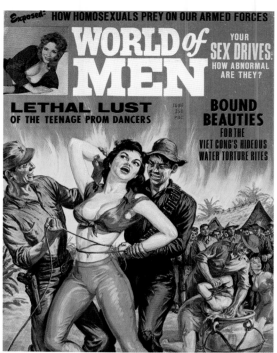

Exposed: HOW HOMOSEXUALS PREY ON OUR ARMED FORCES

WORLD of MEN

YOUR SEX DRIVES: HOW ABNORMAL ARE THEY?

LETHAL LUST OF THE TEENAGE PROM DANCERS

JUNE 35¢ PDC

BOUND BEAUTIES FOR THE VIET CONG'S HIDEOUS WATER TORTURE RITES

WORLD OF MEN, 6/1966, Norman Saunders

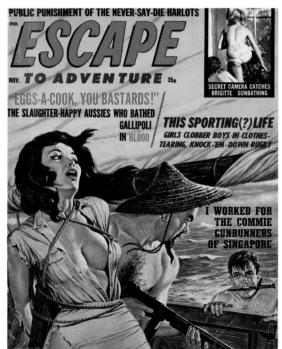

PUBLIC PUNISHMENT OF THE NEVER-SAY-DIE HARLOTS

ESCAPE

NOV. **TO ADVENTURE** 35¢

SECRET CAMERA CATCHES BRIGITTE SUNBATHING

"EGGS-A-COOK, YOU BASTARDS!"
THE SLAUGHTER-HAPPY AUSSIES WHO BATHED GALLIPOLI IN BLOOD

THIS SPORTING(?) LIFE
GIRLS CLOBBER BOYS IN CLOTHES-TEARING, KNOCK-'EM-DOWN RUGBY

I WORKED FOR THE COMMIE GUNRUNNERS OF SINGAPORE

ESCAPE TO ADVENTURE, 11/1964, Syd Shores
◄ **MAN'S EPIC**, 1/1966, Norman Saunders, gouache, 38 x 51 cm

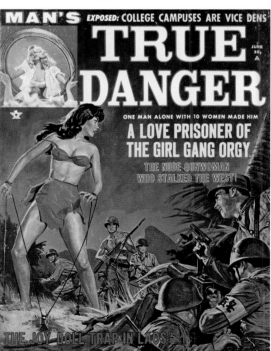

MAN'S EXPOSED: COLLEGE CAMPUSES ARE VICE DENS

TRUE DANGER

JUNE 35¢ A

ONE MAN ALONE WITH 10 WOMEN MADE HIM

A LOVE PRISONER OF THE GIRL GANG ORGY

THE NUDE GUNWOMAN WHO STALKED THE WEST!

THE JOY-DOLL TRAP IN LAOS

MAN'S TRUE DANGER, 6/1962, Norm Eastman

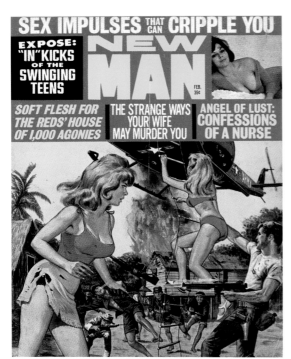

SEX IMPULSES THAT CAN **CRIPPLE YOU**

EXPOSE: "IN" KICKS OF THE SWINGING TEENS

NEW MAN
FEB. 35¢

SOFT FLESH FOR THE REDS' HOUSE OF 1,000 AGONIES

THE STRANGE WAYS YOUR WIFE MAY MURDER YOU

ANGEL OF LUST: CONFESSIONS OF A NURSE

NEW MAN, 2/1969

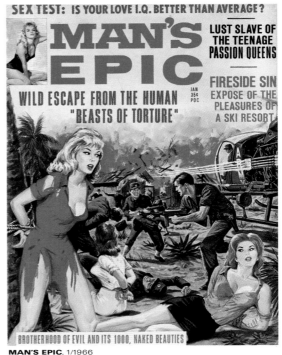

SEX TEST: IS YOUR LOVE I.Q. BETTER THAN AVERAGE?

MAN'S EPIC
JAN 35¢ PDC

LUST SLAVE OF THE TEENAGE PASSION QUEENS

FIRESIDE SIN EXPOSE OF THE PLEASURES OF A SKI RESORT

WILD ESCAPE FROM THE HUMAN "BEASTS OF TORTURE"

BROTHERHOOD OF EVIL AND ITS 1000, NAKED BEAUTIES

MAN'S EPIC, 1/1966

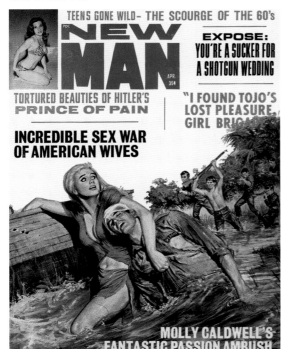

TEENS GONE WILD— THE SCOURGE OF THE 60's

NEW MAN
APR. 35¢

EXPOSE: YOU'RE A SUCKER FOR A SHOTGUN WEDDING

TORTURED BEAUTIES OF HITLER'S PRINCE OF PAIN

"I FOUND TOJO'S LOST PLEASURE GIRL BRIGADE"

INCREDIBLE SEX WAR OF AMERICAN WIVES

MOLLY CALDWELL'S FANTASTIC PASSION AMBUSH

NEW MAN, 4/1967, John Duillo

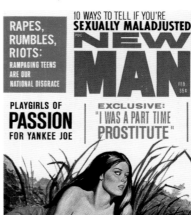

10 WAYS TO TELL IF YOU'RE SEXUALLY MALADJUSTED

NEW MAN
FEB. 35¢

RAPES, RUMBLES, RIOTS: RAMPAGING TEENS ARE OUR NATIONAL DISGRACE

PLAYGIRLS OF PASSION FOR YANKEE JOE

EXCLUSIVE: "I WAS A PART TIME PROSTITUTE"

LAST ESCAPE OF THE CHAINED BEAUTIES OF HITLER'S TORTURE COMPOUND

NEW MAN, 2/1968
MEN TODAY, 3/1968, Norm Eastman, acrylic, 43 x 55 cm ▶

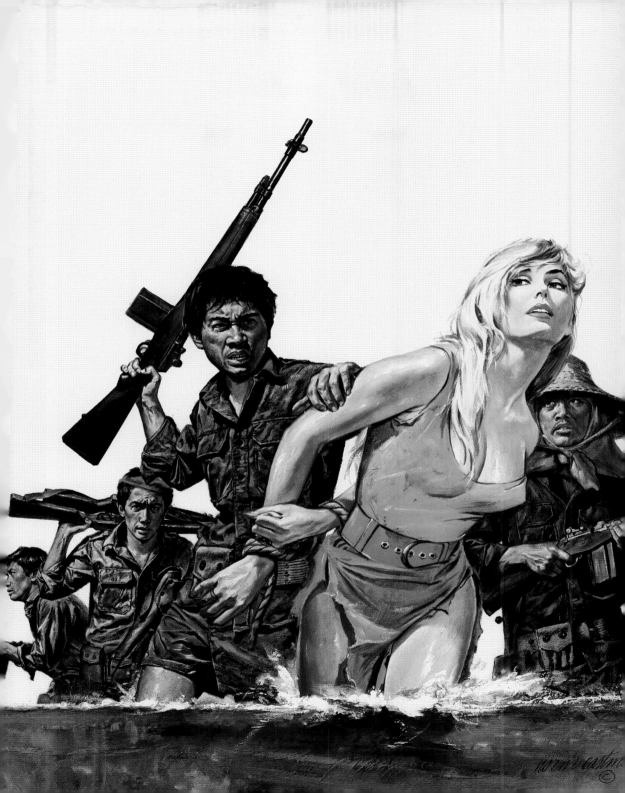

This book is respectfully dedicated to the many artists, known and unknown, whose work graces its pages.

Acknowledgements

From Rich Oberg:
Primary credits go to Leo Brereton of Streamline Illustrations for his amazing ability to help build this collection, sow the seeds of this book, and be a darn good psychiatrist — sometimes all at once. Inspiration and role model award goes to Walker Martin, a "godfather" of pulp collecting and one of my first sources of original art (much of which is in this book). There's no one who understands the mind of a "collector" better. Third, my thanks to Steve Vance the book designer/therapist who helped coach me through this project when I discovered just how much work it takes to put a book together and was running out of gas. Additional thanks go to Mitch Itkowitz (dealer), Craig Clements (collector and part Martian), Pete Lamberton (longtime collecting friend and invaluable reference), David Saunders for his enthusiasm for this book and his many hours of research on its behalf, Mitzi Azevedo, and my daughter Cat and son Alan who've variously helped organize and revel in their dad's weirdness. The fine folks at TASCHEN can also take a bow for their total professionalism in putting this all together.

From Max Allan Collins and George Hagenauer:
A big thanks to Roger Reed, Walt Reed, Fred Taraba Illustration House New York City, Harry Matestsky, Bob Weinberg, Roy Thomas, Matt Masterson, Leo Brereton, The University of Wisconsin Library, The Wisconsin Historical Society, James Peterson, Gary Friedrichs, Barbara Collins, Mickey Spillane; and Chuck King, wherever he is, who got George started on this project thirty-three years ago by mistakenly buying a load of sweats thinking they were comics!

From the editors:
First our thanks go to the artists who so generously provided information about the era and gave their blessing to this project: Gil Cohen, Rafael DeSoto, Jr. (son of Rafael DeSoto), Basil Gogos, Mort Künstler, Samson Pollen, David Saunders (son of Norman Saunders), and, most especially, Norm Eastman. To Rich Oberg, for letting us have a peek at the magnificent obsession that would make a pirate queen swoon; Max Collins and George Hagenauer, for their careful research and tawdry tales of flesh-eating men's adventure magazine editors; Steve Vance, for his valor, burrowing through infested gopher holes to design the book, generously offering his own knowledge on the subject, and generally saving our behinds; Leo Brereton of Streamline Illustrations, for initiating us into the world of men's adventure, one octopus attack at a time; Sonja Altmeppen, Christiane Blass, and Tina Ciborowius, for *not* tying us to a stake and watching us sizzle; Janet Duckworth, the editor every writer loves to love; Dian Hanson, for expertly navigating us through the piranha-infested waters of men's magazines; Blue Trimarchi, for braving thousands of magazines to capture all these attacks on film; Ethel Seno, for swooping at the last minute to save the day; the spies who infiltrated the fact-checking resistance and survived to tell the tale, our interns through the ages, Zel McCarthy-Smith, Jeanette Watson, Danielle Hylton, Drew Tewsbury, and Kate Soto — we thank you all. And, of course, to *el jefe*, Benedikt Taschen, *muchísimas gracias*.

ABOUT THE RICH OBERG COLLECTION

Rich Oberg maintains the largest known collection of men's adventure magazines and original cover and interior illustrations in the world — comprising over 3,000 original, non-duplicate issues and over 300 original cover and interior paintings from the early fifties through the seventies.

The collection began in the late 1980s as an initial stash of around 150 magazines accumulated at a time when the collector's market cast men's adventure art aside in favor of the pulps. An initial childhood fondness for the magazines — one Oberg attributes to an accidental foray into his father's closet as a twelve-year-old — has inspired an amassing of some of the most important artwork of the genre, including originals by such heavyweights as Norm Eastman and Norman Saunders. He boasts complete or near-complete runs of many titles, including *Man's Life, Man's Adventure, Man's Book, World of Men, Men Today,* and *Battle Cry,* sixty of which are volume one, number one, first-edition issues.

The collection of original art reads like a roster from the pulp and men's adventure Who's Who, including: Stan Borack, Mel Crair, Doug Allen, James Bama, Tom Beecham, Rudy Belarski, Phil Berry, Gil Cohen, Charles Copeland, Rafael DeSoto, Howell Dodd, Clarence Doore, John Duillo, Basil Gogos, George Gross, Ray Johnson, Mort Künstler, John Leone, Brendon Lynch, George Mayers, Jim Meese, Bruce Minney, Rudi Nappi, Earl Norem, Victor Olson, Samson Pollen, Walter Popp, Victor Prezio, Harry Rosenbaum, Tom Ryan, Mark Schneider, Syd Shores, Santo Sorrentino, Robert Stanley, and L. R. Summers.

Nostalgia for his youth, combined with a layman's fascination for the artistic talent behind the work, has sustained the construction of an exhaustive collection — a monument to the innovative artists who defined an era of adventurous men. It is art (we're sorry to say) you'll have to enjoy just in the pages of this tome, as the archive is closed to the public.